THE IMAGE BUSINESS

MEAD PRESS
Woodlands
Sandy Down
Boldre
Lymington
Hampshire SO41 8PL

First published in Great Britain in 2021
by MEAD PRESS

A CIP catalogue record for this book is available
from the British Library.

ISBN: 978-1-9196392-0-8

Cover design and layout by
www.chandlerbookdesign.com

THE IMAGE BUSINESS

GET THE PICTURE, TELL THE STORY.

STEVE POWELL

WRITTEN IN COLLABORATION WITH
JOHN WALKER

MEAD
PRESS

CONTENTS

I offer this book to my first Grandchild,
Noah, in the hope that your life is
full of adventures and joy....

.... and to the girls in my life,
Beans, Lucie and Sophie,
without whom

INTRODUCTION

This is the story of how I, who just wanted to be a photojournalist and war reporter, became caught up in the digital technology revolution and drove Allsport to what became the largest and most exciting sports photographic agency in the world.

To all my friends and colleagues who shared these experiences with me, I make no claim that this is the Allsport story; it is not. To do that justice would require a tome as large as *War & Peace* and would be equally challenging to write, and to read.

This is simply one man's story of the amazing times he was fortunate enough to have lived through and shared with you all.

PROLOGUE

Winter Olympics, Nagano, Japan.
11am Saturday, 7th February 1998.

Bitterly cold with the threat of snow showers and freezing rain. There in my role as a member of the International Olympic Committee's Media Commission, we had been negotiating and overseeing the facilities for the 10,000 accredited journalists and broadcasters. As the time for the opening ceremony approached, we were about to discover how well that planning would deliver. More than 2,000 athletes from 72 nations, contesting 68 events in 14 venues, spread around the mountains which the locals call 'The Roof of Japan', had required a lot of planning and understanding of Japanese culture. Now, there was no hiding place. The Games of the XVIII Winter Olympiad were in motion.

Joining 50,000 spectators and the Emperor of Japan in the Minami stadium, we watched singers, dancers, artists, sumo wrestlers and musicians doing their thing. Choirs from around the world belted out Beethoven's *Ode To Joy;* who knew why? As Eishiro Saito, President of the Nagano Organising Committee began his stuttering address, my mobile phone vibrated. It was one of the richest men in the world, giving me the news that I had been eagerly awaiting, that he now owned Allsport.

The company that I had spent the last 30 years building into the world's pre-eminent sports photographic news agency was embarking on its next journey, as was I.

1

ARMY BRAT TO DARKROOM

The benefit of age and the joys of hindsight have helped me realise that by its very nature, life is a rollercoaster of emotional highs and lows, interspersed with moments of euphoria; a constantly evolving learning curve of successes and setbacks. Just how these are met, overcome and capitalised upon define our life stories. As I began to assimilate what had been achieved with the sale of Allsport, I realised that this re-set of my life was one more punctuation mark in a story that began at a different time and in a different world. So, how did it start?

My parents both came from military backgrounds; my mother a good convent girl with family links to the Irish Guards, my father then a corporal serving in the Scots Guards. I was truly an army brat and spent most of my formative years moving around the world with them on my father's postings. This did much for my knowledge of geography, but little for my formal education. Always a towering presence in my life, my father was a tall, upstanding man of military bearing, with a clear, moral code and pride in his family and inevitably, the extended family of his regiment. Part of the Guards Division, the Scots Guards can trace their origins to 1642, when they were raised as the personal bodyguard of King Charles I of England and Scotland. Traditionally, recruits to the Guards Division endure, or occasionally enjoy, a 30-week basic training programme, acknowledged to be the toughest indoctrination of any in the world, producing some of the best soldiers. My father had come through this process and prospered.

Aside from their military function, battle honours from Namur to Mount Tumbledown and Hougoumont to Helmand give the clue, the

It all started here: my parents, Mike and Eileen,
were married in Caterham, Surrey in 1951.

regiment also serves in a ceremonial capacity. I was among the crowds that watched the coronation of Queen Elizabeth II in 1953, as my father was on parade. I can't say that I remember too much about it as I was less than a year old, in a pram, but I was there. One year later I began my travels, when the regiment was posted to Germany to join the British Army of the Rhine near Frankfurt. Then promoted sergeant, overseas postings followed which took us to Kenya, where my Dad often took on the organisation of events, including versions of the regimental *durbar*. He played polo: less gin and tonic, Happy Valley country club, but more in the 'other ranks' style. No social niceties and more to do with finding a pony that fitted and just getting on with it.

My memories of Kenya are of a much more relaxed lifestyle: understatement! I found Africa just the most amazing and exciting place to live and not without its unique challenges. One of my earliest memories of my mother is of her in a large 1950s style floral petticoat dress, using a twig broom to chase what must have been a two-metre-long puff adder from our kitchen and encouraging all sorts of other

Fresh out of training as a boy soldier and aged eighteen, my father and his cohort had been posted to police the disputed zone around Trieste in July 1946 as part of the Central Mediterranean Forces.

venomous snakes off our property. To break the monotony of barrack life, my father would take us on safari in the bush, sleeping under canvas or travelling further afield in a venerable, yet surprisingly reliable, 29hp Fiat 600. We had christened this the *Cocoa Tin* and it carried us on family beach holidays to Mombasa, a journey that took 18 to 24 hours to cover the 500 miles of dirt roads. We saw plenty of wild animals, as the whole country was one enormous game park.

By the time he was posted back to the UK, my father had been promoted sergeant major, recognition for a proper man, doing proper men's things. He believed in teaching by example, and along the way he had shown me what he did and how he did it. How many other children of seven could claim to have fired every hand weapon used by the

Our time in Kenya was enlivened by trips up-country in my father's pride and joy, a 29hp Fiat 600, which we had christened The Cocoa Tin.

British Army; except perhaps the bazooka. To us kids, army life seemed almost too good to be true and too good to last, so we made the most of our freedom. Basically, we were feral and we had a great time, even if my formal education suffered to the point of non-existence. It was this imbalance in my education, good in bush but bad in book, that began to weigh on my parents' minds. It became clear that they had their sights on something a little more formal for me.

My father was eventually posted home in late 1961, seconded to the Army Foundation College in Harrogate, training junior entry infantry soldiers and made the rank of warrant officer. I was despatched to school in Hertfordshire, to learn stuff. My early education had been dire, my knowledge of reading, writing and arithmetic was lamentably poor, as it had never been a priority. So it was, that when I took my place amongst the pupils of St. Dominic's Priory school in Cuffley, at the age of nine, its Catholic nuns found me largely innumerate, illiterate and intemperate, and I was starting at the very bottom of the learning curve. This was to be a recurring feature of my life, though I didn't know it at the time. My mother must have had a fair knowledge of the methods used by the nuns and they certainly didn't spare the rod, so for the two years of my incarceration there, these ladies regularly, if lovingly, beat knowledge into me.

Looking back, I remember those days as not being a particularly fun experience because I was so far behind my fellow pupils and under constant pressure to learn and perform, but it would be totally wrong to say that I had an unhappy childhood. Just the opposite in fact. The joy of being awoken at 4am to serve at early morning mass, in Latin, under the unwavering gaze of the nuns. The terror of getting things wrong was offset by the rewards of breakfast porridge with the top of the milk and brown sugar. The nuns were quick to beat, as nuns were wont to be in those days, but they did it so effectively that I managed to score high enough grades to get me into my next school on academic merit; Queen Victoria School (QVS) in Dunblane, Scotland. Not sure who was most surprised; the nuns, my parents or me.

QVS was founded in 1908 to honour the memory of Queen Victoria, for 'the sons of Scottish soldiers, sailors and airmen'. The school offered a disciplinary regime and ethos designed to produce confident, self-sufficient, hard-working, well-mannered individuals who could think for themselves and get along with their peers. This came as a bit of a culture shock to me, as did the rural location on the outskirts of the town, which I liked a lot. I guess the bigger shock was finding myself required to dress

in the school's regulation uniform of scarlet tunic, kilt and Glengarry. That little detail aside, I fitted in well enough and prospered, though not necessarily in the more formal areas of school life.

Whether the teachers considered that I had fully absorbed the founder's ethos was never made entirely clear, but I certainly became more confident, self-sufficient and sociable, so I guess that three out of six wasn't bad. It was here that my interest in photography was piqued and how it might earn me a living took root, in quite surprising ways. On my fourteenth birthday and after some judicious lobbying with deeply unsubtle hints, my parents gave me a Yashica 35mm, single lens reflex camera, which became the first of many cameras in my life. The school already had a thriving photographic club run by the science master, later deputy head, Ben Patterson, and he worked hard to show us that with a little knowledge, much could be achieved. I absorbed all this like a sponge, although my first efforts were probably not precisely what he had in mind.

My parents were regularly moved around the United Kingdom on home postings, but many of my fellow pupils had been 'parked' at QVS by parents who were on overseas duties in the furthest corners of the globe. Came vacation time, the overseas contingent travelled abroad to spend time with their parents, for which they needed documentation. This, in turn, required mug shots. I saw this as a potential source of income and accordingly, set up my first photography business, doing passport photos. It may seem hard to understand today, but the austerity that had followed the end of the Second World War had not totally disappeared. The currency for my little enterprise was not money or even cigarettes, but was made up entirely of pats of butter, which I could trade on for other more interesting things. Thus, I became the custodian of what was probably Europe's first privately owned butter mountain.

It was inevitable that a military school library would contain many books recording past conflicts in which our armed forces had played a role. As interesting for me were more modern sources such as *Life* magazine and the *Sunday Times*, recording what were then current conflicts. I became fascinated by how they recorded coverage, first by war artists and then by photographers: most prominently Larry Burrows and Don McCullin. Both men were Londoners, both became photojournalists, both made a speciality of war coverage and during my formative school years, both were covering the seemingly endless activity of the Americans in Vietnam. It was not just their abilities with a camera that grabbed me, but their dedicated reporting of the whole, bloody, panoply of conflict seen almost exclusively through the eyes of the regular soldier; in what was a very

irregular war. I was probably too young to realise the true significance of their work at the time, but their vivid and visceral reporting of the minutia of the conflict was to influence me in later years. Burrows' intense and technically brilliant photo essays hooked me on the medium and the message that could be conveyed. Burrows and McCullin inadvertently shaped the direction of my life. Call me impressionable if you will, but nothing I had read before, or have since, quite caught the moment like their words and pictures. The two men's work convinced me, an open-minded teenager, that I wanted to become a war photographer. While McCullin survived his wars and is still photographing today, sadly at the tragically early age of 44, Burrows was killed covering Operation Lam Son 719, the massive, armoured invasion of Laos by the South Vietnamese, when the helicopter in which he and other war correspondents were riding was shot out of the sky.

By then, I had left QVS behind me and was holding down my first job as a runner in the photographic world, working for the Keystone Press Agency at their office in London's Red Lion Square, off Fleet Street. There are a number of concepts in that sentence that almost certainly need explanation to a modern generation, raised on the immediacy of digital images and a free press, before anything that follows will make any sense. What's a press agency, what's a runner and what's Fleet Street?

It was newspaper editor, Arthur Brisbane, who is reputed to have first coined the phrase: 'Use a picture. Its' worth a thousand words'. Today's photographic imagery has moved so far away from the work of the maestro of the camera obscura, Louis-Jacques-Mandé Daguerre, who changed the nature of visual representation techniques for ever, that neither he nor Brisbane would recognise it. The Frenchman might have started photography on its hike into history, but more than 1.4 trillion pictures would be taken in 2020 alone and 7.3 trillion stored on some sort of database. Most will have been taken by digital cameras or smart phones and a vanishingly small number taken on negative or colour film to be developed and printed in what had once been the standard format for every newsroom and picture editor in the world. The school photographic society had taught me the messy business of using developer, stop solution, fixer and hypo-clearing solution to bring my efforts from exposed film to end-prints and happily, this stood me in good stead when I applied for my first job.

It came out of a conversation with my father who never wanted any of his sons to follow him into the military. Indeed, he wouldn't have followed the flag himself, had it not been for family financial

circumstances. Losing both his father and his income which, preventing him progressing in his chosen career as an architect, this left him with no real alternative. He certainly wanted us to have more freedom in our choices than he had experienced and encouraged us to follow our dreams, insisting that job satisfaction was more important that money or security. He'd had an adventurous life and wanted the same for us. In my case, it was to be photojournalism.

From QVS I had secured a place at the London School of Printing to read for a BA in photojournalism, but after a summer doing portraiture and wedding portfolios for friends, I got to thinking that a further four years of study would be a waste of my time. Being young and impulsive, I thought that what technical skills I had amassed at school would let me walk me into a job as a professional photographer, but I was quickly disabused of that idea. What I found was an organisation called the Keystone Press Agency and simply, if naively, I approached them for a job. Surprisingly, I was invited for interview.

The London office of Keystone was owned and run effectively by the dapper, urbane and efficient Bertram Garai, into whose presence my father and I were ushered one bright day. My father thought it only proper that he should oversee the interview process, but in truth, I didn't get a look in after the first minute. Bertram was ex-Tank Regiment and recognising my father's regimental tie, they fell to discussing all things military rather than anything much about the young man sitting squirming in front of them. Finally, after a lengthy interview that didn't involve me, I can remember the great man announcing that any son of a guardsman was good enough for him and I had a job, as a 'runner'. About the lowest form of animal life, but importantly, my entry point into the intoxicating world of photography and newspapers.

In the hierarchy of professional photographic agencies, it didn't get much better than Keystone. Bertram had spent the years of the First World War in America translating stories and captions wired back from the Front whilst working for the Press Illustrating Company. When it merged with the Keystone View Company he was promoted to manage the enlarged business and returning to the UK in 1920, he established Keystone Press Agency in London, which quickly rose to prominence. His philosophy was summed up in what might now be called a mission statement; 'see beyond the borders'. Its role was quite simply to employ photographers who it dispatched hither and yon in pursuit of news stories. Recovering their exposed film, it was processed, selected frames printed and captioned, and the finished product delivered onto the desks

of the newspaper and magazine picture editors as soon as was humanly possible and certainly before the opposition agencies. Historically, this last link in the chain was fulfilled by a truly mixed bag of people who supposedly ran from the Keystone office to the picture desks of all the national and regional daily and evening newspapers, then based in the dark caverns off Fleet Street. Hence the term, 'runner'.

Joining Keystone in 1969 aged seventeen, I was a very junior cog in their wheel. The whole ambiance and operation of their business, located as it was in the very heart of Fleet Street, was all just a bit awe-inspiring, but it was the first step on the ladder to becoming a professional snapper or picture editor. It was also a deal more appealing to me than doing a stint at college which might have taught me useful stuff and delivered a portfolio and letters after my name, but which would lose me another four years at a time when I thought life was passing me by. As Keystone photographers used to win most of the British press awards each year, I figured that I could learn more from working with the cream of the crop.

I quickly got into the swing of things, talking to the photographers as they returned from chasing their stories, watching their films go into the darkroom and the picture editors making their selection from the negatives. From these, the print room would rapidly knock out between a dozen and one hundred black and white photoprints. Then we watched as the editor wrote and Xeroxed the appropriate caption, glued it to the back of each print and passed them to us messengers and runners in dispatch. The first picture to hit the newsrooms was almost inevitably the one that got used and that was my job.

If my driving ambition was to get a camera in my hand and take wonderful photographs, not all my colleagues shared the same motivations for joining. One of my greatest friends, who made an international name for himself, was David Ashdown: we joined Keystone on the same day. He later admitted that the bigger lure of becoming a messenger, the elite of runners, was to get his hands on the motorcycle that went with the job rather than the meagre pittance that went with it. My weekly wage of £4.50 amounted to just eleven pence per hour. 60% of that wage went on rent for my share of a one-bedroom flat in Brixton. Paid next to nothing, however hard the going, it bred survivors in the industry, and I guess we both qualified. My rejection of a military life had led me to cultivate a thriving head of hair and pretensions to being a hippy. On the other hand, David favoured leather and saw himself as more of a rocker. I am still hairy, and he became a multi-

award-winning photographer. When he left the *Independent* newspaper, he had been its longest serving and unquestionably most successful staff sports photographer.

In the late sixties and early seventies, and still influenced by an intoxicating mixture of history and modernity, Fleet Street was dominated by newsprint, red wine and the law, all of which added to the romance of our business. Go back 500 years and it was an apprentice to William Caxton with the highly unlikely, yet somehow appropriate name of Wynkyn De Worde, who set up his own printing shop in Shoe Lane, the first of many established to serve the needs of the legal profession. The Inns of Court, those professional associations for barristers, together with many legal practices set up to serve and support them, occupied ground on both sides of Fleet Street, clustering close to the Courts of Justice. Where lawyers and printers gathered in any quantity, so you would find all manner of taverns and wine bars to keep them lubricated and fed. A proximity as natural as the daily rising and setting of the sun.

The glory days between the wars and into the fifties were the heydays of the old-style press barons, and barons in every sense of that word; proprietors riding unchallenged over their family fiefdoms. Beaverbrook at the *Express*, Northcliffe at the *Times* and Rothermere at the *Mail* all had enormous influence over the political and economic scene and were not afraid to concoct thunderous leader columns in support of their chosen causes. Evelyn Waugh's novel, *Scoop*, barely touched the sides. By the time I began working there, Fleet Street was overshadowed in architectural terms at any rate, by the classic facade of the Reuters building and the more modern edifices opposite occupied by the *Daily Express* and *Telegraph*.

Equally, it was overshadowed by the progress-crippling archaic practices of the print unions, to whom newspaper owners were in total thrall. Nothing could or would happen in the process of bringing a newspaper together without sanction by the various journalistic or print unions. Woe betide a crusading editor or noble owner if they suggested anything that was likely to change the existing and often highly dubious practices of the workforce, whose ability to milk money from the system was unparalleled. Each union had its own chapel, the fathers of these chapels held total sway and their control of working practices and pay was absolute. Restricting freedom of practice, maintaining jobs for their chosen few, whether real people or ghosts who only appeared on the payroll and never on the print floor, or generally holding the business to ransom, if they could exercise their views then they would; and did.

Fleet Street and its back streets hosted a warren of small offices and no title worth its name was unrepresented there. Thus, alongside the bigger titles, we also sought out the picture desks of the *Sketch, People, News of the World, Mirror, Guardian* and others. These included more esoteric publications and titles specialising in any other sport or pastime, from athletics and boxing to horse racing, fashion, football, rugby and pigeon racing. To put things into proper perspective, in proportion to its population, the sale of newspapers in Britain was greater than any other country in the world and its lifeblood was all around us. When we finished dropping off pictures at the *Punch* offices in Bouverie Street for example, it was difficult not to stop for a moment to watch the enormous rolls of newsprint being winched up to the upper floors of the printing houses opposite. Nor could we avoid the rows of delivery vans queuing in Tudor Street. Loading any one of up to eight daily editions of the *Evening Standard* or *Evening News*, before delivering them to every street corner and railway terminus in the capital, for dispatch across the country. From the *Times* to the *Beano*, Nigel Dempster to Rupert Bear, all life was here, and I absolutely loved it.

International photo-news agencies were operational around the clock, their copy takers recording the words filed by their journalists and stringers around the world. Their teleprinters, phone lines and wireless connections churning out the copy that would grace the country's breakfast tables the following morning, set in hot lead and rolled off the presses. Words were nothing without pictures and apart from earning reproduction fees from the newspapers for what we called the instant fix, the pic on the day, the better agencies had a much more valuable resource. This was vested in their immense and constantly growing picture archives.

Keystone's archive amounted to many millions of images, many generated in house but supplemented by many more that had been acquired and amassed from widely differing sources over 100 years of news gathering; from the Russian Revolution, through the Great War and Third Reich, to the moon landings; all were stored here if you knew where to look. Every day the archive grew and merely keeping pace with this tide of visual information and storing everything correctly so that it could be found again, as required, was the work of genius. Our boss presided over this task with amazing good humour and a handle on everything.

There are some obvious parallels to be drawn between publishing and photography. In both cases, creating an end-product is the easy bit. The more difficult bit is in having outlets for that end-product so that

London's Fleet Street pavements in the sixties and seventies were pounded daily by people carrying bundles of photoprints, en route between the agencies and news desks and I joined this group of 'runners' in 1969.

Photo: Alamy Archive

it doesn't just sit about gathering dust on a shelf or warehouse floor. Keystone's owner was a past master at developing methods for storing his growing accumulation of negatives and photoprints so that he could maximise the asset, on demand, but as one observer at the time remarked: 'In the beginning there were just picture libraries. There were no rules, no terms and conditions, no directory and no trade association'. When I joined Keystone, the agency marketplace was like the Wild West.

Now it is unlikely that any trades or professional organisations are not banded together for mutual benefit or commercial protection, but it was different then. Later, the British Association of Picture Libraries and Agencies came together to protect agency interests, but then my interests were pitched slightly lower and closer to home. Whether by good luck or good judgment, I learned so much from Keystone's archiving policy that stood me in good stead later in life when I faced similar problems, but within three years of my joining, three events had occurred that changed the course of my life forever. I advanced from runner to darkroom technician, developed as a freelance photographer and met Tony Duffy. Together, he and I would go on to pioneer and shape the way in which modern picture agencies operated.

2

LONG JUMP INTO
THE FUTURE

Because of its reputation and location, Bertram Garai's Keystone office became the meeting point and clearing house for a good many practicing and aspirational photographers. An interesting bunch from many different backgrounds and walks of life, all appeared to share a fascination for taking pictures and were keen to discover how to make a living as freelancers; from what for many had been only a hobby, until the passion bit. I came in at very much the lower end of the food chain, wide-eyed and wet-behind-the-ears, fresh out of school. I was eager to listen and watch my elders and betters doing what I wanted to do, absorbing their stories, fact, fiction and anecdote, and sucking up the atmosphere.

Sweating it out amongst the Keystone runners, it wasn't long before I became aware of the name and work of Tony Duffy, who long before my arrival, had been one of the more regular visitors to the little courtyard off Fleet Street. In what he has always acknowledged was a mixture of pure luck and serendipity, his hopes of swapping his life as an accountant to become a real-life sports photographer had taken a major leap forward in the 500th of a second it had taken him to capture Bob Beamon's Olympic and World record long jump at Mexico in 1968. Tony was a self-confessed amateur with little knowledge about the theory or mechanics of photography, but a passion to take photographs of any sport and at any level of competition. What knowledge he had amassed was purely by experimentation. His emotional drive was simply the need to be on the same tracks and in the same arenas as the athletes, talking to and rubbing shoulders with them, a real sea-change from his less glamourous job among the tax ledgers. Having paid his own way to Mexico, managing to

capture the Beamon picture despite having a very basic manual operation camera and one 300mm lens which he had only acquired just before flying out, was nothing short of remarkable. On the face of it, the chances of him getting anything notable might have seemed remote.

Having manoeuvred himself down from the bleachers to trackside, he discovered himself close enough and head-on to the long-jump pit, where he focused on the early rounds of the men's competition. The most notable jumper was Beamon. Following the action through his viewfinder, he caught the American delivering his remarkable competition-ending leap of 29ft 2ins (8.90m), which shattered the previous record by 1ft 9ins (55cms). It remains the Olympic record still, arguably meriting the accolade of the greatest single athletics feat of all time. Once several measurements had confirmed the initial disbelief at the distance and people had realised that something momentous was in progress, Beamon had lost interest. The reality swiftly dawned amongst the professional press corps that if you hadn't been there for those early qualifying jumps then you had missed the scoop of the games.

By some quirk of fate, Tony Duffy the amateur, had got the shot that every professional snapper in the stadium wanted, but even he didn't realise until some days later that the prize was his. Back in London he submitted several of his pictures from Mexico to the magazine *Amateur Photographer,* including the shot of Beamon, which they used as part of a spread entitled '*Mexican Ballet*'. Not his first photographs to be published, but much later it was to become the stuff of legend. Along with many more experienced photographers, he must have wondered how he had taken something so special, so iconic in the real sense, that it was subsequently selected by *Sports Illustrated* as one of its photos of the century and by the Olympic Committee to illustrate one of the greatest moments in Olympic history. When it came down to it, it was simply right place, right time and pure luck.

Tony was a dreamer, an absolute fan of sports, any sports, who talked himself into the photo industry as a way of getting closer to his passion. He never quite got his head around the fact that he went from being not a particularly talented photographer to being a very good one indeed. What he possessed was a brilliant eye for a shot and the skill to frame the subject in just the right way to inform and excite the viewer. Initially, he admitted, he was on a steep learning curve. He was, and remains, an enthusiast first and foremost and it was that passion for sport that drove and motivated him. On the other hand, I enjoyed taking part in sport, but was never a sports fan. Even much later at the height of my career as

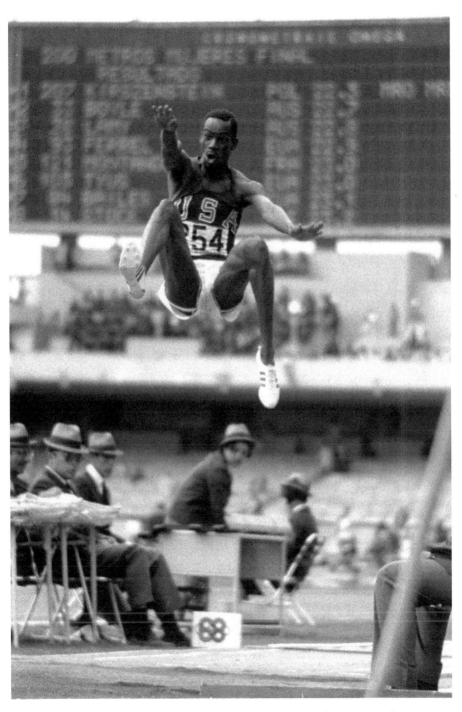

The genesis of what became Allsport was the unique and iconic image from the 1968 Mexico Olympics of American athlete, Bob Beamon, breaking both Olympic and World long jump records.

Photo: Tony Duffy/Allsport

a sports photographer I never watched sports on television and still don't today. My passion has always been for telling a story with my camera and some of the most emotional stories can be found at the edge of human endeavour, particularly sporting endeavour. What I could not have imagined on the first occasion that we met, me at the age of eighteen and he in his mid-thirties, was that he would become my mentor, employer and friend. Later we became business partners and shared 22 years of hard slog, working together to develop what became the single most successful sports photography business in the world and ours the most successful partnership in the industry.

Six months after I began working at Keystone, I had graduated from runner to dark-room technician. It was while industriously employed in the half-light amongst the carboys of chemicals that I saw most of Duffy, who became an even more regular visitor. Whether he recognised any latent talent in me at such a young age or just tagged me as an ambitious kid looking to earn a few shillings on the side, he never revealed. Always cautious and looking for a deal, the arrangement that we came to was that when I was not flat out on developing our own photographers' work, I would surreptitiously run some of his negatives through the process and produce prints for him out of the back door. This was against the rules, but the lure of cash in hand to a poor lad for doing what were described in the trade as 'red hots' was hard to resist, so I became familiar with his style. What was transparent was his single-minded commitment and enthusiasm, which I found very contagious.

At the time I started with Keystone and on the bounce from his encouraging results from Mexico, Tony must have thought that he might make it from improving part-time amateur to full-time professional, but it was during this transition that he encountered the problems that all independent freelance snappers had faced for many years. Getting access to major sporting events was limited to accredited front ranking photographers. The pecking order was Associated Press (AP), United Press International (UPI) and Reuters, followed by national newspapers, major photo agencies and the occasional magazine, usually *Sportsworld*, which was the official publication of the British Olympic Association. This left precious few openings for freelancers whose challenge was to get into a position where they could actually shoot at an event. Without proper access the chance of a one-in-a-million Beamon shot was always going to be just that: one-in-a-million. For anyone beginning at the bottom of that pecking order, they had to find a way round this seemingly insurmountable obstacle. Blarney, bluff and bullshit only went so far, and

it couldn't last. Newcomers, however talented, had to find a less traumatic way of gaining access, preferably a legal one.

Without the accreditation that came with commissions from front rank organisations and publications, the answer presented itself amongst the photo agencies, the bigger of which employed freelance photographers to cover events for them. The deal was that the agency supplied the credentials, the snappers shot the event at their own expense, returned the film to the agency, which would then process, print and distribute, mainly to the dailies. The proceeds from any sales were then split on some pre-agreed basis. All the big newspapers and agencies were on Fleet Street and anyone starting out on the periphery discovered what I did years later: that just by being there allowed you to feel the excitement and energy of the place as the world›s happenings and breaking news were discussed and dissected. Like many of us before and since, Duffy pitched up at Keystone Press. Unlike me who initially had nothing to offer except interest and enthusiasm, he came to meet Bertram Garai, regaled him with the story of the Beamon scoop and how he shot many sports, especially track and field, and they agreed to a trial run. I'm not sure whether he or Keystone enjoyed the bigger benefits from the arrangement.

When we first met, Tony had a reputation for moving in more glamorous social circles than anyone else I had ever encountered. Much earlier for him this had included the world of Formula 1 motor racing and its more outrageous camp followers. In retrospect, at the time he may have regarded photography not so much as a proper business or even a method of creative expression, but more as a way of circumventing the onerous currency legislation imposed as a travel allowance for British citizens going abroad. Even to my young and relatively inexperienced eye, he had an obvious talent for framing a shot and as he was to demonstrate many times, a great sense of timing. Having scored his own first major photographic success in track and field, he had begun his own upward path.

Even as I started to find my feet at the bottom of the Keystone hierarchy, I began to look for stories and take photographs in a freelance capacity. Not too much of my early stuff was used, but Bertram and his editors tolerated my enthusiasm and indeed, encouraged it, because they figured that one day, I might just grab a scoop that would make us all some meaningful money. While Tony was establishing himself on the athletics scene and I was labouring in the darkroom, my thoughts kept wandering back to how I saw the use of the camera in telling the story

and capturing the moment on the sharp edge of news gathering. That meant conflict zones. From my school days I had been interested and fascinated by war reportage, so I was always looking for ways in and I talked to anyone who I thought could or might advance my cause. In retrospect, I did some things that were on the edge of reason, but perhaps the most extreme example occurred in 1972.

My interest in photographing conflict had been muzzled by the simple fact that there was not much happening in any part of the world that I could afford to visit. And then there was Northern Ireland. Ever since its partition in 1920, Ireland had been simmering in dissent, its geographical borders drawn and maintained by political and religious considerations. By 1969, the fault lines were being reinforced, not least because the Irish Republican Army (IRA) had begun to recruit and re-arm again. Few things quite brought home the dissatisfaction and potency of the struggle between the conflicting communities than the activities and actions that divided the City of Londonderry. Long before Bloody Sunday and even before the first British serviceman died on the streets of Belfast, Londonderry became the focus for conflict and inevitably the focus of my interest as a photographer. With an Irish Catholic mother and a Protestant father, I never professed to support either side, but I had the naiveté and arrogance of youth to believe that there were answers. I was soon to be disillusioned.

I will never forget the first time that I visited the Bogside and Creggan estates, walking past the gable-end wall at the corner of Lecky Road and Fahan Street, and reading the prophetic slogan writ large upon it: You Are Now Entering Free Derry. It had been painted there the previous year by local resident, John Casey, in response to the first big incursion into the Bogside by members of the Royal Ulster Constabulary (RUC). By its own definition, Free Derry – note the removal from the locals' lexicon of its previous name Londonderry as a pointed objection to rule from Westminster – was a self-declared autonomous, nationalist enclave and its inhabitants intended to make a statement of such power and unification that it would put down a marker for the struggles yet to come. I don't know whether it scared the British government, but it scared the hell out of me. So why did I spend my hard-earned cash and holiday allocation visiting Northern Ireland at all?

Once again, my interest had been piqued by events there in 1969 and the part that press photography played in telling the story of 'the troubles'. Before the real shooting war started, the struggle for power was often played out by people who regarded outside influences more

as an offence against their civil liberties than the fight to the death over political power which it later became. A small group of students from Queens University in Belfast had decided to show their solidarity with the cause of liberty by joining a people's democracy march, though how they thought that this might aid anyone's cause was unclear. Leaving their campus on New Year's Day 1969, four days later and about five miles short of Londonderry, they reached the river Faughan and Burntollet Bridge. Here, the marchers, including this modest group of unarmed students with high ideals, were set upon by around two hundred thugs wielding clubs and other weaponry. Only afterwards did it become evident from studying the photographs of the ensuing riot that appeared in the local press that around half of the attackers were members of a branch of the Ulster Special Constabulary, which traded under the name of the B-Specials, a largely Protestant group formed in 1920 in the fallout from partition. This inflamed an already unstable situation and made Londonderry a focal point for all parties, a quasi-war zone.

If I'm strictly honest, I don't think I knew what my presence could, or would, add to the mix, or what personal risk I might be running. If questioned on my motives for attempting to make a career among the band of brothers who chose to photograph war, my answer would have been that like any young and politically aware hippie child of the sixties and seventies, the job was to stop war by exposing its horrors. How egotistical was that? Naive and callow as I may have been, at least I was bright enough to understand that I wouldn't get anywhere close to any action without some form of press accreditation. So, I forged a letter on Keystone stationery that purported to cover this less than trivial matter. Armed with this, and taking one week's holiday, I set out and eventually blagged my way into one of Londonderry's no-go areas and began to photograph the surroundings.

With emotions running high, the presence of any outsider, photographer or not, was totally unwelcome and within hours, I was snatched off the street. Three hooded and extremely persuasive gunmen bundled me into the back of their car, sped around the streets to disorientate me, before hauling me into a rather shabby terrace house for interrogation. It soon became clear; my abductors represented the interests of the Provisional IRA (Provos). Somewhat intimidated, if not terrified, I nervously presented my 'forged' letter of accreditation from Keystone Press, I explained that I was a freelance photographer working for Keystone. The subsequent interrogation was less onerous and threatening than it might have been. After satisfying themselves

that I was young and relatively harmless, I was released with my own 'official' Provo press pass and given access to photograph anything in the no-go area. The IRA understood the power of the press to highlight their cause and played this card at every opportunity.

I wandered the streets of Londonderry, or Derry, depending on which side you were on, and became exposed to the poverty, passions, pain and humour that was life in Northern Ireland in the early seventies. I quickly learned that when street kids run up to you shouting, "Take my picture Mister!" you didn't ignore them or tell them you were too busy, because the ensuing fusillade of rocks that came your way were both accurate and painful. The editors back at Keystone were to ask later why there were so many images of grinning children?

Though I make light of it now, Northern Ireland was no walk in the park. I discovered real fear when I became trapped on Londonderry's Craigavon Bridge between the British Army on one side and an advancing Protestant march, led by Ian Paisley, on the other. Both hated the media in equal measure and partly blamed press coverage of the early civil rights marches in the 1960s for the problems that they now faced. The Army had been ordered to hold their line and let no-one through, especially not some hippy with a couple of cameras slung around his neck. Equally, the Protestant marchers, now rioters, thought it was great sport to edge one of the hated 'Catholic Media' over the parapet. I escaped, but only by being very, very humble!

Despite the troubles and pain there were also many moments of wonderfully surreal humour, like walking towards a British Army checkpoint made up of an armoured personnel carrier and about six soldiers, all facing the no-go area. Emblazoned out of view on the vehicle's rear in yellow letters three feet high was the unequivocal message, 'Fuck You'. On closer inspection, the perpetrator had crept up behind the squaddies, who unsurprisingly were concentrating on what was occurring in front of them and had made up the lettering from dozens of little yellow stickers, each one carrying the equally unequivocal message, 'Jesus Loves You'.

At the end of that week, I returned to London with lots of pictures, but uniquely, pictures of the first armed guard of honour to be mounted at an IRA wedding in the Province. When I confessed my actions, Bertram found it in his heart to forgive me my little deception and forgery by syndicating those images through Keystone. Widely used by the national press they set me on the road to respectability. Subsequently, I went to Northern Ireland on two further occasions with

An unlikely image from my first visit to Northern Ireland during the troubles was of a wedding party complete with IRA gunman in support, courtesy of my Provo Press Pass.

Photo: Steve Powell/Keystone

Keystone's support. The last of these visits was at Christmas, when I was covering the British army in Londonderry, in the aftermath of Operation Motorman the previous July. As the BBC reported at the time: 'The city of Derry was a major stronghold for the Provisional IRA, the most prominent republican paramilitary group opposed to British rule in Northern Ireland'.

Motorman was the name given to a massive military operation mounted by the British Army to reclaim no-go areas set up by republican paramilitaries in towns across Northern Ireland and was a response to Bloody Friday, the Provo bombing of Belfast ten days before. That atrocity put huge pressure on the British government to improve security. The two primary targets were Londonderry and Belfast, but there were smaller operations in other towns and Motorman was then the largest British

military operation since the Suez Crisis of 1956. As a prelude to it, British Army foot patrols were sent into the city's staunchly republican Bogside estate. Then, on 30th July, soldiers moved into Derry in preparation for the retaking of the no-go areas. In the early hours of 31st July, over one thousand troops in more than a hundred armoured personnel carriers entered Derry's Bogside and Creggan estates, accompanied by armoured ambulances! HMS *Fearless*, an amphibious assault vessel, had earlier come close inshore under cover of darkness to unload four huge, armoured bulldozers and as troops secured the streets, these giants smashed aside the barricades. Such was the overwhelming scale of the operation that the army met with little resistance.

Any rumours I might have heard that problems no longer existed were quickly disabused. I went straight to Londonderry and was granted permission to join an Army post - for post read fort - on the Creggan estate, in the heart of the city's Catholic community. It became very clear to me that despite Motorman, this bit of the British Army, at any rate, was surrounded and under siege. Being shown around by a senior officer, I was ushered into the 'other ranks' living quarters; an overcrowded, windowless trench-like basement, a scene that reminded me of an open dungeon. As I looked around, marvelling at the resilience of the squaddies, out of one dark corner a small voice piped up. "Hi, Steve," it said; "you won't remember me, but I went to Queen Victoria School." He was right, I didn't remember him, but his name was Simon. A year behind me at school, of course, one would never talk to younger boys, except to admonish them. I admit that despite my military upbringing, I was openly shocked by how different our lives were, yet this could have been me. After this encounter, I went on patrol to get pictures of British troops on the streets of Derry, a space that had until recently been denied them. It was while out on this patrol that a young kid delivered a chilling threat: "My Dad knows who you are Mister, and he says don't come back to Derry." It appeared that my Provo Press Pass had been revoked. Keystone syndicated my pictures for many years thereafter and I had taken my first steps to becoming a professional photographer.

3

COMING AND GOING

It was only after his success with the Beamon picture from the 1968
Mexico City Olympics that Tony Duffy began to take things more
seriously. By the time I met him in early 1971, he was an established
figure on the track and field circuit, but running what was a double life;
half as a suited and booted accountant and half as an itinerant freelance
sports photographer. In anyone's book this was a likely recipe for burnout
and sure enough, later that year his health had suffered sufficiently for
his doctor to advise him he couldn't continue doing both. He needed to
prioritise and decide which road to follow. Probably the easiest decision
of his life: it set him, and later I, on the way to establishing the mould-
breaking photographic agency Allsport.

Committing to photography full time might have worked for him as
an individual, but he had one lucky break when he had been introduced
by a mutual friend to fellow photographer, John Starr. Their backgrounds,
interests and training could not have been more different. Tony was self-
taught and more of the point and squirt school, relying on his eye for
framing his shot. John was college-trained and had worked with Norman
Gold, in one of the advertising industry's leading studios. He came with
a love for exploiting the technical side of photography and maybe the
attraction for Tony was that he could learn from John. For John, the
attraction was that he could be more his own boss, but whatever their
relative motivations, they began collaborating.

Tony and I had been talking generally about his plans when out of
the blue he invited me to West Croydon one weekend to meet John and
visit a potential studio. What they showed me was a large, high-ceilinged

room, full of garbage, behind the Nicholas Paul Insurance Brokers office and before I could back away, they had explained their plans, which seemed to include me! They suggested that the studio needed to be cleared (which I detected might be my first job), before outlining the glamourous role that could be mine. It was a mixture of gofer, darkroom technician and studio assistant, to do all their processing work and to support John in the studio. I agreed, as the challenge and opportunities were obvious. The only problem was that they couldn't afford to pay me. To cover the rent on my one-bedroom flat in Brixton, I continued to work eight-hour shifts in Keystone's Fleet Street darkroom, before jumping a bus down to deepest darkest West Croydon every evening to work another shift there.

The studio was just one room behind the insurance brokerage and John knew Nick the proprietor of old. The deal was simple. Clear out the accumulated garbage and decorate the room, in return for which it could be ours rent-free for three months, which turned into three years. I must have thought that having a job in a photo agency would look good on my CV as I struggled to establish my career as a freelance snapper. However, my personal deal was less attractive, as my 'wage' consisted of Mars Bars, cigarettes and the occasional Chinese takeaway, often provided by our landlord if he thought I looked in need of nourishment. Which, as a growing lad, I often did. Aside from being half-starved, for most of the first year, the only sleep I got was on the darkroom floor and this workload, split between Keystone and Duffy, soon started to take its toll. I thought that I could rely on youth and enthusiasm to keep me going, but it wasn't going to be enough.

At the other end of the glamour spectrum and because of his reputation gleaned after Mexico, the British Olympic Committee (BOC) had accredited Tony to shoot at the 1972 Summer Olympics in Munich. Now, we take for granted that previews of major events have the potential to generate as much, if not more income than coverage of the events themselves, but back in 1972 the concept hadn't really been explored or exploited.

About six months before these Games, Tony and John began thinking how they might develop preview material. What resulted proved to be one of the most fundamental business models that would ultimately drive all our commercial futures. Early in 1972 they travelled to the German city that would go down in history as host to the most infamous Olympics of all time, to cover the German National Olympic Trials. These trials were of no actual interest at all to our market, but Tony and John photographed

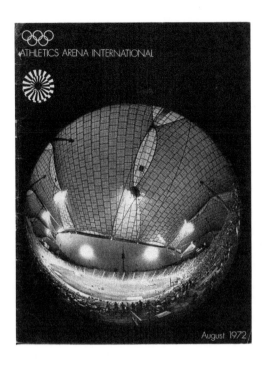

ATHLETICS ARENA INTERNATIONAL

August 1972

Innovative use of a fisheye lens to capture the sensuous lines of Munich's new Olympia Stadion sold widely and established our precedent for capturing the unusual, beyond pure athletics.
Photo: Starr-Duffy Studios.

every venue with athletes in action. It was no coincidence that the trials were being held as a dry run in the new, state-of-the-art stadium and John's off-the-wall approach coupled with the creatively distorting effect of his Nikon 8mm fisheye lens lent itself to the very futurist architecture of the Olympia Stadion, which had been hailed as ground-breaking in its design and structure. The architects, Günther Behnisch and Frei Otto, wanted the venues to be light and open, to reflect a feeling of a 'Happy Games', deliberately in contrast to the Berlin Olympics of 1936, with all its dark, unhappy memories. Their vision created what was the first light-weight suspended roof in a major sports stadium, their theme of lightness ran through all the venues and public spaces and was a major success.

The iconic images that Tony and John captured sold all over the world in the months leading up to the Munich Olympics, establishing the model for all of Allsport's subsequent coverage of major events. Coincidentally, throughout the 1970s and most of the 1980s, this was the only way that our non-union agency could get its pictures published, beyond book publishers and more specialist interest magazines. The lucrative world of newspapers showed a closed door to us, a closed shop you might say, because of restrictive union practice. Later, while Tony travelled out to Germany to cover the Olympics, I drew the shorter and

altogether less glamorous straw; remaining in England, far removed from the action, serving as the baseman in Croydon, busying myself doing all the processing and distribution.

Those Munich Games will be forever tainted and remembered not for sporting prowess, but for the actions of a group of Palestinian and German terrorists, who first captured as hostages and eventually executed, eleven members of the Israeli team. Whilst those in the sporting press corps may have grabbed some glory from the trackside, the most memorable images passed around the world came from Associated Press photographer, Russel McPhedran, who captured the Black Septemberists on the balconies of the athlete's village before the massacre. True to form, while all this was going on, Tony decided that his priority was still the sport. For him it was seventeen days of high intensity, moving around the Olympic village and stadia from dawn to dusk to capture the best images of track and field. For me, it was a continuation of commuting up and down from London to Croydon, grabbing the occasional stopover in my Brixton flat, interspersing the long hours in the darkroom with occasional breaks to help John with studio shoots. It was a real treadmill.

After the effort of delivering the material from Munich it became obvious that I couldn't continue with the long hours and constant commuting. The pressure was getting to me and my health was taking a hit so, like Tony before me, I had a choice to make. By now I had reached the exalted rank of senior printer at Keystone, with the promise of imminent promotion to junior photographer, so my basic choice was either to stick with them for the long haul or quit, gamble, and go to work with Tony and John. I chose to leave the security of a full-time paid job on Fleet Street to work with a couple of freelancers behind an insurance brokers in Croydon. It might look like a strange decision, as they still could not afford to pay me beyond the occasional cash handout when they made a sale, but I could see the potential. Happy with my decision, the reality was that I couldn't keep the flat in Brixton, so needs must, and I moved back to live with my parents, within an easy commute of the studio.

If I thought leaving Keystone would ease the workload, I was to be proved wrong. The load just increased and throughout 1972 and 1973 it became enormous, with Tony travelling constantly to cover major events, swinging by to drop off film, before moving on to the next assignment. The problem was that he was also handling all the filing and captioning of both colour and black and white photos, in his flat in Sutton. As neither John nor I had access to that treasure trove in his absence, the

filing was getting out of control. We rarely saw the light of day from our windowless backroom, occasionally taking a cigarette break in the front office with our landlord, Nick, where he would regale us with stories of ludicrous things people do for which they try to claim on insurance. Rather sadly, these conversations amounted to the bulk of my social life at the time and my days didn't include any time to archive or administer our expanding library.

It was during this period that Tony devised and established the mould-breaking principle of retention of copyright, a concept that we stuck with to the end. In those days, a freelance photographer could make a living by working day shifts on a newspaper or magazine, but the newspaper or magazine retained all rights to the images. Cash was tight and the temptation to accept a day shift or assignment, any assignment, to swell the coffers but lose copyright, must have been great. Bankrolling everything himself, Tony stuck to his guns, never deviating from the path of copyright retention and history would show that this one decision formed the trading basis for what was to become the largest, fully owned sports photo library in the world. Whereas most picture agencies did not own the rights to the images they sold and had to pay the photographer fifty percent of all sales, we would be different. We would retain our own copyright and as we expanded and needed more photographers, we would hire them as full-time staff members so that Allsport would benefit from the full value of the sale and copyright ownership. To avoid any doubt about copyright and torpedo the temptation for odd jobs on the side, which was common for staffers in the industry, we all signed contracts that assigned to Allsport the copyright to any and all of the photographs we took. Much later, I realised that technically this also included all our holiday photos and family pictures as well!

In the early summer of 1973, Tony received an interesting proposition when he was approached out of the blue by Michael Rice & Partners. One of the most prominent public relations practitioners in London, Michael Rice's agency was on a retainer from Mohammad Reza Pahlavi, Shah of Iran, whose autocratic regime needed some good publicity. Like many people before and since, the Shah had identified that sport could be the silver bullet to rehabilitate his country on the international stage and the vehicle he had identified was the 1974 Asian Games. Iran had been recognised by the International Olympic Committee (IOC) as far back as 1947 and its athletes had competed at every Games since then, but the opportunity had arisen to host the next major sporting event in the region and the Shah was determined that it should be his. Thus, Iran

would become the first country in the Middle East to host the Asian Games and Rice had been tasked with coming up with a campaign to graphically represent its ambition.

It never became clear how or where he had seen Tony's iconic images from the Munich Olympics, but they had clearly triggered an idea and Rice wanted to create posters for each sport in the run up to Tehran '74. The brief was that the images must obscure the identity of the athletes and convey a distinctly Asian feel. Grasping the opportunity, Tony sold Rice on the idea of us creating a different and eye-catching design for the posters that matched their brief, provided it was only his pictures used. It was agreed, always assuming Rice and his team liked our ideas and that we could meet what was becoming a very tight deadline. Tony rushed back to the studio, asked us for any ideas and then rushed off again, leaving us to figure it out.

A bit nonplussed, John and I looked at each other and realised that we had not the foggiest idea of where to start. We began by going through all our old photography books looking for inspiration. A couple of days later John remembered seeing the work of Man Ray some years before so he dug it out and explained to me the process called 'solarisation' which Man Ray invented in the 1920s. Born Emmanuel Radnitzky in 1890, he had produced major works in a variety of media but was best known for his fashion and portraiture photography and processing experimentation with differing exposures. On the face of it, the technique looked easy to execute. Just a matter of switching the light on briefly during development. In black and white processing, this created halo-like outlines around the body and areas of partially reversed tonality, a positive negative. It worked in black and white, but would it work with colour origination?

The only way to find out was to start experimenting, each time trying various exposures and different processing methods. Each print had to be a large format 20x16 inches and if one treatment worked, it would become the original for that sports' poster. We had realised very early in the proceedings that replication was almost impossible. We would need the highest resolution that we could manage, so every attempt had to be an original and testing wouldn't help. We began with a famous picture from the USA vs. USSR men's basketball final, showing two players leaping for the ball, but as per the brief, we had to disguise the nationalities of the jumpers and make an interesting and creative image. Endless failures finally gave us a print that looked perfect, but it had taken a long time.

Man Ray's 'solarisation' exposure process became the template for our original and experimental treatment of posters for the 1974 Asian Games in Tehran. Each one was totally individual, witness the unique treatments of weightlifting and basketball.

Photos: Tony Duffy/Allsport
Posters by John Starr & Steve Powell

Michael Rice, who had commissioned us, descended from his office in the West End to our scrubby little studio in Croydon to review our work, expressed his approval and confirmed that we had the job. That was the easy bit! Now we had another fifteen sports to do and not a lot of time in which to deliver. Already exhausted before we started this job, John and I lived in the darkroom and studio for the next three weeks and just in time, we handed over the sixteen completed originals, one for each of the sports represented in the games. These images became iconic in their own right, not only as posters for the games, but also as back-drops at many of the venues and finally, in a full set of postage stamps.

Pressure shows in different ways in different people. By now I had been working eighteen hours a day, seven days a week, for eighteen months and this intense pressure and constant exposure to chemicals,

just added to my run down, ill-nourished state and general exhaustion. My then girlfriend, Virginia, had been working in Switzerland as an au pair, so her announcement that she thought she might be pregnant heaped another level of pressure upon me. Though the pregnancy turned out to be a false alarm, the emotional damage had been done and after we finished the Asian Games posters, I suffered a serious nervous breakdown.

It took me totally by surprise. I was young and big, believed I was invincible and that I could handle anything, but events had proved me wrong. After a short break and a reunion with my girlfriend in Switzerland, I was keen and ready to get back to work, only to discover that I couldn't. I physically could not face going back into a darkroom or to even pick up a camera and a darkroom technician who couldn't go into a darkroom was no use to anyone. What I faced was truly an earth-shattering moment. All my hopes, dreams, aspirations and ambitions had been invested in photography since I had left school and it appeared that the future I had lived and planned for was slipping away. After a lot of soul-searching, I faced the inevitable and resigned.

4

INTO THE VOID

Having quit the only career I had ever wanted and had ever known, I now had two priorities: recovery and remuneration. After a suitable period for rest and recuperation, I had to face the minor matter of paying the rent which was becoming critical. To address this problem, I took the rather exotically titled job as Hygiene Consultant with Initial Towels. For hygiene consultant (read salesman) for soap dispensers and towels, but however lowly it might have appeared, I learned a lot about selling things to people. My mentor in the sales department, who believed in the adage that 'less is more', had developed a method of marketing Initial's dispensers that made him about the most successful salesman in the business. Whereas most of his peers would spend many minutes extolling the technical benefits of their products, my mentor had at his own expense, acquired a smart leather covered box with a velvet lining, in which mounted a pristine, if ordinary, chrome dispenser. Having got himself in front of the buyer, his presentation consisted of placing the box between them, slowly opening it with a degree of theatricality, studiously polishing its contents with a spotless yellow duster and then sitting silently studying the contents. The entire process took several minutes. The buyer would be mesmerised like a rabbit in the headlights. Unspoken, our man had established the perception of value, and rarely did he fail to secure a sale. I learned that when all your rivals' products are viewed as equal to your own, the perception of value becomes the key selling point. A tenet that made the difference when we took Allsport more widely into the market.

Humble beginnings they may have been, but that job provided me with a car and gave me cash in my pocket for the first time in my life. Nor was

my sales education solely restricted to towels in lavatories. I graduated to selling mobile homes and it was during this period; seeing the tactics used to sell mobile homes to people who couldn't afford them, that I discovered the great truism that I couldn't do a deal that wasn't fair to both parties. My long-term career as a salesperson was going to be shaped by this revelation, either blighted or immeasurably improved, I believe the latter.

By the end of 1974 my life had been transformed in several ways, notably providing my passage into adulthood. Virginia and I had got married and much to the delight of my newly acquired mother-in-law, I had a proper job and bought a basement flat in West Croydon. For the first time in my adult life I wore a suit to work every day, had a haircut and although I still had secret longings to be a photographer, I no longer owned a camera. I'd fitted into life as a married salesman, I was playing the role and remarkably, I appeared to be succeeding. I would occasionally meet up with Tony and John on my visits for a coffee with Nick Paul and we'd all chat about how things were going. However, behind all the glamour and glitz of being a mobile home salesman, these occasional visits prodded my subconscious and reminded me that there was still some unfinished business. Subconsciously, that weighed on me. I envied them the excitement, the uncertainty and although I still had a major phobia about darkrooms and cameras, the challenge of photography remained unfulfilled.

I can't remember how it happened, but early in 1975, Tony and John came by with another proposition. They were achieving some fantastic creative results and doing splendid work, but they were struggling to maximise the income stream from all this material. They asked me to join them again, only this time in charge of sales and marketing. At twenty-one, my photographic career had looked to be over before it had started, but two years later it was rekindled. While I had grasped the rudiments of selling things, my knowledge of marketing as a discipline was sparse, but the lure of the photographic world was strong, so I agreed. For the second time in my brief life, I found myself working out of the West Croydon studios, but with a much bigger brief; to make Allsport commercially successful.

When they came to persuade me to work with them again, the young hippy darkroom boy was long gone. Now before them stood a more polished, silver-tongued salesperson, smart of suit and suave of manner. Playing the role clearly worked, but beneath the confident exterior was a nervous young man just desperate to get back into the photography business, in any capacity. I missed it so much. The adrenaline-fuelled news,

journalistic and sport worlds, the thrill of each approaching deadline and seeing your efforts and work published for all the world to see. I had just spent two years in emotional neutral, thanks initially to medication and then the nine to five lifestyle, five days a week, that had just bored me rigid. I needed challenges and excitement and targets to shoot for. Tony and John offered that and more, as with their offer of employment came the additional bonus of a proper wage and a small share of the equity. Having accepted their offer and decoupled myself from my previous job, my life slipped easily into the busy role of salesperson, visiting publishers and magazines, trying to find an edge that would make them call on us to supply them with pictures before our rivals. I was also trying to find commercial work for John so I would spend my mornings in Tony's flat, still the administrative centre of our world, reviewing leads and ideas, then head up to London to visit potential clients and, just to stop me going soft, often spend evenings helping with studio shoots.

At this point it was still very much about Starr/Duffy Studios, but part of the deal was that we would stop trading under that name and begin trading under the more flexible Allsport Photographic. However hard it might have been for Tony to accept, he was as good as his word and we changed the trading style. In retrospect, this was the moment that our partnership began and although it was an increasingly challenging relationship, we worked together for another twenty years. At the start, his was a steadying influence on my youthful enthusiasm and, as in many successful partnerships, he acted as a much-needed foil. He challenged every idea and project that I proposed, but as I discovered, it was not because he was automatically against any idea he hadn't thought of himself, but more that he wanted to satisfy himself that I believed in and understood the impact of what I was suggesting. The cautious accountant in him rearing its head, I guess. Probably no bad thing, though it led to a succession of long and often heated discussions over lunch tables, most leading to solutions that cemented our business partnership and improved the business itself. I had always looked for challenges and what I was being asked to do for Allsport was certainly that.

More than anything, I saw in Tony a mentor with a practical grasp of business that I still lacked and needed. His actual strengths, despite becoming a very talented photographer, were his in-depth knowledge of a wide range of sports and his extreme financial caution. Once an accountant, always an accountant. Having spent most of his life's savings just staying solvent as he pursued his passion for sports photography, beneath it all he was a saver who worried about where the next payment

was coming from. I, on the other hand, was a serial dreamer and a spender, and had very little appreciation of the real value of money other than as a tool to help achieve my aims. The saver and the spender. Therein lay the subtle difference between us and, on balance, the reason that we worked so well together. If he could teach me the basics of running a small business, I would try to convince him that security can only come from making it into a gigantic business. He was so careful that he never threw away a sheet of paper if it hadn't been used on both sides, while I was figuratively buying leather bound notebooks.

What also became apparent the more I worked with him was that he was a shrewd self-publicist, constantly looking for ways of bringing his name and that of Allsport to an ever-widening audience. He had made a significant breakthrough in this endeavour when, in mid-1973, the Editor of the *Sunday Times* had bought and run his pithily titled feature 'Sport and the Body'. Pardon the pun, but *this* particular body of work comprised a portfolio of internationally known sports stars in all their naked glory, but in the best possible taste. So off the wall was it that it caused something of a stir and brought the agency nationwide publicity and fame, some said infamy. By the time I re-joined Allsport, digging deep enough would reveal these pictures in what was a large and randomly filed archive, covering many sports and studio shoots, some of which we would euphemistically describe as less than mainstream. One of my early tasks was to sort through this archive and try to bring some order to it by instituting a logical catalogue system for rapid retrieval.

It was only when I started doing the rounds of magazines and publishers that it became obvious that alongside specific commissions, all too rare in those days, the biggest asset we possessed was our back catalogue. We were not the only agency in London that specialised in sporting imagery, so I looked at our opposition, mainly to see how they were doing business and for ways of building critical mass in our sales. I often found myself in competition with Colorsport which had been founded by Colin Elsey and Stewart Fraser in the 1960s and had grown by acquisition, absorbing the Wilkes and Provincial Press libraries and the Barrett Collection along the way. It might have been an unspoken aspiration, but at the time, we weren't financially robust enough to consider buying them, or any other of our rivals. Aspiration or not, later that year we were presented with an opportunity that would take all our courage and money to secure in what could turn out to be another pivotal moment in our development; *Sportsworld*, the UK's leading sports magazine, went bankrupt.

5

BACKBONE OF
THE BUSINESS

Sportsworld had been a regular client of ours and we knew that this official publication of the British Olympic Association had only one realisable asset. Their photo library now hung in the limbo of receivership. It was one of the finest collections of images in the world, featuring international sport from the first Olympic Games in 1896 and colour coverage of the world's greatest sports stars since 1948. All the serious syndication libraries began circling the corporate corpse, awaiting news of how the Official Receiver would value it, expecting that it would come up for auction, at which point their financial resources would out gun any smaller outliers who wanted it for their own. We knew that compared with the likes of the *Telegraph* and *Daily Mirror* syndication departments we were out of our financial league if it came to a bidding war, but we were still eager to get hold of it if we could. Few people had yet got to grips with valuing intellectual property, but we had realised the increasing value of old pictures, so we decided to talk to the Receiver anyway. It was a fair bet that he wouldn't know what he was looking at and might be interested in a quick fire-sale to get it off his desk. But how to get alongside him and what to offer without being laughed out of his office?

Don Morley had been *Sportsworld's* staff photographer at the time they went out of business and thus, was out of a job. He became particularly helpful in opening the door for us with their shell-shocked interim management, suggesting that we were not bad people and were worth meeting. We agreed that Don, who had been offered the first option on the files, would join us full time if our bid succeeded. This was

The cover of Sportsworld's final edition: optimism over expectation allowed us to acquire the magazine's extensive historical photo archive for very little money and began Allsport's growth as the go-to library resource.

Photo: Allsport Archive

one of the few occasions that Tony and I agreed instantly on spending money. He, probably because of his love of sports photography, and me, because I knew what our clients were hungry for: our back catalogue. A visit to Tony's bank flushed out the last of his savings, literally every penny he had, so armed with this we hired a van and a trolly and drove to *Sportsworld's* office. After a little negotiation and more in hope than anticipation, we put the cash on the receiver's desk, saying that was how much we thought the library was worth. Remarkably, and after a certain amount of tooth-sucking, he agreed with us and we drove away that day with what was to become the backbone of our business. Overnight, it established our credentials as a picture agency, no longer represented by just our own photos. Now we owned and represented a library that included 80 years' worth of priceless imagery from the Olympics and the collective staff photography of *Sportsworld* and its predecessor title, *World Sports,* which together, had been publishing for thirty years. On the back of this, combined and integrated with our own archive, Allsport's library was now on the way to becoming the largest and most comprehensive in the world. Which, I guess, is where a little chutzpah gets you.

As we approached the end of 1975, Allsport was growing in its coverage and professional stature. Tony majoring in track and field

action and John, the technical expert, specialising in studio shoots, now joined by Don, whose particular interest was motor sport and motorcycle racing. Having been instrumental in our acquisition of the *Sportsworld* photo library, he had agreed to join our merry band, where his name and international standing added more breadth to our portfolio and heft to our reputation. With the agency's higher profile and our more proactive approach to marketing its services, our workload increased beyond recognition. Tony and Don were spending an increasing amount of time out of the office on shooting assignments, often abroad, while John was ever-active doing studio shoots and running darkroom operations. This left me to busy myself on client visits and selling-in their collective output to specialist sport magazines and more general interest media.

The core of Allsport has always been its photographers. By 1975, it had become recognised as a growing force in providing the best sporting imagery, spearheaded by (L-R) John Starr, Don Morley, Tony Duffy and the author.

Photo: Allsport Archive

After our acquisition of the library, things started to take off and we found ourselves able to undertake whole book projects, supplying all the pictures any publisher might need for any title, but space was becoming our biggest issue. Currently our operation was split between two less than ideal locations. Administration and photo files were still housed in Tony's flat in Sutton while the studio, darkroom and archive files were half an hour away in West Croydon. Co-ordination was becoming a major problem, so we desperately needed to find new and bigger premises. The debate advanced along what were to become traditional lines. Tony, ever cautious, argued that we should rent somewhere a bit bigger to meet our current needs and I argued that renting anything was not a viable option in the medium or long term, so we must buy freehold and a much bigger building than we needed today, if we were going to grow.

Some noisy meetings ensued between the four of us, sitting on the floor of the studio as it was the only space available. We finally agreed that we would look for a freehold property and try to arrange what would be our first bank loan. Don had a good relationship with his bank manager so we agreed that he would approach him, which is how we began what would be our long and fruitful relationship with the National Westminster Bank. John and I were tasked with finding the right property and coordinating the move. Our search led us to an old dairy in Morden which came with a shop frontage which we could turn into an office, space for darkrooms behind, a courtyard for car parking and large ground floor offices. Once a high-ceilinged shed housing milk floats, it was large enough to accommodate John's studio needs. Don negotiated the necessary loan with our new bank manager sitting on the studio floor, while we convinced him that this scruffy crew had a future and could afford to service a £15,000 loan (about £75,000 today); then, it was a small fortune. He agreed on a handshake, backed by our personal guarantees and supported by our assets, minimal though they were, but we all had homes, so these were now at risk. Now we all had skin in the game, and it was amazing how that sort of thing focused the mind.

Moving in within weeks, at last we had our entire operation more efficiently located in one place and for the first time in Allsport's life, it had proper offices. We had the space to build darkrooms for processing both monochrome and colour film and, with an increasing reliance on colour transparency film like Kodak's Ektachrome, we made what was another enormous investment and bought our own E-6 colour-processing machine. An additional bonus was that we could now host clients more professionally, and last, but not least, we had a large open-plan

Not the most pre-possessing premises, but all ours. Allsport's first wholly owned studio and offices in a redundant dairy in Morden, south London.

Photo: Allsport Archive

office with a purpose-built light box table in the middle and a scattering of five-drawer steel filing cabinets around the walls. Unlikely as it might seem, this was the beginning of what was to become the world's largest sports photographic archive. We had invested so now we just had to deliver growth and profitability.

If my ambition to become the biggest, best serviced, highest quality and most respected sports photo agency in the world may have seemed a bit far-fetched, by the start of 1976 we had made some giant strides towards meeting that goal; creatively, technically and commercially. Faced now with a new studio, better facilities and a bank loan to service, we were poised to grow further, and the year ahead provided us with some big challenges and bigger opportunities. For months we had been debating how we could move the agency forward, maximising our bread-and-butter coverage of sporting events and supplying the media with what they needed. However, the age-old problem of access to major events kept rearing its head and we knew we could not build the agency based purely on covering minor events.

Although we were members of the Professional Sports Photographers Association (PSPA) and had been since its inception in 1972, we were still seen by many in the industry as nothing more than independent freelance photographers. In that climate, we struggled to get accreditation to the majors and our problem was heightened by the attitude of the Newspaper Publishers Association (NPA). No doubt egged on by their staff photographers who saw us as annoying competition encroaching

on what had always been their exclusive patch, they maintained a very tight hold on accreditation. We are talking about a time when newspaper circulation was huge. Over twenty national dailies and Sundays, each of the broad sheets typically employing two to three staffers dedicated exclusively to sport, with the tabloid 'Red Tops' employing even more. Despite all the lobbying efforts of our professional body, the NPA was steadfast in its opposition to giving freelancers accreditation, so this forced us to re-think our strategy. It was pretty obvious that any success we had in getting into events was helped by the support of the various sports governing bodies or by using credentials granted to a specialist magazine. Often this was the official publication of a governing body, such as *Athletics Weekly* for the Amateur Athletic Association (AAA) or *Swimming Times* for the Amateur Swimming Association (ASA). If this approach worked, what we needed were more relationships with national and international sports governing bodies who could accredit us directly to their events.

Although all Olympic and most other sports were still strictly amateur, the world was changing rapidly as commercial companies were starting to move into all areas of sport, mainly by buying naming rights and sponsoring events. Why did they sponsor events? To promote their brand to its target market via exposure in the media; so we found this wonderful virtuous circle. Sports' governing bodies needed money to run their events; sponsors needed publicity so paid those governing bodies for the privilege of sponsoring their events; the governing bodies introduced us to their sponsors and granted us accreditation; the sponsors paid us, and we got pictures published all over the world in the media, who also paid us. The governing bodies were never charged anything and always got free usage of our pictures. Happy days.

It seems so simple now, but it would be wrong to say that it all came about as a blinding flash of genius. Really it just evolved over time and recognising opportunities as they presented themselves. The first thing we needed to do was to become trusted and valued by each governing body. We had a head start with two amateur sports through Tony's connections in athletics and swimming and very soon we acquired 'official photographers to' status with the AAA and the ASA, who controlled swimming in Great Britain. Good, but we needed more so we started targeting small, specialist magazines, primarily covering existing Olympic sports, or sports that aspired to join that family.

Our approach was simple. Find a smaller sport that had potential but was under-exposed. Task one of our photographers to immerse themselves in that sport and its organisation. Identify any specialist magazines that

covered it, often small and impecunious who couldn't afford to employ staff photographers of their own but had automatic accreditation rights that they were willing to 'loan' to us. Supply them with high-quality pictures at prices otherwise unaffordable, which gave them a higher graphic profile and gave us exposure in that sport. Finally, once we were well established and had achieved significant exposure, it was a short but important step for the governing body to grant us accreditation to their major events and they would also be open to our ideas on how to support and expand their sponsorship base.

Like many things in life, it started with a gamble. We had always been on the lookout for clients who might appreciate our creative approach, the bigger the better in Tony's view, and few clients came bigger than Colgate. Already a major sports sponsor on both sides of the Atlantic, this company had recognised that where male sports led, female sports would inevitably follow. What better way to give them influence in marketing their lines of household products, whose target buyers were predominantly female, than to look at women's sport as a clean vehicle to get them recognised. Amongst their areas of influence, they had identified women's golf and in 1972, had rescued the Ladies Professional Golf Association (LPGA) and its tour as they became its anchor sponsor and steered the Association into the television era.

In 1974 they had introduced big money prize funds to the UK for women's golf, with the inaugural Colgate American/European Women's Open which played out in August over fifty-four holes on the Sunningdale course, but it was an 'unofficial' LPGA championship event. Tony and John Starr thought it was still worth covering, purely speculatively, and after three days on the course, produced large colour prints of the best shots, all featuring Colgate branding. Tony then proceeded to blag his way into the London office of Colgate's Director of Public Affairs, Peter German, put the prints on his desk and waited. German liked what he saw, commissioned Allsport to cover the 1975 tournament and the following four. By now, titled the Colgate European Women's Open and a part of the official LPGA tour, from 1976 I became responsible for managing what was at the time the biggest retainer that the agency had ever negotiated.

We had known for some while that to sweat our assets, both personnel and the ever-increasing photographic archive, we had to look way beyond just taking photographs and selling them to our media clients. The Colgate contract was the catalyst. If the image we were selling provided the intro for us, then we had to find ways of capitalising on the opportunity that

the sale of those images offered. Initially, there appeared to be four parallel streams of potential revenue to explore and exploit. First were the images themselves which would always be our core business and door opener; secondly, the short punchy news stories that we could hang on the image; thirdly, there were the expanded picture stories that gave editors built-in, oven-ready features; and fourthly, there was the management of whole projects that utilised our creative skills and linked them to our increasing logistics capability.

For all the need to be creative with camera in hand, in reality the whole business was one of applied logistics, particularly if it involved working at distance from home base and familiar facilities. I was really in my element now, identifying which venues or subjects were worth photographing, organising accreditation, planning travel and accommodation and then getting film processed and delivered. This was all part of the job and something I enjoyed, deriving great pleasure when a plan came together. It also gave me the opportunity to start picking up a camera again, with little or no pressure, but the first real opportunity to vent my emerging organisational skills came after a meeting that Tony and I had with Warwick Charlton. One of the larger-than-life characters inhabiting that grey and misty hinterland between publishing and public relations, Allsport had good reason to be grateful to him for the opportunity he provided.

To say that Warwick's background was varied was a gross understatement. As press officer on General Bernard Montgomery's staff in North Africa during the Second World War, Charlton's achievements included the humanising of General Bernard Montgomery, from a piss and vinegar martinet, to Monty, the beret-wearing man the British came to love by the time of his victory over Erwin Rommel's Afrika Corps at El Alamein. Once demobbed, one of Warwick's later projects saw the building of a replica of the *Mayflower* which he contrived to get funded and finally, sailed aboard on its 1957 voyage from Plymouth, Devon to Plymouth, Massachusetts. Described by colleagues in the industry as having great imagination and drive and enjoying gargantuan appetites, he stood well over six feet in height. His wife once confided with tongue in cheek that he sometimes seemed a lot taller, especially when he was in full vocal flow!

It was this bundle of latent energy that approached us, initially asking for help in supplying archive photographs of famous sportsmen and women for a charity function he was planning. Throughout the 1960s and into the 1970s, the London casino scene was suffering from very mixed publicity as it struggled to raise itself from blatant illegality to compliance with the new gaming laws, but however much progress

was made, there was still a whiff of sulphur about gambling. Warwick had some knowledge of casino operation and one of his PR clients was Cyril Levan's Victoria Sporting Club. As he spelled out in our first meeting, his task was to devise ways of raising the Club's profile and he saw that linking squeaky-clean sporting success in adversity ticked lots of good-news boxes. Enter the International Award for Valour in Sport. Already a year in the planning, his project had attracted the support of everyone from the Lord Mayor of London to an array of internationally respected competitors as Patrons, to a judging committee chaired by Sir Matt Busby. Levans' concept - probably Warwick's concept - for making the awards had struck a chord: "They should go to someone who is more than a winner ... for courage is more than skill." said Levan, and one who agreed with his sentiments was Alan Hubbard, who had been *Sportsworld's* Editor and was right behind the project. After our acquisition of its photo archive, we became the obvious port of call to source all the material that the event might need.

Warwick was persuasive and we could see the advantage of Allsport's name being associated with what appeared to be a very worthy cause. After agreeing to supply all the pictures free of charge, I tentatively enquired who was producing the commemorative programme. When he confessed to having no one in place yet, we saw this as a way of making at least some money and it would show that we had an organisational string to our bow. Within minutes we had volunteered to do this and as time went on, took on the full gamut from producing layouts and designs for the stage set within the Great Hall of the Guildhall in the City of London, to commissioning and installing all the national flags. The newly created supreme award, a golden laurel wreath of no obvious provenance, needed something tangible to create and enhance its perception of value. I designed a blue velvet plinth and curtained velvet booth as a backdrop for its presentation. Shades, perhaps, of the soap dispenser salesman!

By default, I found myself dropped into the thick of detail planning, bringing together the many strands of support that Warwick had started weaving, while positioning Allsport as more than just a group of talented snappers. Now, we were a company that could be relied upon to deliver complex projects at many levels. The build-up to the event on 20th February 1976 was certainly an eye-opener for this spotty 23-year-old. Having plodded down the corridors of power, pulling things together and effectively coordinating much of the evening, I found myself in a slightly surreal atmosphere when eating dinner on a table whose other diners included Geoff Hurst, Colin Cowdrey, Ann Moore and the Kenyan

High Commissioner in London. Perhaps buoyed up by the evening and the company, I shared riveting stories with these people of growing up in Nakuru and other parts of Kenya visited with my father.

My world had changed over the years, but so had my motivation. Following my return to the Allsport fold, I had quit working anywhere near the darkroom and taken a sabbatical from toting a camera around, to concentrate on the commercial side of the company. However, the pressures of growing the business by building its sales and market base inevitably took its toll on my private life and in 1977, Virginia and I decided to separate and ultimately, to divorce. Secretly I acknowledged to myself that however motivated I was by marketing and syndication, what I really loved was the buzz I got from capturing definitive images of my own choosing. To broaden my base and the agency's, I started looking for and then covering literally any sport that appealed to me that might move us into yet another market, from pétanque to powerboat racing. From this, we developed a business model that was based on gaining a foothold in less well publicised sports and activities, now referred to as minority interest stuff. Based upon Tony's early work, we continued covering track and field athletics and then concentrated our efforts on sports that were growing in interest or would ultimately feature in some future Olympics. Crystal ball gazing on a grand scale, but it was the old story of needing to speculate to accumulate and it began to pay off.

We used to joke that no sport was too small for us to cover and the way our operation worked allowed us to put considerable effort into any new activity we chose to photograph. Initially this may have been for a less than break-even return, but our relationships with sponsors and sports organising bodies were beginning to bear useful fruit. In 1976 for example, we were approached by Stiga Sports AB, the Swedish manufacturer of some of the best table tennis products around. Stiga's tag line was that they had been building world champions since 1944, selling their products first in Scandinavia and then to other countries, as each took up the sport more seriously.

Like most Swedes, serious was what you needed to be to appreciate the degrees of technical finesse achievable from their custom-made bats, blades, rubbers, clothing, shoes, balls, bags, and all the kit that an aspiring champion could possibly need. They also built excellent table tennis tables and nets, but their pressing problem was how to impact their name in countries with populations living in happy ignorance of these excellent Swedish products. What to do to redress that imbalance? Get their equipment photographed and their name promoted, which is where we

came in. March 1977 was to see Birmingham host the 34th International Table Tennis Federation (ITTF) World Table Tennis Championships, to be staged in the newly opened National Exhibition Centre and Stiga saw this as an opportunity to get prominence for their brand. Additionally, while table tennis had appeared at every Paralympic Games since Rome 1960, it was still awaiting recognition by the International Olympic Committee (IOC) for the higher profile Summer Olympics, not getting the nod until Seoul 1988. Stiga knew that the sport was already big in Europe and gathering pace in Asia, but their question was how could they help to make table tennis big in Britain and elsewhere to their benefit? By now, we were producing full packages of expanded photo-captions, small stand-alone stories, which were finding favour with our magazine clients. We said that we could take their brief as we already had the client database of general magazines, from women's titles to Sunday supplements, who would always look at any stories we put in front of them.

The work that we did for Stiga before and during the World Championships hit all their publicity targets. It also marked another watershed in our approach to commercial sponsors, giving us a clear idea of the way in which we could creatively maximise our returns. The Colgate and Stiga contracts formed the basis of a working model that was to become the backbone of our business. It would steer this small British photo agency towards becoming official photographers to a wide range of national and international sports governing bodies including all the major league sports in the USA, together with the International Olympic Committee, British Olympic Association and International Amateur Athletics Federation. Bizarrely for a British agency, we were also appointed in a similar role by the organising committee of the 1998 Winter Olympics in Nagano, a story in itself and one contract that no one in Japan thought possible. As I said, it all seems so simple now!

6

HOT PROPERTIES

Our first priority had been to establish a commercially viable business model facing outwards towards our client base, which offered scope for growth and a platform on which we could form alliances within sports at all levels and in all territories. Now we faced the bigger hurdle of gaining acceptance within the industry for who actually owned the intellectual property rights to the images we had, and would have, in our library. Tony had been approached by *Time-Life* and *Sports Illustrated,* two major US magazines, to cover European sports events for them, but although very generous, their terms were still no better than industry standard. They paid a substantial day rate plus expenses but retained all rights to all the images. Terms that we had been rejecting for years as it left no residual rights or revenues for us. Equally long standing had been the industry's grasp on those rights in what it saw as Holy Writ, but after much persuasion and horse trading, Tony being Tony, stood his ground for weeks before eventually managing to agree a rather unusual set of terms with them. Aside from paying him a day rate and covering all his expenses whilst on assignment, the magazines would only retain rights to the actual images they used. Rights for everything unused from his coverage would remain with him.

The effect of this agreement was highly significant, particularly when looking at the numbers. A typical assignment, the British Open Golf Championship say, would involve one day setting up and preparation and four days shooting. The first two days were mainly used in shooting stock images of all the players to make sure that we had a picture of everyone in case there was an incident or a shock result. By the third day we had a

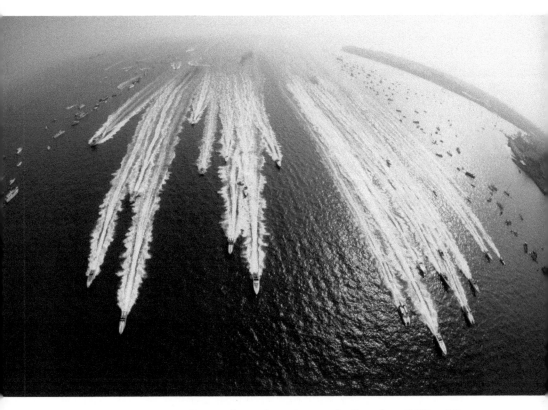

For my first major assignment for Powerboat & Waterskiing magazine, I decided to photograph the thunderous rolling start of the 1978 Cowes-Torquay-Cowes International Offshore powerboat race. Taking my life in my hands, using a 16mm fisheye lens, I dangled below our helicopter, held in place by the Editor Ros Nott, to capture this spectacular image.

Photo: Steve Powell/Allsport

good idea of how the leader board was shaping and changed our shooting style to follow only the top groups and finally, just followed the leaders on the last day. This strategy meant we shot on average 30 to 40 rolls of film per day, so with 36 frames per roll, at the end of four days shooting we would have amassed anything up to 5,500 images. *Sports Illustrated* would probably use three, maybe four in the story and by default, the rest became ours: this was a regular occurrence.

By 1978, I had got back into photographing events, first for a small magazine called *Powerboat and Waterskiing*, then slowly adding to my portfolio of magazine clients reporting on minor sports. Then I was

offered an assignment by *Sports Illustrated,* mainly because Tony was already working for them elsewhere and he suggested they try me out. They asked me to cover the Wightman Cup finals in the Royal Albert Hall between Great Britain and the USA. It was won by the British team led by Virginia Wade and Sue Barker, although you wouldn't know it from the published story. The magazine used two small photos, one each of Tracy Austin and Pam Shriver, somewhere near the back of the issue and ten days later I received back 80 rolls of colour transparency film, which, after editing, amounted to something near 2,000 prime stock images of the world's top women tennis players. Almost without asking, the principal of us retaining copyright and syndication rights on our images had been established, whichever Allsport photographer went on to shoot for *Time Life and Sports Illustrated.* Now there were two of us shooting for the world's top sport's weekly magazine with tens of thousands of images coming back to our archives at zero cost to us. In truth, this represented a profit as we were being paid a daily retainer of US$200 plus expenses, (about US$800 today), for the privilege.

Running any creative agency or, indeed, any publishing house is a fine balance between generating the product, whether photographic image, newspaper or magazine, and finally getting it into the hands of its target market. In this, we were no different, but the baggage that had come with a business that was physically unwieldy with vast files of transparencies and prints, posed singular problems of recognition, archiving, storage and future accessibility. The need to capitalise upon creative talent was the key. After viewing thousands of other photographers' images and giving talks to numerous amateur photography clubs, it was clear that there were many talented photographers out there who were commercially invisible. I would give my talk about life as a sports photographer and then take questions and view their work. Time and time again, I'd look at someone's portfolio and ask them why they weren't doing it professionally. The responses were very consistent. 'I'm only doing it for the art'; 'I don't like the money side'; 'I've never had a break'. Very quickly I realised the key difference between an excellent amateur photographer and a professional photographer was not solely vested in the quality of the pictures, but much more in the ability to sell them. You could take some of the best and most amazing photos in the world, but if you left them in your bottom drawer and didn't know how to sell them, breaks were not going to make you a professional.

Experience had taught me that I should think of photos less as works of creative genius and more as marketable assets. What concerned

me through most of my waking hours was how to sweat those assets to give us the best return. This mental effort suggested to me that the key to making the assets work was simply to store and package our product better, offering seamless access that was easy for clients to tap into; so that's what we set out to do. What it ultimately led to was a high-speed digital delivery system, but that was still some way in the future.

In the here and now, and firmly established in our Morden studio, we were working on a staffing ratio of three support staff to each photographer, be they darkroom technicians, editors, or researchers. I had to adapt my style and learn the technique of people management to run this growing head count effectively, especially as both Tony and I were now spending more and more time on the road on assignment. It made the time we had in the office critical. He was essentially a full-time photographer on assignment most of the time, which made him happy, but I was still constantly pushing hard to grow and expand the agency and take on more staff. Our lunches and discussions over them became epic. First, they were in Ed & Rita's Cafe, the greasy spoon truck-stop across the road from the office, where we could make a cup of tea and a full English breakfast last for hours, while arguing and debating loudly in front of a passing stream of bemused lorry drivers. When a few more cheques came in, we upgraded to the local *Emma Hamilton* pub and entertained a slightly more discerning audience made up of local office workers. I often wondered what they thought overhearing our loud debates, which ranged from expenditure on pricy pieces of equipment to budgets for some very exotic world travel.

Having developed and improved the basis for servicing our clients and secured recognition within the industry that we held the intellectual property rights on our images, the third important factor was to refine the working relationship with our team. The inward-facing business model we developed paid the photographers and provided all materials and expenses, but the agency owned the copyright on everything and the ability to syndicate it. We turned down lots of commissions in the early days because we would not surrender copyright. Often, they were tough calls influencing our fragile finances, yet after Tony had brokered the deal with *Time-Life* and *Sports Illustrated*, the combination of retained stock and new material coming in daily helped us build a much more valuable archive. It had dawned on me some time before that the industry was changing and if we were to survive and grow, we needed to change the industry's perception of Allsport, by being just that bit different to our opposition. The simple lesson in selling I'd learned from my mentor

at the Initial Towel company was that in order to be successful, it was essential to establish a perception of value in the mind of the buyers. Once we had that nailed down, a sale would most often follow: but would the same tactics used for soap dispensers work equally well for pictures? Well, yes, it did. Begin with an excellent product - we had that with our pictures - then back it with industry-leading service and support, which comprised the added value. All that aside, I came to realise that at the level we were aspiring to, most of our competitors used great photographers too and supposedly they all offered excellent service and support, so how to present ourselves differently and better?

When a client puts out a call for a picture of some international sporting star, you knew that all your competitors would flood his picture desk with images of that man or woman, so my problem was to devise ways of increasing our chances of a sale. The answer was to make our customers' busy lives easier and appear valued, and this included establishing the perception of value in our offering. Part of that value equation was to keep our name in front of the market. Among other ways, we did this by the simple ploy of regularly entering our staffers' work in photo competitions. We won a few - we were later to win most - but just entering was sufficient to keep us firmly in the crosshairs of the trade press and our increasing raft of commercial clients. In my less than perfect world, where we didn't have a monopoly on good photography, we worked hard to give the impression that we did and very soon, the perception amongst the world of picture buyers was that our work won everything.

Unlike all other photo agencies at the time, we always asked our clients to give a photo by-line to the photographer before the agency, as I believed that this protected the photographer's interests and allowed them to build individual reputations in the industry. As most photographers we hired were successful freelancers before joining us, they understood the importance of keeping their name in the spotlight. It appealed to their egos, something all of us enjoyed, but more importantly, it built their individual reputations in the publishing world. This combination of great photos, first-class service and renowned, award-winning photographers became our perception of value moment. I am convinced that in the final moments of decision for a picture editor faced with two equally good pictures, the recognition of either the photographers name or the Allsport logo out of the corner of his eye would often close the sale.

Among our 1978 intake was Adrian Murrell and his speciality was cricket. His in-depth knowledge of the game and its players helped him to regularly produce quality shots that had already made him

the go-to man. His work, gathered from cricket grounds around the world, had appeared in every British newspaper from the *Mirror* to the *Sunday Times* and many top line specialist sports publications, for the best of reasons. He was very, very good and very, very reliable, so it was natural for us to want him on our team. Adrian was a natural freelancer who had been inspired to become a photographer by many of the same people who had inspired me, the greats from the Vietnam war era and more recently, by his future brother-in-law, Clive Limpkin, a top, multi award-winning press photographer for the *Daily Mail*. His work for the *Mail* during the Northern Ireland troubles was published in a book called *Battle of Bogside* and won the prestigious Robert Capa Gold Medal, an award presented for 'best published photographic reporting from abroad requiring exceptional courage and enterprise'. An award which, incidentally, had been won three times by my hero Larry Burrows.

Adrian's route into photography was typically perilous and circuitous, having started on the formal apprenticeship route as junior assistant to a well-known commercial photographer. Then he had signed up to a three-year Diploma course at The Guildford College of Art and Design, considered to be one of the best courses available, but after a year grew frustrated with the lack of progress and left, to work in the city as a marine broker. Again, he soon got bored, despite, or maybe because of, the lucrative pay and the long, drink-fuelled lunches. Looking for a different sort of excitement, he went on a year-long overland trip to Afghanistan and India in a beaten-up old Ford Transit van and a couple of Land Rovers, with a group of people he'd never met before. This trip got him back into taking photos and gave him a unique insight into the subcontinent.

Returning from this adventure, he settled into a daily life of freelance shifts for national newspapers, mostly the *Daily Mirror*. It was not always the most glamourous of jobs as it involved doing the stuff the staff photographers didn't want to do, so in 1976, when he read that the England cricket team was going to tour India, he reasoned that while he had never photographed cricket before, he knew the country. Armed with this simple logic, he embarked upon what would become a three-month odyssey following the play. In true freelance fashion, he saved a fortune by staying in Salvation Army hostels and using India's extensive third-class rail system. Because of his contacts at the *Daily Mirror,* they agreed to look at any pictures he sent back, provided he 'wired' them every night after play had ended. Today that makes absolute sense.

Now, you could probably zip a few dozen back on your iPhone while enjoying your first sundowner of the evening, but back in 1976, the process was a little more challenging!

Having spent all day in the heat, battling officialdom to get into the stadium, humping heavy equipment through teeming crowds of fans and concentrating hard on every single ball of the innings, he would then go back to his one-star hostel room to process his film before trekking cross-town to locate a suitable wire service. In India and Pakistan this was most often a general post office, but Cable & Wireless offices were the preferred option. Back in the 1970s, C&W provided the most reliable communications network in the world, especially in less developed parts of the globe, but both post offices and all C&Ws' bigger offices had Muirhead-Jarvis photo wire-machines. A hangover from the 1930s, they were substantial pieces of hardware that needed a skilled team to service and maintain them and negotiating access was the key. This was, in itself, something of a major challenge requiring patience as the queues to use them were often long, as every one of India's regional and national newspapers would also have a reporter demanding access and local police would be sending mug shots of criminals to other cities across the country. The staff of the Indian Government Department of Posts tended to regard its customers as major security risks, so Adrian was forced to hand over his pictures and they disappeared into the back office to be sent. The only simple bit of the transaction was the payment: it was rendered with a C&W credit card and billed back to the respective national papers.

Even in the C&W offices, a young Englishman claiming to work for a British newspaper came a long way down the food chain. Even then, when access was secured, it could be a slow and frustrating process. Wiring a black-and-white picture took a minimum of 20 minutes per image, providing there was no 'noise' on the line to distort it. After sending the image, Adrian would wait patiently on the line for the newspaper's wireman, a union man who did things when he chose to and was generally impervious to the shouting and screaming of Indian operators wanting you off their only international line, and after a respectable wait, because the wireman had to make clear to everyone who was in charge, Adrian would eventually get to ask the question. Was the image clean and not distorted? If the answer was no, he would have to go through the entire process again, until it was right. These proceedings often added another three to four hours to what had already been an exhausting twelve-hour day, so it was no surprise that unless he

had captured something really special, Adrian only attempted to send back two or three pictures a day. Cost was also a factor as each image sent down the wire would be charged at around £70 – the equivalent today of £250 – so understanding what was likely to be the story of the day and his good editing were vital.

Against all the odds, Tony Greig's English side won and around forty of Adrian's pictures appeared in the *Daily Mirror* during the tour. As there were no other British press photographers wiring pictures from India, he made an instant name for himself amongst the Picture Editors on Fleet Street. The following year he was assigned to cover the British Lions rugby tour of New Zealand by the *Sunday Times*. This newspaper was at the height of its fame with the great Harold Evans in the Editor's chair and any photographer would die to get a picture published in their pages. We met Adrian in early 1978 at the British Sports Photographer of the Year Awards while he was receiving an award for his portfolio of pictures from that Lions' tour. Shortly afterwards, he agreed to join us.

As we went into 1979, a big part of the game plan was to expand our global presence. One of the overseas territories that had always fascinated me was Japan and this was the year in which I made the first of what would be many visits over subsequent years. Initially my visit was to find an agent to represent us and sell our work, but it was as much to immerse myself in the country's culture and how companies there did business. Preparation is all, so I had set up several meetings with different agencies and scheduled about six meetings over two days. Negotiations were often difficult to comprehend, and business was conducted at a glacially slow pace, as although we had been assured that every company had English-speaking staff, it was usually a junior employee just out of school pressed into translation duties, who was equally terrified of foreigners and his boss. I also discovered the Japanese love of Chinese food and, as each meeting concluded and regardless of the time of day, the people I was meeting insisted that we had lunch. It was always at a Chinese restaurant.

Throughout my time at Keystone in London I had been aware of their corresponding agency in Japan, and I had purposely held that meeting back until halfway through the second day, by which time I thought I would know how the land lay. On arrival I was greeted by Irene Kirkpatrick, a character who could have come straight out of central casting. A Scottish expat who would, in any other life, have been seen leading little orphaned children over a mountain pass and out of harm's way; very Ingrid Bergman. An attractive lady of a certain age, she had lived in Japan most of her life and spoke perfect Japanese. In the Japan of

the 1970s, it was very unusual to have a woman working in any position of responsibility in any business, never mind a foreigner, but she was well known in the industry and highly regarded by the senior management. Knowing that I had been meeting other agencies, she immediately questioned me on how many Chinese lunches I'd had, and did I need another one, explaining that it was the Japanese way. When I politely declined, she was much amused.

After a tour around the offices and an introduction to her senior management, I was invited to dinner later that night. As was customary, there was a big turnout from the Japanese contingent, perhaps a dozen from several layers of management, all sitting very formally and waiting politely for the Managing Director to lead the conversation; he at one end of the table, me at the other, with Irene keeping the conversation going between us. The Shabu-shabu hotpot was excellent and the drink plentiful, but to my surprise everyone's choice appeared to be whisky with a side order of Coca Cola. Having followed in my father's footsteps and been a whisky drinker all my short life, I felt confident that I could hold my own, so matched my hosts' consumption drink for drink, with many toasts of fraternal friendship and good business.

Unsurprisingly, I awoke the next morning with a crippling hangover and a slight sense that I might have presented myself in a less than perfect light in front of my Japanese hosts. Irene phoned to say I'd agreed to meet the Managing Director at 9:30am to sign the deal and that she would pick me up. Feeling rather sheepish, I apologised and asked if I had embarrassed myself in front of her colleagues the previous evening and how on earth could they drink that much whisky and not fall over? She then gently explained that in fact, my capacity had impressed them as they had been taking a sip of whisky and then spitting it into their Coca Cola all evening, which explained the constant demand for fresh Cokes. I was to go on to fall in love with Japanese culture and food, but always in the back of my mind was the thought that I was a foreigner and as such, fair game. We appointed Keystone Japan as our agents, influenced in no small way by the fact that they had one very savvy English-speaking lady on their payroll; Irene Kirkpatrick.

Working at the sharp end of the agency with a camera in my hand again produced some big breaks, not least in July 1979, when Tony and I were assigned to two major stories for *Sports Illustrated*. Front covers and opening spreads to lead stories in any magazine were important, but for sports photographers, scoring in either category in one of the most influential sports magazines in the world was the Holy Grail. In one

week, we had the chance to land a front cover and the opening spread, in the same issue.

The first story was of Sebastian Coe smashing New Zealander, John Walker's, world record at the Golden Mile in Oslo's famous Bislett Stadium. Tony and I had been there earlier in the month to witness Seb break Alberto Juantorena's 800 metre World Record in the same stadium, so expectations were high. Kenny Moore, senior staff writer for *Sports Illustrated,* passed the word that if the mile record fell, we stood a very good chance of getting a cover, so we had everything to play for. Tony and I rigged remote cameras, high and low, on the finish, on the start, everywhere. Then we set off into the infield of this small, intensely atmospheric stadium, each of us armed with four Nikon F2's around our necks and a multitude of lenses from 24mm wide angle to 400mm telephoto. We were determined to deliver.

The evening wore on and finally, by the time of the start of the IAAF Golden Mile, we were ready. It was an exciting race in a stadium known for its knowledgeable crowd, so we photographed every lap from multiple angles including from our remotes. Seb led from the start and nailed the record in 3.48.95, beating New Zealander, John Walker's previous record of 3.49.04. Fair to say that we were pumped as Seb went into his victory lap, a little high on excitement and adrenaline. As usual, the lap ended with a struggle between photographers each trying to get the best angle of the victorious athlete; elbows had been known to have been involved. Then throw in TV crews, all pushing for their shots and it can be challenging. Eventually, Tony and I realised the only people elbowing us were ourselves, so we figured we had it covered from every which way.

We packed up our kit and handed the film over to a local courier, on the first leg of its journey back to New York. As an evening meeting under floodlights that didn't finish until around 11pm, it was late when we made our way back to our hotel which, as always happened when travelling on expenses, enjoyed a certain style and presence. We had been taught well by *Sports Illustrated* staff photographers we'd worked with not to let the side down, so we lived well while on assignment, especially so this evening, as we had an almost guaranteed cover story. There we were, two rather tired and distinctly grubby snappers in jeans and trainers with something of a raging hunger and thirst marauding about this very smart hotel late at night, looking for something to quell those needs. Inevitably there was only one place left open at midnight and that was the classiest restaurant in the hotel. Nothing daunted, we

scruffy two sashayed our way around couples in ball gowns and dinner jackets and approached the desk.

To give him the best of it, the maître d' was less than welcoming, but we pressed the point that as guests we had a right to be seated and fed. Realising that while his professional reputation might be forever scarred, the reputation of the hotel was more important, so he ushered us to the very back of his plush restaurant and presented his menu, *cordon bleu* of course. Then he introduced us to our waiter, fully liveried. On the basis that a place of this class could hardly screw up a good steak, that was what we ordered, plus a bottle of their best champagne. We had a cover story, remember; we could do no wrong. Just as our man was poised to run for it with his menus and our order, I realised that what would set off my steak to perfection would be a couple of fried eggs on top. To this day I remember his look of abject horror when I ordered it, so I enquired: "What's the problem, can't you do it?" His response was both quick and epic: "If Sir can eat it, we can cook it." They did, I could, and Tony and I collapsed into laughter from the champagne and the high of one of our most successful working days.

The second was of a very pumped-up 22-year-old Severiano Ballesteros breaking through the gallery at the Royal Lytham & St. Anne's links course, having just won the 108th British Open Golf Championship and the first of his five majors. It was my first assignment for *Sports Illustrated* without Tony as a partner and although I'd done a few assignments for them since my Wightman Cup debut, the magazine still saw me as a number two photographer; second man in the team, as I had been in Oslo. Just to be on the safe side they assigned me to an experienced freelancer, Graham Finlayson, who had shot for them many times before. Graham was a lovely guy and a brilliant photographer, having come up through the regional press in Yorkshire, then worked for the *Daily Mail* and the *Guardian,* before going freelance in 1965, but he wasn't Allsport, so the competitive juices flowed. I listened and learned with long chats over breakfast in our hotel, particularly how *Sports Illustrated* liked you to approach covering a major golf championship like this. First and second days for stock shots plus the wide scene-setting shots; the third day following the top groups and getting action shots of all the lead contenders; the final day covering it as news, the leaders only, with an eye out for incidents and that one big atmospheric picture. Later in my career, my speciality became that one big atmospheric picture, spending lots of time at the back of grandstands or on stadium roofs to get the unique image.

Graham also taught me some things during those wonderfully laconic chats: that every time you frame up a picture in your camera's viewfinder you must think, front cover or opening spread. The rest is just a waste of time. It was advice that served me well in the coming days and years. Having got all the early stuff in the can, on the last day of the Open, Graham decided, as was his right, that he would go out on the course. He would follow Hale Irwin, two under par overnight, having led the field for most of the week, while I would spend all day sitting on the 18th green, photographing the responses of the leaders as they came in, covering us in case there was a sudden shock result. It was very much the number two-man spot.

A long day perched beside the 18th. green at Royal Lytham St. Annes finally delivered this image of the 22 year-old Seve Ballesteros breeching the gallery on his way to winning his first British Open Championship.

Photo: Steve Powell/Allsport

Irwin's playing partner on the last day was Seve Ballesteros, the popular young Spanish golfer who had broken onto the professional scene at the age of 18, just four years before. It was to prove eventful out on the course. All day I sat there in my nominated position, dutifully photographing the early finishers while listening to the public address system relaying all the dramas and action happening beyond my view. Despite repeated excursions into the rough, Seve always seemed to find his way back to the green and on the 16th, he famously hit his tee shot into the carpark, yet still managed a birdie. Finally, on reaching the 18th tee his win was almost guaranteed, as Irwin's game had fallen apart, dropping seven shots on the day, while his closest rival was Ben Crenshaw, three shots behind. As Seve played his second shot towards the flag, the crowd erupted and thousands invaded the fairway to surround the green. This created a huge wall of fans blocking not only Seve's progress up the fairway, but also that of my exhausted colleague, Graham, who had been battling crowds and marshals all day.

Seve fought his way through the crowds to eventually break the thin blue line of British bobbies and marshals trying to hold the wall back. A wave from Seve and a wry smile, click; the double page opening spread was mine. The wonderful faces on the fans, the contained intensity of the bobbies and marshals, all except one who carried a large 'Quiet Please' sign while screaming his head off. It made for one of the most iconic images of Seve's career, and mine.

When the story was published a few days later, I had the double page opener and two of the three other pictures used. After a week's hard work, all the pictures used came from that last day and all mine were taken from that number two-man position, I didn't even need to stand up to get them. Competitive? Me? Never.

We also made the front cover with the material from our Norwegian trip: Coe set against the Oslo crowds sporting the Union flag, but because our films had become mixed in transit to New York, the picture was credited to both of us. More than anything, that one issue of *Sports Illustrated* heralded the real start of my photographic career, and the start of the most exciting period of my life as we entered the eighties.

7

GET THE PICTURE,
TELL THE STORY

The year 1980 started well with the annual awards ceremony on the first night of the London International Boat Show, organised by *Powerboat and Waterskiing* magazine. It was the biggest event in powerboating, with all the major names and champions from offshore and circuit racing flying in from around the world to attend and invitations were at a premium. Although powerboat racing was attracting some major sponsors, it was still mainly the playground for the very rich. The offshore version was once famously likened to standing in a cold shower, ripping up hundred-dollar bills, while being beaten over the head with a sledgehammer. Difficult to immediately see the joy in that, but since 1959, these heroes, both men and women, had met regularly to race against each other in exotic locations. Surprisingly, it was still a small, friendly sport, dominated by boat builders and engine manufacturers.

Having started taking photographs for the magazine three years before, I had built a bit of a name for myself by then and was asked to run a slide show as a backdrop to the awards. Which I did, to the sounds of Ravel's Bolero. A little cheesy I know, especially as the scene from the film *10* with Bo Derek and Dudley Moore, was causing a sensation in the cinemas at the time. I thought this high-speed, adrenalin-packed sport designed for the rich deserved no less and the audience seemed to agree. I suspect for many in attendance it was the first time that they started seeing their sport as sexy. Always expensive, often painful, but sexy; not so much. It raised what was to be a chicken and egg question that I would often need to answer about many sports in the years to come. Was the sport having a media and sponsorship heyday because of

my pictures being published all over the world, or was I being published all over the world because the sport was becoming popular? If I could somehow demonstrate that it was the former then I could capitalise on that. If it was the latter, well, just profitable opportunism then.

Powerboat and Waterskiing was one of a stable of specialist magazines produced in cramped offices in Buckingham Palace Road, the entire operation run with a sort of benign paternity and occasional eccentricity by their publisher, Anthony Churchill. Not immediately recognisable as a magazine publisher, and definitely not as a powerboat racer, he was more famous for being the long-time navigator for the British Prime Minister, Edward Heath, aboard his ocean racing yachts, *Morning Cloud*. Churchill was something of a patrician figure who always looked as if he had dressed hurriedly in the dark and hinted at a mysterious past with links to countries behind the Iron Curtain. On the plus side, he appeared to populate all his magazines with dazzling and very pretty girls. Not least *Powerboat and Waterskiing*'s editor, Ros Nott, with whom I had built a great professional working relationship.

We had just returned from the USA, reporting on the Parker 7-Hour Enduro race on the Colorado River. First run in 1963 as a 9-hour marathon and as one observer of that first race said, was mostly entered by Californian chrome-nut inboard folks, it was reduced to seven hours in 1974 in deference to fuel conservation but remained a surreal event which was truly a 'run what ya brung' race. In true American style there appeared to be no specific rules or classes, although no doubt there were, but the goal was more to survive for the full 7 hours. A bit like the 24 Hours of Le Mans, but for boats and of shorter duration, although it could be argued, a little more challenging. Travelling at high speed in any boat for hours on end is tiring at best and dangerous at worst. Every shape and form of boat was there, from little cathedral-hulled Boston Whalers to high tech Formula One tunnel-boat speedsters. The only common theme across the fleet was they all had huge engines and made a lot of noise which, within the confines of the canyon walls, was deafening. After a few hours of me photographing boats doing high speed passes up and down the river and Ros interviewing anyone who would talk to her, we both agreed it was getting a little boring.

To offset that, I had tried wading waist-deep into the pits area during driver changes and refuelling, which produced some interesting images; but mainly just upset the marshals as there were massive propellers churning up the water all around me. Desperately keen not to upset the nice Englishman, they all just looked on in horror. So far, the

highlight of my day had been a Boston Whaler running up the beach next to me, only for the driver to leap out and start rummaging in the stern storage box. Assuming some grave mechanical woes, I enquired if all was well; "Yep, just need to change my 8-track music tape and grab a beer." He pushed his boat off the sand and sparked up his engines just as the eventual winner, F1 World Champion, Billy Seebold, in his Mercury powered factory machine screamed passed at over 100mph; truly surreal.

Eventually I persuaded Ros that as I had enough pictures of boats on the river, we should look for something else to amuse us. I had heard that the Americans love their desert sports and every weekend you can find something going on somewhere, so we asked around and were told about a Sand Dragging event going on 'out in the des'; just follow the oil cans, you'll find it. And find it we did, in our rented 1975 Cadillac Coupe Deville, which was totally unsuitable for the rocky dirt roads and tracks that we had to crawl over for nearly an hour. In hindsight, it reminds me of a wonderful conversation I had many years later with a gnarly old desert racer, Tom Webb. On enquiring which was the best truck to get to use in the desert, his instant answer was "a rental".

Our rental got us safely to a spot in the boonies that appeared to have no identifying features other that hundreds of trucks, buggies, cars and bikes of all sizes and colours gathered there. Everyone appeared to have a large mobile home and chrome was the finish of choice. For a young guy brought up in Seventies England, who thought go-faster stripes on his Ford Anglia was the height of cool, the sight of all these oversized toys was jaw dropping. Most exciting looking by far were the custom-made buggies and I soon set up a drag race between two of the most dramatically colourful of them. After a couple of runs I asked if I could ride in one while photographing the other, showing the opponent just a little ahead. Hard to believe, but sometimes photographers have been known to set things up to tell the story: "No problem," was the drawled reply. "We'll strap you to the nitrous tank, the only place we can fit you in." The explosive start was so violent I forgot to take any pictures. They suggested that they had only been going at half throttle, but yes, we could do it again. I got the picture I wanted second time around. It was all blue sky, yellow sand, red paint, gold trimming with chrome. It didn't get much better. This one picture went a long way towards paying for the entire trip.

When not being an editor, Ros was a bit of a matchmaker and had introduced me to Geraldine Carpenter at a circuit powerboat race in

Cardiff docks in 1978. Affectionally known to everyone as Beans, she was, and still is, a glamorous blonde who had just been voted Miss Yardley Powerboating. Ros and Beans were close friends and although she didn't work at *Powerboat and Waterskiing*, she used to join us in the early evening social milieu that gathered below the office in Tiles wine bar. For two years I admired her from afar, never quite plucking up the courage to ask her out and I suspect Ros knew this, so when I found myself sitting next to her at the awards party, I knew I'd been put there for a purpose. I finally asked her out for dinner, just days before I left for the States to cover the Winter Olympics and other sporting events that would keep me out of the UK for over three months. This in the days before email, mobile telephones and text messages could keep fledgling relationships alive, so it was no great surprise that when I called her on my return that her response was: "Steve who?" We persevered, but neither of us knew then quite what a whirlwind the next forty years - and still counting - would be, what it would bring and how far we would travel together.

The Winter Olympics of 1980 were held in the classic Adirondacks mountain town of Lake Placid in upstate New York. Among other titles that would take my material, I arrived there with a slightly unlikely commission from *NOW!* magazine. Launched in 1979 as a weekly news and current events magazine and aspiring to be 'the best of the best', it always appeared to suffer from having too many famous faces on big salaries and not enough workers doing the important stuff. However, a commission was a commission. The Games turned out to be a great assignment and eye-opener for me. My experience of doing stuff in sub-zero temperatures and snow was slim and nil, and I discovered that it was a good deal easier to come down a mountain carrying 60lbs (about 27kg) of camera gear than to climb up one carrying that load. Mental note to self; learn to ski!

I will always remember those Games for the highly unlikely victory of the young American college kids over the USSR's professional hockey team in the Gold Medal match up. The atmosphere in that stadium was extraordinary, with an electricity in the air that made the hairs on the back of your neck stand up. It became difficult to breathe because of the excitement and tension, it was my first experience of really watching history being made. 'The miracle on ice' was to become one of those 'Where were you when…' moments. Well, I was there, and I can think of nothing more to add to that, other than the warm glow of memory. Smug? Maybe a little, but forty years later, my neck still tingles.

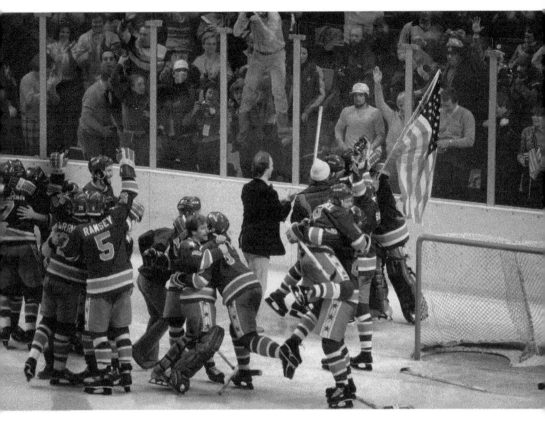

Certain moments still resonate years after they were photographed. The 1980 Winter Olympics in Lake Placid produced just such a picture when I captured the amateur US College hockey team having beaten the USSR professionals in what became known as 'The Miracle on Ice'.

Photo: Steve Powell/Allsport

The other abiding memory from those games was the weather. It started warm and spring-like with temperatures that soared one day to +50°, causing the organisers to use snow machines for the first time at an Olympics. It then plummeted to -20°, with the wind chill dropping it still further on some days. The small resort of Lake Placid (population 2,700) wasn't prepared for this and the lack of planning and resources soon became apparent. Having banned all private transport in the region to avoid gridlock, the organisers then failed to supply enough buses, and those that they did provide were old school buses that broke down repeatedly in these conditions. Tens of thousands of spectators were left,

often for three or four hours, waiting for buses in sub-zero temperatures. They treated hundreds for frostbite and then declared a localised state of emergency to help bring in State and Federal aid. It led to one *Sports Illustrated* writer to describe it as "this Siberian nightmare", and it wasn't just the fans that suffered. There were over 1,000 athletes and 10,000 officials, marshals, members of the media and television crews, that all needed ferrying around between venues and accommodation dotted all over the region. The little hamlet of Lake Placid struggled to host a temporary population twenty times their normal size.

Working in those conditions was nigh impossible, but you had to, as once the games start, they stop for no one. I would spend most days on Whiteface Mountain, the venue for the Alpine skiing. The routine began with a struggle to reach the venue on whatever bus you could find, often arriving three hours before the start. This was followed by a hike up the mountain with my payload of camera gear to find the favoured spot and await the action, all in arctic temperatures. There is nothing that can keep the cold out in these conditions. Camera batteries drained in minutes, the film would become so brittle that it would shatter as it was being loaded and your fingers would stick to frozen camera gear. I know of several photographers who were treated for frostbite, but you learn quickly how to survive and function in these conditions. Thin silk gloves that allowed you to use a camera without losing skin quickly became a black-market item. Those and thermal socks, with the toe cut out and bundled around the wrists, allowed us to work. We all developed the 'Lake Placid shuffle', as we stored all our batteries and film in the warmest place on the body until the last possible moment. Which for a man, strangely enough, is in his underpants.

Having been on the go for nearly twelve hours, trying to be creative in the most challenging of conditions, I'd shuffle back down the mountain to the media bus stop and pray for a bus to my next venue, usually figure skating or ice hockey. Another four-hour session, but at least it was indoors. Typically, we'd finish at around 11pm and then head to the Main Press Centre to edit film and ship it back to the UK. By 1am it was with relief that over the MPC speakers came the announcement "Last bus to Wilmington", at which point I'd scrabble to get on it, hoping that the twenty-minute journey wouldn't take two hours, which it frequently did. Then, just a few short hours later, it all started again. The memories of Lake Placid are still very much with me. Bittersweet, yin and yang, and always there to remind me. In a drawer somewhere, I still have my treasured 'I survived Lake Placid 1980' t-shirt, a best seller at the time.

When the Games ended, we were all very relieved to leave but I was not yet heading home, having planned another two months in the States. I had several fixed events to cover, including Alan Minter's bid for the World Middleweight title against Vito Antuofermo in Las Vegas. I used Vegas as a base for the next month or so, as Caesar's Palace was offering to put me up for free in the hotel's Fantasy Tower. Well, there were some perks to being on the accredited press corps. While there I travelled around looking for interesting and unusual sports to photograph and although hang gliding had a following in the UK, it was most certainly not mainstream. However, launching off the cliffs of La Jolla near San Diego, with a nudist beach below, was certainly different, but in those days everywhere you turned in California you found someone doing something different.

Getting the best shots frequently meant getting close to the action. Here I am, second from the left at ringside, as Minter and Antuofermo slugged it out in Las Vegas for the World Middleweight title.

Photo: Paul Harris

For us in the UK, the 1970s had been a pretty depressing decade. Socially and economically scarred, among other things it had suffered from a world oil shortage, a 3-day working week and the stifling intransigence of the unions that had come close to crippling business. People were hungry for anything new and exciting and skateboarding was another sport that suddenly gained popularity. Tony had stumbled across it a couple of years before and his coverage ended up as a major cover story in the *Sunday Times Magazine*. So, the model of commissions to cover a set

number of fixed events and filling in the gaps looking for other interesting stuff proved a viable format. It also meant that we didn't have to fly back and forth to the UK, as that was just too expensive. I even learned to ski, after a fashion, with a quick trip to Steamboat Springs. The stay in Vegas convinced me that gambling was strictly for the birds. Though I loved it for its colourful people, excitement and lights, and I was to return many times in the next twenty years, I never gambled. Coincidentally, I was back there later in the year to cover the bout between Larry Holmes and Muhammad Ali, which Holmes won on a technical knockout.

Back in the UK, I renewed my courtship with Beans and revisited what was happening in the business. This was to become the pattern of my life for many years to come, constant travelling, often for extended periods, requiring hard work on both personal relationships and the business when back at base.

If the Keystone process for selection, printing and distributing black-and-white photo prints was a truly gargantuan enterprise requiring lots of staff, then colour origination was a whole new deal. We had invested heavily to develop a high-quality duplicating system that allowed syndication of best picture to multiple clients and began building a network of representation in overseas territories to further support this facility. The duplication equipment for colour transparencies had been out there for a while, but nobody was using it in volume, purely because of the expense. We bit the bullet, invested, and once again found ourselves ahead of the curve in our market.

The challenge was not so much investing in the equipment, but more, changing the market thinking to accept duplicates, with what was inevitably a slight reduction in quality. Essentially, this came down to ensuring that the content of our work was absolutely the best and stubborn, pig-headed determination not to allow our best 'red dot' pictures to leave our offices. The term 'red dot' became an industry standard for the best pictures from a shoot; the edited selections that would go to be duplicated for syndication, but its origins are more mundane. It all started one day in the late seventies when Tony and I were editing one of his shoots. Looking for something to mark the good ones on the cardboard transparency mount, Tony found a strip of small red dots in his drawer and so a legend was born. Eventually, clients were persuaded that if they wanted to use one of Allsport's red dot images, they had to accept a high-quality duplicate. This market-leading initiative finally gave us easy syndication of the best pictures to multiple clients, worldwide. Alongside our client base of publications and newly emerging

sponsors, we began to capitalise on the complete package of words and pictures, and I found our back-catalogue of images from smaller sports to be increasingly valuable; after all, who else had covered ping pong, powerboats and pigeon racing?

We were now working in a much more methodical and predictable fashion. We had to, for now we had nearly thirty agents in overseas territories and a host of colour magazines all over the world that were relying on our generated coverage and stories. Every month we would do an agent's release, based not just on our coverage of the month, but with two other important elements which we christened the Preview and the Feature. Recognising the long lead-times of magazine publishing, the former listed major events coming up as much as three months ahead. This coverage would include stock pictures of the venues, main contenders, young hopefuls and some 'artsy' pictures of the sport, enough to give a busy editor an instant space-filling story. The Feature would include a short story with between ten and twenty pictures, the picture collection themed, sometimes with rather tenuous links, but it worked. 'Pretty Girls in Sport' (sorry, different times), 'Silhouettes in Sport', 'Accidents in Sport', 'Celebrations in Golf', 'Celebrations in whatever', and so on, and it delivered. Busy editors all over the world managed to take an early lunch because they received a package from Allsport that morning that filled an empty space in their pages.

Probably the classic example of how this could work was with the Indian *Sportstar Magazine*, a publication that Adrian Murrell discovered in 1980 on his trip to cover the England vs. India Jubilee Test. Staying with the England team at the Taj Hotel in Bombay, now Mumbai, and suffering a mighty hangover having been drinking with Ian Botham and others in his room, he had left the drinkers in the early hours of the morning to try to prepare for the next day's cricket. Feeling rather jaded, Adrian took a call from reception early that morning informing him that someone from the Hindu Publishing Group wanted to see him. V.V. Krishnan, the *Sportstar* chief photographer, arrived at his room and expressed a desire to use his cricket pictures in the magazine. At the time, Indira Gandhi ruled India with an iron rod, so V.V. had to explain that because of extremely strict foreign exchange laws, he could only pay in rupees. We had discovered that in India, bartering Levi jeans or a bottle of Johnnie Walker whisky was worth a week's worth of fine dining in a five-star hotel. Not dissimilar to Russia, as the photographers who later went to the Moscow Olympics found they could live like kings for a few US dollars or a pair of Levi's. Still carrying a mighty hangover, Adrian politely declined as he was not

interested in getting tons of rupees that were almost useless outside India. Ending the conversation, V.V. departed, and Adrian thought no more of it, going off to the ground to cover the day's play. Legend has it that Botham had stayed up all night drinking with friends, but if he had, it clearly hadn't inhibited his game. He scored a blistering century and then took thirteen wickets in the match. All in 100 degrees!

At the end of the test series, Adrian was packing to go to the airport when V.V. visited again. Very proudly, he told him that he had spoken to the owner of *The Sportstar*, Mr Gopolan Kasturi, and they agreed to pay us monthly in foreign exchange cheques. Mr. Kasturi was also the Chairman of the Hindu Newspaper Group, one of the oldest and most revered newspapers in India. Hugely influential in Indian politics, he must have used his considerable clout to obtain permission from the state's Ministry of Finance to allow foreign currency to leave India. At the time, many multi-national companies were struggling to get foreign currency out of India, even BAE Systems, who were selling arms to the Indians, but every month we got our cheque in pounds sterling. From that moment we built on the relationship, first sending all the images we took from world cricket followed by our Previews, Feature sets and event coverage. They paid just £30 a picture, regardless of how big or small they used it, but they used everything. *The Sportstar* went on to be the most successful weekly sports magazine in India and one of our most profitable and trusted clients, making us hundreds of thousands of pounds over the years.

Traditionally, photographers had always been justifiably cautious about selling cheaply into the third world, mainly because of the cost of servicing the market and the difficulty in monitoring usage. We changed all that with our cheap and easy duplication and distribution systems, using our globe-trotting photographers to do the monitoring. We would happily sell the same picture in Africa for US$25 that would fetch US$500 in the US. As technically we weren't selling the duplicate transparency, just the rights to use it, once our production and distribution costs had been incurred there was no further cost of sale, so multiple sales from the same duplicate at whatever the market could bear was a realistic business model. From a small UK operation, we showed the way in growing our business internationally in a very tough commercial environment, doing everything that Prime Minister Maggie Thatcher had encouraged businesses to do. Getting out in the world. It also made Adrian famous in India, as exposure of his pictures and bylines meant he was often mobbed at Test Matches for his autograph!

While working on getting our systems accepted in the industry, we also had to keep the assignments going. As June rolled into July, I covered Alan Minter's rematch with Vito Antuofermo, at Wembley Stadium and then Wimbledon again. Two weeks of non-stop tennis, ending with the men's final between the ice-cool Björn Borg and the incendiary John McEnroe. McEnroe had already had a fairly tasty run-in in the semi-finals with crowd favourite, Jimmy Connors. Being booed as he came on to Centre Court to face Borg obviously added spice to their clash. Fighting for his life in the fourth set, McEnroe saved five match points in one 20-minute-long tie-break which he eventually took 18:16. Borg's service proved unbreakable in the fifth, which the Swede nailed to take the title, in arguably one of the best tennis matches ever played. I watched it and captured it all.

Later in July I had hoped to be in Moscow covering the Summer Olympics, but the Russian invasion of Afghanistan led to its boycott by the USA and 64 other nations, so getting any commissions was difficult, to say nothing of securing guaranteed access credentials. Tony and Don Morley covered it for Allsport, returning with harrowing tales of surveillance, hidden microphones and insane security. Having had one unpleasant experience that year with the Winter games, when I heard their stories, I was slightly relieved not to have been involved. I was to experience Russian hospitality later, as in the next few years I became *Sports Illustrated's* 'Man in Moscow'.

1980 had also been a busy year for Alan Minter, as in the space of six months he'd won the World Middleweight title, successfully defended it, and then lost it. The last fight, in Wembley Stadium against the American, Marvin Hagler, turned out to be a riot. Literally. There had been the usual banter between the fighters in the lead up to the weigh-in, but there seemed to be a definite racial edge to it. Minter, from south London, having gone to America to win his title then successfully defend it in the same stadium, was revered in England. Every bus and tube station had posters of him advertising sports clothing and the sports pages of the national press pumped out hundreds of column inches. By the time the fight started, although they had both tried to pull back from overtly racist comments, the scene was set. 10,000 drunken Minter fans, many of them unashamedly National Front members, were baying for blood.

I was shooting for *Sports Illustrated* from a position at ringside so had a perfect view of what transpired. The fight began at pace with Minter pushing hard, but every time he came forward, he would walk straight into Hagler's left jab and by the end of the first round, had a minor cut over his eye which Hagler worked on mercilessly. By the fourth round it was

clear to everyone that Minter couldn't carry on. With at least four cuts and obviously blinded by blood in one eye, the referee stopped the fight and got no protest from Minter or his corner. Victorious, Hagler dropped to his knees in celebration and I leaped up onto the ring apron to get the picture. The next thing I registered was that beer bottles, full and empty, were raining down on us. Hagler's seconds, instead of celebrating with him, were now huddled over him trying to protect their man. I was hit several times, but to be honest, I was in work mode and the pictures were just happening everywhere. I would take stock later, when it was all over, but meanwhile, I kept pressing the camera shutter. Clive Gammon, the great *Sports Illustrated* writer, wrote later: "It was a tainted night for Hagler, a disastrous one for Minter and a shameful one for England." All the above was true, so how was it that I felt elation and excitement, but no shame as an Englishman. Quite simply, I'd got the pictures. I'd told the story.

Alan Minter's defence of his Middleweight crown against Marvin Hagler took place at Wembley Stadium, but while the American boxer triumphed, my colleague, Clive Gammon, remarked that the riot that followed was shameful for the sport.

Photo courtesy of Sports Illustrated

8

ASSIGNMENTS, AND 'THAT PHOTO'

B y now, Allsport was growing in its scope, widening its coverage of individual sports and beginning to be recognised as the 'go-to' agency by everyone, from specialist publishers to organisers and associations. This brought additional, but welcome, pressure. Inevitably in this fast-moving world, we were judged by our most recent output of pictures and stories: for all of us it meant getting out there and delivering the goods. For purely business reasons, we were spending less and less time on speculative coverage and relying more and more on editorial commissions. During the early eighties, the assignments came in thick and fast, mainly but not exclusively, from *Sports Illustrated* and *Time-Life* and with our 'use or return' agreement, this allowed us to progressively build up our image bank.

Each year now I was covering most of the European track and field Grand Prix meets, Wimbledon, Monaco, the French Open Tennis and the British Open Golf. Just to spice things up, I added the Men's and Women's Ski season to my repertoire and learnt to ski. More functional than elegant, my skiing mainly comprised of side sliding and snow ploughing down horribly steep ice walls, which, of course, is where downhill courses are. If that was not difficult enough, I was also hauling a huge rucksack of gear and carrying the larger 600mm lens in one hand. Franz Klammer I was not!

The reality was that I would look at any assignment if I thought that the returns warranted the investment, but other less mainstream photo opportunities often presented themselves. One of these was when *Powerboat and Waterskiing* magazine commissioned me to cover a little-known lunatic adventure called the Maratón Del Rio Balsas. The publication had featured

this in the past when its then Editor, Quentin Van Marle, had persuaded Heineken to sponsor him in 1973/4 and it is fair to say that things had not gone well on either visit. Contested over about 400 miles of the tortuous shallows and rapids of Mexico's Rio Balsas, it is the waterborne equivalent of a destruction derby, entered by people who really should know better. Competitors race in a selection of inboard engine jet boats and outboard powered rigid inflatables (RIBs) and the Van Marle boats had suffered from what the more experienced participants called 'terminal rock rash'.

Run first in 1970, the course starts at about 4,000 feet (just over 1,200 metres) above sea level in the sleepy little village of Mezcala in a remote and dusty part of south-west Mexico. For 363 days each year the village and its residents doze peacefully in the shade because it is not big on the tourist trail, being almost inaccessible except by mule. The terrain, infrastructures and communications appeared not to have changed much since the days of the Spanish conquistador, Hernán Cortés. On their two annual days in the spotlight, upwards of 60 boats and their crews arrive from New Zealand, Canada, USA and Europe to launch, test, repair, test again, repair again, park on a sandbar and ultimately blast off down the river. Before their first event, the organisers had thought that they would flag the whole fleet away together in something approaching a Le Mans start. Then they stopped to consider the very real possibility that all might arrive together at the pinch-point of the first rapids travelling at 60 miles per hour and suffer mutual damage and loss of life. Wiser heads prevailed, so the boats now get flagged off one by one, racing against the clock. This still doesn't prevent them from running into each other further down the course, but it apparently minimises the risk!

For most of its length, the course runs precipitously downhill, because most of Mexico is built on a slope, and the river winds and tumbles through the spectacular Guerrero desert until it meets the Pacific near Acapulco. Competitors face a mixture of raging torrents, narrow gorges, shallow rapids and finally the open sea, and the river's banks are littered with the wreckage of boats from previous years driven by the over bold, the over optimistic, the under qualified or just the unlucky. The entire event lasted seven days and was basically a moving campsite, supported and fed by the Mexican army. The key features of this were that pretty much anything that the Mexican army fed you would kill you, and the only safe liquids were bottled beers. Sleeping on a riverbank in the open each night with US$20,000 worth of camera equipment presented its own security issues, so I took to sleeping with all my cameras and lenses in the sleeping bag with me; reassuring but most uncomfortable.

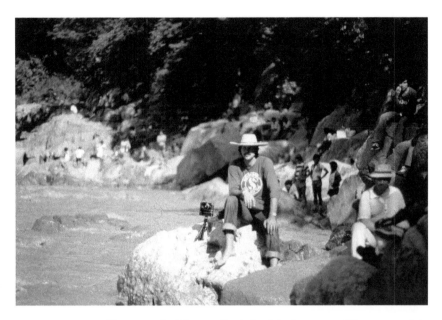

Not so much sitting on the dock of the bay, more sitting on a rock in a river. It was easy to get into the spirit of things while photographing the Rio Balsas powerboat marathon in Mexico.

Photo: Allsport Archive

If actually getting to the start was tricky enough, then covering the seven subsequent days of racing was something else again. Transport for the small band of media was by helicopters provided by the army, as road transport was nigh on impossible through this part of the desert. Each day their pilots would fly us down to an interesting section of rapids and drop us off, picking us up later that day to take us on to the overnight camp that they had pre-positioned. All good, until one day I teamed up with an ABC film crew and we asked to be taken to a particularly remote and beautiful spot that would not have hordes of drunken Mexican fans as a backdrop to our pictures. Initially, this went very well and having watched all the boats scream past, we sat down in the blistering heat of early afternoon to wait for our helicopter lift to the next overnight camp.

Well, it never came; someone had forgotten us. Truthfully, everyone had forgotten us and as day turned to night, we became a little concerned as we had no idea where we were nor if we could get out. Although we had a moderate supply of water, we had no food, but then, in the hot, still air we heard music, loud Mexican music. Following the noise, we saw twinkling lights in the distance. Picking up all our kit we went

exploring in the dark and came across a small Mexican village in what appeared to be the early stages of a fiesta. Speaking little or no Spanish we still managed to enquire about the availability of telephones and the possibility of transport. Perhaps inevitably there were neither, so we decided to enjoy ourselves and join in. After a hearty meal of burritos and beans, the party really started and our hosts became more and more drunk. Finally, they heralded the arrival of two horsemen in full Mexican cowboy outfits who proceeded to dance their horses to the music. An incredible and surreal sight as horses and audience all began moving to the rhythm of fiesta music in the firelight.

Everyone was now very drunk, and then the guns came out. Initially, the horsemen shot wildly into the air, which was fine and very 'carnival' but it wasn't until they started shooting into the ground around people's feet did we realise that they were playing with real bullets. Eager not to be left out, the rest of the crowd joined in and the atmosphere turned scary. At this point we realised that being the only gringos in town, who also happened to be in possession of tens of thousands of dollars-worth of camera and television equipment, it might not end well. In true Fleet Street tradition, we made our excuses and left, before hiking back to where the helicopter had dropped us earlier in the day. After an uncomfortable night sleeping on the desert floor, early next morning we fashioned a large 'H' on the nearest piece of flat ground and waited for rescue, which fortunately came a couple of hours later.

The final day of the marathon was a 30-mile dash down the last of the rapids, past the accurately named Infiernillo Dam into the estuary and open sea, before a 60-mile blast down to the finish in Zihuatanejo. I managed to hitch a ride in one of the jet boats for this last section and secured all my kit in waterproof bags, before what became the ride of a lifetime. The rapids were exhilarating, but the *coup de foudre* was the finish. Coming down the coast at high speed, we spotted smoke rising from a beach and although Zihuatanejo is a popular tourist spot today, then it was just a small town, and the partying crowds were all local. On approach, I saw several boats that had started before us that were now some 50 or 60 metres up the beach surrounded by a milling throng of locals. Thinking that they had helpfully pulled the boats up from the waterline, I was soon to find out differently. My driver applied full throttle, the navigator screamed a warning to hold on tight, we left the water still travelling flat out and screamed up the beach into the mass of people. First prize for winning the main event was a modest US$3,000, but apparently there was also a prize for the boat that could get the furthest up the beach,

though what that might have been was never made clear; and we didn't win it. The party that followed was a huge barbecue of fresh fish cooked in trenches in the sand, with margaritas and tequila that left me very hungover but thrilled. Proof that the life of a photographer could be quite exciting, if not a little dangerous.

Commissions and assignments came in many forms. At the polar opposite on the scale of personal danger was my part in an attempt to break the UK 24-hour bird spotting record. To this day I don't know what qualified me for this, other than that I was asked to cover it by an old friend and colleague, the late, great Clive Gammon. Clive was one of the nicest, most talented and well-rounded men in whose company it had been my pleasure to spend time and as a star staff writer for *Sports Illustrated*, we had shared many a reporting mission. Had he lived another life he could have been anything from the leader of a jazz-band, to poet, international rugby prop forward, or host of a good bar. Instead, he grew up to be a fisherman, teacher, author, top sporting journalist and friend of some of the most famous sportsmen and women alive.

Clive was also a countryman, but if he knew about 'birding' or 'twitching', this was an entirely new activity for me. Though apparently not to an American friend of his, who had flown over to the UK for the specific purpose of seeing or hearing birds fly over him! We met up at a convenient location on the Norfolk Broads: the American birder, his assistant, a three-man BBC film crew, Clive and me. We were to spot or hear and record as many different species of birds as possible in 24 hours, starting at midnight. I spent all the preceding day camouflaged in a hide, shooting stock images of birds and that was a first. The BBC and *Sports Illustrated* were funding this attempt and probably taking it a bit more seriously. At the early evening briefing I realised that everything was being done in style. We had Land Rovers, light planes and helicopters pre-positioned in convenient places all over the UK, but it also became clear that the birder wasn't interested in the story. He just wanted the resources we supplied. Hardcore birding enthusiasts will go to extremes to gain a competitive edge, and lest we screwed up his chances of taking the record, we were told, in no uncertain terms, to stay out of the way.

We spent the next day jumping in and out of the vehicles, traversing the country in light aircraft, spinning and circling over the Cairngorms in helicopters chasing eagles, which, if it wasn't illegal then, it almost certainly is now. We religiously ticked the box of species spotted or heard as we went, while all the time the birder was trying desperately to lose us. Knowing that if we became separated our story was history, we

stuck to him like glue and as evening approached, we all found ourselves perched precariously on a cliff edge just south of John O'Groats, the most northerly tip of Scotland. By then he had equalled the record, but that final record-breaking bird still eluded him. The pressure was beginning to tell, and the light was fading, so the BBC crew and I were very keen that he should spot the last bird before it got too dark to see or record anything. All the hours of preparation and dashing about the country had produced nothing, but at least we felt we could get a good celebration shot of the record-breaking moment. So, we jostled for the best angle and light as he peered through his tripod-mounted binoculars. Suddenly, a quiet murmur from the birder: "There it is. A Storm Petrel." Not a word of thanks or appreciation, no celebratory fist-pump of elation at a record broken, merely a note in his book as he walked away. Supper that night summed up the previous two days. As the only guests in the small pub nearby, the birder and his assistant sat in one corner, the BBC film crew sat in another, and Clive and I sat in a third; all glaring at each other. No-one in our business really expects too many thanks, but one would have been nice!

If covering the birder had been a thankless assignment, what followed made up for it big-time. The following day, Clive and I drove south through the Scottish Highlands to the Corrieshallogh Gorge to meet Joe Brown, a man considered to be the most accomplished climber of his generation. Nicknamed 'The Human Fly', he was also a keen fisherman, which was probably why Clive wanted to interview him. Joe was in his early fifties and although still a remarkable climber, most of his rock work now was more for leisure and pleasure. He was a charming and gracious Mancunian and Clive, no mean angler himself, had heard that his favourite fishing pool was beneath the old Victorian suspension footbridge overlooking the Falls of Measach. Joe's party piece was to attach himself to the footbridge, lower himself 200 feet (about 60 metres) on a rope in a controlled abseil descent, and, still dangling in mid-air, fish the pool below. We were to recreate that for the cameras. While Clive interviewed Joe, Mo Anderson, a young man who was climbing with him, took me off to learn how to abseil with cameras. It turned out that because of my height, well over six feet, and the length of my legs, I was a natural - going down. However, getting back up from the floor of the gorge below using Jumar ascenders, a method of pulling yourself up a single rope, was a bigger challenge with all the extra weight of the cameras. I managed it and got some great pictures while Joe had a great afternoon fishing, with Clive watching on from the bridge.

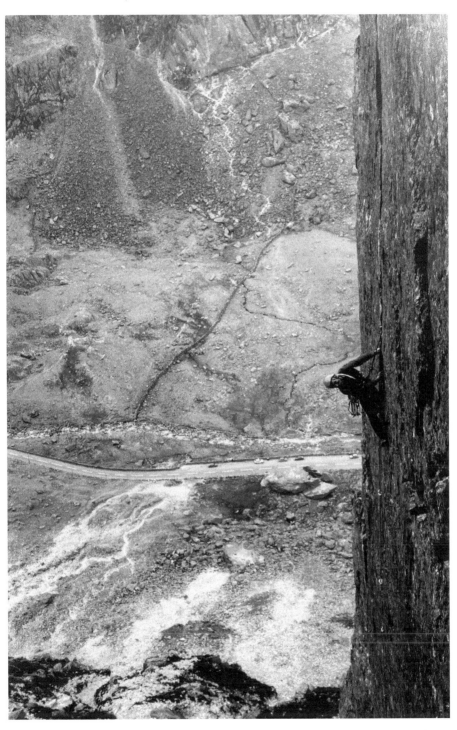

Abseiling down 150 metres to hang half-way down the Left Wall rock face at Cenotaph Corner in North Wales, I photographed Joe Brown recreating his most famous climb. Not for nothing was he called 'the Human Fly'.

Photo: Steve Powell/Allsport

The next day, we all drove down to Snowdonia in North Wales and reconnoitred Cenotaph Corner in the Llanberis Pass, a climb Joe had pioneered and climbed solo in 1952, by finding a route up the infamous Left Wall. Once again, we planned to recreate that famous climb, with Mo, acting both as my tutor and safety man, managing to get me up a simpler route before helping me abseil down the wall. The picture of Joe climbing and looking across to me with the A4086 road 1,000 feet (a little over 300 metres) below was to sell for many years to come, though *Sports Illustrated* didn't run either this or the 'birder' story. It was, after all, Clive having a bit of fun. Joe was the consummate professional and after a stellar climbing career, sadly died in April 2020.

Assignments continued to come in all guises. I was commissioned to cover the World Cup in Spain in June 1982, where I was to be third man in the team, supporting Manny Milan and George Tiedeman, both experienced *Sports Illustrated* staffers. Politics should never get in the way of sport, nor its coverage, but by the time we arrived in Spain for the football, Argentina was already two months into a war with Britain over ownership of the Falkland Islands, which they had invaded in April. To redress the balance, the British Expeditionary Force had set sail a few days later, landing on the Falklands on 21st May, after re-taking South Georgia. By the time of the opening game, many lives had been lost, the Second Battalion Parachute Regiment had 'yomped' across the island, the Scots Guards had taken Mount Tumbledown, overlooking Port Stanley, and it was not a great time to be British in Spain.

The night before the opening game, Manny, an American of Spanish descent, invited us all out to dinner. He had been pointed towards a great steak house by the hotel concierge and the meal started well enough until it slowly dawned on me that we were eating Argentine steak in an Argentine restaurant. It became obvious that Manny had made a mistake, when a folk singer got up on stage and started belting out very heated revolutionary songs about the battle for the Malvinas (Falklands). Although I spoke little Spanish, I quickly got the gist of what they planned for the invidious British. When the audience started pumping the air and singing along, I rapidly developed a strong American accent and spent the next two weeks speaking slowly with a Louisiana drawl, but only for safety and survival.

The opening night was unique in the first round, staging only one game, so we all wanted to attend to get our eye in at the stadium. It wasn't an important game, but it was between Argentina and Belgium and Maradona was playing, by this time a sporting legend. As was his

right, Manny said that he and George would take position at opposing goals and I should find a spot up in the crowd, which, being the junior partner in the outfit, I dutifully did. It wasn't an exciting game! An off-form Argentina was eventually beaten 1:0 by Belgium, but early in the second half, the South Americans were awarded a free-kick just outside the penalty box. The crowd clearly expected something spectacular to follow, but Ossie Ardiles took the kick, passed straight to Maradona who remarkably, was unmarked. The wall of Belgian defenders swivelled towards him, and from up in the Gods I clicked. Maradona attempted to loft it over the defenders but failed to bring any magic to the moment, the game lost intensity and rather fizzled out. I had no idea precisely what I had captured but shooting at my first World Cup I was more concerned with delivering good coverage. When lots of my pictures were published in the *Sports Illustrated* story, including the final and presentation of the Jules Rimet trophy, I felt I had delivered well.

It wasn't until weeks later when all my unused images were returned that I realised that I had mined a bit of a gem. That click from up in the Gods had captured the exact moment of Maradona facing the Belgium wall and had rightly been rejected by the picture editors, as an unimportant moment in an unimportant game and not germane to the story. However, to my eye, the composition and colours were perfect, and the look of terror on the faces of the six Belgium defenders was priceless. Maradona's positioning in the shot looked as if he *was* about to take them all on, no doubt to score. I filed it as a red dot, thinking no doubt it would make a good stock image in the years to come. I was not to be disappointed. It sold steadily as an ideal preview shot every time Maradona played in any major tournament, but that photograph would take on a life of its own and come back to punctuate my life in the future.

Unbeknownst to me, my photo - 'That Photo' as it was to become known - was gaining legendary status in the football world. Wherever fans gathered and talk turned to Maradona, someone would inevitably ask: "Do you remember that photo?" Not being a football fan, all this passed me by, until eighteen years later. In 2000, I received a phone call from a journalist on *Shoot Magazine*, the largest circulation football title in the UK. He was bursting to tell me that by popular public vote, my photo had been selected as the best football photo of the Century. I was slightly taken aback, but he explained its legendary status amongst football fans and surely, I must know that? He sounded slightly surprised when I explained to him that I wasn't a football fan and it had been my first and only World Cup. It was only polite to graciously accept the prize of

camera equipment, I made some appropriate remarks for publication and promptly forgot about it.

By the time of the 2014 World Cup in Brazil I had retired from professional photography and was enjoying a blameless Mediterranean day, shared with my wife and our Cavalier King Charles spaniel, 'Bertie the Seadog'. Lunch at the Royal Malta Yacht Club was concluding when I had successive phone calls from my daughters. Their message was the same: "Be careful Pops, you've just gone viral." Now I don't do viral, but apparently the hot player in the Argentian team was Lionel Messi and he was being compared with Maradona in all the media and, of course, on Twitter. Then some keyboard warrior tweeted that he knew a secret about 'That Photo'; that Maradona had not scored a goal from that position, he felt he had been deceived by the photographer and was it ethically right to do that? Hmmm.

I might have been retired and living on a boat, but I knew what a Twitter storm was, and within minutes of the calls from my daughters, my phone came alive in permanent action. I spent the next 24 hours calmly explaining to most of the national press, football press, radio and digital media that indeed, he had not scored a goal. That it was simply a great picture of Maradona and six Belgium defenders and had never been presented as anything else. Any other interpretation of my image was taking it out of context. What all this proved was that clearly the photo had done its job and communicated its underlying visual message that this was a man who could score at any time. Many of the national newspapers and most of the football press wrote supportive articles recognising the blindingly obvious, and Jonny Weeks wrote my favourite piece in *The Guardian*.

> "In the pantheon of great World Cup photographs there is one which, in common perception at least, stands above the rest. It is the image of Diego Maradona being confronted by six Belgium players at the 1982 World Cup. If ever a photograph encapsulates a player's genius, this is surely it. It is a simple snapshot which, on face value, showcases Maradona's audacity and the opposition's utter terror at the prospect of facing him; terror exemplified by the sheer numbers they had apparently dispatched to mark him. Or such is the myth.
>
> "The photographer, Steve Powell, confirmed that the reality was rather different. 'It happens to have great colours – the green of the grass and the orangey-red of the Belgium shirts – those are wonderful contrasts that make for a good image, and the composition is strong,

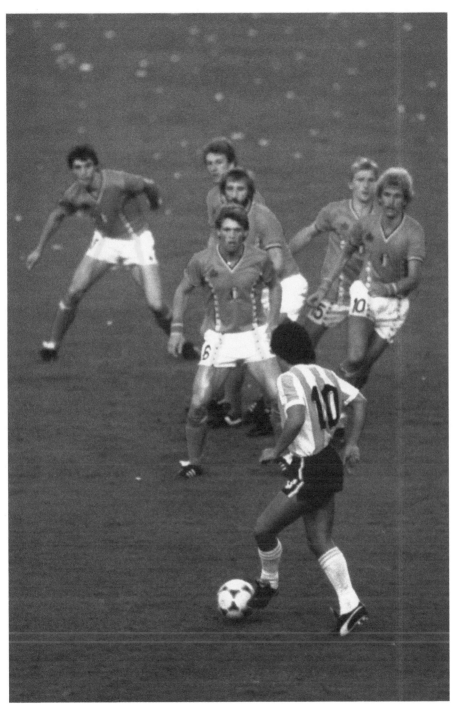

Never an avid football fan, my shot of Diego Maradona apparently mesmerising six Belgians in the 1982 World Cup, taken from high in the stands, was selected as the best football photo of the century and subsequently 'That Photo' took on a life of its own in the Twittersphere.

Photo: Steve Powell/Allsport

too, with the beautiful fan-like effect of the players,' Powell said, when I asked him what makes the shot so good. 'There was an awful lot of luck involved in getting it, but lots of memorable photos are like that. You just have to concentrate and be ready for the opportunities.'

"*The arrangement of the players is the pivotal aesthetic quality. In some ways, though, the real brilliance of the photograph is the idea it induces: looking at it you might imagine that Maradona jinked his way past all of the players in front of him before casually stroking the ball into the net beyond a disbelieving goalkeeper (much as he did four years later). So, here's the rub; beautiful though it may be, the photograph is intrinsically misleading. Maradona wasn't being man-marked by a huddle of Belgians. In fact, he wasn't even being marked.*

"*The question, of course, is, does it matter that the image is so suggestive of something which did not actually occur? I think the answer is no. The fundamental nature of photography is that it selectively captures a moment in time, it doesn't necessarily speak of what went before or after, or of what happened beyond the bounds of the frame. Everyone knows that, we just forget it sometimes and we make assumptions. In this case, the invitation to see Maradona in his pomp is just too inviting. As viewers, there's no reason to feel robbed by the reality of Powell's image. His image is in itself, honest and accurate. Instead, we should delight in it simply for what it is: an apt reminder of an exceptionally talented footballer. After all, that's why we all loved it in the first place, right?*"

What I said at the time completely agreed with Weeks' analysis. Ultimately it was not about the composition, not about art and not even about that particular game. It transcends all that. It's about communication. It communicates the power of Maradona and the fear he instilled. It's about this one man and the relationship he had with opposing players and, at its roots, good photography is always a matter of good communication. Weeks and the serious media understood. It was just on Twitter that I was public enemy number one, but the thing about Twitter storms and the 'Twitterati' is that for them to hurt you, you have to care!

9

WIMBLEDON TO MOSCOW

From the moment that I began photographing the bigger sporting events in the more iconic stadiums and arenas, my appreciation of the physical business of photography began to change, influenced by how each location had rewarded my creativity and persistence. If there was one photo assignment that taxed the patience of saints, yet rewarded the patient, it was the All England Lawn Tennis Championships at Wimbledon. Each year when the doors closed and the circus moved on, I had mixed feelings. Each subsequent year when the doors opened again, I found myself equally committed to do battle with the same organisation and media scrum, all pushing for the optimal location.

Any sporting venue that continually hosts a major championship for a number of years will develop a certain mystique, be that the threat of the away-team dressing room, the difficulty of mastering the playing surface or just handling the intimidation of the spectators as they surround the action. At Wimbledon, it was partly the unpredictability that came with more than a dozen outside grass courts and a draw that could produce a wild-card performance on any of them. Unsurprisingly, it was the fabled Centre Court that held everyone's attention, whether player, spectator or member of the media. Of the outside courts it was Number 2: that was the least predicable and least liked by the top seeds, gaining the unhappy name of the 'graveyard of champions'. So many tipped for success fell by the wayside there.

Another notable feature of Wimbledon was the almost total absence of any commercial branding, but 1983 was to see a change. Boasting two of the longest-running sponsorships in sport in Slazenger, who

supplied the tennis balls and Robinsons Barley Water, who supplied the hydration, the All England Club had resisted the lure of other big-money sponsorship. As a small acknowledgement to progress, this was the year they allowed their own logo of two crossed rackets on green in a circle of blue, to breach the sanctity of the Centre Court for the first time. Previously, the only break in the clean green backdrop had been a small Slazenger logo. On seeing the new branding for the first time I knew I could work with it and as I was on a mission to get the definitive shot of Björn Borg, during his early round games I shunned the front row press seats and wandered around the public areas looking for the perfect angle. I knew exactly what I was looking for. Borg was renowned for his precision and focus and I knew if I could find the right seat, using a very long lens, I could focus on the intimate moment when he addressed the ball just before serving. The long lens would throw the background out of focus, while the colourful circular Wimbledon logo would create a halo behind his head.

I wasted two early round matches trying to find the right angle and realised that what I needed was so critical for the picture that there was probably only one seat in the entire Centre Court that would deliver the correct sightline. But the seat had to be empty, and I still hadn't worked out which seat it was. The next day was a lay day for Borg, so I focused on a small area in the crowd, convincing them to let me swap seats with them at every change of serve, slowly focusing in on the optimal seat. Eventually I found it, made a note of the number and section, said my thanks and went to prepare for the next day. It was the culmination of three days patiently setting up what I needed.

To get my shot I badly needed to secure that unique seat; but how? Given it was Borg's third round match against the popular Australian, Rod Frawley, it was unlikely to be empty. I went in early the next day and sat in the seat before the fans arrived. Slowly the Centre Court filled and inevitably the couple that had reserved my seat arrived. I politely explained the situation and what I was trying to achieve and asked them that if I could find empty seats for them, would they mind moving? The glorious thing was that by the time I had explained all this, the man and his wife and all the surrounding fans were in on the conspiracy. Moments before the start of the game, like a life-size Rubik's Cube game, the entire section got up and switched places, with shouts of: "If you move down two and I'll go one across." With their cooperation we did it, managing to get one empty seat at the back of the section down to me and everyone had a seat next to where they were supposed to be.

The picture of Bjorn Borg showing all his concentration during Wimbledon 1983 looks simple, but took considerable planning and not a little help from many spectators to get me in the only seat on the court that would achieve the correct framing.

Photo: Steve Powell/Allsport

After that, getting the picture was simple. The final picture was exactly how I had visualised it. I held it in my private desk drawer until the following year and then released it worldwide, six weeks before the next Wimbledon Championships began. On the Sunday before the start of The Championships, that photo featured on no less than eleven front covers of major magazines across the UK, Europe and the United States. Four patient days well spent.

Photographing prima-donna tennis stars at Wimbledon always had an element of jeopardy about it, should the players react badly to the sound of the camera's dreaded, if essential, motor-drive. You never really knew from the fusillade of abuse you received if a player thought it had distracted him for real, or whether it was just gamesmanship. Either way, it was off-putting. Ilie Năstase was the worst at this and as a photographer, we would enter the Centre Court with trepidation if he was playing. One year he decided it was me that had distracted him on his service and started screaming and pointing directly at me. The entire audience in the Centre Court now knew who he thought the culprit was, but I just carried on shooting, as his behaviour was providing great pictures. The following year Năstase's agent called me and asked if Ilie could use the picture of him shouting at me on the cover of his biography. I said yes, of course, and supplied it free of charge, as long as it carried my photo-credit. He used it, but very deliberately did not credit me. He never did like photographers!

Now, imagine a location as far removed in history, gentility and ambiance from Church Road SW19 and you may get a taste of how I spent much of 1983. No strawberries and cream on my next commission for *Sports Illustrated,* travelling in the Soviet Union and some of its satellite countries. My commission was to shoot every World Championship in Olympic sport. These pictures were to support the special issue they would produce for the next Games, awarded to Los Angeles in 1984, a huge story for them. Relationships between the USSR and the USA had deteriorated significantly since the Soviet invasion of Afghanistan in 1979 and the subsequent boycott by the USA of the 1980 Moscow Olympics. American journalists and photographers were finding it increasingly difficult to get visas for the Soviet Bloc, so my British passport came in handy. My first assignment in the east had been in Poland for the World Modern Pentathlon Championships at Zielona Gora. I was paired with *Sports Illustrated* staff writer, Anita Verschoth, who held dual US/ German citizenship and whose presence could thus be considered less inflammatory, and we were to travel a lot together over the next few years.

Anita was an experienced hand in the ways of communist countries and introduced me to the joys of bartering with US dollars and Levi jeans. Arriving in Warsaw, we had a 300-mile drive to Zielona Gora, so she hired a taxi, as you do, for the week; at US$5 a day! The official exchange rate at the time was about four zlotys to one US dollar and we were getting close to 300 zlotys to the dollar on the black market, so the driver was a very happy man. We were also armed with Levi's and discovered that the stories heard in various press rooms in the West were indeed true. When we got to the event both Russian and Polish teams made it very clear that they had large quantities of Beluga caviar to exchange for our Levi's.

The event itself was not memorable, but the atmosphere was electric, as Poland's Solidarity Movement was leading the charge in the struggle for independence from the Soviet Union. On market day, I strolled through the main square and marvelled at all the speakers around the town broadcasting Elvis Presley songs. I thought that was a nice touch, until my translator told me that just a few months ago they had all been blasting out non-stop communist propaganda. This was truly a country coming out of the dark ages. Our taxi driver took us back to Warsaw at the end of the event, with our baggage stuffed full of 500 gramme tins of Beluga, and delivered us to the Victoria Hotel. Our final overnight stay was in what was truly a five-star establishment, even under communism. That night a group of us journalists dined in its premier restaurant on French Champagne, Polish vodka, Black Sea caviar and local Polish suckling pig. We ate like kings and paid in zlotys, probably the cheapest and certainly the best meal I had ever had in a hotel. Just one more example of the joys and spending power of the American dollar in the communist Soviet Bloc.

Relations between Russia and the US continued to deteriorate until early September. Then they hit rock bottom, after a Soviet jet fighter shot down a Korean Airlines Boeing 747 carrying 269 passengers and crew, killing all on board. Initially, the Russians denied it, but when the wreckage was found two weeks later, tensions mounted significantly with threats of war on both sides. Meanwhile, I was sitting in my room in Moscow's Intourist Hotel, just off Red Square, on my way to Kiev to cover the World Greco-Roman Wrestling Championships. I was talking with an editor at *Sports Illustrated* and getting feedback on when, or even if, the writer who I was due to work with on the story was going to arrive. It was during that conversation when it dawned on me that I was really sitting at ground zero if it all got ugly, but they instructed me to continue to Kiev, promising to keep me advised about the writer.

Once there, for me the event was progressing well. I was getting lots of excellent pictures of the top Greco-Roman wrestlers (the Press Chief was my new best friend) when it became obvious that the promised writer could not get into Russia. My editor asked me whether I'd be happy asking some questions at the final press conference and if I would feed them enough to stitch a story together. I agreed, so they said they would telex the questions through to the Press Office by the morning. Sure enough, the next day I arrived for the finals with my customary cheerful smile, only to find my new best friend looking decidedly unfriendly. Approaching me, he waved a sheet off the telex and demanded an explanation.

Obviously, I had no idea what the problem was, so I started to read it. Everything looked fine, with intelligent questions about various Russian wrestlers, until about halfway down the long printout when the tone and content veered away from sport and towards politics. The last nail in my coffin came with the request that I was to ask the Russian coach how he feels about the murder of 269 people on Korean Airlines Flight 007? I was unceremoniously frog-marched out of the stadium as I realised that *Time* magazine, *Sports Illustrated's* sister magazine, had got wind of the fact that I was there and had decided to hijack our telex message with their own questions. Very unsporting.

It wasn't my last visit to Russia that year, nor my last clash with authority. My next trip was a month later to cover the World Weightlifting Championships in Moscow. I knew that ever since I had started travelling to work in the Soviet Bloc, I was being followed all the time, that my telephone calls were tapped and that the pretty translator allocated to me was actually an agent of the Komitet Gosudarstvennoy Bezopasnosti (KGB). Nevertheless, it came as a bit of a shock when I approached the immigration desk at Moscow's Sheremetyevo airport, only to be stopped by a large gentleman with KGB written all over him, sporting the stereotype fur hat, red star, and even a leather coat: "Good evening, Mr Powell, and why are you visiting my country again?" I'd only just walked off the plane, so how the hell did he know it was me? I explained the reason for my visit. He examined my papers thoroughly and then let me through, but my card had truly been marked.

My final trip that year was a disaster from the get-go. Tony Duffy had worked regularly with *Track & Field News*, an American monthly magazine known as the bible of the sport. He and the editor, Gary Hill, had been working on a story for months, trying to bring together a feature on three of Russia's top women marathon runners at their training base at altitude,

somewhere near the Chino-Russian border. The Women's marathon was going to be a first at the Los Angeles Olympics the following year and although everyone assumed that Russia would boycott the Games in retaliation for the US Moscow boycott, *Track & Field News* felt they had an exclusive angle. Many promises had been made by the Ministry of Sport in Moscow that they would make the girls available and supply the necessary permits for internal travel for everyone involved.

Unfortunately, it was not that simple and, typical of the Ministry, they kept delaying. The girls weren't ready, there were problems with the permits, and anything else they thought might seem plausible to stop us. Then they finally came back with a yes, the Minister had agreed, and the meeting was to be next week. The only problem was that Tony was already assigned to another story and Gary Hill couldn't go, so they decided that I was the man for the job. Armed with an open-ended ticket and a briefing to get the job done, I flew back again to Moscow and presented myself early the following morning at The State Committee for Sports and Physical Education of the USSR - Ministry for Sport to you and me. My letter of introduction to the Minister cut no ice and I was met with blank stares at reception. I spent all day talking to various officials, none of whom professed to know anything and no, the Minister himself was not in the building. I went back to my hotel and called Gary to explain the situation. He didn't sound particularly impressed and I distinctly detected the suggestion that he thought perhaps I wasn't trying hard enough. He would make some calls the next day.

I was not feeling my best and was pretty down. Months of negotiations had gone into this assignment and I'd hit a brick wall. Maybe it was me? I decided to have dinner in the hotel where the dining room was huge and could probably seat over a thousand people. All the tables set for ten appeared full, but the maître d' managed to seat me on a table with nine other guests, though it wasn't clear whose guests they were. I think all of them were Russian, as foreign tourism wasn't particularly well developed then; and apart from the black marketeers, they didn't really want it.

Ordering a steak, which I knew from experience would be horse, I ordered a bottle of 'what they were drinking', which I knew would be vodka, but it looked so pretty, encapsulated and frozen in a lump of ice. Then I prepared to wait for my steak. Experience had taught me that I could judge the quality and service of Russian restaurants by how many cigarettes could be smoked while waiting for the food between ordering and delivery. As usual, when it arrived it was barely edible, but the vodka was good and slipped down very easily. That's the thing about frozen

vodka. You don't notice it going down until you try to stand up, as I was about to find out. I finished my meal and made to rise, my mind as clear as crystal, but having raised myself to my full two metre height, I realised that standing and moving were no longer options open to me. Like a rather tall pine tree receiving the attentions of a chainsaw at its base, gravity took over and I slowly pitched forward to collapse face first in the middle of the round table for ten. There was mayhem, with food and vodka liberally splattered over the other guests. My mind was still clear as day, it was just my body that wouldn't function. I'd drunk an entire bottle of strong Russian vodka all on my own and it took four burly waiters to get me to my room, much to the amusement of all present.

I returned to the Ministry of Sport on each of the next two days, still getting fobbed off by all and sundry, with Gary making calls all day and starting to understand the problem. Finally, on the fourth day, I was invited into a large board room and was faced with what looked like the full Politburo of at least a dozen grim-faced, heavy-set men straight from central casting. They explained to me that the Minister had been 're-assigned' the day before I arrived, and they had no records of any agreement with Gary Hill to allow access to their athletes. For re-assigned, think Siberia, because that's what I was thinking. For three days I had been followed everywhere with no degree of subtlety. I could hear the wiretaps on the phone with no attempt to hide them, I had been lied to constantly, and questioned about the authenticity of my papers, which were essentially my passport and a letter of introduction from the magazine. The bullying and intimidation were clearly designed to persuade me to get on a plane for home and when this was obviously not going to work, I started getting promises: "Don't worry, we will work something out…" or "The new Minister wants to help." I was already beyond sceptical.

Back and forth we went, day after day, me asking when I could fly down to their training base, them lying to me, saying the permits were nearly ready, or the girls were at home and would fly back to their training camp soon. After eight days of this constant surveillance and intimidation, they finally admitted that they could not get permits for me to fly, so as a huge favour to me, the Minister had arranged for the girls to fly to Moscow, and I could take pictures of them in Red Square. In fact, better than that, they were there now and there was a car waiting outside even as we spoke. After months of negotiations and eight days of frustration and harassment, I had all of fifteen minutes on a wet, grey day with three frightened girls and their KGB minders in Red Square. I only took a couple of rolls of film.

The following day I arrived at the British Airways desk to fly home and checked in with a sigh of relief, but they hadn't finished with me yet. While going through security, they pulled me to one side and said they wanted to scan my camera bags again and insisted that my film should also go through. I explained the damage that airport x-rays could do to film, but they just became more pressing. Eventually, they scanned my camera bags and film not once, not twice, but regularly for the next 18 hours. I was stuck in the security hall while different shifts took turns, all the time saying they thought I was smuggling gold rings out of Russia. In my mind I kept saying to myself stay calm, they want you to overreact.

The thought of a couple of years of 're-assignment' in a Russian gulag while the misunderstanding was sorted out through diplomatic channels helped focus the mind wonderfully. I kept calm, some might say cowed, but I was up for whatever it took to get me through this and on my way home. After almost a full day of mind games they eventually relented and allowed me through, where I found a BA rep who got me on to that day's flight. She didn't seem to be at all surprised. I never returned to Mother Russia and having finally got their message, I am not sure who was happiest with the outcome; them or me.

10

DIVING WITH DALEY

B ack in 1976 at the Montreal Olympics, Tony Duffy's sharp eye had
spotted a rising young British athletic talent in the substantial shape
of Daley Thompson. He placed 18th in the Decathlon at the age
of eighteen, competing against a powerful field in the most challenging
discipline in track and field: it was a remarkable achievement. However,
it was only the start of what was to become an even more remarkable
sporting career, and an example of what could be achieved by mutual
cooperation between photographer and athlete.

Tony's view was that if you recognised latent talent early in an
athlete's career and helped them along the way with pictures that they
might find useful in promoting themselves, then the payback in terms
of access and stories would be priceless. On returning to the UK, Tony
continued to monitor his performance and photographed him training
a few times. I first met Daley when he came into the office to pick up
some free prints and we got on well. The following year, in 1977, he
won the European Juniors and then captured Gold in Edmonton at the
1978 Commonwealth Games, so we kept in touch and did the occasional
photoshoot. In 1980 there was a lot of interest in him, particularly from
the UK media, as a medal potential for Moscow, but this was initially
based more upon speculation than hard facts. Until May that year.

He had hinted to me that he was going to a tiny mountain village in
the Austrian Alps called Gotiz: "Every year they have a Decathlon there
and it's a lot of fun; you should come." I wasn't sure whether this was just
for fun or if it had any potential for a story, but only later did I realise that
this was classic Daley. He would never give you the full picture, but just

wanted to see if you could figure things out for yourself. I was rightly concerned about the cost but decided it was worth a gamble, so I headed to Austria, very much on the cheap. It was everything he promised. A beautiful location, and then he obliged by smashing the world record, scoring 8,648 points. Having trusted his hint and spent two intense days together on the track, I had my exclusive story and had made a new friend.

Then Daley went on to Moscow and comfortably won Gold. He was now an international track star, so everybody wanted a piece of his time; interviews, photo shoots at home or when training, literally anything they could get. Daley was having none of it, because his training always came first. The media are a persistent bunch and the constant pressure on his time and fending off their approaches was beginning to rankle him. One day, chatting about it, I suggested that he had to do something more proactive, as the attention wouldn't go away and would probably get more intense, the more successful he became. However, if he did an exclusive with somebody, the rest of the pack would back off. Thinking about it for a bit he said that he definitely wasn't interested in an 'at home' photo-feature. That was sensible, as to be honest, his home was pretty modest with piles of track clothes on the floor. Instead, we talked about a holiday.

I had learned to scuba dive some years before and had often talked about it, so as 1981 was a quiet year competitively for Daley and his training had been going well, he mentioned one day that he quite liked the idea of diving. Could we do it? I immediately agreed and suggested we get a magazine to pay for it. This would not only give us and our girlfriends a free holiday but would also go some way to take the media pressure off him. But where to go? I contacted an old friend, Martin Sutton, who had taught me to dive in the Red Sea, but who was now based in the Cayman Islands. His new company was called Fisheye and was dedicated to supporting underwater photographers, so that ticked all the boxes. Explaining the situation to him, I said that we would first need to train and qualify three new divers: Daley and Tish, his girlfriend, later to be his wife and Beans, later to be my wife. Then, having trained them, we needed to photograph Daley doing exotic things underwater. Having agreed with Martin that all the above was possible, I then set about selling the idea to a publication, which, not surprisingly, proved to be quite easy. The *News of the World*, Britain's biggest selling Sunday newspaper, had just launched a magazine called *Sunday* under its Editor, Bridget Rowe, and she thought this would fit perfectly, so snapped it up and we set off for the Caribbean.

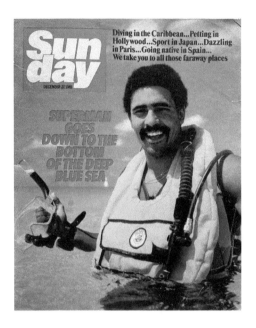

To deflect increasingly intrusive media pressure, it was Daley's interest in learning to scuba dive that took us to the Cayman Islands and produced a feature and front cover for the newly launched Sunday supplement to the News of the World.

Photo courtesy of Sunday Magazine

We had a fantastic time with lots of laughs, but needed to take the shoot seriously, as it was no small task that we had undertaken. We only had two weeks and Martin was insistent that he would take no one underwater unless he was confident that they were all safe and ready. Everyone qualified and I had loads of brilliant pictures of them training, especially Daley being given cardiopulmonary resuscitation (CPR) by Beans. This caused a little shock for an elderly English tourist who thought it was for real and rushed over to help. When she realised who it was, she was the one that looked as if she needed CPR. Martin took us on several well-planned underwater photo shoots where I got pictures of Daley diving with turtles, surrounded by fish and feeding Waldo, the huge Moray eel that was famous in those parts. The article ran in the magazine's New Year issue, right in the middle of the English winter, with a front cover and seven pages inside as very much a feel-good piece for their readers. As an afterthought, the magazine gave some useful information about who to contact if they wanted to learn to dive in the Caymans. A year later when I was diving there on honeymoon, I was introduced to the head of the Cayman Island Tourist Board, who promptly started berating me about the article. It wasn't that he didn't like it, but he explained that it was because I hadn't warned him in advance. They were only a small island, he said, and they had been inundated with calls and inquiries that frankly, they couldn't handle.

It was interesting for me to discover first hand the power of the press in action, and the Cayman Islands are now one of the top tourist dive venues in the world.

1982 was to prove another exceptional year for Daley. Having received the nod again about Gotiz, I didn't need telling twice, so I called *Sports Illustrated* and tried to talk them into assigning me. They weren't sure, as they had a lot of other stories on at the time and Daley hadn't really done anything since Moscow, so once again, I set off speculatively and arrived in Gotiz the day before the two-day event started. The first day started well and as it progressed, if nothing went wrong, he was clearly in the zone to break the world record. Late in the afternoon I phoned *Sports Illustrated's* Picture Editor, Barbara Henkel, and told her he was well on schedule. To her credit, her response was instantaneous: "Right. You're on assignment and we need today's film as soon as you can. If he breaks the record, tomorrow's film on the evening Concorde out of Paris to New York. Can you fix it?" Of course, ever the optimist, that was my job. However, what Barbara failed to realise was that I was in a tiny village in the middle of the Austrian Alps with access to only one telephone in a press room that was of the 'two men and a dog' persuasion.

I realised that if I could make the London flight from Zurich that night with my first batch of film, even if we missed the following day's Paris deadline, the magazine had at least enough film to run the story. I immediately set out on the modest five-hour drive to Zurich Airport and talked a passenger on the flight into hand carrying the film to London, where they would be met by a courier. Almost impossible today, but we used to do it all the time. Then I turned around and drove the five-hour return trip. Hotels didn't feature too much in the Gotiz area, so I was billeted in a family home and being thoughtful, slept in the car for two hours so as not to disturb them. A swift shower and breakfast when they woke at 7am and I was back in the tiny press room within the hour, trying to charter a private plane, on a Sunday, in the Austrian Alps.

That morning progressed at a frantic pace for both Daley and me. He continuing to stay on world record pace, while I rushed in and out of the press room in the breaks between photographing his events. I had recruited two local press men - and the dog - to help me with language and logistics, and eventually, I spoke to an Austrian pilot at home and apparently in the middle of his family's Sunday lunch. Explaining that I needed to get to Charles De Gaulle airport in Paris by early evening, but couldn't leave until 4pm that afternoon, I asked if he could help. He replied confidently that it should only take about an hour in his private

jet and that he would be ready at a small airfield close by and ready to embark me as soon as I got there. Much relieved, I relaxed into my event coverage as once again Daley obliged by smashing the record with 8,730 points. Immediately the competition was over I left for the airfield, dumped my hire car, to be met by two uniformed pilots waiting by the smartest private jet I'd ever seen. We were off the ground within minutes, and I relaxed and took stock.

My film and I were both in the air and heading in the right direction. The car? Well, I could call the hire company tomorrow and tell them where the car and keys were and while they'd charge a fortune to recover it, I was on assignment for *Sports Illustrated*. As we reached cruising altitude, the co-pilot turned around and after offering me a drink casually asked how I was going to pay for the flight as they didn't take credit cards. Pay for it? In all the excitement I'd forgotten I would have to pay for it. Normally, the magazine would have made all these arrangements, but I had set this up and we had less than an hour's flying time to Paris. How much, I asked tentatively? 53,000 Austrian Shillings came the reply. They could have been talking Double Dutch as I had no idea how much that was, but certainly not cheap. I started thinking frantically. Not enough cash in my pocket. He suggested travellers' cheques. No, that wasn't on either, so I was now worried that they'd just turn back and leave me on the runway. With a show of bravado that I didn't feel, I took out my personal cheque book, waved it around purposefully and to my utter surprise he looked at me and in broken English said yes! I quickly wrote out a cheque before he changed his mind and when I got to the pounds sign, confidently scrubbed it out and wrote 'fifty-three thousand Austrian Schillings'. As an added bonus, I wrote my £50 Guarantee Card number on the back. He took it, smiled and put it in his pocket, while I was still in shock as I wasn't even sure I had enough in the account to cover the guarantee, at least we'd get to Paris.

We arrived at Charles De Gaulle on schedule, landed in the 'Privé' side of the airport, and as the co-pilot lowered the stairs, I could see my favourite French courier, Claude, standing right there. My most immediate worries were over as he would now get the film onto Concorde, so I sat there on the steps thinking about finding a hotel and booking a flight to London in the morning. Then the pilot wandered over and asked what I was going to do next, so I told him I had to get home to London. He looked at me with a soft Austrian smile and said: "OK, I go shopping for my wife in London, get back in." And they flew me home. I often wonder whether he'd planned it all along.

The great thing about working for publications like *Sports Illustrated* and *Time Life Magazines* in those days was that they understood their priorities and as their man in the field, made sure you did too. Our biggest imperative on any assignment, most often ending on a weekend, was to get the film back to New York by their Sunday night deadline. It didn't matter what it cost or what you did to achieve this, they would cover you without question and the lengths to which they would go to get the film back were becoming legendary. Seldom was this better illustrated than in our coverage of the World Cross Country Championships in Gateshead, on England's North East coast.

In the pantheon of great and noble sporting endeavours, cross-country running doesn't rate very highly, but *Sports Illustrated* were looking ahead to the Los Angeles Olympics the following year. Long-distance runners don't compete too often so the chance to see some top Ethiopians, Kenyans and their own man, Alberto Salazar, in action was thought newsworthy. Unfortunately, the event was on a Sunday afternoon UK time, making it difficult to get the film back to New York that night. Seeking inspiration and guidance, I had talked with Lavinia Scott-Elliott, *Sports Illustrated*'s London Bureau Chief, to develop a plan that would work. Now I should say that Lavinia knew about moving stuff quickly across the Atlantic, having assisted in getting American competitors in the *Daily Mail* Trans-Atlantic Air Race home and hosed back in 1969, so she had form. In this case, we had to get the film south from Gateshead to Heathrow in time for the Sunday evening British Airways Concorde departure at 6pm on the evening of the race. We decided that we'd need a helicopter from the race finish line to the local airport, then a private jet to Heathrow, where we'd drop the film off with BA's Urgent Freight department.

The team for this commission would be Tony and myself, and as we had a private Lear Jet at our disposal, we'd take my brother, Mike, to assist and for the experience. Younger than me by twelve years, Mike had been employed by Tony as an apprentice photographer in 1981 while I was on holiday. He had left school at sixteen, decided he wanted to be a sports photographer, approached me for a job, for which I turned him down, and then got on board anyway. My reasoning seemed simple and straightforward at the time. He was a young, impressionable lad, with a big brother rushing around the world covering all the world's great events. Who wouldn't want to do that, but was it really right for him? I knew how tough a job it was, and my biggest fear was that he would expend all his most productive years trying to become a top sports photographer,

while being propped up by his big brother, before missing out on the big prize as many did. This industry was tough and took no prisoners. When he couldn't get a job with any of our rival agencies because of who I was and having eventually found him on our payroll, rightly or wrongly I was determined to put the pressure on him in the early years, reasoning that if he buckled, he buckled early.

This little adventure was showing him what fun our job could be, sitting in a private jet heading north early one Sunday morning. The event itself was wholly unmemorable. Alberto Salazar was soundly beaten, but what was to follow is the actual story. It had been raining hard all day, so we and the runners were soaked and covered in mud. The start of both the men's and women's events had been delayed, pushing everything back and making our schedule a little harder to keep. According to plan, as the winners in the men's event crossed the line, we three climbed into our helicopter positioned nearby and flew to Gateshead airport. Landing next to our Lear Jet, we took off with the minimum of delay and headed for London Heathrow, but I was getting anxious as I knew we were running late, and Concorde waits for no one.

I got the pilot to radio ahead and get a message to Lavinia outlining our situation and, as there was not much more that could be done then, I sat back to eat a lobster salad that someone had thoughtfully provided. We would dump the film with BA's freight handlers and head home for a hot bath, but flying into headwinds was adding to our problems. As we approached Heathrow, I worked out that there was little chance of us getting there in time, so I became resigned to failure on this occasion. Having landed, things took a turn for the better. The pilot was directed to taxi away from the usual private section of the terminal and towards the main commercial stands, finally coming to rest right next to Concorde. On opening the doors, an airport official handed me a note and a ticket and insisted I hurry. How they had achieved it I didn't know, but Lavinia and *Sports Illustrated's* New York office had spent the last hour convincing British Airways to delay Concorde's take-off. Lavinia's note simply said that I was to take only the film and go to New York asap, so an immigration officer did the passport check with security at the bottom of the steps. Sunday evening's Concorde flight was carrying its normal complement of the high-rolling great and good when I made my grand entrance, soaking wet, in a pair of old jeans and an army combat jacket, covered in mud and twenty minutes late. While Tony and Mike headed home with all my kit, I sat in the back of the aeroplane dining on steak with a glass or two of a good claret. This amazing piece of British

engineering landed in New York's JFK airport about three hours later and once again, I was met at the gate and ferried to the Time-Life Building to deliver the film.

Who knew what that commission had cost in time, effort and money and to be blunt, I didn't really care, but the inherent message was simple enough. If the story was worth covering, then whoever had been commissioned needed to know that they were supported and not working alone, and knowing this instilled a wonderful sense of confidence in the field. It was something that I tried to replicate in the years to come at Allsport: set your priorities, agree what they are amongst your team and then stick to them. There is nothing worse and more destabilising for someone working solo than worrying about whether they are being second guessed back at the office. I trained my team to remember that when they were working in the field they should operate as a ship's captain would: Master under God and taking decisions that right or wrong, were final.

In September, I set off to Athens for the European track and field championships, on assignment for *Sports Illustrated* again, and Daley was now hot favourite for the decathlon Gold. The event was full of the usual highs and lows of any major competition, punctuated by violent thunderstorms. Daley's competition endured its fair share of torrential rain, but as he cruised through the second day, all he needed was a personal best in the final discipline, the 1,500 metres, and he'd break the world record again. This was the discipline he liked the least!

Instead of being on the infield for this race, I opted to be head-on to the finish. The race was going well for him and as he came into the final straight, the crowd who were watching his time on the big screen erupted. As faster runners crossed the line, they collapsed in exhaustion on the ground, but Daley didn't have to win the race to win gold. Just not to lose by too much. As *he* crossed the line, he stopped dead, put his hands on his hips and just stood there looking around at all the other competitors sprawled on the track in exhaustion. I took the picture, looked up and realised he'd not only won Gold, but put in a personal best for his hated discipline and smashed the world record yet again. That picture was to become my personal favourite and one of the most iconic pictures ever taken of Daley. Standing there, the conqueror, with hands on hips and the vanquished foe at his feet. Daley was to comment when asked about the photo and the suggestion that he must have been exhausted as well, why he didn't collapse at the end: "I wouldn't give them the satisfaction. Next time I compete against them, they have to remember and believe that I still had something left."

1982 was turning into a marathon. We still had to go to Australia for the Commonwealth Games in Brisbane during October, and I was due to get married later in the month. Tony and I were tag-teaming again for *Sports Illustrated* and they had booked us a great beach apartment on the Gold Coast, Australia's playground. The Commonwealth Games is a multi-sport event, so we were busy every day and evening covering many events, but when Daley stepped out to start his two-day decathlon, I was there again. He won gold and hosted my stag party on the last night of the Games. For some bizarre reason, Qantas Freight had consigned our precious film to locations around the world and, as I knew that I had to recover and deliver it to *Sports Illustrated*, my route home now took me via Sydney, Fiji, Los Angeles and New York, before returning to London. I arrived home a few days later than scheduled, much to my wife-to-be's consternation, as it was just seven days before our wedding. Beans and I were married on the 23rd October 1982 and immediately flew back to the Cayman Islands, to go diving on our honeymoon.

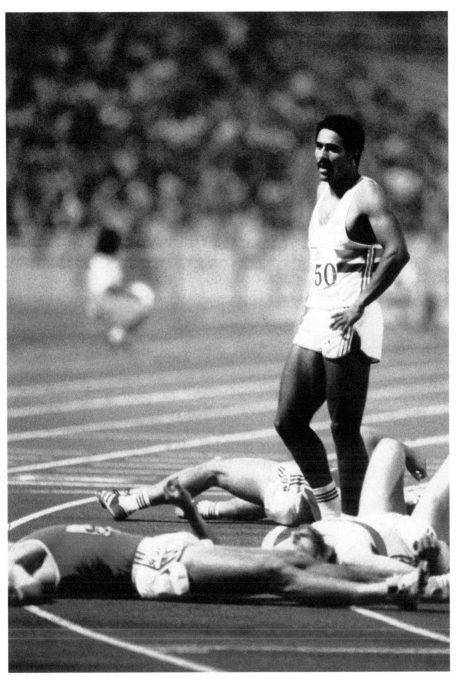

I had developed a good working relationship with Daley and covered most of his medal-winning performances, but the most iconic image and my personal favourite came from the 1982 European Championships in Athens and shows the conqueror standing arms akimbo with his beaten rivals at his feet.

Photo: Steve Powell/Allsport

11

HOW AN ACORN
CHANGED OUR WORLD

B y the time Beans and I celebrated our first wedding anniversary in
October 1983, we had spent over two hundred days apart in that
first year of married life, with me on assignment overseas. Working
at an intense pace, it was a bit like being on a treadmill. Looking in the
diary it showed trips to Austria, France, Italy and Switzerland for skiing
events; Berlin, Brussels, Cologne, Helsinki, Lausanne, Oslo, Paris, Rome,
Stockholm and Zurich covering track and field; Monte Carlo and Paris
for tennis; Brussels and Madrid for motorcycling and Budapest, Kiev,
Moscow and Warsaw on various other commissions for *Sports Illustrated*.
Added to that was a domestic agenda of all the UK's major sporting
events, and it is more understandable why Beans and I rarely saw each
other. It is perhaps less understandable why she tolerated me, but she
did, and our arms-length marriage was to become a constant stream of
reunions for the next eighteen years.

Even when I was back in London, I was always in the office and
there our biggest administrative problems were threefold. First, there was
an enormous increase in the amount of new imagery being generated.
Secondly, there was the continuing issue of publishers holding on to
our original transparencies for too long, and ultimately not using them.
Thirdly, although we were encouraging publishers to take our duplicates
rather than originals, getting them to buy-in was still work in progress,
as was keeping track of stuff. Although we had handwritten delivery
notes to clients kept on file, our manual systems were creaking and as
our client base grew, it was becoming increasingly difficult to track just
where our images were at any given time. What was clear was that at any

one moment, large quantities of our best pictures were sitting unused and unavailable on client's desks. I began looking into how this could be resolved, and salvation came in the unlikely shape of the British Broadcasting Corporation (BBC).

In its mandate to assist in educating children, the BBC initiated a literacy project and commissioned Acorn Computers to build them an own-brand personal computer that could be introduced to schools across the UK. Even though it was considered highly priced then at around £400 (£1,400 today), I saw this as a way forward and invested. Do I ever buy anything cheap? It came with 16KB of user RAM, an 8-bit microprocessor and ran the BBC's version of Beginners' All-purpose Symbolic Instruction Code programming language software, or BASIC as it is better known. It was also notable for its ruggedness, expansion capability and the quality of its operating system, but you had to learn the essentials of programming to use it as a word processor, or even to just play games on it. At the time, my knowledge and experience of computers could rightly be described as sketchy, but I appreciated their overall capacity to do stuff more quickly than any manual process. Biting the technological bullet, I took a month away from work, set up my newly acquired kit in our dining room, taught myself BASIC and then wrote what was to become our first image-tracking software programme. If I had done it right, then this programme would enable us to efficiently supervise the distribution of our pictures and monitor how they were being called off and used by our client base. It worked and was a total game-changer. As knowledge is power, in one stroke it became a tool of immense value, and a defining moment in Allsport's success story.

Previously, whenever a magazine or book publisher wanted pictures of a particular sportsman or woman, everything about fulfilling the request was manual and time consuming. We would have to visit the files, make a suitable selection from the original colour transparencies we held and laboriously complete a hand-written delivery note giving full details of what we were releasing, to which client and on which date. All essential stuff, but pedestrian in the extreme. The fundamental problems that this system generated hit us in two ways. From the moment the material left us we had no control over what happened to the images, nor for how long the client retained them. Apart from depleting our stock and restricting availability to other clients, if the first publisher ultimately decided not to use our stuff and took forever to return them, they were not generating any income. What was to be done?

Our image tracking software programme was a ground-breaker, but our fledgling picture library still relied upon a basic light box and filing cabinets. (L-R) Lee Martin, Simon Bruty and Steve Rose all became key players in Allsport and the wider industry.

Photo: Allsport Archive

To address the first issue, we had to encourage an industry that had never been too fussed about retaining pictures while they pondered what to use, to behave differently. The simple delivery note programme I had written now allowed us to create a database giving our client contact details, how many of our images they were holding, what they were, and critically, for how long they had held them. In one simple yet effective hit we had given birth to the ground-breaking concept of charging clients a service fee or holding fee. A simple recurring monthly charge for any images retained beyond 30 days. If the quality of our work and attentive backup service already held our clients' hearts and minds, it was remarkable how the concept of paying for that service quickly grabbed their attention and how rapidly we saw material returned to us for further distribution. Hearts and minds to bottom line was a winning formula, and I recognised the potential of new technology and how to use it.

Much later, other newer, unimagined technologies would help us solve other problems that had dogged the business. Everyone longed for the day when a photographer could get his images onto an editor's desk almost as he had finished shooting them, but we were still some way away from film scanning devices and portable computers; and even further away

from digital cameras and the internet. The success for Allsport remained vested in how quickly and efficiently we could duplicate and distribute colour transparencies. The move to new premises, bigger and better studio facilities, darkrooms and library, plus the image tracking system that gave us a more efficient income stream had seen our team in South London rise to a head count of around 30 people. Spread between photographers, darkroom staff, editors and researchers to service our client base, we were perfectly positioned for further expansion.

Perversely, these new systems, new employees, new horizons and the need for a much more formal service to our clients, highlighted a widening gulf between Tony and I. It must have been difficult for him to appreciate quite what was going on in the business as I think that really, he only wanted to be a photographer and still viewed Allsport as his own small, personal business fiefdom with its staff primarily there to service his needs. There was nothing wrong with that in a small lifestyle business, but we were growing. I had other visions of where we might

Our move to new and bigger studios, darkrooms and library had allowed us to streamline our service on the back of image tracking and among our growing team in London were (L-R) Mike Powell, Ian Down and Darkroom Manager, John Gichigi.

Photo: Allsport Archive

go and by now, the use of my BBC Micro had piqued my interest in the business side of the agency. I had always been interested, but the potential for change that this little school computer demonstrated had excited me.

Very few things in business remain the same and by the beginning of 1982, both John Starr and Don Morley saw their futures outside the business model that we were creating so left with our blessing to pursue their own creative careers. Without the moderating influences that John and Don had brought to the table, this left Tony and I running the business. We still had our regular lunches when opportunity arose and were often on assignments together. We even wrote a book on sports photography on a return flight from Sydney, but in my mind, there was still an underlying worry about differences in our way of working. Most frustrating was his apparent inability to leave systems or forward planning in place. Frequently when I came back from an assignment, I would find that in my absence he had swept in and made strategic changes with no reference to me, or anyone. Then I would patiently explain why things had been planned as they had been, then we'd talk about it, and then he'd agree that my original planning had been right. The problem was that I was never really sure whether he fully understood how, or why, he had caused the problem, which was always the same. Basic differences in management style, or as I was to realise, lifestyle verses growth.

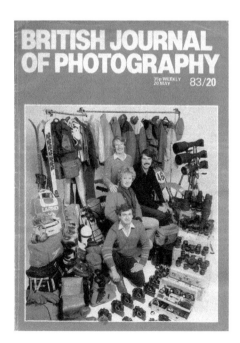

The industry took a keen interest in our development and in 1983, the British Journal of Photography featured Allsport. Their front cover showed just some of our kit and equipment surrounding Tony Duffy and I, with our most recent signings, Adrian Murrell and Bob Martin.

Photo: Courtesy of British Journal of Photography

This difference in our approaches to our core business strategy would prove to be a constant challenge and become a major source of friction between us. If we both wanted to be out on assignment taking pictures then we wouldn't have the time to micro-manage fast-moving business decisions, so we needed to find a way of motivating and empowering our staff, which required clear focus and obvious leadership. I built my mantra for leadership on trust, respect and consistency; words and concepts learnt at my father's knee. I've always believed that if you hire well and make a job interesting, 95% of people can be trusted to get on with it. They will rarely let you down and they deserved your respect for that. In return, you, as a leader, must also be consistent in your approach to all your decisions and shouldn't agonise over the other 5%. They shouldn't be working for you anyway, and frequently they came to that conclusion themselves. I was also very conscious that nothing demotivated and destabilised a workforce more than watching the principals figuratively biting lumps out of each other, as though the ship that they steered had no obvious direction. Sadly, that was what was happening with Tony and me. By the end of 1983, he and I had talked enough to realise that only one of us could run the company and shape its bigger future, and to understand what came next, it is necessary to look back to the beginning of our relationship.

Though I never asked him about it, when he first offered me a job I'm fairly sure he saw me as cheap labour, perhaps with some creative potential. When I returned from my first trip to Northern Ireland, he probably reassessed me and recognised ambition. When he offered me a job on the second occasion, he recognised sales skills that would supplement what he saw as the creative mainspring of his photography. Although he never said as much, he probably thought that I might last two or three years before moving on, but interestingly, I doubt he ever regarded me as any kind of threat to his world and how he ran it. In retrospect, I am pretty certain that he never did, but the difference between our styles was becoming an obvious barrier to progress. The dichotomy of Tony's accountancy background, carefully watching every penny, and his primary drive of his passion for sport, were significantly different from mine. I was more emotionally driven, less interested in the fine details and much more in the bigger picture; consistently growing the business, which mostly required spending money.

In itself, this might have blown our relationship apart and that it didn't says much for our friendship and ambitions. As is so often the case with opposites, against the odds, it managed to produce a two-man team that was complementary, if feisty. At the beginning of the

1980s, it had basically been just he and I who ran the business. A lot of planning and decision-making was done over our very long lunches, with conversations that became progressively more and more heated as we struggled to reconcile where the company was heading. He wanted to retain management control but was not in the office often enough to deliver the necessary continuity, while I became increasingly aggravated by what I perceived to be his inability to see the big picture as I did. A classic recipe for commercial disaster. Tony had always been attracted by the idea of big-ticket sales. Colgate was a prime example, but his accounting background kicked in whenever I suggested speculating to accumulate, which inevitably required investment. While this was a good rein on me in earlier years, I was now carrying much of the management load and struggled to get across to him what I felt were essential concepts. I had always been keener on having a larger client base and tried to explain that we would be less commercially vulnerable with one hundred clients each spending £10 as opposed to one client spending £1,000.

My supplementary problem was that much as I like people, I didn't much like actually dealing with clients, this despite the little detail that I had been responsible for sales for a long time. It wasn't that I didn't like them as people, but more that I didn't like the power they exerted. I was determined to be truly independent, creatively and as a business, beholden to no one. This realisation gave me a clue for how we should restructure the business, based around a group of talented freelancers, each responsible for their own sales within their own unique sports segments. Understanding what we had to do to bring this together was truly huge, but I think Tony continued to see the agency as being there to support him and his photography, expecting everything to revolve around him and his needs. This meant that all the effort generating independent leads and projects which I saw as the way to grow the company and had initiated, would come to a grinding halt, as he didn't understand the reasoning. This destabilised the team that I was putting together to deliver them.

Eventually the tension between Tony and I became too obvious to ignore. We argued at length about the issues around the problem, but avoided clashing head-on with the problem itself: a fundamental difference in management style and skills. Whether through my skills of persuasion or Tony getting what he wanted (a move to California), by the end of 1983, we finally agreed that there was a simple and obvious solution to break the logjam. Tony had made several successful trips to the West Coast of America. Each time he had returned with exciting and very saleable stories on the latest US fads, skateboarding being one of the biggest.

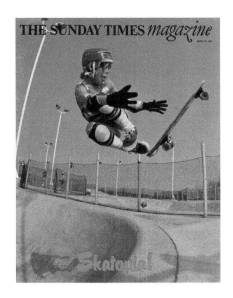

Many new sports and pastimes were emerging in eighties America. Skateboarding captured UK media and public interest, witness the front cover of the Sunday Times Magazine.

Photo: Tony Duffy/Allsport

He obviously enjoyed the lifestyle there, so we eventually agreed that he would move to the United States and establish Allsport USA. This would give him the freedom and enjoyment of working in a small agency environment once more that centred primarily around his work - a lifestyle business; in turn, this gave me the freedom to grow Allsport UK into the international agency that I dreamed of - a growth business.

The American operation would become a wholly owned subsidiary of the British parent company and would give him the space to expand his own portfolio by shooting more track and field athletics at every level from college to international competitions. This agreement that we should each play to our individual strengths led to Tony decamping permanently to Los Angeles in January 1984, to start small again and establish Allsport USA. He chose Santa Monica, California, and set up home there. Our modest presence in the Land of the Free comprised of him and a filing cabinet of pictures in his bedroom, but it was a start.

Of much greater importance to me was that this presence would give us a solid base for our projected coverage of the 1984 Olympic Games in Los Angeles. It was always the holy grail for sports photographers, both for the quality of competition and the general atmosphere and buzz in the host cities, press offices and athletes' villages; there was nothing to touch it, summer or winter. I felt it as much as anyone and as we moved through the eighties, the Olympic Games and its governing organisation became one of the most important influential elements in the development of Allsport as a company, and me as an individual.

12

LOVE AFFAIR WITH
FIVE RINGS

With Tony Duffy now decamped to what would become his permanent base in America, in February 1984, David Cannon and I photographed the Winter Olympics in Sarajevo for Allsport and *Sports Illustrated*. These would be the first games under the guidance of International Olympic Committee President, Juan Antonio Samaranch, and the first Games for young, English marketing man, Michael Payne, from International Sports & Leisure. Between them they would transform the fortunes and direction of the Olympic movement. I was accredited through the British Olympic Association's limited media allocation, but Dave just came along with a brief to shoot whatever and wherever he could, particularly the Ice Dancing, where Jayne Torvill and Christopher Dean were competing and had a good chance of a medal.

Whereas I had full access to all the media facilities and all my expenses and accommodation paid for by *Sports Illustrated*, Dave had no media access and no budget, so he followed the freelance instinct of adapting and improvising. He found a local family who rented him a room and he wandered the mountains, shooting skiing and occasionally talking his way into smaller events. One day after covering skiing from among the spectators, he was editing his film in a local bar near the media centre when he started chatting to a girl who appeared very interested in his pictures. After viewing them she took him off and introduced him to her boss, Goran Takac, a Yugoslavian publisher with links to the IOC through his father, Artur Takac, who was an advisor to Samaranch.

Goran had gained the rights from the IOC to produce the official book of the Games for both Sarajevo and Los Angeles, so we met for a

drink and immediately recognised that we had the recipe for a perfect deal. He had a shortage of quality photography at an affordable price, which we could supply. We had a shortage of Olympic photographic accreditations at any price which, as the publisher of the official book, he could supply. We shook hands that day on what was to become a friendship and working relationship that lasted many years. This not only resolved Dave's immediate access problem by giving him full media accreditation, but also allowed us to bring in our photographer, Trevor Jones, to work on the book. More importantly, it resolved our problem for the LA Games and would allow me to take a much bigger team than had been originally planned.

Sports Illustrated had a huge presence in Sarajevo, including most of their top staff photographers. Jerry Cooke, Jacqueline Duvoisin, Heinz Klutmier, Manny Milan, Ron Modra, Bill Eppridge, Tony Tomsic and Lane Stewart; all working to a meticulously planned shooting schedule, organised by Deputy Picture Editor, Therese Daubner. It was going to be tough to shine in this company, but I had a front-row seat and watched in awe as Therese had planned everything down to the last detail; event schedules, photographer briefs, equipment selection and distribution, with over 700lbs (just shy of 320 kilos) of camera equipment shipped in for the use of their staffers. She also managed a stream of chartered jets in and out of Sarajevo, sometimes flying in terrible weather, to get the film back to London to meet the New York Concorde connections. It was a master class in how to cover a massive event under difficult conditions. I watched and learned.

Not everything worked seamlessly in Sarajevo. The weather was crazily unpredictable, with snowstorms that blanketed the carparks outside the city where all the residents had been forced to take their cars, afterwards only visible by the top of the occasional radio aerial. The Yugoslav organisers hoisted the Olympic flag upside down at the opening ceremony and the first Winter Olympics to be held in a communist state was to be marred by petty officialdom and rules, but it wasn't all bad. Torvill & Dean *bolero'd* their way to a unique and perfect score in the Ice Dancing, watched live, strangely, by my mother and father. The daily film run via one of Therese's private jets became a commuter route for friends and family of the *Sports Illustrated* team and while Beans managed to jump the jet for one day, my parents drew the winning ticket, by arriving on the day of the Ice Dancing finals. Getting them there was moderately simple, logistically, but this event had been a sell-out for weeks. To finally get them in to the finals required a series of sleight-of-hand deceptions

and blatant blagging, involving half the photographers in the stadium. My lasting memory of that evening was glancing up from my rink-side position to see two very nervous-looking parents sitting in the back row, holding hands, while a large Yugoslav soldier, complete with fur hat, red star and Kalashnikov, stood behind them.

Although 1984 was to be dominated by the Olympics, still staging both Summer and Winter Games in one-year, other events and commissions also continued at pace. We had a full schedule of pre-Olympic stories, plus all the usual majors in athletics, tennis and golf, and for the first time that year, *Sports Illustrated's*, full editorial team descended on our ex-dairy offices in Morden to edit and put the Wimbledon issue to bed. I had just come from the French Open at Roland Garros in Paris. There, Martina Navratilova had finally won the Grand Slam of Wimbledon, the US Open, Australian Open and now the French Open, but the big story was how John McEnroe's game just collapsed in fury and anger in the finals against Ivan Lendl. Some imagined, or tried to justify his behaviour, by suggesting that disturbance from a TV camera had ignited his famous temper, but whatever, the French crowds didn't like it. They jeered, and he jeered back as his game fell apart. I got the front cover of Martina on that issue, while the ongoing story of McEnroe moved to London, SW19.

Wimbledon that year was totally dominated by the brilliant, if unpredictable, American, who behaved in a much more civilised manner, probably down to and helped by a much more sympathetic gallery. He won in straight sets against Jimmy Connors and I got the front cover again with my favourite picture of him. Backlit, flying gracefully across the court, dust spraying from his feet, ball and eyes making contact. It was the perfect cover format, and the headline ran: 'Mac the Nice'. I had my best ever Wimbledon both photographically and business wise. I earned myself the nickname 'The Businessman' from *Sports Illustrated's* Picture Editor, Barbara Henckel, when she introduced me that way to Mark Mulvoy, her Managing Editor, or God by any other name. I dominated the coverage with another *SI* cover, but strangely it was the new accolade of which I was most proud. Clearly if others with bigger clout in the industry saw me in business terms I was getting there. From raggedy arsed photographer to 'The Businessman' sounded good to me, and people were taking notice.

However, it was later in the year that Allsport really came of age as an agency, when we flew in with what seemed like a cast of thousands to cover the Summer Olympics in Los Angeles. In 1984, and for the second

occasion in its history, Los Angeles had won the Summer Olympics by default when the only other bidder withdrew. They had done the same in 1932 coincidentally, but this time it was partly because of an unhelpful political situation in Iran and pertinently, of the escalating costs of staging the games. It had been widely reported that Montreal had lost a fortune in 1976, what happened financially in Moscow in 1980 goes unrecorded, but who cared?

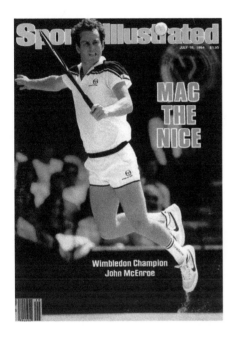

In the realm of perfection. Backlit, ghosting across the Wimbledon grass, dust kicking up from his feet and eyes making contact, it was the perfect cover format and Sports Illustrated ran it with the headline: 'Mac The Nice'.

Photo: Courtesy of Sports Illustrated

History is always illuminating. The 1948 Summer Olympics in London, named the 'Austerity Games' in the shadow of wartime rationing, had one official sponsor, in the unlikely shape of the tobacco brand Craven 'A'. Successive Games received support from companies of all sizes, but in a mark of what would eventually transform the Olympic financing and the IOC, Los Angeles was supported by a group of key sponsors and suppliers. These included the McDonald's fast food company – who funded the build of the swimming venue – Fuji Film, IBM, with the Dallas-based 7-Eleven Inc. who paid most of the cost of the Velodrome and signed up as the official convenience store. The big deal that made these games the most financially successful at the time was the realisation of the value of television rights.

To put that into proper perspective, the 1956 Summer Olympics was the first for which television broadcasting rights were sold; in 1960, CBS paid US$444,000 to secure the US transmission rights for both Winter and Summer Games. By the time of the 2004 Summer Games, NBC paid almost US$800 Million for the equivalent rights. By 2012, the fees charged to broadcasters had increased fifteen-fold, probably stimulated by the increasing dominance of the umbrella grouping of the European Broadcasting Union (EBU). From a contribution of 8% of total rights to cover Moscow in 1980, their share had risen to 50% in 1996, and by Atlanta in 1996, the EBU's bid topped US$250 Million, an increase of 800% over their bid for the rights to Seoul in 1988.

Biggest money was still vested in the US broadcasting rights alone. The 2010 and 2012 Games went for US$2.2 Billion and in 2011, NBC sank US$4.38 Billion into coverage of the four successive Games, at the time the most expensive TV rights deal in Olympic history. By 2014, the IOC granted NBC rights to all Olympics from the 2022 Winter to the 2032 Summer Games for a massive US$7.65 Billion.

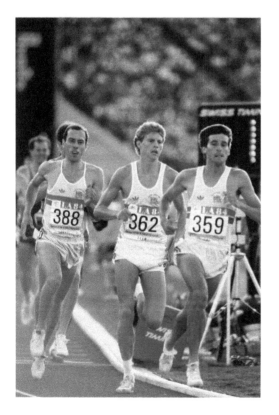

By the eighties, all sports were beginning to sell papers, magazines and importantly, TV advertising. The public interest around middle-distance running was stimulated by three British runners and their rivalry on and off track. (L-R) Steve Ovett, Steve Cram and Sebastian Coe set and broke records which sold pictures and generated increasing revenues and kudos for our agency.

Photo: Steve Powell/Allsport

It was Roone Arledge, ABC's legendary Sports & News Network President, who famously described the broadcasting bidding process: "It's like the IOC place three scorpions to fight in a bottle and when it's all over, two will be dead and the winner will be exhausted." It still didn't stop him bidding, as he knew that the imagery was just too valuable to lose for his viewers and advertisers. Having been persuaded six years in advance to pay US$309 Million for the rights to Calgary 1988, at the time the highest amount ever paid for one sporting event, a notable downturn in sport-related advertising revenue had left him with a US$60 Million deficit. Temporarily burned, he opted out of Albertville 1992, whose rights finally went to CBS for a more modest US$243 Million, and refused to bid again for eight years, leaving NBC to take on the mantle for the Summer Games in Seoul in 1988 and CBS a free run to pick up both Winter Games in Lillehammer 1994 and Nagano 1998.

By now Allsport had an overseas network of 34 territories to supply and the Official Book of the Games to produce and, thanks to the extra credentials that came via the book status, I headed to L.A. with a big team of young photographers and support staff. I had never felt so exposed or nervous in my professional life. We had rented a college house, Sigma Chi, on the University of Southern California campus, for the duration. I'd flown out straight after Sarajevo to check it out and agree the deal. It needed a lick of paint, but other than that it was ideal. We could set up an office there, only a few minutes from the main Olympic Stadium, and it would accommodate us all. I was very aware that if we were doing our job correctly, throughout each and every day our people would be returning with rolls and rolls of E6 film stock which we had to do something with, and quickly. With more than 200 finals in 16 days of intense competition, we had to get our processing and distribution right. If we weren't ready when the big play started, we were dead. I recalled how we used to do things at Keystone and could think of no better system. Accordingly, we built a vast rack of cardboard boxes which became our sort and despatch system, each box labelled with a client and country. Simple, but it worked, and we delivered.

There were 140 nations competing in 221 events over 21 sports, from pistol shooting to synchronised swimming, and sixteen eastern bloc nations boycotted in retaliation for the American-led withdrawal from Moscow. A hero called Bill Suitor arrived during the opening ceremony in the Coliseum wearing a Bell AeroSystems rocket pack and, thanks to our Official Book status, I photographed it from the roof of the stadium. Directly above the box occupied by US President, Ronald Reagan,

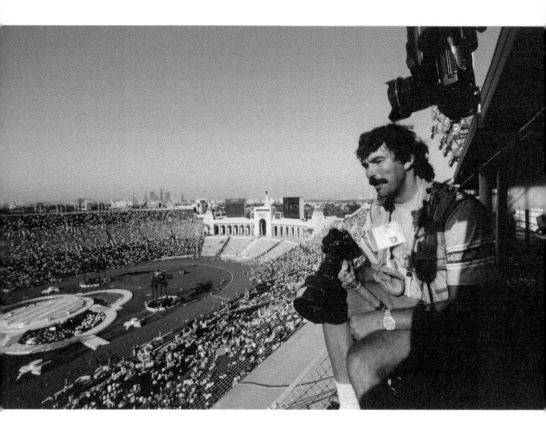

He's above you! Little did US President Ronald Reagan know who was perched above him throughout the opening ceremony of the 1984 Los Angeles Olympics. After him, I had arguably the best seat in the house.

Photo: Allsport Archive

I required special Secret Service vetting, which was all quite exciting. Carl Lewis won four Gold medals and Mary Decker tripped over Zola Budd, who failed to win anything, despite the hype that surrounded her re-nationalisation from South Africa to the UK. Daley Thompson won Olympic Gold again and caused controversy by having a T-shirt made up suggesting that the world's second greatest athlete might be gay! In front of Carl Lewis' home crowd! Not to disappoint his British fans, he also whistled through his National Anthem after receiving his medal. The media went ballistic, the fans said, 'that's just Daley for you' and Daley claimed that he was whistling God Save the Queen. Well, he was now double Olympic decathlon champion, arguably the greatest athlete in the world. Tony certainly knew how to spot them.

By the end of these Games I had discovered that my spiritual home in all future Games coverage would have to be in the Main Press Centre (MPC), a gladiatorial pit as competitive as any Olympic arena. Thousands of writers, photographers, agencies and newspapers all vying with each other to be the best, fastest, highest, longest; sound familiar? All the major players had offices in the MPC, so AP, Reuters and huge national news agencies from all over the world found themselves in close proximity. All the leading newspapers had offices and of course *Sports Illustrated* had one of the biggest, but we weren't in the MPC. On its own, Allsport was still too small an organisation, something I vowed to change before the next Olympics. This arena gave me all the excitement and adrenalin I needed, much like Fleet Street in my early days, but on steroids. I had now seen the big players in action at two Olympic Games and knew exactly what I needed to achieve credibility in this industry.

Los Angeles also saw the first public introduction of email, a straw in the wind if ever there was one, and it fascinated me. I used it constantly, but failed to get everyone else to use it; but what it told me was that my investment in our huge Telex machine was soon to be outdated. Time to change the ground rules and playing field again.

13

PLOTTING AND THE ARMS RACE

Opportunities continued appearing, helped by the profile boost we had achieved from our presence at the LA Games, but now I had to live up to my promises and make sure that the London business boomed. Although I still had a busy winter of assignments for *Sports Illustrated,* I took some time off for planning, or 'plotting time' as I came to regard it. During the 1980 Lake Placid Games I was socialising with the great and the good of the sports photographic industry and regaling some of the biggest names in the business; Heinz Kluetmeier, Walter Iooss Jr. and Neil Leifer, with my hopes and dreams. One of them, I don't remember who, buttonholed me a little later and asked me if I had a plotting room, a space where I could sit quietly and plan the future. Everything from career to life. His point was that to achieve our dreams we shouldn't just *let* life happen, but we had to *make* life happen. I had always been a notorious planner with a selection of one-year, three-year, five-year and life plans, but this advice gave them form and legitimacy. I took the advice to heart, and my first plotting room was to be in a hotel room in Italy.

I went to Bormio in January 1985 on assignment for *Sports Illustrated,* but deliberately arrived three days early to give me time on my own with no interruptions. I had my plotting time and spent those days in my room mapping out the future of Allsport. I guess the concept would later be identified as blue-sky thinking, looking at all the 'what-ifs', but I'd spend all day working through a particular theme or strategy and dismissing or embracing any possibilities, advantages or dangers that might apply. In the evening, as a reward for my efforts, because it's important to reward,

Covering sporting events often presents opportunities to capture less mainstream but equally marketable images. Four hours on a biting cold morning on the side of a Swiss mountain produced this remarkable picture of a ski marathon in progress at St. Moritz.

Photo: Steve Powell/Allsport

I would sit quietly in the hotel restaurant, enjoying a decent dinner and a good bottle of wine, reviewing my day's thinking. I had inadvertently discovered quality plotting time and this was to become my future modus operandi. I'd lock myself away in a pleasant hotel for three or four days and come out with a strategy.

Although I was now Managing Director of Allsport Photographic, the main UK company, when I got back from Italy with my plan, I still had Tony and my senior management colleagues to convince, so I set about selling it to them. My plan was essentially simple, as all good plans are, and covered two key areas in our current business model that I felt could be significantly improved.

First, getting accreditation at major events was still a big problem, as witnessed in Los Angeles where we had to scrabble about trying to get extra credentials from any source for our photographers and editors. We now had the market for much better coverage of major events, but if it wasn't for our *Sports Illustrated* assignments, there were still many venues closed to us, or to which we could only get the access we needed in a restricted way. Wimbledon was a case in point. It was just minutes away from our HQ and the biggest tennis championships in the world yet Allsport still did not have its own photo accreditation. We had limited access to a pool of accreditations handed out to freelance photographers, but as demand was high, getting into the key matches was always a lottery and not one that we could always guarantee winning. We were growing fast and our reputation as a major player was becoming established, our commitments to clients worldwide demanded better, so we could not rely on such a lottery. This had to change.

For some years we had been courting the various sporting governing bodies with increasing success, but I proposed that we focused harder on them. We were now official photographer to the International Amateur Athletics Federation (IAAF) and FINA, the International Swimming Federation. Now I needed us to focus on all Olympic sports, large and small, so that by the time the next Games came around in four years, I wanted us to be the official photographer for every Olympic discipline. This would hopefully overcome the traditional media allocations that had too often been denied to us and guarantee the access we needed. This, I reasoned, would give us the supplementary benefit of access to all the sports' increasingly wide range of sponsors.

To achieve this, we would need to hire more photographers, more researchers and more editors, and formalise a process that was already happening, but which we hadn't really recognised. The operational model for how our photographers and clients interacted was now becoming obvious. In the independently minded world of the media, particularly editors and publishers, there had always been a very intimate relationship between them and their contributing writers, photographers and designers. Producing newspapers, magazines or books was a cooperative process between the different creative skill sets. We now had a growing number of photographers, each with a specialist relationship with their chosen sport. Many of these were not Allsport relationships in the traditional sense, but freelance relationships between editor and photographer, sharing a common interest in each sporting discipline. Although all our photographers, including ourselves, were employed as

full-time staff members, to the outside world we appeared to operate as freelancers, a life form much more agreeable to the creative sensitivities of some of our publishing clients. What no-one fully appreciated was that behind the individual photographers plying their creative calling was our increasingly large organisation which was managing, selling and distributing their work, and providing resources and support that freelancers could only dream about.

Then, when we began supporting this work model with specialist editors and researchers, we saw significant growth and made serious inroads into the governing structures of each sport. It was still the same basic approach that we had pioneered years before; build a relationship with small specialist magazines and give them quality photography of a level they could never hope to achieve or afford with their in-house resources. Get seen by the sports' governing bodies that inevitably wanted to use our pictures in their house magazines, which we would, of course, offer for free. Then, in no time at all, we were the 'official photographers to …'. From that moment, we had access to every major event in that sport, so we could service our paying media clients worldwide. If an Olympic discipline, we would have the additional bonus of qualifying for a specialist credential, which would solve many of our access problems. I was determined that we would go to the next Olympics in 1988 at full strength, ready to take on all comers, and this was the way we were going to do it. As it turned out, there was another way, just over the horizon.

The second big idea to come out of my plotting wasn't so much a blinding flash of original thinking, but the realisation of the power of something we knew we had but hadn't fully recognised. We saw ourselves as a bunch of successful freelance photographers working together. We all loved our own specialist interest whether it was cricket, football or athletics and we knew that every four years we'd have another Olympic Games. The great truth was that sport was, and is, wonderfully repetitive in its own structure. Before the arrival of global pandemics, almost regardless of bad times, recessions or good times, sport carried on. In the years between each Olympics we'd have another World Cup, four Wimbledon's, Opens and Masters. If we could get our access right, this repetitive structure would give us a guaranteed income forever. That was a major bankable asset. I realised that if we could show that we had a guaranteed income for the next five, ten, fifteen, twenty years, because of the repetitive cyclical nature of the sporting calendar, associated media and sponsor interest, we could convert that into pretty much anything we wanted. We now owned huge image archives and even if we stopped

all photographic coverage that day, the stock would continue selling for many, many years. Of course, we weren't going to stop our coverage. We were going to expand it significantly.

Looking back on it, neither of my big ideas were original, as we had recognised them years before and had been getting closer to them for some time, but that wasn't the point. I had stopped, got off the train and sat in a darkened room plotting, which meant that I was looking for meaning and structure and looking for a way to make sense of a fast-moving and sometimes out-of-control behemoth called Allsport. What both ideas would require if they were to deliver was investment and this would be in the rapid expansion of back-office staff, photographers, technicians and editors. More importantly, we would need bigger and better everything, including larger offices and studios to accommodate them.

To interpret our current and projected revenues I would need to understand a lot more about our business and what was happening to it, and for this I needed the numbers. Much as I loved it and what it had allowed us to achieve, my little BBC Micro with its dot matrix printer wasn't going to tell us very much at all, as our accounts were still hand-written in a ledger and had no connection to our modest client database. This also had to change, but change is always difficult for a company. Some fear it, others embrace it, some managers demand incremental change, while others believe in ripping the plaster off. I am a 'ripping the plaster off' man, especially in times of crisis. This was a time of crisis, but not one that was immediately obvious. We'd just had what appeared to be a successful Olympic year, and we were expanding into the USA, but personally, things were in a state of flux. That January, at the age of nineteen, my brother Mike had come out from under my shadow and left the UK to join Tony in the Santa Monica office. I had still been making life difficult for him, but he was hanging in there despite my efforts and his work was improving, though his parting words to our mother were: "I've lost a brother and gained a boss, so I'll be better off." That made me think a bit.

Now, despite all the business positives, a crisis threatened to engulf us. An unfortunate twist of fate forcibly suggested that our hype was outstripping the reality. To drive the business, we needed to catch up with our own marketing. It was not a problem that I could share as it was entirely self-inflicted and, as I'd been in charge of everything, it was down to me. I just knew that we couldn't endure another year like that again. We had scraped through both Winter and Summer Olympics by the skin of our teeth, leaving our team exhausted and we had worked

them into the ground under extremely difficult conditions. We had made it, though not with the benefit of any proper planning or use of resources, but just through pure willpower and determination. I knew that I couldn't justify continuing to put people in that position as they would either burn out or leave, so we had to expand rapidly if we wanted to be credible at the next Games. If we didn't, we would remain a small UK sports photo agency with a one-man office in the States and all our Olympic hopes would fade.

Change it had to be and rapidly, so I started an audit of all our systems and found most of them wanting. I knew that simple systems worked best, so I streamlined everything that we did in the agency and started by looking at every operation that we had in place. From the darkrooms, through accounts, sales methods, post room, to the archives; if any job could be made simpler, quicker and more efficient by buying a piece of equipment, I bought it, learnt how to drive it and taught it to others. Now, with computers in the mix, everything was potentially up for change and it helped that I had experienced every job and process that made Allsport function, and I knew them inside out. This knowledge and experience proved invaluable and would serve me well in the coming years. We needed to get our bank on side so my pitch to the NatWest showed a very profitable Olympic year and projected that with the repetitive nature of sports that gave us our core income streams, we could confidently predict our revenues and growth with recession-proof certainty. The message was taken on board and we got our funding. Then we upgraded everything, and in doing so we embarked upon the biggest injection of funds into Allsport in its history. The bank had bought my concept and with its backing we proceeded to build the future.

First, we found a brand-new freehold warehouse. Here, the 2,000sq.ft. (186m²) of offices and 10,000sq.ft. (930m²) of warehouse space in Colliers Wood, South London, became Allsport's new worldwide headquarters and gave us the potential to more than double the size of our operation. One half of the ground floor became devoted to a bespoke darkroom, alongside production and despatch departments. We also constructed a massive studio facility, large enough for major set piece shoots, in the other half. We then built upwards with a mezzanine floor, giving us an additional 5,000sq.ft. (465m²) in which we set up an open plan photo library. All of this was to be supported by a new IBM System 36 mini-mainframe computer that allowed access from multiple terminals throughout the building. It also allowed us to run a multi-currency accounts package, integrated into a bespoke library management, client

support, and image tracking package. All based on my little BBC Basic program, but with bells and whistles.

While all this was happening, I was still travelling on assignment, a lot, but also project managing both the new software and the build-out. Both were to excite me beyond expectations and probably led to my lifelong passion for technology and building or renovating. Beside the full schedule of coverage that kept us busy every day of the week, a couple of other exciting things happened that summer. Still a bit away from our move into Colliers Wood, *Sports Illustrated* descended on our small offices in Morden again for Wimbledon fortnight. This time, however, they would not edit the film and then ship via Concorde, for an expensively delayed deadline. Oh no!

This time they were sending the entire story, pictures and copy, via satellite. After processing, editing and selecting all the images in our office, they would bike these to Central London to be scanned in high resolution and then bounced on by microwave link to the British Telecom Group's earth satellite tracking station at Madley in Herefordshire. Commissioned into service on a disused World War Two airfield in 1978, it was the first UK satellite site to send a fully digital transmission via time division multiple access, and over the years played a central role in global broadcasting. Once our images had reached Madley, they would be beamed up to Intelsat V. Each picture took 12 minutes

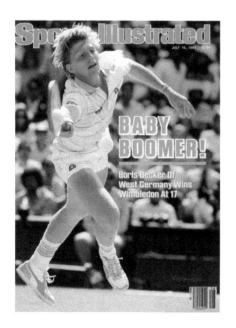

Ever-changing technology gave new ways of working with our clients. Boris Becker, top-flight tennis's first 'Baby Boomer' won Wimbledon men's championship in 1985 aged just seventeen and the cover that resulted was the first digitally generated high resolution cover ever printed by Sports Illustrated.

Photo: courtesy of Sports Illustrated

of transmission time and were received in Etam, West Virginia, before being moved on via a telephone line to the *Sports Illustrated* production facilities in Manhattan. The whole Wimbledon story was transmitted and printed in high resolution colour for the first time in *Sports Illustrated's* history. My picture of 'baby boomer' Boris Becker winning Wimbledon at 17 was the first digital cover ever printed by them. I witnessed the future and took note.

A few days later I had a call out of the blue from Michael Payne, an old friend who I hadn't seen for years. Michael had worked for West Nally selling trackside advertising and sponsorship, and one of his jobs was to attend the Grand Prix track meetings all around Europe. We'd meet, two Englishmen on the road, have the occasional drink or dinner together, but apart from asking me the best place to stick his advertising on the side of the track, he lived in a very different world to me, and we went our separate ways. His call was mysterious at best, but I took note again. "Steve, I am going to be away for a year or so, but when I get back, we'll talk Olympics." I naturally tried to get more from him, but he remained tight-lipped, other than to offer the even more intriguing throwaway line: "I work for the International Olympic Committee now." Intriguing, though I had no idea what to make of it.

I had enough things to concentrate on from project managing the software system design and physical build-out of our new headquarters which was still taking much of my time. We were also upgrading pretty much every piece of kit in our darkrooms and production department, investing in new E6 processing machines. These huge units could process 120 rolls an hour and new duplicating cameras that could run a 200ft. roll of film through at two frames a second. Every department had something new and exciting, but the crème de la crème was the new IBM System 36 mini-mainframe with its bespoke software, designed exclusively for us and to our specification. If you're going to make changes, do it all, at once; rip the plaster!

I have always justified the cost of these changes and purchases to myself on multiple levels. The obvious benefits that they would bring to the job, but also the purchase of an expensive piece of equipment not only helped streamline our systems, but helped build the morale of our staff. If we were willing to spend that kind of money to make their job easier, it gave them confidence. It was also a marketing tool, subtle, but still effective, for if you look successful, you probably are. Best of all, it rattled our competition and changed the playing field. We were to do this many times and on every occasion that we bought a new piece of kit,

I made sure that everyone in the industry knew about it. It was a subtle version of what Ronald Reagan was doing to the Soviet Union at the time. The nuclear arms race, in its simplest form, was designed to tell the Russians that in order to stay competitive in this nuclear world, these are the toys that you will need, and they *are* expensive. The heavy cost of trying to keep up with American spending on nuclear defence contributed significantly to the demise of the Soviet Union, exactly ten years after Reagan had become the 40th President of the United States.

We moved into our new World Headquarters in May 1986 to much fanfare and with a big party for clients and friends to show off the new toys. I had my own little arms race with the competition, so in my role as Chairman of the Professional Sports Photographers Association at the time and as all our principal competitors were on the committee, I invited them down to our new building for a meeting. In reality, it was a slight ruse and all about changing the game again. After a quick courtesy tour, they all looked suitably chastened and I didn't need to say anything, because they all saw that in order to stay competitive in our particular arms race, these were the toys you needed, and they *were* expensive. Looking back, I believe that this was the day that we departed the world of the small, independent agency and began to think and be recognised as a big, international business.

14

GATEWAY TO SUCCESS

Every industry, however well established, can benefit from an injection of fresh blood and new thinking once in a while, and for the traditional union-dominated newspaper industry, it came in the buccaneering shape of Eddy Shah. Born in Manchester to Anglo-Iranian parents and educated at Gordonstoun School, he became a floor manager at Granada Television, before working in the newsroom of the Manchester Evening News. Fired from there in 1976, he decided that he could do better as an independent. Having self-financed the purchase of the Messenger Group of six papers, he became a news story himself when going head-to-head with the National Graphical Association (NGA) in a lengthy stand-off at his Warrington print works. He was the first newspaper owner to invoke Margaret Thatcher's anti-trade union laws.

Fleet Street had watched him battling the NGA from a safe distance, but everyone suspected that he would come south one day. Our big break came in 1986, when this maverick owner launched *Today*, the UK's first colour and technologically advanced newspaper. After a phone call from his newly appointed Editor-in-Chief, Brian MacArthur, Lee Martin, who by this time headed our UK sales team, and I, met with Eddy and Brian to explain what we could do for them. In simple terms, the deal we offered was to provide the paper with a comprehensive colour stock photo library from our resources, one that his picture editors could dip into and select from, right next to their own desks. It would be ready for them within one week, at no cost to them, so all they had to do was just pay for what they used. This, I explained, would help tide them over to the time when their own photographers could begin to build up *Today's* own archive.

The idea was really quite simple. We bought five, 5-drawer steel filing cabinets, each capable of holding approximately 25,000 duplicate transparencies, and we created a mini version of the very best of Allsport files. Covering solely the major sports, this delivered 100,000 colour images to their editors within days. Our thinking was that once established right there next to the picture desk, why would any picture editor bother to phone around other agency sources for stock pictures when they had them all on tap beside them? In return, and by far the most valuable quid pro quo, was that we could sign the first newspaper contract by a non-union agency. Doing this would help to break the print union's invidious stranglehold on outdated working practices and free enterprise in supply. Once Eddy broke the unions' hold and managed to print in colour, it became obvious that the whole newspaper industry would eventually go that way, so the advantage gained from our pre-emptive move was immense. Getting in fast and establishing an in-house colour photo archive for them not only generated significant revenue, but created what became our own barrier to entry over the competition, as it would become increasingly difficult for them to get their pictures seen. We continued supplying *Today* with live coverage and updated their stock archives to dominate usage, as their own staff photographers never did quite catch up with Allsport.

Based upon our experiences with *Today*, we assumed that all the other UK newspapers would follow suit by starting to publish in colour, so Lee prepared similar mini archives in that expectation. Over the next couple of years, every time we heard that a newspaper was about to change to colour, off he'd go in a truck with his filing cabinets full of the best of Allsport files, ready for their use. In a short time, we created the biggest barrier to entry in the newspaper industry, eventually giving us something like 60% of all images printed on the sports pages of UK National newspapers.

Later, in the summer of 1986, I received the long-promised phone call from Michael Payne: "Steve, it's time to meet up and have a chat, can you come to the International Olympic Committee headquarters?" I flew out to Switzerland a few days later and drove along the shore of Lake Geneva to Lausanne and Chateau de Vidy, home of the IOC. Michael, now it's de facto marketing director, though still project managing the IOC's marketing portfolio from within International Sports & Leisure (ISL), met me in reception and wasted no time in explaining the situation and the reason for his call. The IOC's problem was historical. Previously there had been dozens of sponsors and

Michael Payne's invitation to me to visit the International Olympic Committee's imposing headquarters at Chateau de Vidy on Lac Leman provided an answer to one of his problems handling the ever-growing number of sponsors and a gateway for Allsport to work at the highest levels in sport and enhance our international reputation.

Photo: courtesy IOC

suppliers of all sizes and relative values and no little ambush marketing, hijacking the amateur spirit of the Games. That was about to change with the institution of The Olympic Partners (TOP) programme, which would comprise an elite group of companies whose bank balances would be regularly and increasingly dented as the years went by, for the privilege of supporting the five rings. For their investments they were granted exclusive global marketing rights and were expected to participate in the aims and objectives of the IOC. Most notably amongst these were the furtherance of technical expertise: grassroots support of sport; environmental improvements; youth programmes; legacies; global promotion and, of course, increasing the overall revenue stream. All without compromising the IOC ethos of amateurism, with no visible commercialisation within the sporting arena.

Michael and the team at ISL had spent two years creating TOP, and its aim was laudable and far reaching. Simply to generate diversified revenue that could be shared on an equal footing between the organising committees of successive Games and the Olympic movement itself.

Sponsors had to buy-in to a four-year commitment, equivalent to the Olympic quadrennial period. The TOP nine group had included Coca Cola, Kodak, Fedex, Visa, 3M, Philips, Panasonic, Brother and Bausch Lomb and initially, each was required to pay around US$15 Million (today a more eye-watering US$200 Million) to secure and retain their place at the Olympic top table. If anyone could claim to be instrumental in the transformation of the IOC from financial basket case, often with its survival in the hands of capricious politicians, to be the best independently funded sporting property in the world by a country mile, it was Michael Payne. An engaging man of considerable charm and great industry, he had seen success as a British free-style skiing champion in the 1970s and, having created a role for himself in finding sponsors for his fellow competitors, graduated to the event management business. He achieved this first with West Nally, a business put together by BBC commentator, Peter West and sports marketing guru, Paddy Nally, then following Adidas founder, Horst Dassler, joined his new Swiss-based marketing company, ISL, as their Olympics project manager.

In 1983, ISL had secured a contract from the IOC to develop a global marketing programme and Michael was head hunted to manage the project. He then assumed the fully fledged role of Marketing Director when he moved from ISL to the IOC, until the relationship foundered and he created the IOC's own in-house agency, Meridian Management, as a wholly owned subsidiary. For the first time in its history, this gave the IOC an ever-increasing degree of control over at least one important aspect of its commercial destiny. By the end of his time in the movement he had contributed largely to the initiation, development and delivery of a multi-million-dollar marketing programme that reached across the world.

The ground-breaking success of this programme was based upon twin ambitions: capturing growing, yet commercially justifiable, income from broadcasting rights and exploiting the Olympic brand through sponsorship, whilst preserving the essential historic Corinthian spirit of the Games and what the movement stood for. What Michael came up with and was originally christened 'TOP', morphed into 'The Olympic Programme' and later still 'The Olympic Partners'. The big sell-in to everyone was simply that this removed the complexity of what had developed into a truly Byzantine bidding process for different slices of the Olympic pie, which often involved the IOC, individual Games' organisers, National Olympic Committees and widely different territories. If I thought that selling our photographic services across different territories and multiple partners was tough enough, then Michael's problem was

much, much bigger. What he was proposing was to simplify the whole rights and sponsorship bidding issues by combining and packaging every aspect of what was on offer in over forty product categories. Once launched, the TOP programme was to attract a growing legion of world-leading companies that included Coca-Cola, Kodak, McDonald's, Visa, Samsung, Swatch and Panasonic. As he outlined it, his problem centred upon how he could service them.

Michael had immediately captured my interest and, as our discussion continued over dinner that evening, at some point it became clear that he was offering Allsport the status of 'official photographers' to the International Olympic Committee, a role that had never existed before – providing we could find an equitable way of servicing the photographic needs of all his sponsors. On the face of it, my response to his offer should have been a simple yes, but as is often the case, it wasn't that easy. Under the terms of the IOC Charter, neither he, nor it, actually had the facility to hire any commercial photographer and give them access to the Games without a variation to that charter. We both knew that any attempt to change those ground rules would come under immediate attack and be resisted strongly by all the establishment media as a perceived sell-out to sponsors. Every square metre in every Olympic venue is fought over by every vested interest from officialdom, television, media and public ticketing, and to introduce yet another category of privileged access would be nigh impossible.

We had spent the past 15 years working to establish our media credentials and fighting furiously to rebut attempts by the traditional media agencies which sought to portray us as commercial photographers with no rights to free media access to sporting events. Establishing our status had been an enormous battle, which we were just starting to win. I was very aware that if we got it wrong, there was a significant risk to Allsport, so my job was to find a way around the problem. This was not going to be easy.

Michael had booked me into the Beau-Rivage Palace Hotel, with a room overlooking the lake. I awoke very early the next morning and watched the sunrise from the balcony while the enormity of what had just been offered to us sank in. This, I realised, was probably the most important moment in my professional life and I was on a high, but the stakes were equally high. We had very carefully built our reputation as a legitimate media agency which provided the lifeblood of our business, so we needed to maintain the division between our pure news output and what could be an increasingly important service to sponsors. Crossing the

line was beyond dangerous to our business model and ethos if I got this wrong. However, if we were successful in putting a proper programme together that satisfied all the vested interests, it would resolve all our accreditation and access issues not only with the IOC, but with just about every other international sport governing body. If the IOC recognised us, how could anybody deny us?

I had been invited to return to Chateau de Vidy one month later to meet senior members of the IOC Media and Marketing teams to explain my strategy and make my case. This was a bit daunting for a young sports photographer, but the window of opportunity had opened wide and I just needed to come up with a feasible proposal and bring some good ideas to that meeting. From my side, I knew that working closely with the IOC could add enormously to our reputation and potential revenue, and give us huge clout in the industry. Here was our problem: we could justifiably argue that our status as official photographers to the IOC was compatible with our status as a media agency, but our involvement with their TOP sponsors could not be argued in the same way, so a solution needed to be found.

It came in the shape of a 'Chinese Wall'. I probably first became aware of the concept through friends in powerboating or Beans' friends in the Turks Head Rugby Club, many of whom were bankers or brokers. It was not a concept that any young photographer would normally have encountered so it took a conversation with David Hagan, a past Class 2 world offshore powerboat champion, City money broker and lifelong friend, to explain the rudiments to me. From him I learned the ethics that a Chinese Wall could offer: the creation of a separation between groups, departments or individuals within the same organisation, forming a virtual barrier that prohibited communications or exchanges of information that could cause conflicts of interest or jeopardise integrity. Sounded like a plan to me.

Returning to Chateau De Vidy, I had mentally adopted the idea and suggested to Michael that we establish a Chinese Wall within our coverage of the Games, servicing the TOP sponsors at one remove. Effectively, this meant that although the photographic team that was to work with the sponsors was accredited through the Allsport media allocation, there would be a complete embargo on any of their pictures being distributed through our media outlets or, in fact, being handled by the media team at all. This resolved the IOC's need to find a way to accredit photographers to work for their sponsors and maintained our editorial independence. I could legitimately argue with the international

media agencies, Associated Press, Reuters, Agence France-Presse and the rest, that our media status was entirely separate from our sponsor team. It was probably a bit of a tenuous argument, but with the support of the IOC Press Director, Michele Verdier, and Michael, we got away with our proposal and the Charter remained unchanged. Michael saw how we could help him solve a small but pressing problem by integrating the TOP programme into the accreditation system to deliver a minor but strategic gain for him. If we could make our proposal fly it would be a substantial gain for us. Everyone bought-in and our system for managing the Chinese Wall came into being and was operational by the time we went to the Winter Games in Calgary, as the IOC's first official photographers.

Calgary would be a steep learning curve for all of us. We would have all the right credentials and access for the first time, which would allow us to really work the Games, but also presented an immense challenge in personnel management and logistics. It was also the first time that we would have the sponsor support team in place, albeit just a small team of three, led by Dick Scales, who I had hired in February 1987, shortly after signing the contract with the IOC. He was probably my brightest appointment, made at precisely the moment that we needed his sort of expertise the most. His CV included stints in the BBC Radio sports line-up as journalist and reporter, so he understood the media and how it worked, followed by a role in the public relations and marketing team at Adidas France, so who better to understand the needs of major sponsors?

Tony had known him since 1972, when they had shared the traumas of the Munich Games, and I had known him for many years. In 1984, when working for Adidas, he famously bought a special effect photograph of Daley Thompson doing each of his ten decathlon disciplines in one photo. Something that today would take an average Photoshop user about ten minutes to assemble took me all night in a stadium in San Diego, with Daley repeatedly running, jumping and throwing. The exercise was exhausting for both of us, but the resulting picture was great. Sold to Adidas for an astonishing £10,000 (about £32,000 today), it became the pivot for their next marketing campaign.

Perhaps unsurprisingly, we were still thinking like a small, entrepreneurial business, great for being quick to react to opportunities, but our commercial model was changing and now we needed to know how to organise ourselves as a larger company and I recognised this. The new opportunities offered by working alongside major sponsors were

going to play a big role in this change and in looking for someone to head our new sponsors division, I wasn't looking to hire just a conventional commercial manager. I needed someone who understood the sensitivities of the media world towards commercialisation and how to shape and organise a larger company, so Dick's background at the BBC and Adidas seemed a perfect fit. He didn't disappoint.

What we did for art! A commission to produce a definitive composite image of Daley Thompson's ten Decathlon disciplines took us all night in an empty San Diego stadium and multiple exposures using a 5x4 plate camera to achieve what today might take ten minutes using Photoshop software.

Photo: Steve Powell/Allsport

1987 was to be a fabulous year for us personally. Beans and I had been trying for our first baby for some time, but the pressure of work and my travel schedule hadn't helped. Beans was also a busy professional, running one of London's best hairdressers on the King's Road, so as 1986 came to its close we had decided that we would get professional help in the

A photo safari to Kenya for Daley and I, together with wives Tish and Beans, quickly led one of the most photographed sportsmen on the planet to monopolise my cameras and discover first hand the techniques for taking good pictures. Which, being Daley, he picked up very quickly.

Photo: Steve Powell/Allsport

new year, but have a holiday first. Once again, we teamed up with Daley Thompson and Tish, now his wife, and went on a safari holiday in Kenya. I took my cameras, all my long lenses, plus my first JVC Video camera, a huge thing by today's standards. The moment we began the safari, Daley stole all my cameras and started photographing everything in sight. He picked up the techniques of framing and focusing very quickly, as he did with everything, so as he concentrated on stills, I concentrated on video. By the end of the holiday, he had taken some superb wildlife pictures which are still out there being used, but with my byline; sorry Daley.

When we got back to London, we had the best news possible when we discovered that Beans was pregnant. All we had actually needed was to spend some time together and relax. And relax I did, as the business was doing well, the new building was amazing and all my plans were coming together. We had a long, hot summer and Margaret Thatcher won an historic third term in the June election, which provided a major boost for businesses. Everyone felt that life was good, and the future looked decidedly rosy.

While Tony appeared totally focused on developing his photography in the US and while all the major corporate and operational decisions were being initiated by the directors in the UK, we chatted regularly to keep him up to date with what was by now beginning to be a very fast moving business. I continued to shoot all the usual events; Wimbledon, the Open and all the European track meets, but I was much more relaxed and confident as we now had a great management team in place in London that could be relied on to deliver without my constant presence. Adrian Murrell took on a bigger management role in Allsport UK and he was supported by Lee Martin, heading up sales, and Mavis Streeton, who ran the accounts department. With a mixture of rod of iron and tea and sympathy, she also took on the role of Mother Hen to all our young photographers, teaching them how to manage our money and submit their expenses promptly and properly. They were backed up by John Gichigi in the darkroom, overseeing the engine room of the agency, producing thousands of high-quality duplicates of our best material, and by Robert McMahon who was in charge of managing the archiving of several million images, with thousands more being added daily. Alongside them we had Steve Rose running our very embryonic digital services department, Tony Graham, managing our agents who were by now handling 40 overseas territories, and the recently hired Dick Scales. Apart from his role of managing our newly emerging sponsor services, his wider brief was to plan the restructuring of Allsport to meet the needs of our expansion.

All were to provide vital contributions to our transformation from small photographic agency to major world player. Inevitably, at the heart of our team were our two most senior photographers, Bob Martin and David Cannon, both playing active roles in management and sales, on top of their photographic duties. I had always been determined to keep photographers at the centre of the decision-making process and ultimately, of the seven members of the main Board responsible for both Allsport UK and Allsport USA, five were photographers.

Having such a powerful team in place freed me from the daily grind of management and allowed my imagination to roam. One hallmark of Allsport was taking the risks that came with constant change, always trying new ideas, some successful, some not so, but growth demanded experimentation, which involved trial and error. I saw embracing change as a good thing, as long as we were equally prepared to drop ideas quickly if they showed signs of not working as planned or not delivering the returns we expected. We hired our first journalist to write stories for syndication with our photos. Nice idea; didn't work. It wasn't core to our

business and our clients preferred that we just gave them a story outline with our photo sets, leaving them to fill in the gaps written with their own readership in mind. We set up an Allsport video unit to syndicate sporting clips and take on commissioned work. It was great fun setting up a full video editing suite, but this again proved a cul-de-sac when it became apparent that although there were many extremely creative cameramen about the place, success in this field was more about high-tech cameras and equipment. The message that this wasn't for us finally came home to me when I stood on the side of a mountain watching a men's downhill race alongside the BBC's Ski Sunday camera team of three and realised that I was being paid more to be there than all three of them put together. I was being rewarded as a creative communicator; they were being paid as camera operators. Different worlds at every level.

I was constantly looking for the next big idea, the next big splash, the thing that, if publicised widely enough, would separate us from the competition. I found it when I was reminded that 1988 was the twentieth anniversary of the picture that could technically be attributed as the foundation of Allsport. Although Tony had been a tourist at the time and didn't formally set up Allsport until 1972, his photo of Bob Beamon breaking the world and Olympic long jump records was an extraordinary story, which, I realised, was also the stuff of myth and legend. When Tony returned from Mexico in 1968, the photo was used in several publications and hailed as an iconic image of an historic moment, but largely after that it was consigned to the files. Other than its occasional use, primarily in athletic magazines, the story of the picture went quiet. This was evidenced by the fact that in all the major interviews and articles written about Tony and Allsport right up to 1987, there is not one mention of that photo, but there was certainly a story to be told. So, I set about telling it and making it happen.

We hired an in-house designer, started planning our first book dedicated to the work of Allsport photographers and began looking for a publisher and a major exhibition site in London to launch it. We did this on top of planning the coverage of two forthcoming Olympic Games. Fortuitously I had discovered the joys and planning capacity of Excel spreadsheets, which may be an unusual talent for a photographer, but a love affair with this management tool was to last a lifetime.

Our last major event in 1987 was coverage of the World Athletics Championships in Rome, which finished on 6th September. It was perilously close to our baby's due date, and I thought long and hard about attending: but it was such a major event for us, and I was shooting for

Sports Illustrated again, so I really needed to be there. We had a large team on the case and success here would define the future of Allsport's event coverage. I like to think that if baby had been due right in the middle of the Championships, I would have stayed at Beans' side: but if I was lucky, I could do both. I reasoned that I've always *been* lucky, so armed with an open return ticket and a promise to catch the very next flight, regardless, if there was any hint of the baby coming, I was granted permission to travel! Everyone performed to perfection, the championships went well, and Ben Johnson broke the World 100 metre record by an astonishing 1/10th of a second to take gold. Although this was an enormous story at the time, it was to be eclipsed the following year when he tested positive for drugs in Seoul and lost both medals and his world record. While things went well in Rome, they also went well at home. Beans did her bit by keeping baby's arrival on schedule, I photographed the last day's events and jumped a plane, arriving home just a couple of days before the birth of our beautiful daughter, Lucie Elizabeth May.

There is a postscript story to the birth of our daughter. Three weeks later, I flew into Los Angeles to meet with Tony and discuss my plans for the next year, a big one for Allsport with two Olympic Games and our twentieth anniversary celebrations to deliver. I was staying just across the road from our offices in Santa Monica on the eighth floor of the Miramar Hotel on Wilshire and Third. Early the next morning, 30th September, I phoned Beans to see how she and Lucie were, when in the middle of our conversation, 7.42am to be precise, the whole hotel started to shake. Looking back, I rather foolishly said to my wife, at home with our three-week-old baby: "Hang on, I think I am in an earthquake…" as the phone line went dead.

This was my first earthquake, it was terrifying, and I probably did everything wrong. I remember looking out of a window overlooking the swimming pool that had enormous waves steadily emptying it, like a bowl of water on a swing. Then I started to worry and tried to call Beans back. It took me nearly five hours to get an international line and, with impeccable timing, I woke her in the early hours of the morning, which was probably not something a new mother would appreciate. It worried me that she might have thought she had just lost her husband and the father of her child, but when I got through and explained that I was alright, with remarkable sangfroid she just sighed, said she was glad and wished me a good night. Calm? Yes. Long suffering? Probably.

15

CONSPIRACY OF SUCCESS

I had visited Calgary about a year before the Games for a full reconnaissance of all aspects of where we would work. While I was there, I also sorted out a base for operations by renting a large house with a huge cellar and enough space to accommodate our full team of photographers and technicians. We needed flexibility to operate shifts in all areas around the clock, on a roll-out that started a week before the opening ceremony and lasted for 24 days. Awarding the Games to this Canadian city, once a western cow town famous only for its annual rodeo, but now reaping the benefits of an oil boom, was a gamble from both sides, but finally delivered what Juan Antonio Samaranch and Michael Payne had been seeking. These Games were one of the most expensive in Olympic history but made a profit for its organising committee. The final income from broadcasting rights and sponsorship deals allowed the city to build its five primary world class venues which continue to be used for their original purposes and have helped Calgary to become the centre of an elite winter sports hub. The legacy box was well and truly ticked.

Michael is generally credited with turning the Games into a financial success through his TOP programme for sponsorship, and for the coordinated marketing and television deals he negotiated globally for the benefit of the whole Olympic movement. Handling the licensing of image distribution, particularly dealing with the longer established heavyweight US networks, and those emerging integrated communication groups in other parts of the world was one of the trickier bits of his play. It was here that we started working together as he continued to create a totally new relationship between the IOC, its member nations, organising cities, sponsors and media.

It was at about the same time in the mid-1980s that media groups around the globe were grasping the potential value of archived imagery, particularly film. Michael already had his eyes on the important prize of moving images, so he initiated an IOC policy which set out to purchase seemingly every frame and clip ever broadcast at, or from, the Olympics. But how to acquire and make them work for the IOC? At the time, no-one on his team had the experience to do this, but he knew a man who did. Stewart Binns, one of Mark McCormack's key lieutenants at the International Marketing Group and an award-winning historical documentary maker, was instrumental in what followed, with the creation, after Barcelona 1992, of the Olympic Television Archive Bureau (OTAB), which took on the role of acquiring and exploiting all moving imagery. The movie archive that resulted, reputedly around 50,000 hours' worth and consolidating every moment of Olympic history, is now worth billions of dollars.

Staging the Winter Games in Calgary, Canada was a calculated gamble for the International Olympic Committee and stretched our administration working 24/7 for three weeks with athletes and sponsors. The closing ceremony was spectacular, and welcome!

Photo: Bob Martin/Allsport

Photographing at Calgary for the IOC, we were not exactly casual observers, but to those people who only read the headlines, the abiding memories were probably of Jamaica's 'cool running' bobsleigh team and the slightly comical sight of a myopic Englishman competing in the ski jumping. Neither the Jamaicans nor Eddie 'The Eagle' Edwards made it to the podium, yet both made Olympic participation real again. For us, the Games was another opportunity to pit ourselves against the best in the industry. Thanks to our newly won status with the IOC, we had no problems with accreditation, so we arrived with a full team of photographers, editors and technicians and occupied an office in the Main Press Centre (MPC). It was also the first time that Dick Scales had led our small but dedicated Sponsor Services team, independent of our media team, in support of the TOP programme.

We suspected that there would be push-back from the other agencies citing what they perceived as commercialism, with sponsor photographers being given access to what they believed to be the pure sanctum of the independent media. We went in prepared. Dick and his team had been thoroughly briefed to play it low key and not to try and prove anything at these Games, just to get in and do as much as they could for the sponsors, without upsetting the apple cart. Our goal here was to establish the principle of sponsor photographers and explain the concept of the Chinese Wall as often as we could.

Personally, I was very concerned that if the major agencies, Associated Press (AP), Agence France-Presse (AFP) and Reuters all pushed back hard, it could create a media storm to which Michael and Michele Verdier, the IOC's Media Chief, would be duty bound to respond. It would be the last thing that they would want in the middle of an Olympic Games, having to defend their approved activities against the mainstream media. I met with the local organising committee and explained it all and how it would work. The Photo Chief came onboard, stating clearly that provided our Chinese Wall remained intact and that he didn't find any of our sponsor photographers in media seats, he would be prepared to live with it.

Then I crossed my fingers and waited. We were not to be disappointed. Initially, the push-back came from all quarters, but it was disorganised, with everyone busy with their own priorities and I began to suspect that the threat that they posed didn't seem that big. After all, it was just a couple of photographers running around the Athletes' Village and the Olympic Park, never straying into a venue and by default, never occupying seats assigned to the media contingent. Trying to understand the ramifications

of what they were seeing was not high on our competition's priority list. In their estimation we were still small fry, which was exactly how I wanted it. The real prize for Allsport was the Summer Olympics later that year in Seoul. At risk was the whole contract as official photographers to the IOC, so we kept our heads down, our eyes on the prize, and just quietly went about establishing the principle.

I was still very much a working photographer and one of the less glamorous parts of my job was to be at the wheel of our rented minibus at 5am every morning ready to head out with our photographers to the Nakiska Ski Resort, one hour's drive from Calgary. Now an hour's drive might not seem much in the normal scheme of things, but in the context of photographing an Olympic winter games and multiple events each day in different venues, it was truly a logistical nightmare. To use the official media transport system would have meant at least two hours each way, so we solved the problem with our dedicated minibus. Others, however, found more exotic solutions. Germany's press corps had talked Audi into sponsoring them with a fleet of Quattro's, which were very fast and very red. In the first few days of the Games there was a book running amongst the British photographers on how long it would take for one of these to be wrecked. Sure enough, within the first week there were three bright red Audi Quattro wrecks on the highway between Calgary and Nakiska. Fortunately, to my knowledge, nobody was seriously hurt, beyond badly damaged egos.

The Calgary Winter Games were turning into the usual slog of long hours in very difficult conditions, but we were all in the same boat, so we just buckled down and got on with it. Everyone was, on average, working an eighteen-hour day, with the photographers doing multiple events in multiple venues. The editors and darkroom technicians were locked in the MPC office all day and were lucky if they got more than four hours sleep any night. On top of my photographic role, one of my main tasks at the end of each day was to assign our photographers to the following day's events, as unlike every other major press agency we did not allocate one or two individuals to each venue for the duration of the games. This would have been the easiest option, cut down on travel time and reduce the logistical complexity, but I always felt that it had a negative impact on the creativity of our coverage. If you stuck one guy in the speed skating stadium all day and all evening, day after day, creatively the mind would go numb.

Although we had a duty to be photographers of record and make sure that we had pictures of all the gold medal events, we also had a duty to

our clients and ourselves to look for the unusual and creative angles, so I chose to mix and match as much as possible every day. There were always a few specialists in the group who were keen to photograph what they considered to be *their* sport, but most of the guys wanted to photograph everything at some point. Allocating them was not a job I felt I could pass up, as anyone who took it on would be harassed mercilessly for the peachier assignments. I enjoyed it because it gave me the chance to mould our coverage. Occasionally, putting a young photographer into an unfamiliar situation or out of his comfort zone to see what would happen produced surprising results.

It was during one of these assignment sessions that I heard the IOC was getting push-back from AFP about our sponsor photographers once again. I was determined to nip it in the bud, so wandered around to their offices in the Press Centre, introduced myself to their Bureau Chief and calmly explained what, why and how the Chinese Wall operated. He didn't appear to be overly impressed and dismissed me with a classic gallic shrug until, that is, I admired his portable digital scanner sitting in one corner busily scanning and sending pictures out. He proudly explained that it was a prototype Hasselblad Dixel 2000 that they were trialling, and AFP had ordered several. Whether he knew it or not, he was doing a Ronald Reagan on me as he explained that they cost £35,000 each (£80,000 in today's money) and the digital picture desk to support it at the other end would cost over £100,000 (nearly £250,000 today). These were the toys you needed, and they *were* expensive. I made a mental note and my apologies as I left.

It was during the Calgary games that I first saw a prototype Hasselblad Dixel 2000 portable digital scanner, a piece of equipment that would change our world and how we serviced our clients forever.

Photo: courtesy of Hasselblad

The Games went well for us and, at one point, David Leah from our Mexico Office and a fluent Spanish speaker and Gray Mortimore, a Canadian by birth, somehow found themselves invited into the IOC President's private box to watch a firework display. Here they sat happily chatting away with President Samaranch and his wife like old friends and I didn't question how this had come about but guessed that we had truly been accepted into the inner circle. Our media team worked diligently, with no massive breakthrough, just dogged persistence, our Chinese Wall held firm, and our Sponsor Services team kept us out of the firing line; managing to avoid any major challenges to our IOC status because of our sponsor photographers. We didn't have the huge financial resources of the state sponsored agencies like AFP, but like any competition, the team that dug deepest into their physical and mental reserves invariably came out on top. I always suspected that initially we all suffered a little from underdog syndrome and desperately needed to prove ourselves, so the Allsport guys just dug a little deeper and we delivered.

Back in London, one of my first priorities was to see how our book project was taking shape. I found our production team in full swing under the creative leadership of Mary Hamlyn, our newly appointed designer. Working with two of our best picture editors, Robert McMahon and Darrell Ingham, she had roughed out the basis of a great book that would feature all the most famous and instantly recognisable images shot by our photographers during the previous two decades. Working on the project since the previous September, our efforts were clearly paying off with a publisher in Pelham Books, a sponsor in Crosfield Electronics, a charity to support in SportAid '88, and a major exhibition planned at the National Theatre on London's South Bank. Ours was to be the first such exhibition ever hosted there and after a run of seven weeks in London it was to go on a national tour.

We then started an in-house-driven publicity campaign designed to tell the Tony Duffy/Bob Beamon story, how from this one glorious moment and one great picture, the Allsport Photographic Agency had been born, twenty years before. The message was surprisingly simple. We had the pedigree and our Agency's history was inextricably entwined with one of the greatest records in Olympic history that still stands today. We started blitzing the photographic press, then all the specialist sports magazines, then general magazines and newspapers, and the story, our story, appeared everywhere. It was direct and inspirational. If Tony Duffy, an accountant on holiday, could become a famous sports photographer

based on one glorious moment, there was opportunity out there for everyone. Even today, if you Google 'Tony Duffy/Bob Beamon', that story is still all over the Internet. Then we set about approaching some of the greatest names in sports journalism to contribute short essays to appear alongside the photographs in the book. The take-up was astonishing, and I like to think of it as a testimony to the growing reputation of Allsport and its photographers. The *Daily Mail's* Ian Wooldridge, probably the most highly regarded sports journalist of his era, wrote the main introduction and it bears repeating here.

> *"In the genial argot of sports journalism, photographers are known as smudgers and reporters are called blunts. For obvious reasons, blunts are frequently reluctant to go overboard in praise of smudgers. It is a question of space: a dynamic picture used boldly across a newspaper page inevitably restricts the wordage available to the writer working in tandem. He is also conscious of a challengeable axiom: one stunning photograph can generate more impact than 1,000 chiselled words. Just try describing 10 horses mid-air over Becher's Brook.*
>
> *"For years that tended to be more true of war and news reporting than sport. Specialist sports photographers were rare. More often than not the old office lag was packed off to squat at the dead ball line with an even chance of snapping the winning goal. That changed dramatically a couple of decades ago. A new breed of sports photographers emerged. High marks for technical merit were taken for granted. The battle was for the highest marks for artistic impression. The winning goal became yesterday's cliché.*
>
> *"How, now, to convey speed, pain, anguish, elation, even death with startling originality. It was a whole new lens game demanding imagination, foresight, much planning and a deep knowledge of sport. A handful of high-performance photographers soared out from the pack. Among them the founders of Allsport.*
>
> *"The huge business gamble they took 20 years ago was justified for a very simple down-toward-earth reason: they never saw artistry as a substitute for backbreaking workload. Allsport men ran. They humped more gear than a commando. They worked around the clock.*
>
> *"In two decades, their agency has become one of the most prolific and preeminent in the world. As a blunt, I am delighted to celebrate their success in a volume containing so much of their hallmark work. If they did not invent the new wave, they have contributed vitally to it, as so many of these pictures will confirm.*

"Unlike blunts, super-smudgers rarely get a second chance. It is a split-second business and split-second pictorial triumphs come not by luck but by strategy. Their vast library is a treasure house of examples.

"Sport as well as pictorial journalism has reaped a rich reward from Allsport's pursuit of excellence. I recall as a child being drawn to sport, and later sports writing, by a single photograph. It was a black and white panoramic view of a packed Sydney cricket ground transfixed by one of the body line test matches and was the wrap around dust jacket on Sir Pelham Warner's book of cricket. It conveyed heat, tension and high drama and inspired a schoolboy to become part of that thrilling world, albeit in a low bluntish role.

"That picture was taken 56 years ago and literally transformed one human life. By the same process I suspect Allsport may have changed more lives than they will ever know."

We attracted ten further top sports journalists who all wrote a short essay on their favourite athlete. Patrick Collins (*Mail on Sunday*) on Seb Coe; Dudley Doust (*The Sunday Times*) on Jack Nicklaus; freelancer, Peter Hayter, on Ian Botham; John Hennessy (*The Times*) on Torvill and Dean; Ken Jones (*The Independent*) on Kenny Dalglish; Harry Mullen (*Boxing News*) on Muhammad Ali; John Roberts (*The Independent*) on Martina Navratilova; John Rodda (*The Guardian*) on Bob Beamon; Neil Wilson (*The Independent*) on Daley Thompson and Paul Zimmerman (*Sports Illustrated*) on Walter Payton. With that line-up, good press coverage was almost guaranteed when the book was launched.

With the guts of the publication resolved and in place, we began working on how best to stage the exhibition. The plan was to turn the National Theatre's main foyer and walls into an Olympic arena using huge hanging drapes printed with a soft-focus shot of a stadium full of crowds; then we would mount our images, all framed and signed by the relevant photographer, as limited-edition prints, with no more than 25 of each. These would be available for sale throughout the exhibition and the tour, with all proceeds going to SportAid '88. They were to be printed on Cibachrome paper which came with a claimed lifetime of 30 years before any colour fading might become visible, something that at the time, no other colour printing process could claim. I can verify that claim, as now, 33 years later, I still have four of my favourite photos from the exhibition on the wall of my gym and the colour is as good today as it was on the day they were printed.

Growth in our business needed constant exposure. Winning photography competitions was good publicity, but to celebrate the first twenty years of Allsport, we brought together all our best work and launched it in a book. Visions of Sport was presented to the press and clients at a very good party in London's National Theatre and gave us more momentum.

Photo: Allsport Archive

Visions of Sport: Celebrating Twenty Years of Allsport, The International Sports Picture Agency launched to much acclaim in early June. The audience included a reviewer from every National newspaper, most of the sporting journalists in the country, the BBC, and representatives from many overseas newspapers, prompted to attend by our agents in their territories. We had also called in other favours and had asked some big-name sports stars to attend. Daley Thompson rubbed shoulders with Sharron Davies, Suzanne Dando, Duncan Goodhew and David Gower, an all-British galaxy of stars, which gave all the 'blunts' plenty to write about. The first review I saw was in the *Sunday Times*. The reviewer described us as "The legendary agency, Allsport". Job done, I thought. I'd set out to create a story from a myth, which swiftly became a legend, and we'd done it. However, my hubris was short-lived as the same reviewer in the Monday edition of *The Times* described us as "The near-legendary agency, Allsport". He probably had second thoughts after recovering from his hangover.

We made two other major commitments that year, both were to take Allsport right to the edge of disaster and both were to be pivotal to our eventual success.

From the moment in 1983 when Tony and I had agreed that to defuse some of our more spirited clashes on how to drive the business forward, he would move to California to establish Allsport USA, I had rather left it up to him as the man in the territory to make the plays. His target was to establish a bigger presence for us in what is probably the most varied and sports-conscious nation on the planet, think baseball, basketball, gridiron, ice hockey and athletics, and give us a stable commercial base with room for expansion as opportunities arose. I still don't know quite what I was expecting from Allsport USA. Perhaps I hoped that Tony's love of sport at all levels, particularly track and field, would occupy most of his time and keep him busy and my brother Mike's move across from the UK to the USA in 1985 was designed to help the agency there to spread its wings. They would shoot stateside and supply all their material to us in London to market and distribute worldwide.

I had always been quite open to growth by acquisition, and we had been considering options in Europe, so I suppose that I shouldn't have been surprised when in early 1988, Tony suggested that we could enhance our reputation and gain acceptance among the American press by buying an existing American agency. Based in San Diego, Focus West had been founded by Don Wiener and Ron Haase and had steadily built up an enviable national network of contributing photographers over the years. What made it doubly attractive was its reputation for quality and service, so it appeared to be a good fit. So too was the creative fit, bringing our strong Olympic and international sports bias alongside its specialisation, which majored more on American professional sports. The proposition had considerable merit, if handled well. On pure economic grounds we had not been selling enough of our Olympic and international based sports material in the US to justify an office set up so Allsport USA relied for financial support on UK and overseas sales. It was an acceptable situation provided we maintained a small staff and low overheads, but any expansion would need a significant increase in US sales; something that was unlikely to happen without entering the US domestic sport market. Tony's proposal would be a shortcut. I agreed, Tony went ahead negotiating terms and the two agencies merged in April 1988 as the first major commitment.

All appeared good on the face of it, but looking back, what let us down was that having merged into what was intended to create the

largest and most comprehensive sports picture agency in the USA, Tony persuaded us to keep both agencies trading out of their current offices; us in Santa Monica and them further down the coast in San Diego, retaining the Focus West name as well. Once again, his reasons were cost driven, as integrating the two offices would require a new building and an expensive new lease. I wasn't sure I agreed with him, but he was the man on the spot, and he had been very supportive of all my ideas, so I felt I had to go along with him. Besides, I had quite a lot of other fish to fry, but this would later prove to be a huge and costly mistake that would change my life significantly.

The second commitment came from an unsurprising direction; my enthusiasm for technology. On returning from Calgary, I immediately contacted Hasselblad and asked to see a demonstration of their Hasselblad Dixel 2000 scanner/transmitter. They obliged and sent a scanner and technician over to put it through its paces for us. Having seen it in action in the AFP office in the heat of the Olympics, I needed little convincing and was already sold so I immediately ordered two, provided we could take delivery before the Seoul Olympics four months away. A bit of a challenge for them, as the one I had seen was a prototype, but I also placed an order for their first fully digital Picture Desk. Still in development, I was promised a Beta version in early 1989 and I was determined to be the first agency to go fully digital on image transmitting.

Having just made a commitment to buy approximately £170,000 worth of equipment (well over £500,000 today) I needed an urgent meeting with our friendly NatWest bank manager. Armed with my treasured and trusty spreadsheets, I explained how this investment was going to transform our business and the industry. Fortunately, we had developed an excellent track record with our bank, whose managers at ever escalating levels of seniority matched our increased borrowing requirements. They always seemed to get very excited when I approached them for money. I always played up the glamorous world of sports photography and the cyclical nature of the revenues from the Olympics, which I guess made a change from funding low margin widget manufacturers. Based on our track record and the value of our asset base, for the first time I managed to agree the terms of the loan without putting our houses on the line, which I thought was quite a vote of confidence. Our two Dixel 2000s arrived two weeks before we departed for Seoul and we would be way ahead of the opposition. This, as it turned out, was the problem. I was to find out later the dangers of being too far ahead of the curve.

There was to be nothing low key about our coverage of the Seoul Olympics. Dick Scales and I had visited a year before to present our proposals for managing the TOP sponsors' needs and in an audience that included IOC President Juan Antonio Samaranch, Michael Payne and senior representatives of all the sponsors, we were able to demonstrate the creative viability of the TOP programme with material that we had harvested from Calgary. Seoul was also the first real opportunity for Dick and his team to help move us on from what he had uncompromisingly, but correctly, described as a mess in Calgary, to a much more polished delivery. This started by occupying a prime working space in the MPC, relocated from a small office on the third floor to a big office on the ground floor, and next to Kodak, probably the highest profile spot in the media working area.

In our coverage of the 1988 Calgary Games, Dick had been responsible solely for sponsor liaison, identifying shooting schedules and handling all the detail work to keep our sponsor clientele content. When we got back, and after recognising his experience in coverage of major events, I broadened his remit. Now he was to be responsible for the logistics and planning for getting our much-enlarged team to Seoul with the tonnes of equipment we would need to build a complete production office from scratch in the MPC. One of his bigger coups was in shipping the one tonne E6 photo-processor into and out of South Korea at no cost to us. Our team arrived in Seoul five days before the Opening Ceremony and immediately set about building our office. Alongside the traditional processing, editing, duplicating, mounting and distribution departments, for the first time we had a digital department. Tiny by later standards, consisting of our two Hasselblad machines and associated telephone lines, for the first time we would transmit 'live' colour photos from an Olympic Games.

After processing the original transparency film and editing out the best frames, each transparency would be painstakingly digitally scanned using our Dixel 2000s, then transmitted in analogue format over regular telephone lines into our London office. Once there, an analogue receiver was linked to a black and white printer. Using multiple banks of 9600 baud modems, which compared with today's technology is very slow, we scanned each colour image as a three-colour separation. Each separation took on average 20 minutes to transmit, always providing there was no noise on the line. If there was, the entire transmission process had to be re-run. The downside was obvious, because although at this point the scanning was digital, the analogue transmission was achingly slow by

comparison, as there were still no receivers capable of taking our digital output. When the three separations were finally brought together at the receiving point and re-photographed, the product was a full colour image. Then it was innovative and cutting edge, but still a long way from high-speed digital image transmission that was our real goal. Looking back and in the face of today's advances, it seems remarkable that we managed to get pictures out at all, but at the time, we were state of the art and the talk of the MPC. We had flooded the media centre with copies of *Visions of Sport* and it was received well by most, but we had changed the goal posts once again, as AFP, AP, Reuters and the rest looked on. Photo agencies were now expected to create art books!

It led to an amusing moment. Travelling in one of the media buses, two AP photographers sitting behind me were unaware that I was there as they discussed the book: "What do you think of the Allsport Book?" "A bit flashy!" "Yes I agree; do you think they're hiring?"

By the time of the 1988 Seoul Olympics, we fielded a large team of photographers, technicians, and sponsor handlers to deliver our work. Now we had two Hasselblad Dixel 2000s, seen here in full operation (top left), run here by Steve Rose, our Digital Picture Desk Manager.

Photo: Allsport Archive

After the Calgary Games, and on the back of Allsport's role as official photographer to the IOC, they had asked me to sit on the 27-member Press Commission (IOCPC) as its photographic representative. This was made up of experts in the fields of Olympic sports journalism and photography, plus representatives from the IOC, International Federations, National Olympic Committees, the International Paralympic Committee and the IOC Athletes' Commission. Its aim was simply to ensure optimal working conditions for all representatives of the photographic and written press at the Summer and Winter Olympic Games. Our experiences in Calgary had made me realise that expecting anyone to deliver their best results with anything less than the best working conditions was asking too much. I came to the Commission with practical experience and still bearing the scars. Collectively we had the responsibility for advising the IOC and organising committees on the provision of working conditions, and to regularly review what facilities and services those local organisers were proposing to provide.

During my term on the Commission, our Chairman was the quietly spoken, but ruthlessly effective, Australian, Kevan Gosper, and it would be difficult to imagine anyone better suited. The ex-Chairman of Shell Australia, he had been involved in the Olympic movement since Melbourne 1956, when he ran the anchor leg for the Australian 4x400 relay team, winning a silver medal. When he spoke, people listened. "I believe that an open and free press, properly equipped and supported at Games time, is a very important element of a successful Games", was a mantra that we could all buy into.

Many people remember Seoul for the rather unfortunate episode when the doves of peace were given their liberty at precisely the same moment and in the same air space as the cauldron housing the Olympic flame was ignited. Unfortunate results, inevitably captured on film by our snappers and gleefully distributed around the world, which despite our official photographer status, underlined our editorial independence. The first of many occasions when our friends in the IOC were left wondering whose side we were on, though they accepted it with good grace.

Seoul '88 was absolutely our breakthrough moment, after which all the major agencies knew exactly who we were. They could no longer give us a Gallic shrug and dismiss us as unimportant. Now this small, annoying sports agency was no longer the underdog, but was serious competition. This was also the moment when I first experienced what I liked to refer to afterwards as the conspiracy of success. Put simply, once you break through the glass ceiling or dismember the status quo, or

however else you care to describe it, life really does get easier. We were no longer selling in; we *were* in. Part of the inner circle, dinners with the chairmen and CEOs of major public corporations, and guaranteed appointments with senior executives amongst the world's biggest players. In this rarefied world of senior corporate executives, we might still have been regarded by some as just a bunch of photographers, but that was missing the point. Now we came with a brand label. We were the 'Official Photographers to the International Olympic Committee', one of the most immediately recognisable and respected brands in the world; and that opened doors and commanded respect.

16

DISASTER AND TRIUMPH

I t was in the Spring of 1989 that I was brought face to face with an event that put the agency in the national spotlight and made me stop to consider the responsibilities that came with the job of photographing sporting events when things go wrong. April 15th was a glorious sunny Saturday. I was in the office catching up on reports and preparing for a projected trip to Los Angeles to talk about the issues that had flowed from our acquisition of Focus West. As usual, the London office was manned in what was a quiet weekend for international sport, but we had photographers out covering League Football and the World Snooker Championships in Sheffield. Coincidentally, also in Sheffield that day was our photographer, David Cannon, covering the FA Cup semi-final between Liverpool and Sheffield Wednesday at their Hillsborough Stadium.

Just after the 3pm kick-off, Steve Rose who was managing our newly installed Hasselblad digital picture desk came into my office and told me there was something going on at Hillsborough. I followed him back and together we watched the disaster unfold on one of the television sets above his desk. The BBC coverage had gone into wide-angle stadium shots which appeared to be their default policy whenever there was crowd trouble, and the commentary team were obviously struggling to identify and report on what was happening. Steve reminded me that David was there, and I remember thinking, poor guy, I hope he's OK. He had been shooting at the Heysel Stadium less than four years before and seen first-hand the fatal effects of a human stampede; this had inevitably left its mark. All we and the BBC audience could see was a crowd in the distance

with extremely limited information coming from the commentators. As we watched the images it became clear that there was a major disaster developing in front of us and my feelings escalated from curiosity, through concern, to anger. It was not as if the Football Association hadn't been warned about the potential for a disaster like this. Ever since the Bradford City stadium fire that killed 56 spectators four years before and Heysel with its 39 fatalities, there had been numerous incidents, reports and recommendations about the risks associated with caging fans like animals. All responses had been fudged, promises ignored, lessons left un-learned, and football just carried on gaily as before.

Around 20 minutes before the scheduled kick-off, David realised that all was not well. Waiting in the tunnel area, he overheard a conversation between the FA's Media Manager, Glen Kirton, a Sheffield Wednesday stadium official and a senior police officer. David had got to know Kirton really well from covering England trips and various finals and during the conversation he heard him offering to have the kick-off delayed because of crowd congestion outside the stadium. The police advice was that this was not thought necessary. As the start time approached, David set up his camera in a position behind the goal line at the Leppings Lane end, where he had always planned to be, to get the best light, just six feet in front of the cage containing Liverpool fans. Aware of a problem in the crowd even before the game began, he had begun to photograph it, but when the match got under way, there was a huge surge which increased further when Liverpool came close to scoring.

It was at that point that David pointed out to the nearest police officer what was happening, finally shouting at him to stop the game. Minutes ticked by with no action. David got more frustrated and finally, six minutes into the game, he physically manhandled the officer on to the field of play screaming: "You must stop the game!" At that point, the referee finally halted the match and David continued to do his job. After about 15 minutes he decided there was nothing he could do to help and left the stadium, but ever the professional, he knew his duty was to get the film back to the office. Finding his own car blocked in, he flagged down a passing car and talked the driver into giving him a lift to the Crucible where he knew Pascal Rondeau was photographing the World Snooker Championships. Pascal abandoned his coverage and immediately returned to London with the film, David called me and explained the situation, warning me that there would be images of fatalities amongst the fans. Eventually recovering his car, he drove to his parent's home in Leicester.

From that call I knew now that we had three rolls of film containing potentially explosive images about three hours away, so I called in extra darkroom and picture desk staff and briefed them. Everyone was obviously stressed and a little shocked by the situation, but I explained what was happening and that after processing, all the film would come directly to me, without review. I explained that I would edit the film and the decision and responsibility for all images released would be mine and mine alone. At this point I still had no idea of the extent of the disaster that was unfolding, as the BBC's coverage remained vague.

When I finally got to see them, the images were every bit as horrific as David had suggested they would be, so I was well aware that they were likely to cause distress amongst the families of the bereaved and injured, if and when they were published. I thought that we had no option but to distribute them, but this was absolutely nothing to do with commercial reward and everything to do with what I believed was a greater duty; to reveal the truth. All my history and training as a photojournalist told me that nothing was going to change unless people really saw the truth of what had happened at Hillsborough. The BBC's coverage hadn't shown it, so I selected about a dozen images, certainly not the worst, but to be honest it was a difficult edit.

The lifeless faces of those young football supporters pressed against the wire cages that I was peering at through the magnifying loop haunt me still, as I know they do David, but I released my selected images to the national newspapers and waited. If I had made the wrong call, I was certain in the knowledge that senior editors would just sit on them, but they didn't. The next morning every Sunday newspaper in the land ran those pictures all over their front pages. For football and its administrators, the game was up, and they couldn't ignore this.

Initially, there was a lot of anger directed towards us, both from the public and the authorities. David received a serious death threat from a Liverpool fan, after the *Daily Mirror* had published his name, which was beyond our control, and bizarrely, it was we who were being accused of bringing the game into disrepute. Had this happened today it would have inspired a huge and ill-informed twitter storm, no doubt causing big problems for David, myself and Allsport, but things were more balanced then. People understood that when society has a problem, there is no point in shooting the messenger; he's just trying to tell you something that you probably need to know. As we know now, football changed from that fateful day, and for the better. The government, the FA and the

football authorities finally put in motion plans to remove the fences and bring in the entirely safer all-seater stadia that ensured the safety of the fans who are, after all, the backbone of 'the beautiful game'. I lay no claim that it was because of those haunting images, but they certainly played their part in reminding people of the price paid when the authorities had effectively ignored all the warning signs for years.

Since that day in April 1989, David has attended and given evidence at all the inquests and enquires. On each occasion, he has been assured by the presiding judge that it was recognised that he was a professional doing his job and that he probably played a significant role in finally getting the police to force the abandonment of the match. David was Allsport's main football photographer, but from that day, he struggled to cover club football at even remotely near the levels he had been used to. Without his professionalism and the ethics of releasing the pictures into the public domain, I am convinced that the football authorities would have fudged the findings of the subsequent inquiries, skated over reports of 96 fatalities and over 700 injuries, and continued with the meaningless mantra that 'lessons would be learned'. The football authorities and football could no longer ignore their failings. For David, football's loss has been another sport's gain, as he has become the most highly regarded and respected photographer of golf in the world today.

———◆———

At an entirely different level and just in case I thought that running Allsport and taking photographs was my entire existence, I had a sharp reminder that I had a personal life outside the office, which was throwing me some curveballs that needed dealing with immediately. Thanks to a change in the law on mortgage relief that Chancellor of the Exchequer, Nigel Lawson, had introduced in his April 1988 budget, we and what seemed like everyone else, had gone on a giant spending spree. The UK housing market was booming and August 1988 was the cut-off for exchanging contracts, or significant mortgage relief would be lost. Well, we *were* planning to up-size and had just exchanged contracts on a six-bedroom Victorian property ripe for improvement in an area of Streatham that was allegedly on the cusp of being gentrified. We moved in during October, shortly after my return from Seoul and, between all my other jobs, I got down to planning the improvement works. I did all the right things: appointed an architect, got planning permission and put the job out to tender amongst local builders, so everything was in place when

our contractors began work in early 1989. We had planned to knock the back of the house down, but every room needed work, as did the roof, so the plan was for us to move around the house keeping one step ahead of the building work.

With all my plans in place for what I believed would be a seamless transition from dated to modern, I continued with my regular jet-setting life. A skiing event here, an assignment there, but every time I came home, Beans and Lucie were camping out in a different room and the works just got messier. In the middle of it all Beans gave me the glorious news that she was pregnant again, with the baby due in September. We were obviously delighted, but I could see that things were swiftly sliding out of control. Building works were not progressing to plan, and life was getting very difficult for Beans with our 18-month-old living on a building site. I expressed my thoughts and disappointment in no uncertain terms to the architect and builder and promptly left for a two-week trip to Los Angeles to meet Tony, to address some of the growing problems he faced in getting the Allsport and Focus West offices to work together.

On my return in early May, I walked into a disaster area. A heavily pregnant Beans and little Lucie were by now living in the attic room with a microwave oven, while the rest of this large Victorian house resembled a war zone! It is easy to get obsessed with work and commitments to others, but sometimes you have to take stock. It's not as if Beans hadn't been warning me of the problems. She had, but as usual, she'd tried to make the best of it and shield me from the worst. I was seriously angry with myself as I'd let my family down and with another baby on the way, things were only likely to get worse. Desperate times call for desperate measures. I fired both the architect and builders and decided that the only realistic option open to me was to project manage the job myself. I went into the office the next day and told Adrian and Lee that I was going to be busy for the next few months and they should just carry on. And they did, which was one great advantage of having a management team used to seeing their boss swanning around the world and rarely there. It wasn't a situation Tony would have been happy with, but it was very much my goal since the beginning.

Perhaps benefitting from my father's genes – he had studied to be an architect after all - I set about the building works by hiring bricklayers, plasterers, electricians, plumbers and other skills straight from the unemployment queues on the basis of as and when needed. We vacated the building site to stay with friends nearby and every day,

I would work alongside whichever trade was active at the time. I had a splendid summer, learning how to be a builder! Probably our biggest challenge was positioning and securing a 24-foot (7 metre) beam across the rear of the ground floor, with a total lack of access and without the use of a crane. No small task, but we tackled new challenges as they arose, and slowly, it all came together. I'd always prided myself on being a Jack-of-all-trades kind of guy, but that summer I realised that the trick was not knowing all the answers, just knowing the questions to ask. I guess I had been doing this throughout my life, but when faced with very specific problems beyond your own life experience, you soon recognise the need to ask the right questions of the right people. Later, as the issues facing Allsport became more complex, I needed to become part lawyer, part banker, part negotiator and specialist in other disciplines, so I'd draw on this experience. Received wisdom suggests that a little knowledge can be a dangerous thing, but I worked on the basis that a little knowledge was essential to find the questions that would lead to the right answers, and this approach has served me well ever since.

We were putting the final touches to our new kitchen when Beans went into labour and, nine hours later, we had another beautiful baby girl; Sophie Victoria Ann. Five months later, *House Beautiful* magazine used a

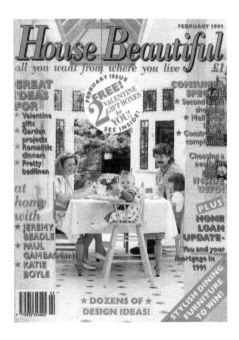

Even in the heat of business battle I found time to first project manage and then run the major 18-month conversion of our new London home. Must have done something right, as House Beautiful magazine ran a feature and family Powell shared their cover with Jeremy Beadle, Paul Gambaccini and Katie Boyle.

Photo: courtesy of House Beautiful

picture of our house on their front cover with a further eight pages inside and it featured on posters all over the London Underground.

My sabbatical over, I had to concentrate once again on Allsport and its commercial and management development. Once Dick Scales had cleared up all the issues after the Seoul Games, I had asked him to take a serious look at our corporate structure, or lack of it, particularly the challenges we faced with a growing and more complex company operation. By now we had photographers flying all over the world, independently covering their own sports, making their own marketing decisions within their sport sector and developing multiple routes to market, which often created conflicts. We also had a burgeoning support structure and all this needed prioritising and guiding. My six-month enforced absence from the front line hadn't helped, so all these challenges needed identifying and describing, as without really understanding the issues, it was going to be difficult to make improvements. Even so, I could see that things had to change. Senior people in our management team like Adrian Murrell and David Cannon were now shouldering the demands, not just of their fulltime photographic careers, but of managing aspects of our business too. While we still expected them and all our team members to be responsible for their own bottom lines, the work ratio was all wrong and we needed to bring together much better management practices to support them.

Dick set about the task of implementing these with his usual efficiency and identified every role in the company and where everyone fitted into the corporate structure. He then compared what we had with what he had seen during his time at the BBC and Adidas. Clearly there was no comparison between the size of Allsport and those mighty organisations, but, by comparing roles, he could come up with a credible structure that we could all buy into. He identified all the responsibilities that came with each role, including my own, and when I returned to work, his plan gave me the ideal working tool to revisit everything we were doing. A review of our routes to market showed we were doing well in our traditional areas of stock photo sales, through library enquiries, into our book and magazine markets. Assignments with major magazines such as *Sports Illustrated, Time-Life, L'Equipe, The Sunday Times Magazine, You, Observer,* and *Sunday* all continued at pace, with the added benefit of thousands of paid-for images being added to our archive daily. Reassuringly, whereas previously it had just been Tony or I who benefitted from commissions from those and other titles, now all our named photographers were accepted and were regularly working for them.

This happy state can be attributed almost exclusively to our earlier decision always to byline each photographer's work and insist that when pictures were published, the photographer byline was printed right next to the photo, along with Allsport. Unlike other major agencies, who only wanted to see their agency credited, we were bucking the trend and creating celebrity photographers with individual reputations. As their exposure and fame increased, the biggest risk to us was of them being poached, but the risk was worth it, purely in billable assignment work. I also relied on the fact that because our photographers had such a major say in how they worked and what they worked on, why would they risk working somewhere else? In effect, they enjoyed a risk-free environment with all the freedoms of an independent freelancer, working with a full agency support structure and paid as staff.

It was this structure which had led to the success of our oldest route to market, the individual relationships within specialist sports. If the Allsport agency could be likened to the broad-based platform that underpinned everything, the individual sports silos provided its bread and butter; the lucrative money maker, the beating heart of the operation. Each sport was fronted by at least one well-known photographer who had all the knowledge, friendships and contacts. This firmly embedded one of our team in each sport who could regularly get stories published globally, often in non-specialist magazines, which to the sport and its organising bodies, was pure gold. Organisers had always relied upon pictures in their own sport-specific press, be it *Athletics Weekly, Tennis Today, Shoot Magazine, Motorsport Magazine, Golf World* or whichever, but now they started seeing their sport regularly featuring more widely. From men's and women's magazines, kid's comics, Sunday supplements and foreign language magazines all over the world, this led directly to more lucrative contracts with their sponsors. Individual freelance sports photographers with key relationships, underpinned by the Allsport platform, was clearly a winning formula.

However, the area in which we were struggling was the most recent addition to our client base, the newspaper market. It wasn't that we weren't making money from papers. We were, but the cost of servicing the market was rising uncontrollably. We had invested hugely in technology aimed almost exclusively at newspapers, but we were a long way ahead of the curve and desperately needed them to keep pace with us. Transmitting images into our offices, printing them out as 3-colour separations and then biking them around to each newsroom was a long and costly operation, and deeply frustrating as we knew that we could do it better,

if only our clients bought in to our technology. Equally frustrating was the cost in time and effort of supporting our 5-drawer filing cabinet archive resource in every newsroom by having to monitor every paper, every day, for usage before calling them up to agree fees. Apart from persuading the papers to upgrade their technology, a process that made the unions deeply suspicious of potential changes in working practices, we needed to devise a way of being paid which avoided the hassle of invoicing on a per-picture basis.

There was no quick solution to the technology issue. We now had our own Hasselblad digital picture desk installed with high-speed ISDN digital phone lines and this reduced the transmission times from our photographers to our office to a blisteringly quick 5 minute 40 seconds for each full colour image. However, the final link in the chain still relied upon a man on a motorcycle or, for the more technically advanced newspapers, transmitting to them at analogue speeds which delivered closer to one image per hour. For our big investment to work, the newspapers needed to invest in expensive proprietary digital picture desks. At that point, they saw no overriding need for it as they had their traditional systems, which, although slow, still produced the results. We would have to wait until something changed to make the investment imperative to their core business.

The picture pricing issue had a simpler solution. We had to show our clients that we could deliver a serious 'live' service before we could press them to subscribe to our platform, and we had several opportunities to demonstrate what we could do. The Commonwealth Games in Auckland, the American Super Bowl and the biggest opportunity of all, the England vs. West Indies cricket tour, followed by the World Cup in Italy in the summer of 1990, would give us the opportunities we needed. All the papers were used to the idea of subscription-based agreements because that was how they already dealt with the larger traditional news agencies like AP and Reuters, so we agreed that the right moment to approach them was immediately after the World Cup when we had proved our point.

Allsport had been growing rapidly, predominately shooting on colour transparency stock for high-end magazines and book usage, together with our increasingly important work for sponsors. In these areas, there was no real-time rush or urgency and, although we had entered the newspaper market with our filing cabinets full of stock images, apart from some events, effectively test events such as Seoul, we had not really entered the highly lucrative market of live picture coverage for the papers. It was an

extremely competitive sector and would bring us into direct head-to-head competition with the established major news agencies.

The biggest challenge we faced at the outset was a basic decision for the agency. Our reputation came from the delivery of high-quality colour positive transparencies, based around our core business of high-end colour magazines, book publishing and sponsors. The newspaper picture market was a whole new ball game. It required colour images on deadlines and in the case of the West Indies test series, very tight deadlines indeed because of the time difference. It would be impossible for Adrian Murrell to shoot on his traditional Fujichrome transparency stock and get it processed quickly enough to meet the London deadline so he would have to shoot colour negative film, easier and quicker to process in the field; but a complete shift away from our traditional business.

The decision on whether Allsport should enter this market in addition to the regular high-end work caused much debate, and a little angst throughout the company on two counts. First, it would need a massive shift away from transparency film to colour negative for transmission: could we balance the two core aims? The secondary consideration was the vast cost to the agency of the Hasselblad colour transmitters and setting up a 24/7 picture desk, for what at the time was still for us an unproven market. The risk, of course, was that in chasing the newspaper 'live' market, the quality of our coverage might decline and affect our other established markets. It had been a debate that had been raging at all levels in the agency without being properly resolved, since I had taken the unilateral decision to invest in the Hasselblad picture desk and transmitters.

It had been the Italian photographer, Franco Riciardi, who had introduced David Cannon and Tony Graham to the concept of shooting in colour negative from which to make a positive duplicate transparency. He had been developing the technique to overcome the terrible lighting of Milan's San Siro stadium. His experimentation had led to very high-quality positives and once he had demonstrated the technique, it instantly changed the approach to shooting football under floodlights. John Gichigi managed our darkroom and I had tasked him with looking into the possibilities for duplicating from colour negative into colour positive. He reported back that it was possible, but it would challenge us. It would require our best technicians to be retrained, mainly because adjusting contrast and colour balance was more difficult without a positive original to compare with, particularly in the quantities we normally produced. It would be expensive, time-consuming but definitely do-able, and he

reported that there was a silver lining. Results from using colour negative and then duplicating to positive, especially from images shot in indoor arenas or general poor light, were game changing, giving almost studio like results from a night football game.

So, the decision was taken. Adrian embarked on what became an arduous and often unglamorous working tour in pursuit of the infamous 1990 England West Indies test series, tasked with providing a daily live service using colour negative film as his primary medium. It was to be our first proper live service to the UK newspaper market and incidentally, the first time Sky TV broadcast live from the West Indies. David Hill, the legendary brains behind Kerry Packer and Channel 9's revolutionary cricket coverage, is often quoted as saying it was immensely difficult working in the West Indies and proved his greatest challenge in sports television production. We all knew that when Adrian set off with our deputy darkroom manager, Ian Down, it was going to be tough and white sandy beaches and rum punches probably wouldn't feature very highly. Just trying to work and get things done in the West Indies was difficult at the best of times, but now with very tight deadlines to meet, it could be almost impossible.

The contrast between Adrian's equipment needs for live coverage as opposed to our traditional coverage of a cricket tour was extraordinary. In addition to his heavy camera bag, an enormous Nikon 600mm lens and several hundred rolls of film carried in a tennis racket bag as hand baggage, plus luggage for three months away, Ian carried £35,000's worth of expensive transmitter and all the paraphernalia that went with it. Our intrepid duo also carried a vast quantity of processing chemicals as we were uncertain of what facilities for colour processing might be available in laboratories throughout the islands. Adrian remembers checking in at Heathrow with a huge, reinforced case weighing over 80 kilos, which was carrying dangerous inflammable chemicals. This greatly exceeded the baggage limit for someone flying Economy Class and I am certain that today, he would be arrested as a terrorist. As every Allsport photographer worth his salt did, he smiled sweetly at the lady at check-in and got away with no charge for his excess baggage. Impossible today, but times have changed.

Once in Barbados, they established a basecamp and split up all the chemicals to allow for easier transportation on small planes between the islands. The first Test was in Jamaica and only having had the equipment for a short time and learning all the while, Bob Martin flew in to help with on-the-job training for Ian. Bob is rightly credited as not only one

of the best sports photographers in the world today, but probably the best technical photographer, so his help was invaluable. Ian was to be the technician for the entire tour and would process the colour negative film in various hotel bathrooms and then wire the images from the Hasselblad whilst Adrian continued shooting during play. They were up against incredibly tight deadlines as play started some hours behind the UK and phone lines were not the most reliable throughout the West Indies. Using traditional equipment often resulted in interrupted transmissions requiring a restart, but with our now end-to-end digital system, when the line quality inevitably deteriorated, the system would just pause and wait for it to improve, before resuming transmission. This was a huge improvement in time and we could now fairly spit out colour images. Using multiple analogue lines and modems for re-transmission,

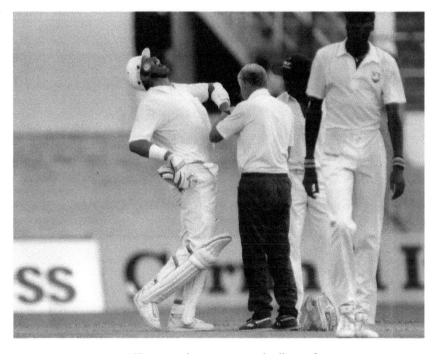

To service the more urgent deadlines of our growing newspaper market, we chose to shoot some sports in colour negative rather than transparency. Adrian Murrell proved the logic of the decision with his stunning coverage of the 1990 England v West Indies test series which included England captain, Graham Gooch, hopping in the air after his hand had been broken by Ezra Mosely.

Photo: Adrian Murrell/Allsport

we could move images to our newspapers before their daily deadline which, because of the time difference between the West Indies and the UK, had previously never been possible.

Throughout that tour we worked on assignment for *Today*, *Sun*, *Guardian* and the *Observer*, and had hundreds of images used on a live basis throughout the three months. These included the memorable front page action image of England Captain, Graham Gooch, leaping in the air with a hand broken by Ezra Mosely during the third test in Trinidad. England came close to winning an historic series, and revenues from that tour alone made a significant return towards the cost of the Hasselblad system; what we had demonstrated was the first step in convincing newspapers to invest in their own new technology to receive our digital feed. There was now a real thirst for live colour imagery, and we had shown what a service we could deliver. The decision to change our modus operandi for event coverage was another turning point that gained Allsport recognition as a global player, marrying the quality end of the photographic marketplace to the lucrative and increasingly important subscription-based live arena. This was another world.

17

ROYAL TOURS AND WORLD CUPS

You could say that jetting around the globe photographing the world's elite athletes and top sporting events is unquestionably one of the ultimate lifestyle businesses and, in theory, we could all have continued quite happily doing this for the rest of our working lives. However, from the moment we introduced equity holdings, as Tony Duffy did when re-hiring me back in 1975, although we didn't know it at the time, its days as a lifestyle business were numbered.

This message was reinforced for me when, early in 1990, the BBC aired a television series called *Troubleshooter*, anchored by the entrepreneurial business executive, Sir John Harvey-Jones. It was a very early reality show in which this genial, if direct, ex-Chairman of Imperial Chemical Industries was parachuted into various businesses to advise their management. From the Morgan Motor Company to Apricot Computers and Triang Toys, they were mostly smaller concerns: some family run, some struggling to grow, some just struggling. Having run his rule over their trading performance he offered advice straight from the shoulder on how to survive, grow or become profitable. I became addicted to watching and listening as he dispensed many pearls of wisdom, but the most telling and influential pearl for me was his statement that no one should treat their business like their baby. Or worse, their hobby. He made a big point about the difference between a lifestyle business and a growth business, a point that I took on board. Growth businesses should be created to make money for those that work in them and for their shareholders. There is nothing wrong with lifestyle businesses, providing they are limited to a family or a set of partners that share the same passion equally.

I had a growing suspicion that despite his move to America with the brief to establish Allsport as a serious player in the USA, unfortunately Tony still appeared to regard the company more as the means to deliver *his* lifestyle than to build a thriving business with an increasing asset value. His strength was that he was a natural sports photographer with an unfailing eye for the critical moment in an athlete's performance, but he had been moved to California to set up and operate Allsport USA as a profitable subsidiary of our parent company. This wasn't happening and it was becoming a bit of a cause célèbre. In retrospect, I suspect that many of the issues between Tony and I at the time were based around this different approach to how businesses worked; lifestyle or growth. Looking back, it is amazing that we managed to work together so closely for so many years. We were fundamentally different in almost every way, from our approach to sport, photography and critically, our approach to business.

Whereas he was and would always be the ultimate sports fan and lived for the image, I on the other hand, being more a photojournalist, framed my pictures to tell a story of either the subject or the moment. Maradona, the fear and awe that he instilled in his opposition; Borg, the precision and intensity of his game; Thompson, crossing the line in Athens showing him as he destroyed the opposition athletically and psychologically, all told a story. But I was not a sports fan and never had been. What I brought to the party was an entrepreneur's instinct for recognising opportunities and spending money if I felt the investment was worth the gamble. At times, this could have been mistaken for recklessness, but style apart, another big difference between us lay in our approach to the medium and long-term future. What was happening in America was in danger of delivering an entirely different dividend to what we had projected. If I left things to continue unchecked, they would come close to destroying what we had worked so hard to build up. If Tony was regarding this as a lifestyle business, I had always seen the future as protecting the jobs of the people we employed, while we owned and grew the business. Eventually, I saw us realising the asset with a tangible return for our investment of time, money and angst over so many years. We had discussed this ad nauseam, but I had no confidence that Tony still shared my view.

All my life had been about finding challenges and projects to complete, but everyone knew that it was also about finding good people to take over from me when the projects were up and running. Much as I had taken pleasure and pride in Allsport and growing it into something meaningful, I had never wanted to be sitting in the same chair and doing precisely

the same job in ten years' time. Tony's move to set up Allsport USA was the perfect out for both of us, defusing the atmosphere that had built up. While we continued as co-directors in the business and friends, his move gave me the latitude that I needed as CEO of the Group to get on and build the company which is what I really wanted to do, whilst his newfound freedom allowed him to spend his time shooting sports on the West Coast, which is what he really wanted to do.

I was fortunate that Adrian Murrell, Lee Martin, David Cannon and our Company Secretary, Mavis Streeton, who with me comprised the rest of the Allsport Group management team, all worked out of our London office and all knew perfectly well what had been going on between Tony and me. It was no surprise that they were equally eager to preserve the company they had worked so hard to build up and supported my plans for our future. I regarded all of them as most trusted lieutenants and all had been with me on the long journey that had brought our business from its early home in the converted dairy in Morden. Still based in the same area of south London, we had invested heavily in buying a much more sizeable building which had cost a small fortune to set up and equip, but you can't deliver if you haven't got the tools. The investment had been made on the back of the growing revenue stream from our increasingly dominant market position in Europe and we were looking at potential acquisitions. That was Europe, but our problem resided on America's West Coast.

Tony had been joined by my brother Mike, mainly for him to get away from me, but it was a good move and launched his career. Initially, the US company acted primarily as a source of American-based sports images fed into our London office and onward to our international agents. However, as the business grew it became apparent that it rarely received calls soliciting or commissioning pictures from US titles or clients, unless it was Olympic-orientated. To grow in the US, we badly needed to access mainstream American sport, so when the opportunity arose to buy Focus West it seemed an attractive option. The rationale behind the purchase was sound enough and important for our development over the long term as we badly needed access to that mainstream. Buying an existing, well-respected agency was a fast track into that market.

I had foreseen some difficulties when I had allowed myself to be convinced to keep both companies trading from their existing bases: Allsport USA in Santa Monica, and Focus West, 135 miles south along the Pacific Coast Highway in San Diego. It made little sense to me, but at the time it was a typical accountant's cost-saving exercise. I guess I was

totally focused on our new building, our 20th anniversary, and the Seoul Olympics. Tony had always supported me, so I went with it. By the time cracks appeared in early 1989, my eye had been off the ball, probably for the first time in my career, as I'd allowed family matters to take priority. By the end of the year, it was becoming very obvious that we had major problems. Running the two American offices in parallel was inevitably producing resentment and this was feeding into discontent, leading to trading losses.

I made several trips, visiting both offices each time to try and find a way for them to work together, but to no avail. They continued haemorrhaging cash, and it became evident that I would have to become more deeply involved. In early 1990 I moved the family to California, initially for three months, to begin a make-or-break review of our operation there. After a certain amount of territory marking and establishing lines of demarcation, I found that we had been running our Santa Monica and San Diego businesses as entirely separate entities and had made competition between them a big thing. That was anathema to me as I'd always seen competition as something between us and the opposition, and not some internal struggle for supremacy just for its own sake. As the parent company, we were bound to be the source of funding to support the enlarged business, in both locations and with two headcounts. Worse yet, our newest agency acquisition was still working on the traditional lines of rights to their pictures belonging to the individual photographers, who received 50% of the sale price from us.

Without full and proper integration, implementation of our acquisition was a potential disaster and the costs of running two companies, both with employees eating their heads off, began to seriously impact our cash flow. Late in the day I recognised the unpalatable truth that the UK parent company was responsible for all the debts without being able to control the management process. Even with the added credibility of working with a recognised American agency, we were still not growing the business as we should. It also became apparent that our difficulty in getting recognised by the most important US professional sports bodies was being stoked by rival US freelance photographers, who were putting it about that we were a commercial photo agency. Without our ethical cloak of editorial independence and integrity which we had worked so hard to establish in Europe, inability to establish that reputation Stateside would have been the death knell for Allsport in the US and possibly elsewhere. We would need to deal with this, so I found that problem in the crosshairs.

Not that there wasn't enough to photograph, for North America lives for sport and some of them have become indelibly imprinted on the American psyche. From track and field athletics to frisbee throwing, it's all there, but for us to get real traction we needed to break into the big four national professional sports: Major League Baseball (MLB); National Basketball Association (NBA); National Football League (NFL) and the National Hockey League (NHL). To give some idea of scale, baseball is rightly called America's national game and has seen 252 teams play from Alabama to Wisconsin. NFL Gridiron earns upwards of US$11 Billion a year, of which television revenue comes in at US$5 Billion and it has average viewing figures of 16 Million.

These were the heavy hitters and the MLB, NFL and NHL had been running professional leagues for over 100 years. Right behind them came the newly emerging Major League Soccer (MLS) - think David Beckham - the Canadian Football League (CFL) north of the border and the National Association for Stock Car Auto Racing (NASCAR). We should have been accredited to all of them, but we were relying on freelance photographers with local team contacts to submit their images to us for sale as stock. We had no 'live service' capabilities, although we had some transmitting facility in our Santa Monica office, while Focus West was still just a standard stock photo library.

Before I had seen the operation close up, and just based upon the losses being accrued, I had privately favoured shutting the whole operation down as we were doing really well in the UK, so why risk it all now on an untapped market? I therefore did what I had always done when faced with a big issue and took myself off, alone, to a decent hotel where privacy allowed me time to plot and get my thoughts on paper. Having had time to think things through and analyse forensically, it became obvious that anything less than total success in the US would rightly be seen as failure, not something that I was willing to countenance. We'd been in crises before, but had always turned them into opportunities, so what was on the horizon that might give us the levers we needed?

The 1996 Summer Olympics would be the Centennial Olympiad. As such, everyone assumed they would be awarded to Athens, the historic home of the Games, but I knew that there were dissenting voices and the Greeks had not played their hand very well. In the end Athens over relied on what it saw as its God-given right to be hosts and there were serious doubts about their ability to organise and fund such an event. The TOP sponsors, who had no direct vote in the decision, lobbied hard for Atlanta, incidentally, the home of Coca Cola.

Predicting against the odds that the 1996 Summer Games would go to Atlanta and with the 1994 Football World Cup fast approaching on the same continent, I concluded that with proper management, financial control and some judicious marketing, we could justify further investment in Allsport USA. I also believed that these two major events would form the basis of our future success in the US and how we handled our coverage of them would showcase our offering to American professional sport and give us the entry point we so desperately needed. *If* we could pull this off, we would truly be the biggest and the best. I followed this plotting time by writing a full business plan, upsides and downsides, plusses and minuses, pros and cons; what emerged was to become a pivotal paper for the future of Allsport in the USA and, by extension, globally.

Once again, I had lunch with Tony and explained what I believed to be the way forward. Keeping the two agencies separated geographically was irrational and overheads needed to be cut, so the only way forward was complete integration and quickly. We also needed rapid growth and to catch up with London technically if we were to take full advantage of the two major events in view. He agreed with my conclusion. However, I explained that for it to happen, I and my family would need to move to Los Angeles full-time to allow me to drive through the changes. Tony was to have the honorary title of President of Allsport USA, but all executive decisions would ultimately, after suitable consultation, be mine, and he agreed to this.

Having brought Tony onside, I then flew the family back to our lovely London home and as Beans wasn't keen on renting this out, we prepared to mothball it. I argued that it might only be for a couple of years and it would be useful to still have access to a home in London, before explaining my planned move to a rather surprised but ultimately supportive London management team. I had also agreed with Tony that as the next stage of our growth and the very future of Allsport would rely heavily on the support and commitment of our management team and directors, he and I would both put a significant tranche of our shares in the company into an executive share option scheme. This would not only help to focus people's energies but put an eventual sale or float of Allsport clearly on the agenda. What followed became known to my family as the 'commuting years'.

Back in the London office, our Hasselblad picture desk was now working flat out servicing the five digital scanners we now had in the field. Adrian Murrell's daily coverage of the cricket test series from the

West Indies in the winter of 1989/90 had been enough to prove our point and the editors loved our service. Adrian and his techies had had to struggle daily with bad phone lines, but our coverage of the 1990 Commonwealth Games from Auckland, New Zealand, another difficult time-zone, was a master class in what this new technology could deliver. For the first time we had Switched 56 kbps phone lines installed at both ends, which enabled full digital scanning, transmitting and receiving, giving us numbers that were game changing. We could now receive full colour images from the other side of the world in just 5 minutes 40 seconds, with no appreciable loss of image quality.

Game changing those numbers might be, but we were still re-transmitting to our newspaper clients at an average analogue speed of 16 kbps, over three times slower, and prone to line noise and the inevitable re-transmissions. How could we make newspaper proprietors sit up and take notice when every conversation with their Managing Editors or Picture Editors started with: "It's the wrong time in the budget cycle…" or "This year's budget is all gone, and we can't buy anything until next year." Struggling to get our own clients to invest in the technology required for them to receive our service was a classic chicken and egg situation. Then good fortune came our way in the unlikely shapes of Prince Charles and Princess Diana.

A top news photographer, Mike Moore, was covering Princess Diana on Richard Branson's Necker Island for *Today* newspaper. At the end of this assignment, he was re-routed to Antigua by the legendary Picture Editor, Ron Morgans, because Mike had a satellite phone. Ron asked if he could help Adrian, who had been struggling with poor phone lines, to get the last Test transmitted via *Today's* satellite phone. This was more a phone in a suitcase, but by a process of mutual admiration or osmosis, Adrian recognised the possibilities of the sat-phone and Mike couldn't stop talking about the quality and speed of our transmitter. Shortly afterwards we had a call from the *Daily Mail's* Royal Photographer, Mike Forster, who wanted to rent one of our scanner transmitters for the forthcoming royal tour to Lagos, Nigeria. This was a no-brainer. We were sitting on five Hasselblad Dixells, plus the picture desk system and communications equipment, a collective spend of nearly £350,000 (more than £800,000 today). It was an investment that I had been happy to make, but here was a way of seeing an immediate return. We were happy to oblige, and Adrian ensured our fees reflected the importance of the story.

Now equipped with a satellite phone and collapsible dish, about the size of the first Sky dishes, we could transmit from anywhere in the world,

at digital speeds and of the highest quality. Mike just poured images into our London picture desk at digital speeds and we re-transmitted them into the *Daily Mail's* system, much more slowly over the dreaded multiple analogue lines. It worked, and the *Daily Mail* just blew the competition away with multiple colour spreads every day, in every edition. If Sports Editors might have laboured under budget constraints, Royal Editors were not so limited, as the royals really sold newspapers. Now we had their attention, and everyone wanted to know about our system.

For the next couple of years, many of our technicians found themselves on royal tours to exotic locations and we paid for our whole digital investment in less than 18 months. This single event transformed our relationship with the UK newspaper editors, as they asked how they could speed up receiving our pictures. With the FIFA World Cup in Italy looming, we were pushing hard for our best clients to get digitally equipped and even persuaded Hasselblad to loan *The Daily Mail* and *Today* one of their basic picture desks to receive our service, but another breakthrough proved to be the star of Italia '90, along with Gazza's tears.

Contrasting the story of our photo coverage of successive World Cups makes an interesting insight into how quickly things changed and how rapidly we adapted in just eight short years. In the early years of Allsport we had deliberately avoided football. There was just too much competition from other freelancers and specialist photographers and literally everyone was shooting football, so we had mainly made our name from our Olympic sport coverage. Our first World Cup coverage was in Spain in 1982, where I went on assignment for *Sports Illustrated* and although Allsport had no official presence there, I came back with large quantities of stock of international football and 'That Photo' of Maradona. However, we didn't really begin photographing club football until the 1984/5 season when David Cannon started to specialise in it, working to the Allsport model of developing our relationship with each sport. By 1986, David had convinced us he had built enough markets in football to justify a small team going to the Mexico '86 World Cup. Our team comprised just two; David and Mike King, another very talented photographer who we had poached from Bob Thomas, the top freelance football agency at the time. They teamed with our agent Billy Strickland from Ireland, Gerard Vandystadt and Jean-Marc Barey from France, and our man in Mexico, David Leah. All were highly regarded in their own countries and although we had tried teaming with our agents in 1984 at the LA Games, this was to be the first major cooperation.

For our coverage of the Mexico 1986 World Cup, we assembled one of the finest teams of football photographers ever to work together. The back row shows Gerard Vandystadt, David Cannon, Jean-Marc Barey, Mike King and Billy Strickland, with David Leah, our man in Mexico, in front.

Photo: Allsport Archive

Fortunately, having our man in Mexico City helped. David Leah was a talented English photographer who spoke perfect Spanish, having moved there many years ago. By now, intimately familiar with how the wheels turned, he could keep the budgets low by going local, in all his negotiations. We bought cars for transport and sold them at the end of the job; a bungalow was rented for the duration at a knockdown price with scorpions in the loo coming *gratis*, apparently. Between them the team arranged priority processing with Kodak Mexico, set up duping facilities and started shipping film back overnight via a friend of Gerard's on the Air France check-in desk. Our film having already been processed, edited and duplicated for local distribution was being hand carried back by flight crews every night, FOC. We then had our guys meeting the flights in Paris and flying back to London for worldwide syndication.

The local distribution was in fact all the major magazines that had their own editorial teams there, notably *Sports Illustrated, Paris Match, L'Equipe* and *Stern Magazine*. David had agreed a US$100 fee for each duplicate they kept, regardless of whether they eventually used it. They also paid for usage on top which was a master stroke. Fevered competition between different media outlets in these tense environments meant that they were all desperate not to miss out on the best picture, so by paying that initial fee on each duplicate it was guaranteeing them first use in their territory. The fee for *Stern Magazine* alone came to US$30,000.

This was probably the finest collection of football photographers to ever work together as a team, with local knowledge and can-do attitudes, making it a benchmark case for all future coverage. Just four years later though, it was to be outdone in every regard. Italia World Cup '90 converged with our digital coming of age and our acceptance into the newspaper world as a major international sports and press agency. After the respect we had rightly earned from the media for our handling of the Hillsborough story, our timely and challenging coverage of the West Indies tour and the Auckland Commonwealth Games, plus our support of the Royal Tour, we now had a target to shoot for. We were about to cap it all with our coverage of the World Cup, an event that most, if not all the British media and a large chunk of the world's media, rated more important that the Olympic Games.

Planning for this month-long football extravaganza had started a year before. First, our photographers travelled to Italy to photograph all 12 stadiums dotted over the mainland and the islands of Sicily and Sardinia, before travelling worldwide to photograph every player in every squad that had qualified. Our operations supremo, Dick Scales, made preparatory site visits to arrange accommodation, processing and media centre facilities and to access the logistical challenges that this event was going to throw up. We needed to cover 52 matches in 12 different host cities, with at least two photographers at each game, plus editors and technicians supporting every match with transmitters and satellite communications.

We also planned to set up a service to support several newspaper staff photographers with our techies and transmitters. Early in the year we released a full Italia '90 preview set of over 1,000 images. Probably the most comprehensive portfolio of images ever produced for a sporting event, it included portraits and action shots of all 20 players in each of the 24 qualifying nations, together with all their managers, coaches, FIFA and organising committee officials, referees, host cities, stadia, mascots and

fans from each nation. In fact, we previewed every aspect of the World Cup and distributed approximately 150,000 duplicates around the world in one release. Little wonder then, that we dominated newspaper and magazine pre-event coverage.

Our team for the actual coverage of the championship again brought together some of the best football photographers in the world. David Cannon, Simon Bruty and Ben Radford from Allsport UK; Billy Strickland from Ireland; Gerard Vandystadt and Jean Marc Barey from France; David Leah from Mexico and Franco Riciardi from our Italian agents. We backed them with three editing and transmitting teams, one based in Rome next to the main stadium led by Tony Graham, a second led by Steve Rose, whose brief was to just follow the England team everywhere and undertake the responsibility for servicing the transmitting needs of eight UK newspapers who paid us for the service. A third, led by Ian Down, would travel to key non-England games.

For us at Allsport, the creative and technological pinnacle of Italia '90 was the now famous picture captured by David Cannon of Paul 'Gazza' Gascoigne saluting the England fans after an emotional penalty defeat in the semi-finals by England's nemesis, West Germany. I had been watching the game in the London office, tinkering with a Beta version of Kodak's new XL7700 digital continuous tone printer, a new and inevitably expensive piece of equipment that had been delivered just a couple of days before and the very first into Europe. It was huge, needing two men to lift it, but we could now run full colour 8x11 inch prints or transparencies from our transmitted digital files. This was the first chance we had had to use it and, as we watched the image of Gazza's salute coming in, I decided that this was the image that would make the most impact and immediately printed it out in full glorious colour. It had taken just 22 minutes from the moment the photographer took the picture in Turin, to process, edit, scan, transmit and then print it out again in full colour. By anyone's standards, a record-breaking achievement.

18

AMERICAN MOVE AND UGLY ON TUESDAY

Returning to the States with the family, my first task was to get them settled in our new rented home. I had researched where to live in the sprawling city of Los Angeles and its environs by sitting in a hotel next to the office on Wilshire Boulevard with a map. I only had one rule; no freeways. We couldn't afford a decent family home near the office in Santa Monica, so I looked further up the coast and came across Malibu. Well, we definitely couldn't afford to live there, but there was this intriguingly beautiful twisty road that turned off the Pacific Coast Highway and up Topanga Canyon. Following it with my finger, I traced it inland over the Santa Monica Mountains and came to rest in a small township overlooking the San Fernando Valley, called Calabasas.

Known as a quiet, family district with excellent schools, Calabasas was built around an old Spanish farmstead. Leonis Adobe, the farmhouse built in 1884, was still standing and was one of the oldest structures in Los Angeles County. It had a small man-made lake and easy access to the freeway system for those who needed it, and was fast becoming a popular commuting town. I wouldn't need the freeway, as I could drive to our office in Santa Monica through the Canyon and Topanga State Park, then on down the coastal highway with its ocean views. It was the perfect commute and one that I was to appreciate and enjoy. This chance and rather random find turned out to be a hidden gem. Johnny Mathis was our next-door neighbour, and the area was fast becoming a hideaway for the stars with the likes of Will Smith, Miley Cyrus, Jessica Simpson, Justin Bieber, Selena Gomez and most famous of all, Kim Kardashian, who not only called it home, but went on to make it

famous. Grand as all this sounds, the house we eventually bought was a modest little hideaway, but it served us well for the eight years that we needed to live in California.

Once settled in, I had to fly to Tokyo almost immediately as the vote for the city to host the 1996 Summer Games was about to take place and not only did I have a huge stake in the result, I also had some IOC business to attend too. I had made the decision to commit to an American office on the basis that the World Cup was coming to the States in 1994 and my belief, best guess and fervent hope that Atlanta would win the vote and bring the Olympics to the US two years later. I tried to watch proceedings as an impartial observer from the side-lines. The face-off between Athens, which thought it should host these centenary Games by divine right and Atlanta, which came to the table with enormous local financial clout in the shape of Coca Cola, was fascinating to watch. Belgrade, Manchester, Melbourne and Toronto had bid, but we all knew it was going to be a two-horse race. The old Gods on Mount Olympus versus the new Gods of mammon, representing the resurgent economy and politics of America's deep south. Both had their attractions, but only one would work for me.

My contacts at Lausanne were talking quite openly about the arrogance of the Greek approach which was not going down at all well within the IOC. I took the view that however aesthetically worthy

One of the driving forces behind our move to America was the prospect of both a Summer Games and football World Cup in that continent. As always, the selection of Olympic host city was hotly contested and not without controversy, but when IOC President, Samaranch, announced Atlanta it delivered the perfect launch pad for Allsport USA.

Photo: Ross Kinnaird/Allsport

the Athens bid might be and however much sentiment might hang on their centenary pitch, when it came to a vote it would not be driven by sentiment, but by hard economics. In this area, Atlanta held all the cards. There were obviously the naysayers, both inside and outside the IOC family and the world's media, who peddled the rumour that Coca Cola was unfairly influencing thinking by its financial predictions; and that to honour the Centenary Games it should be history and not dollars that held sway. Some people overlooked the little detail that Atlanta, by way of Coca Cola, had been sponsoring the Olympics for over sixty years! Athens may have led the first two rounds of delegate voting, but reality bit and when the result was finally announced and Atlanta came through to win decisively in the fifth, I was sure I heard President Samaranch announce: "And the 1996 Summer Games go to... Allsport."

My bet had paid off. With the Football World Cup heading our way, a major market that we were beginning to dominate, and now the 1996 Summer Olympics coming to Atlanta, another market in which we held all the cards, all my hopes and dreams were being realised. If we could capitalise on two of the world's biggest sporting festivals, then the value of our company would rise and would probably never be higher, so in my view, that would be the optimum moment to discretely put ourselves on the market and seek offers for the business. Now all I had to do was press the button. We had agreed to the plan, the other directors had given me a mandate and the authority that I had asked for, so no excuses.

Returning to LA on a high, the enormity of the task ahead began to hit me, as all the same problems were still there. Two separate offices at loggerheads with each other, inconsistent management disciplines, and staff who I didn't really know and who didn't really know me, especially at the San Diego operation. All I had been to them was the Brit who flew in, pointed out all the problems and flew out, which had not been great for team building, so I needed to fast track my plans to gain their trust. The first problem would be the one that would hurt the most. It would inevitably lead to job losses, as I needed to close the San Diego office, dispose of the real estate and relocate all the key staff and the picture library to Santa Monica. If I allowed myself to get tangled in the politics of the two-office setup and adjudging whose system was best or start debating what was the best timetable for closure and relocation, I just knew that we'd get bogged down in the detail and meet resistance. There was definitely a less than positive atmosphere in both offices and not everyone wanted this to happen, so I needed to do this quickly; rip the plaster off!

I negotiated with our landlords to expand our current office facilities on Wiltshire Boulevard, which would help a lot and then I went down to meet with everyone at Focus West and discover first-hand who could, who couldn't, and who wanted to move to Santa Monica. Probably not the most attractive option for people who had lived most of their lives in San Diego. Fortunately, it was a fairly small operation with around ten full-time staff plus the two previous owners, who definitely didn't want to move. In the end, about half of them agreed to relocate, but the key ones for me were all talented photographers in their own right. More importantly, they knew the files, the clients and the contributing freelance photographers well; Holly Stein, Steve Dunn and Marcus Boesch. Giving everyone just two weeks' notice, we moved everything up to Santa Monica and shut the San Diego office down.

From what had been my relatively easy life in London, sitting at the head of a successful company with a formal management structure and experienced staff who I knew well, suddenly I was facing two dozen people whose names I barely knew. Twelve years my junior, even my brother was a bit of a stranger, as I hadn't seen much of him since he moved to the States. The parallels between the state of the systems and size of Allsport USA in late 1990, with the condition of Allsport UK when Tony handed the reins to me in 1984, were uncanny. Basically, I had to start all over again and this time with strangers, but at least I had a template. I knew what to do as I'd done it all before.

My first task was to upgrade existing systems, introduce new ones, formalise technical training and bring in spending controls, and it was very much hands on. It had to be, as I needed to gain the trust of the enlarged team very quickly. I didn't have the luxury of people with known skills who had grown with me as I did when I took over the UK operation and so the next couple of years kicking Allsport USA into shape were definitely the most challenging and frustrating times of my life. They were talented people and I think they were quite happy with the changes I introduced, but it simply wasn't in my nature to continue using what were, for me, old management and operating systems well past their sell-by dates. Now, I had to revisit and adapt the IBM client management and accounts system that we had introduced in London back in 1986. I thought about getting my old BBC Micro out of retirement, but the quickest and surest way to bring our expanded American operation up to speed was to use all of our existing knowledge and systems. For the next two years we rebuilt from the ground up as we integrated Focus West into Allsport USA.

While this internal stuff was taking shape, we also started to build our relationships with American Pro sports, using the tried and tested methods that had served us well in world sport in the late eighties and early nineties. The National Football League (NFL) had been trying hard to grow awareness of American Football around the world during which there had been several professional games played at Wembley Stadium in London. Always with an eye for an opportunity, we had covered those games and now that we had access to the Focus West files, we could send out regular picture sets to our worldwide magazine client base. American Football stories began appearing in the most unlikely places and countries, from India and Japan to Germany and France, in fact, pretty much anywhere in the territories covered by our 40 agents. Then we made the NFL aware of our worldwide distribution and before long we had our first relationship in place. They realised, as did many world sports bodies, that we could reach places in the media that traditional sports agencies and freelancers simply couldn't. The whole gamut of sports was realising that because of television revenues, preaching to your home fans was OK, but to really drive revenue you needed to build awareness of your sport amongst the wider general population. Courting a different demographic, a picture story in a women's magazine, or a hobby magazine, was doing just that and probably worth more to the sport in the long term than anything appearing in traditional fan magazines.

Outside the office my life became more sociable as Tony and I began to have lunches together again where we'd discuss what was happening in the company, on both sides of the Atlantic. I thought Tony appeared happy enough, taking photos pretty much full-time once more, but still being involved in the big picture. My brother Mike and I reconnected by spending a weekend camping and rock climbing in the Yosemite National Park. Climbing was a long way outside my comfort zone, but it gave him the chance to get his revenge on his older brother and boss, by dragging me up and then dangling me off unbelievably high rock faces.

Our middle brother, Stuart, two years younger than me, had seemed to manage to live semi-permanently in California on a tourist visa with no obvious job, while racing motorbikes all over the deserts of the West Coast and Mexico. He was always the bad boy of the family, and in fairness, he had an excuse. At the age of nineteen, while heading home from work on his Triumph Bonneville motorcycle, a drunk driving a van hit him head on and then drove away, leaving him for dead in the middle of the road. His injuries, mainly internal, were horrific. His surgeons said that had he not been extremely fit, he would not have survived. He spent

over a year in London's Kings College Hospital recovering and had an operation related to that accident every year until the age of thirty. That he could get on a motorbike was amazing, never mind race it across deserts, so I bought a full-size Ford Bronco, my idea of a proper American truck, and started going out to his races in support. Happily, Beans and the kids were loving California, and were all definitely fitting into the local lifestyle. With a swimming pool in the garden and the sun always shining, what was not to like? We adopted our first dog, a golden retriever, which we christened Charlie and we would find him doing lengths in the pool when we got home. Happy dog, happy family.

However, alongside this happy family vibe, I realised how complicated my life was going to get, if it wasn't already complicated enough. My style had always been based on the old tradition of 'management by walking about'. Hire the right people, then let them get on with their jobs, but make sure that they saw you regularly and knew that you were interested in what they were doing and that you understood the issues. It also provides the opportunity to spot problems early and hopefully fix them. Back in London we had a great team, but even they were used to having me around to bounce ideas off, or just to look for some reassurance.

I knew well that one of my biggest strengths - and weaknesses - was my total focus on any issues or projects on hand at any one moment. Trying to maintain focus on projects that were being delivered 6,000 miles away was more difficult. It also demonstrated the downside of walking about, because if people didn't see you regularly, then they would start thinking that you were *not* interested. I had often been accused of losing focus in projects once I had passed them on, which I had always hoped would be interpreted as my trust in the team to deliver, but I accepted that it could be seen as a loss of interest. This was something that now I really wanted to avoid. The management team in London weren't daft. They knew from experience that money was spent and invested on projects that got me excited, so they needed a hearing, especially if London was being asked to fund further major spending in America. To combat that, I determined to establish a regular schedule for allocating my time, four weeks in LA, two weeks in London, fitting in other commitments to the IOC, agents and clients in between. Later, this strategy would go from the sublime to the ridiculous as we opened offices in New York and Sydney, but it worked, and I still followed the grid. Round the World air tickets helped.

Later that year, I stopped off in Tokyo for some official International Amateur Athletics Federation (IAAF) business at the 1991 World

Track & Field Championships. The great thing about sports governing bodies is that all their major meetings were scheduled in the same venue and at the same time as their top events, so we took a full team there, drawn from both offices, deliberately as a get-to-know-you event. Tony, Mike and Gray Mortimore were the main photographers, plus we had a full team of darkroom and digital techies, led by John Gichigi and Steve Rose, with Claire Slater as our senior track and field editor. In my capacity as the photographic representative on the IAAF Press Commission, I was to present my report: *Guidelines for TV & Photographers on the Infield*.

As track and field athletics had grown in popularity and super-stars were made, problems and clashes between photographers and television crews were becoming unsightly and more frequent. Not physical clashes, but just crowding each other on victory laps or seeking interviews. The television executives argued that it didn't look good on television to have all those photographers in shot, rushing all over the place. At the time, television companies were trying to clean everything up, so they had clear, unobstructed views and were talking about bringing in graphic designers to reshape the playing field for their television audience. They were also trying to have photographers removed from the infield, arguing that we could see the action from the stands.

Naturally, I argued strongly against all of this. I pointed out that the sport would lose some of the greatest images of victorious athletes, but more importantly, the clinical vision of an empty infield with a solitary victorious athlete would seriously undermine the excitement of the occasion. After all, I suggested that photographers and television cameramen rushing around were all part of the show. I thought it was a pretty thin argument at the time, but I had an ally in the shape of Jon Wigley, Director of Marketing at the IAAF. Jon set up a working group with representatives of television broadcasters, track officials and the athletes and tasked us with finding a workable and equitable solution. It had taken me two years to negotiate and write the guidelines, so this was the first major international event at which they were to be used. I like to think that those guidelines were successful and went on to be used in every major track meeting in the world, including the Olympic Games. Photographers still have infield access today, but I am not sure the fight is over.

From that moment, when organisers accepted the premise, a large part of my life would be spent negotiating all television and photographers' positions and access at every World Athletics Championships and Summer and Winter Olympics. This would often involve two visits each year to

each host city, for up to three years prior to the event; time-consuming and exhausting, but essential to protect what I had seen as an encroachment on the abilities of photographers to do their job.

After I had concluded my presentation to IAAF President, Dr. Primo Nebiolo, we all wandered down to watch the 100 metre finals with Carl Lewis, Leroy Burrell, Dennis Mitchell and Linford Christie, the four fastest men in the world. I went to our office and borrowed a camera with a 180mm lens and one roll of film, then went into the grandstand, hoping to find a spot to see the finish. Naturally being the premium event of the championships, it was packed, but I spotted Stuart Storey of the BBC in his commentary box overlooking the finish, so blagged my way in and sat next to him. Minutes later the race was over in a new World Record time of 9.86 seconds, with Lewis just beating Burrell on the line. I went back to our office under the stadium where the guys were frantically handling the phone lines, which were red hot. A new world record by an American, and everyone wanted pictures of it: film was coming in from our photographers to be processed as fast as possible. I was still suited and booted from my meeting with the IAAF President when I quietly handed one roll of film to John Gichigi, telling him I'd taken a couple of frames, but probably nothing special.

The next morning on my way to the airport for my flight to London, the next leg of my trip, I stopped off in the office to collect all the original film that the guys had been working on all night. There was no one in the office but plastered all over the walls were fax copies of front pages from newspapers in multiple languages that had arrived overnight. They all featured my picture of Carl Lewis crossing the line, photo finish style, with Leroy Burrell. I am afraid I couldn't resist it, as every now and then it was good to remind everyone that the guy in the suit had still got it. In black felt tip and scrawled large across the faxes I left them a message: 'I guess that's job done guys, see you back at base'. Annoying I know, but these little things.

The World Athletics Championship in Tokyo produced many memorable moments both on and off the track, and while Carl Lewis' 100 metres World Record was one highlight for the Powell family, it was not the only one. Equally memorable was the moment that my brother, Mike Powell, captured his namesake's world-beating long jump leap, but the story behind the moment is worth telling.

Brother Mike had moved to the United States at 19 and instantly became photographer, dark room techie, salesman and executive tea-maker. Several years later he found himself back in Europe covering the

Following my presentation on media access to athletics events to IAAF President, Dr. Primo Nebiolo, during the World Athletics Championships in Tokyo, I grabbed a camera and one roll of film, found myself a location and captured Carl Lewis beating Leroy Burrell to set a new world record in the 100 metres. Widely used, it reminded the young guns that I hadn't lost my touch!

Photo: Steve Powell/Allsport

summer athletics season, circulating from Helsinki to London, Oslo, Paris and Rome, and usually travelling with the athletes and staying in the same hotels along the way. It was during this time that a talented young newcomer started appearing in the long jump pits, coincidentally also called Mike Powell, and they established a friendship. Well, we Powells need to stick together.

Back in the States it was a short skip from Allsport's Santa Monica base to the other Mike's training ground at Azusa and they spent several days together on photo shoots with the athlete's friendly persona and obvious

abilities making him an easy person to like and work with. Travelling the world to the same venues with the same name led to some interesting confusions. They enjoyed the coincidences, and each major event saw my brother at the end of the pit when Mike was jumping. Then, in the lead up to the 1991 World Athletics Championship, while they were putting together a portfolio of action images from short run ups of around eight steps, it became obvious that Mike was jumping out of his skin and that if he could maintain his form, the Tokyo event presented an opportunity for something special. Always in the background was the lurking spectre of Carl Lewis and how often in the past he had beaten Mike, but both men shared immense respect for each other. Both felt that in the right conditions, they had the ability to break Bob Beamon's 8.9 metre world mark, which had stood unimpeached since Mexico 1968, the longest-standing record in the books. My brother knew as well as I did that the Beamon record leap, or rather Tony's photograph of it, held a unique place in Allsport's history, helping him quit accountancy, take up photography full time and establish the agency, so any possibility of history being updated or repeated had to be taken seriously.

With credentials that gave them both privileged access to the infield, Tony let Mike work the long jump, as his personal relationship with the top jumpers would be advantageous. After an evening skipping around covering other action, during which the barometer had been steadily dropping, the evening air promised a storm. With a breeze from behind the jumpers as they sprinted down the runway, just as in Mexico all those years before, fluctuating either side of the maximum wind speed allowing qualification for records, the championship was coming to the boil very nicely. Powell and Lewis both fouled twice. Lewis threw in an 8.91 metre leap on his fourth attempt, a centimetre over the World Record, but also over the permitted wind speed, which would have been a bit of a heartbreaker. What happened next is best described by my brother.

"Mike stepped up and, in that moment, we were both completely focused on what we had to do. He launched directly at me and I knew almost immediately that he was going long as he was filling the frame even more than usual and at a different point in his jump than I regularly saw him. His jump was 8.95 metres with a legal wind, and a new World Record. He celebrated but had to bring his focus and emotions back together as he and Carl had one more jump to come and Mike had never beaten Carl in a long jump competition. Even with a new record in his pocket he wasn't confident that he had won.

"Now my choice was simply which of the two men to follow, Carl jumping for victory or Mike jumping for joy, if his nemesis failed at the last. I went with Mike and kneeling in front of him alongside an NBC cameraman nicknamed 'Too Tall'. All we could hear was Mike muttering to himself: 'Carl's going to do it.' In the record books for five minutes or fifty years, Mike could barely watch, but the last jump of the competition didn't take the honour away and he took off with an explosion of relief and energy as he realised that the longest standing record in the book was now his.

"I've never really been a sports fan, always trying to be a professional, not getting overwhelmed by stardom or athletic prowess, but tonight, a man I called a friend had done the best work of his life and I was as high as he was, still trying to focus on my job, but bursting with joy. When the moment had passed, the adrenalin subsided and I had handed my film over, I knew this was a special night. Later, after events in the stadium were all over, I got together with Mike and we hit the town; dinner; baseball batting cages; clubs; wherever and whatever to burn off the energy and we were certainly not going to sleep. Mobbed wherever we went, Tokyo knew him. For me, the work had to go on so in the wee small hours of the morning I made it back to the hotel, woke up one of our photo processing guys who was not happy, handed him another bag of film and then headed out to cover the start of the marathon. Just another day in my particular office."

My brother Mike's image of the other Mike Powell made the cover of *Sports Illustrated* and another double page spread besides. On his return from Tokyo, the doors of picture editors on all the heavy-hitting magazines were now open to him and to Allsport USA and like Tony years before him, one photograph of a world champion long jumper had put him on the map and launched his career. And I was very proud.

Once back in our Los Angeles office and still gently feeling my way around American working methods, I learned my first vital lesson for doing business there. Within months of my move to the USA, I received my first lawsuit. I had been vaguely aware that doing business in America was likely to involve litigation at some point, particularly in California, but to receive your first multimillion-dollar lawsuit is a sobering moment for a Brit who'd only ever used lawyers for buying a house. We were being sued by a Focus West photographer who claimed that many of his images

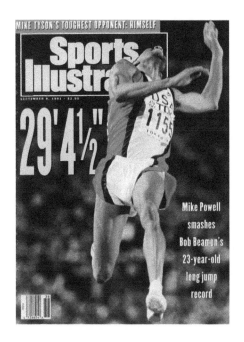

History repeated itself in Tokyo when my brother, Mike, captured the moment when Bob Beamon's world record long jump leap was finally beaten ... by the other Mike Powell. The Beamon picture had kick-started Allsport, the Mike Powell on Mike Powell picture continued the legend.

Photo: courtesy of Sports Illustrated

had been lost during the move, thus effecting his potential earnings over the next 30 years or more. There was legal precedent accepted in the industry that if a client loses an original transparency the compensation was set at US$1,500 per transparency, hence the multimillion–dollar suit. As there was no individual record of every photograph filed in the Focus West library, we had no way of proving or disproving his claim. It would rely entirely on the feelings of a jury and Californian juries were proven to be notoriously anti-business.

To be frank, I was at my wits end. We were experiencing enough problems with the US business without this financial Sword of Damocles hanging over us, not to mention the considerable cost of defending ourselves. At this point, my PA, a young and streetwise Californian girl called Sue Baldus, took me to one side and privately advised me that if we settled this suit out of court or even worse, went to court and lost it, we could expect dozens of copycat suits, so I really needed to do something about it. But what, I asked. Sue him, was her instant reply, and it really doesn't matter what for, so try 'being ugly on a Tuesday'. That should do it.

Although she was joking about Tuesday, her point was crystal clear. In lawsuits like this, you must introduce an element of risk and cost to the other side, so I counter-sued him for US$2 Million, citing

conversion of assets, in American law this is the civil form of theft. As he had had access to the Focus West files for years, there was a chance that he might have taken his own photos out of the files and that would be a matter of judgement by a Californian jury. His lawsuit disappeared overnight, so did the waiting queue of copycats, and the 'Ugly on Tuesday' rule was born.

19

KINGDOM OF THE GEEKS

Technology, technology, technology; the early nineties were all about emerging new methods and adapting them to our needs. As an agency, our search for these next generations of technological improvements coincided very neatly with the expanding development of digital photography and the transmission of high-quality images. We had two major advantages over our competition, the major agencies such as Associated Press (AP), Reuters and the rest. First, and probably most important, was that we didn't have huge legacy systems of old technology hanging around our necks. Strangely, having to do it all again with Allsport USA, something that I resented at the time, actually gave me the chance to re-visit many decisions we had taken in the past and experiment with alternative options now emerging onto the market.

Some options lent themselves to plug-and-play products bought off the shelf and in others, collaboration with vendors, which allowed us to develop bespoke hardware and software that served our purpose better. In turn, this gave us a lead in the two most critical areas of our work speed in processing raw film stock while maintaining quality, together with archiving and retrieving images to offer the best service to our media clients. It was a time of tremendous change in the photographic industry generally and Allsport in particular, as we were on the cusp of moving into digital origination and storage, providing opportunities that we could only have dreamed of five years before.

The success of our agency could be measured both in the creative genius of its photographers, of whom there were many, but as much for our inquisitive willingness to explore and embrace new ideas.

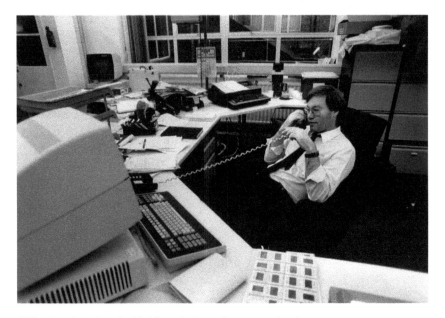

Technology is only valuable if people know how to employ it.
One man who certainly did was the legendary Fleet Street picture
editor, Ron Morgans, seen here on March 4th. 1986 at the launch
of Eddy Shah's Today with the first colour picture desk on a
UK national newspaper.
Photo: Alamy Archive

Looking back now, advances in our history were often inextricably linked to advances in technology and over the years, we worked with many companies. These included Applied Graphics Technologies, Hasselblad, IBM, Kodak, Scitex and Sony, but at that point it was our relationship with the Massachusetts based Leaf Systems Inc. that was to have the biggest impact. Although the Hasselblad Picture Desk system had served us well in the UK and Europe, being ahead of the curve had caused some issues, the main one being that it needed serious investment from the client side to receive our service digitally. Many of our UK and European clients had Hasselblad receivers now, but it had taken quite some time for them to catch on. That take up was driven and led in large part by legendary Fleet Street Picture Editor, Ron Morgans.

People referred to as 'legendary' don't always deserve that accolade, but in Ron's case it was absolutely accurate. He had started working on Fleet Street aged seventeen, had been a photojournalist for 30 years, before becoming picture editor of the *Daily Express* running a team

of 50 cameramen, so he really knew our business from both sides. On the *Express* picture desk during the Cold War, on the *Sun* during the Falklands war, on *Today* managing its coverage of Chernobyl, Lockerbie and Tiananmen Square and finally, on the *Daily Mirror* during the collapse of the Soviet Union, his experience was unmatched and his reputation legion.

He had been the first picture editor to adapt Adobe Photoshop for news coverage in a National newspaper when in the chair at Eddy Shah's *Today* and in his time there, won Picture Editor of the Year on three occasions. We had developed a long-standing and very productive relationship with him during his tenure with Eddy as we spoke the same language and saw the same technical opportunities opening up. He was later to be headhunted by Mirror Group Newspapers, partly because of his reputation for being one of the few 'tech savvy' picture editors on Fleet Street. It was this reputation and our relationship with him that led Adrian and Lee to successfully negotiate our first subscription service deal with a newspaper group. For £350,000 per annum (well north of £700,000 today), it granted Mirror Group Newspapers total access to our output, both live and archive, except for exclusives. This was groundbreaking for us and over the next couple of years we negotiated similar deals with every UK national newspaper and several regional groups, the biggest being Thompson Newspapers.

It is fair to say that things were finally happening for us in Europe. After seeing our sporting coverage and the way we had handled the Royal tours, many newspaper staff photographers came out publicly in favour of the Hasselblad picture desk system as the preferred technological route to follow, as it was for Agence France-Presse and this produced a useful groundswell amongst our clients. However, this was not the case in the USA, where we faced an entirely different and bigger problem. We didn't share the relationships with the picture editors and staff photographers that we enjoyed in the UK, and probably never would, because it was a much more fragmented market, separated by immense distances. Until the advent of *USA Today*, there weren't really any national newspapers circulated coast to coast. While the *New York Times* and *Washington Post* could reasonably claim to have national reach, in reality each city had its own newspaper dealing primarily in parochial local stories with an occasional splash of world news. Why would any US newspaper buy a very expensive Swedish-made picture desk to receive pictures from a sports picture agency that wasn't particularly well known in American professional sports? We had to find another way in.

The biggest player for news and picture distribution in North America was, and always had been, Associated Press (AP). Started in 1846 by five New York newspapers as a way of pooling resources and sharing the costs of covering the Mexican–American War, AP still operates as a not-for-profit operation controlled by its membership of subscribing newspapers, now numbering well over 1,000 worldwide. Despite their huge legacy issues with old and very dated technology, they obviously weren't standing still during this digital revolution and had been using a portable scanner transmitter called the AP Leafax 35, manufactured by Leaf Systems.

Always keen to go to the fountainhead, I visited Leaf in Boston for a demonstration of this system and to hear what their plans were. On arrival I was met by company President, Robert Caspe, who insisted he first show me his new toy, the Leafscan 45. Just released and yet to be hailed as the mother of all modern CCD scanners, it was a state-of-the-art desktop machine designed for digitising colour and monochrome 35mm up to 4x5 inch transparencies at very high resolution and at up to 5080 dots per inch (dpi), many times better than anything I'd seen before. I was beginning to be impressed, as this could make high resolution scanning for magazine quality usage a reality. In fact, he told me, they had a number of magazine clients who were doing that already and along with desktop publishing software, cutting out the middleman. Having done his sales pitch, I eventually got my AP Leafax 35 demonstration and although it wasn't as polished as the Hasselblad Dixell 2000, it was considerably cheaper; and it worked.

What really caught my eye was its groundbreaking USP. Clients didn't need expensive proprietary software as they could receive it on any Apple Macintosh, using Leaf browser software that was free to all AP members. Seeing the opportunity here didn't need a hotel plotting session to recognise the potential. The combination of the high resolution Leafscan 45 and the Mac-based AP Leaf software, still under development, meant two things. One, the possibility of a high-quality digital archive that would attract book and magazine publishers, our core market, was no longer a dream. Two, through the simple software we could have direct access to every newspaper picture desk in the USA. All they had to do was ask.

I flew back to Los Angeles a very excited man. Within weeks we not only had a Leafscan 45 in our Santa Monica office, but we had agreed to co-operate in a planning group with Leaf Systems and AP to develop the next generation in the management of digital images. This was to become

the Digital Image Archive and Retrieval System (DIARS), something I had been thinking about and talking about to anyone that would listen, for some time. The fact that we could now deliver it at magazine quality was an added bonus. Prior to that date, most of the development effort had been concentrated on scanning and transmitting images for instant use, but this programme was a ground-breaker. It would create a system that could store images long term with all their captions and metadata, allow the archive to be searched and individual images retrieved for use. Essentially, that was what all our photo editors and picture researchers did every day, sifting through thousands of transparencies in large filing cabinets, but now it could be done digitally.

The next six months were frantic and, once again, the Olympic Games was the driving force behind our development. This time it was Barcelona at the end of July 1992, when I was desperate to have a working version of our Leaf system to demonstrate. This required many visits to Boston and New York for planning meetings with Leaf's programmers to modify and improve the AP system to meet our specification. Not everyone within the AP hierarchy approved of this unusual teaming arrangement with us, but what finally tipped the balance our way was purely client-led demand. It happened because several AP member papers wanted to receive our images and written into the oldest rules of association in the industry was that AP was obliged to transmit third party content to a member newspaper on request. The fundamentals of this principal were established in a Supreme Court ruling of 1900; 'that Associated Press was a public utility and therefore barred from any form of restraint of trade'. It's something I've always admired about the American people. When anything is deemed as or in public ownership, the military or the space program for example, they really mean public ownership and the benefits filter into the commercial world, mainly free of charge. We all benefit from many of the technologies that the American taxpayer funded, of which the Global Positioning System is the most obvious, but you will find thousands of examples if you look around.

The Leaf team were very keen to have us onboard: although AP was their biggest customer, they didn't want an application that was designed primarily to support any single use system or client, as this would put difficulties in the way of commercial exploitation. Having us on board gave them another perspective on decision-making and wider industry acceptance, as we were driving the digital imaging timetable. When we first got involved with Hasselblad, they came to the party with a finished product. All we had to do was figure out how it would all fit together in

a fast-moving and mobile working environment. Now I was in, if not on the ground floor, certainly early enough in the technical planning process to impact the design and shape of the final product.

Deciding on the hardware to be used was the easy bit, so we ended up with standard industry kit. IBM RS6000 file servers and 20-inch Sony Optical discs for mass storage, the hardware initially all to be housed at Leaf Systems as they developed the software. In Santa Monica, we immediately started a high-resolution scanning program of the full set of preview images for the Barcelona Olympics with the Leafscan 45, so we could populate our new digital archive before the games began. The plan was then to feed the archive in real-time during the games so we could demonstrate it to our newspaper clients and, for the first time, our magazine and book publishers. It was the software that was the challenge. We needed to define what metadata was going to be needed, what image resolution could be stored, how to move images through the system and how to display them.

Our view and that of AP on what was needed in all these areas differed, but we both benefitted from the exchange of relative requirements. AP's knowledge and discipline for handling large quantities of data over telecoms was hugely impressive, but they didn't have to sell the pictures at the other end; we did. We added different ways of viewing the images, increased the metadata and added much more sophisticated keyword search capabilities. In the end it worked for all parties as we ended up with a real-time digital archive that could be updated from a 'live' feed, or a high-resolution scanning program. This could be searched and queried while this was happening and then its images downloaded anywhere in the world at various resolutions with all the attached metadata.

Scarily, we had only months to make all this happen, but when we launched it at the Barcelona Summer Olympics it was probably the first time anyone had seen a working digital picture archive. As a precaution, it was housed at Leaf Systems in Boston to allow their engineers to monitor its performance and troubleshoot any issues in this very beta software. The archive was populated with all our preview images on venues, fans, history of the Games and sports stars, and we were feeding it directly from Barcelona with new live images every day. Demonstrating it to all and sundry, we had a few US newspapers beta testing with us, searching the database and downloading images directly into their system for use. I can't claim outright that it was the first digital archive and retrieval system, as many people and organisations were working on these ideas at the same time and often in a very collaborative way, but it's still intriguing to

think that many of the protocols that underpin today's vast online photo archives were decided in those few months. Launching this system in Barcelona once again ramped up the arms race with our competitors a further notch. It also helped that AP was keen to showcase it at the Olympics, so now we had kudos by association with the world's biggest and most respected media agency.

I was becoming part of a group of people on both coasts of America that could see the future and wanted to ride the tide: Alan Adler from Sammy's Cameras and Paul Harris, the owner of Online USA, a celebrity photo agency, both based in Los Angeles and on the East Coast, Steve Fine from *Sports Illustrated* and Kevin McVea from Scitex. All were dedicated digital evangelists. To say that advancing technology was opening up many new opportunities for us photographers is a bit of an understatement and there was also a good deal of cross-pollination of ideas. Scitex had started life initially as a supplier to the printing and publishing industry and by 1979, was selling advanced systems for correcting colour separations and preparing photographic film to be run on printing presses. I had become aware of them back in 1988 when they had worked as a technical provider to *Sports Illustrated,* and had always looked like a company driven by new ideas and with the hots for acquisitions.

In 1991, Leaf Systems had introduced its first medium format digital camera back, with a resolution of 4-megapixels which they christened the DCB1. The rest of us working photographers had nicknamed it 'The Brick', because of its size and weight. It was their portfolio of desktop and portable scanners, filmless cameras and pre-print systems that had made them a target for takeover and early in 1992, Scitex obliged by buying them for around US$30 Million. Though this is not a history of the far larger and more complex story of the digital image revolution, I was proud to count myself amongst the growing number of technical front runners. There are two small but interesting historical footnotes. By the time of the Scitex/Leaf merger, 27% of Scitex stock was owned by serial book, magazine and newspaper publisher and pension fund raider, Robert Maxwell. Though we only played a small role in that digital revolution, when a US representative of Reuters allegedly walked into Sammy's Camera in LA, the largest source of digital know-how at the time, brandishing a cheque book saying I want the system that Allsport has, we realised that we had got our bit of it about right!

The two major events in the year were the Winter Olympics in Albertville and the Summer Games in Barcelona. Both were to add more logistical challenges than photographic opportunities for me, as

our teams got bigger and our technological offering more complex, so it needed more and more of my time. Although in the shape of Dick Scales I had an Operations Manager who handled most of the pre-event preparations, running the media operations during the event was very much down to me. Late in January I flew back to London to help with the final preparations for Albertville and then drove over with an advance team to oversee the office build-out. By the opening ceremony, that team comprised 36 photographers, editors and technicians.

At the moment the tiny town of Albertville in the Savoy region of France was selected as host, some wag mentioned that nothing dragged a place out of obscurity better than hosting the Olympics, yet only some of the skating, together with the opening and closing ceremonies, actually took place in Albertville. The remaining events were liberally scattered around the local villages of Courchevel, La Plagne, Les Arcs, Les Menuires, Les Saisies, Méribel, Pralognan-la-Vanoise, Tignes and Val d'Isère, so coverage was a bit fractured and organisationally fraught. I spent most of my time at our office in the main Press Centre in the village of

If sport couldn't come to us, then we had to go to the sport. Modern technology allowed us to rig a truck to become a mobile colour processing and transmission centre, which certainly helped us cope with the logistical nightmare of the Winter Olympics in Albertville.

Photo: Allsport Archive

La Lechere, halfway up the mountain between Albertville and Val d'Isère, trying to co-ordinate the efforts of our team. They were spread over 10 towns and villages to cover 57 gold medal events in 13 different venues, all accessed via tiny mountain roads, randomly populated by French drivers. A recipe for disaster you could say, but we survived.

The highlight of the Games for me was when I managed to get out of the office for the Men's Downhill. I had photographed all the main skiers from my position high up on the course, when Jean-Claude Killy joined us, now co-president of the Albertville organising committee. Some of the French photographers knew him well, so there were introductions all round while we waited for the final skiers to descend. Last skier to appear was the Senegalese, Alphonse Gomis, later described accurately, if uncharitably, in the *Washington Post* as, "...the one you may have seen on the highlights, doing unplanned cartwheels, nosedives and slides down the hill." As he came past, very slowly, we all put on our skis and followed Jean-Claude Killy down that famous piste, La Face de Bellevarde, keeping pace with probably the slowest competitor in Olympic history. He did not finish, as he had to stop and de-fog his goggles; we did, all following Jean-Claude Killy through the finish line, in front of cheering crowds.

Once again, the Games were a success for us, but I wasn't happy about the fact that I was still overwhelmingly tied to operations and, much as I enjoyed it, I felt I needed to move on. I knew how to run an Olympics operationally, and what Allsport needed was somebody else to learn those skills. I had to find a way for someone to take over this role, but as it was changing so fast and encompassed so many disciplines, finding people with the correct skill sets was difficult. When we got back to London and before flying home to California the next day, I had dinner with Lee Martin and Dick, during which I explained my problem and how I thought we could tackle it. I would slowly withdraw from operations at these major events and I wanted Lee to take over. He had been with Allsport since the age of 16 and had both the client knowledge and the respect of the photographers and editors. Now just 25 years old and a veteran in Allsport terms, there was very little he didn't know about our operations. He would be supported by Dick, who would continue running the IOC sponsor services programme, while using his experience from the last few majors, Olympics and World Cups, to compile an all-encompassing operation's manual. Done as only Dick knew how, this should allow Lee or anyone else to take a team to a major event, set it up and succeed in delivering. We would use the upcoming Games in Barcelona as the template. To soften the blow, I promised Lee that I would

carry on until Lillehammer, still two years ahead, and that removed any concerns about the handover later in the year. Unfortunately, it didn't quite work out like that, and events would conspire to drop him in at the deep end!

Against this backdrop of putting the future operational management of the company in place and coupled with other commitments around the Games, I had been away from Beans and the girls for seven weeks, the longest trip ever since our marriage and I'd missed them a lot. It was always difficult slipping back into family life from the inevitable high adrenalin-pumping events, but Beans understood and always managed things in such a pragmatic down-to-earth way, that she made it work. She and the kids also put up with my hobbies! Even before moving full-time to California, I'd enjoyed going into the desert and supporting my brother Stuart, the off-road motorbike racer, and I'd try to time my visits to coincide with any big race in which he was competing. For me it was the ultimate drop-out, a way of completely relaxing and meeting people who had absolutely no idea about my business, but as sure as eggs are eggs and encouraged by a few of those new friends, I was very soon tempted to try it myself. They, like Stuart, had been riding dirt bikes and desert racing since their teenage years and were pretty good at avoiding accidental damage. I had no illusions about my skill set, but I was prepared to give it a try.

I had ridden motorbikes when I was younger, but never off-road, so this would be something new. My 40th birthday was fast approaching, and some less charitable friends might suggest, indeed did suggest, that I was suffering from a little middle-age crisis; and they might have been right. It was certainly not a sport that was obviously compatible with my duties and responsibilities as Chairman and Chief Executive of the Allsport Group, but for me, it was another challenge that needed exploring. Which, in a roundabout way, explains why I arrived in Barcelona slightly embarrassed and on crutches, having seven days before broken multiple bones in my left foot and torn all the ligaments around the ankle. On the positive side, it put Lee very much in the hot seat, which pressure I have to say he handled well, as I expected. I spent the entire period of the Games in our office in the main Press Centre with my foot up, offering seasoned advice, or barking orders, depending on perspective.

Although I didn't get out to any of the sporting venues, I knew them and Barcelona pretty well, having been there several times on IOC site visits in the run up. In the Basque region of Spain and the birthplace of IOC President, Juan Antonio Samaranch, these Games brought about

a remarkable regeneration of the city. Encouraging billions of dollars of investment in infrastructure, roads, new airport terminals and the construction of the Olympic Village and port, it opened up the city to the sea, much of which I got to see under development during my visits. All of this vastly improved the quality of life for the local population and made it a go-to place for tourists. It was also the musical games, with the unlikely duo of Montserrat Caballé and Freddie Mercury booming *Barcelona* out over the opening ceremony, though Mercury was dead by then. The Games ended with the equally unusual pairing of José Carreras and Sarah Brightman closing with Andrew Lloyd-Webber's *Friends for Life*. How times change. For Allsport, Barcelona was truly a great Games and probably the first in which I felt we weren't scrambling to keep our heads above water. We had a plan, the guys implemented and delivered it, and I could sit back a little and see it in action. Even though I say so myself, it was impressive. Once again, they all proved that they didn't need me, and nothing made me happier.

20

EXPONENTIAL GROWTH

One of the greatest truisms in life, business life especially, is that success breeds success. If this was true for Allsport it was particularly so in 1992 and beyond, after the high point of the Barcelona Olympics. Doors opened and opportunities and commissions seemed to pour in, which inevitably linked to an exponential growth in activity and income. Suddenly, everyone seemed to have the confidence to try out new things, explore new markets and ask for a higher fee, and it appeared that we were all coming of age.

Back in the eighties I had hired a team of talented young people, all of whom showed a passion for their chosen sports and all of whom wanted to work for Allsport, which they saw as the market leader. By now, many of them had been working with me for 10 years or more, so they understood what I expected of them and what latitude they had in decision-making. My rules were simple and oft repeated. The worst kind of decision was no decision. Even if the decision made turned out to be the wrong decision, provided it was made in good faith and reported immediately, we would attach no blame; we could always find a solution. The final bit of my mantra conveyed to all the team was that any attempts at CYA - covering your arse - would be punished mercilessly. Armed with these fundamentals, we had young photographers flying all over the world covering international sport, initiating deals, setting up sales and making major financial commitments, taking responsibility for their own sport. No-one demonstrated this more than one young Frenchman.

We were always looking for new, young talent who, when trained, could take over the sport in which their work excelled. That's how we

expanded, one sport at a time. One morning a young Frenchman walked into our London office and asked to see me. Introducing himself as Pascal Rondeau, it became apparent that he could barely speak English, so alongside my schoolboy French, the going was slow. He explained that he wanted to be a sports photographer and work for Allsport, and asked if I would look at his work. This wasn't unusual and I always took the time to look. His work was good, but I explained he had a long way to go and he wasn't really ready for us yet. He thanked me and left, but returned a couple of weeks later, with the same request and some new pictures that he had taken. This went on for most of the summer. Every few weeks he would show up and we would go through the same process, but he was polite and obviously trying hard, so I didn't discourage him. I discovered that he had found a job in a French restaurant in London just so he could pursue his goal of becoming an Allsport photographer. During these visits and our times together, he had smiled and nodded a lot as if he understood what I was saying, but I only discovered later that he had a tape recorder in his pocket recording my critique so that his girlfriend could translate my comments for him later. Enterprising, non?

While his work did show signs of improvement, at the time I couldn't see a way of bringing him on board, but that changed a few weeks later. I was photographing athletics at Crystal Palace, where access to the infield was much prized amongst working photographers. Suddenly, up popped the young Frenchman! When I questioned how the heck he had managed to get into that Holy of Holies, he grinned and said he had lied, by saying he was shooting for *L'Equipe*. Admiring his chutzpah and based upon his initiative and some evident latent talent, I offered him a job on the spot. It transpired that he had been born near Le Mans and had a passion for motorsport, so we teamed him up with another motorsport nut, Picture Editor, Darrell Ingham, again one of our recent hires. Their task was to break into the motorsport market generally and Formula One in particular. It was a well-tried model: first year – big investment in time and money, second year – breakeven, third year – profitable. Then, if all went to plan, they would go on to be the market leader. In less than three years, Pascal and Darrell were market leaders. Passion, commitment and patience was all it took.

Some years later when Nigel Mansell moved on to compete in the Championship Auto Racing Teams (CART) Series, for open-wheel car racing in the US, rebranded in 2002 as IndyCar with a more international series, the world's media was watching him closely. He had taken Michael Andretti's seat in the Newman-Haas Racing team, alongside

Mario Andretti who was vastly more experienced on oval tracks and although he'd had a long and distinguished career in Formula 1, culminating in becoming World Champion in 1992, the pundits thought he would find CART very different. His first race was at Surfers Paradise in Australia, a traditional circuit which would suit him better and very different to the ovals that hosted most of the rest of the season in the US. His first major test on an oval track would be two weeks later, in Phoenix, Arizona.

When we discussed how we might tap into this global interest in Mansell it was pointed out by someone that we had perfectly good and talented photographers in Santa Monica and Sydney, both just US$50 flights from most of these events. Why were we even considering incurring the extra cost of flying Pascal out from London, on an around-the-world ticket that would cost close to US$2,000? This debate bounced back and forth between the offices that were rightly concerned about expense, but Pascal wanted to go and, for me, that was the end of the debate. He was responsible for his own bottom line, as was every Allsport photographer, so if he thought that he could turn a profit, so be it. Pascal headed off to Australia to cover the first race, in which Mansell duly obliged by becoming the first rookie to take pole position and win his first race. Then the teams and media circus, along with Pascal, decamped and headed for Phoenix.

I left home with my family to visit Grandparents in the UK and then take the kids skiing in Meribel and once in France, I thought nothing more of it. That was until the following Monday morning, when I wandered down to the village to pick up our daily baguette and the Sunday papers that had been flown in the night before. Mansell had crashed during practice on only his second oval circuit outing and every UK newspaper and quite a large percentage of the European ones, had the incident spread large over their front and back pages. It was the same picture of the crash in every case, carrying the byline, 'Pascal Rondeau/ Allsport'. It was a spectacular image, beautifully framed, showing flames, tyres and bits of car flying everywhere after Mansell had predictably hit the wall at over 170 miles per hour. I knew that there must have been close to a hundred photographers at the event and, as it was an oval, they would mostly all be in the same positions. I also knew that Pascal was probably using the wrong lens to get good tight action images, so I phoned him and asked him about it. His response was a typically Gallic classic: "I knew three laps before that he would crash, so I changed lens and waited." None of the other photographers standing around him were bright enough to have got that shot.

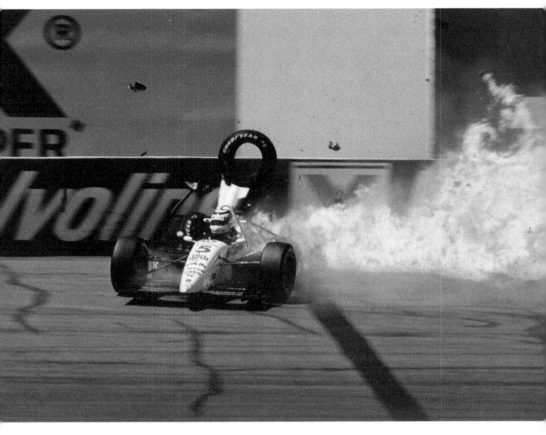

Taking classic action pictures requires a combination of understanding what the camera can deliver and finding the right position to use it. Pascal Rondeau's knowledge of motorsport showed with this image of Nigel Mansell crashing out of practice in only his second CART race in Phoenix. Pascal knew it was likely to happen and where.

Photo: Pascal Rondeau/Allsport

Then I called London and spoke to Lee Martin, who told me that in the first 48 hours following the accident they had made about £70,000 (the equivalent of £150,000 today). Slightly stunned, I enquired how. Lee's response was equally classic: "We sold it to everyone as an exclusive for £5,000 each and explained that the exclusive fee was to make sure they weren't exclusively the only newspaper not to have it." Now that, I thought, was thinking on your feet: in both cases it proved investing in talent pays off and rather confirmed the wisdom of our decision earlier that year to make Lee a Director at the tender age of just 26.

The accident had forced Mansell to withdraw from the Phoenix event with a bad back, but typical of the man, he bounced back by leading at Indianapolis, before finishing third to Emerson Fittipaldi and Arie Luyendyk. He was awarded the Indy 500 Rookie of the Year award and won five more races in the series, with four on ovals, to take that year's CART championship title. No slouch he!

Over the next two years, Allsport was to achieve critical mass, for everywhere you looked, there we were with our byline prominent. Our photographers covered every major sports event in the world and a full schedule of domestic sport in the UK and USA, plus quite a few more exotic events. As just some examples, we had a team following the Whitbread Round the World Yacht Race, dropping into each port ahead of the competitors, hiring helicopters to cover their approach and picking up film from some of the boats for syndication. Nathan Bilow became our man on the Raid Gauloises in Borneo, an extreme event covering multiple sports in extreme conditions; he was eventually to cover six raids and survive. We photographed Elephant Polo in Thailand and horse racing on ice in St. Moritz. On one story alone, the preview for the World Cup, in one month Shaun Botterill was in Ecuador, David Cannon in Zimbabwe, Simon Bruty in Senegal and the Ivory Coast, Dave Rogers in South Africa, David Leah in Bolivia, while Ben Radford covered the Asian qualifying finals in Qatar.

Our photographers dominated every photographic award presented worldwide and slightly embarrassingly, bearing in mind our role with the IOC, we also achieved a clean sweep in their coveted Best of Sport Photographic Portfolio in 1993. Pascal Rondeau taking first place from Shaun Botterill and Mike Hewitt. In that same year, we also took the top three places in the UK based Nikon Sports Photographer of the Year with Bob Martin beating Chris Cole and Simon Bruty. Most of these guys were relatively new to Allsport and all deserved the accolades, but one of the most memorable was taken by David Leah. Our man in Mexico was awarded the 'Goddess of Light' trophy, which was quite remarkable really, as it was for a competition he hadn't even entered. The organisers thought his body of work that had appeared in the Mexican media was outstanding and, on that arms-length basis, named him Mexico's Sports Photographer of the Year!

That, and many other awards from around the world that year, attested to the strength of the team we had put together and it seemed at the time that every aspiring sports photographer wanted to shoot for us; obviously our formula was working. To me it just seemed obvious. If you promoted

the hell out of your photographers by insisting on named bylines on every picture used, this increased their individual commercial value and by extension, the clients' perception of value when using their pictures. It also kept your photographers happy and boosted their confidence as remarkably, we were still the only agency stipulating our photographers' credit on their published pictures. All the others requested that only their agency name should appear, which we thought was short-changing the talent and short-sighted too.

Whilst our team was quartering the world making themselves famous, my life continued as a commuter, but now I also had a New York office to visit. I had tasked Darrell Ingham to set it up and initially he worked alone out of a small apartment on Park Avenue South, which was not as grand as it sounds, but he very soon established a vitally important sales hub. The thing about Darrell and the reason I asked him to set up the NY sales office, was that he wasn't in any way a salesman. Quite the opposite. He was a picture editor first and foremost, loved pictures and importantly, was passionate about Allsport. He was the one person I knew that really understood our ethos and would never jeopardise our brand just for a sale.

His attitude to the company and my confidence in him were perhaps best illustrated in our annual rounds of performance and pay reviews. Back in the days when I used to do these personally on a face-to-face basis, it was generally accepted that you needed to enter the fray well prepared to argue your case, as occasionally, these review meetings became quite gladiatorial. When it came to his turn, Darrell famously announced as he walked into my office: "Let's cut to the chase, I will never leave Allsport, so whatever you decide I'm worth, I accept." I'm still not sure whether this was a cunning ploy, but every subsequent year he played that card and psychologically he always won; just a little! I must admit that back in the day I was still a little paranoid about salespeople and looking back, my paranoia was twofold. One was that I hated the idea that through over-selling we would disappoint a client. The other was simply that I felt that the moment you created a sales department, everyone else in the company would wash their hands of any sales responsibility. Although we had people in London who were rightly regarded as salesmen, Lee Martin clearly being the most important, I had never hired a person specifically for sales, never created a formal sales title, nor had we ever had a department exclusively for sales.

The idea had always been that everyone in the company, photographers through to library researchers, editors and even darkroom technicians, had a sales role. The concept that every individual could come up with

leads and act upon them, selling into their own specific areas and markets, had underpinned our development and growth. Diluting that was not something I could be happy with. I wanted our clients to discover Allsport slowly and that our product would always be good enough to sell itself. When clients really understood who we were and what we could do for them, they would often remark: "You guys are the best kept secret in sport." Strange perhaps, considering how much marketing we did and how high profile we were, but it was more an expression of the client's acknowledgment of our approach and ethos and it always led to close and long-term relationships.

A couple of years later, a young man from New York was recommended to me as a possible fast-track introduction into the Major Leagues and the trading cards business, which was huge in the nineties. Of mixed Polish/Italian extraction, Peter Orlowsky had all the charm of a typical New Yorker and was very much a salesman. To be frank, the thought of unleashing him on our clients terrified me, but the markets he would target were different. I didn't understand them, so I hoped he did. After interviewing him on one of my trips to NY, he came to the West Coast for a second interview, after which I offered him the job, with the caveats that he and his wife move to LA and his desk would be right outside my door. He accepted the job and the caveats and for the next two years, sat close enough to my desk for me to hear everything that was going on.

Some people suggested that my tendency to control freakery was now truly out of sight, but Peter later told me a story that made he and I realise why it all happened. One day, after another frustrating time pitching to sponsors to hire us for some event or other, he stuck his head into my office and asked: "Am I doing this all wrong?" My reply was simple: "I don't know mate; I am learning from you every day." And I was. I'd finally laid to rest the ghost of my mobile home selling days; good salesmen and honest transactions are vital for a growing business. Peter went on to be one of the finest sales and marketing operators in sport. Now working at Getty Images as Senior Vice President of Strategic Partnerships, I like to think that the strategic partnerships part of that title came from our relationship in the early years. Possibly even my pathological distrust of any deal that does not benefit both parties. All long-lasting deals are really a partnership between vendor and buyer, or they should be.

Another important hire that year was my appointment of John Witts as Group Finance Director. Based in London, John was a sports fan and had worked for *The Observer* in that same role, so he understood the media industry. His private briefing was to prepare the agency for sale. It

was a difficult appointment, as Mavis Streeton who had started life with us as our bookkeeper and had moved up to be a Director and Company Secretary of Allsport UK, had given us many years of loyal service. A key part of the team on whom I had relied totally from the early eighties, I was now asking her to report not directly to me, as she always had done, but to a corporate appointee. Growing pains always come with expansion, but ultimately, she came to understand that to prepare ourselves for the next move towards a possible sale, we needed to be seen to be strengthening our financial governance.

Our technological dependence also required constant monitoring. System developments were growing apace, and part of that development of the Digital Image Archive and Retrieval System with Leaf Systems had us move all the hardware from Leaf to our own offices in Santa Monica. It hadn't all been plain sailing since demonstrating the system in Barcelona. Like all new technology, it was often one step forward and two back, so in our eagerness to solve several operational glitches, we occasionally drove up blind alleys and into dead-end streets. In discussing our system with others in the trade, the assumption was that we would be able to happily dash off and digitise our archive of a sizeable proportion of our 4 million images to replicate our existing analogue systems, but we soon found out it wasn't that simple. First, we wanted this system to grow and serve our wider book and magazine publishing clients, for whom resolution was everything. Thus, everything we scanned live at events simply wasn't good enough for long-term storage.

Captioning and creating keywords for every image scanned had to be extensive and accurate, otherwise in the huge image database that we planned we would lose photos and simply never find them again. In the aftermath of Barcelona, we had wallowed in the glory of being able to do stuff, but now, just six months later, I realised that while both hardware and software worked, we needed to find a way of making it work without it costing us a fortune in man hours reworking each image. The first decision was to bite the bullet and re-scan every image we had already scanned, to an even higher resolution: the kind of resolution that we hoped our book and magazine publishers would be happy with 10 years ahead or more. The second was to find a solution for the back-breaking task of keywording and captioning.

Having made a substantial investment in technology, we had begun attending large trade shows in Europe and the US, notably Newstec and Digital '93, demonstrating our system. The hope was that this would help speed up the conversion to digital in a still cautious industry that was just

coming out of another major recession. Bob Martin, Director, award-winning photographer and digital evangelist, led the team in Europe and I led our showing in the USA. Our bigger goal was a full launch to our clients later that summer, by which time we hoped to have 20,000 high-resolution images in the archive, all fully captioned and keyworded. Even this number represented an enormous investment in time and effort. With teams in both London and Santa Monica working twelve hours a day and seven days a week we could barely manage a modest 500 scans from each office each week. Do the math.

We weren't alone. As the digital revolution evolved, almost every newspaper and magazine publisher found itself with a massive archive of back-catalogue material stored on everything from negatives, prints, discs and even microfiche, all of which needed to be scanned in high-res to make it stable, storable, accessible and, most critically, saleable. It was the motherlode, but only if it was dragged kicking and screaming into what was then the 20th Century. It was Scott Brownstein of Applied Graphics Technology (AGT), a partner company in some of our earlier developments, who was instrumental in showing us the potential of an operation called the Electronic Scriptorium. Even now, this still looks a little surreal, as it was populated entirely with members of closed holy orders.

We ran across this religious resource at one of the shows we attended. I freely admit that until that moment, the word scriptorium had been entirely absent from my lexicon; even the scholastic activities of monks and nuns had largely passed me by. However, a little inquisitive research revealed that from their inception, most holy orders had seen it as their duty to gather important documents, both spiritual and temporal, and copy them for wider distribution. This took place in a room called a Scriptorium, quite literally a place of writing. Without the more recent benefits of photocopiers and scanners, monks would produce original documents and copies by toiling laboriously with quill pen on parchment or vellum, to deliver everything from elaborately illuminated religious tracts and bibles to more prosaic land records, maps and contracts of sale.

If I thought that the concept of an online network of monasteries, nunneries and priories sounded surreal, how it came into being and how it came to help Allsport was even more so, involving everything from the US Federal Court to a company making fruit cakes. Back in the 1980s the process of accessing and archiving the court records system was creaking and it fell to Everex Systems' Ed Leonard to manage a US$130 Million project to automate it. Away from this daily grind he became marginally involved in a land dispute in the Blue Ridge Mountains, which threatened

A big issue when we moved to our digital image archive and retrieval facility with Leaf Systems was to embed all the correct captioning and keyword metadata on the hundreds of thousands of pictures. We solved this labour-intensive task by employing teams of cloistered monks and nuns in what was known as the Electronic Scriptorium.

Photo: Alamy Archive

the peace and tranquillity of an abbey of 30 Cistercian Trappists. After discovering what made monks tick in the modern world, he offered to write a programme for their small network of computers, which had been donated to help them with the records of a fruit cake business that supported them.

Always looking at the bigger picture and realising that every religious house had spare capacity within its intelligent members as well as the need to generate cash to support themselves, Ed quit his job reorganising court records and helped create what he christened as The Electronic Scriptorium. He progressively replaced stools, quill and parchment with ergonomic workstation chairs, IBM machines and a customised suite of software. All of this brought together Benedictine monks in New Mexico, cloistered Dominican nuns in Texas and monks in Berkeley, California. All co-operating to catalogue the vast 2 Million items in the photographic archive of the New York Daily News, the problem with which Scott Brownstein and our colleagues at AGT were then wrestling.

However unlikely it may have seemed at first glance, this religious workforce was just the resource that I needed to break the slow and labour-intensive process that had gripped our offices and get Allsport's back catalogue scanned and ready for market. Even without a nod from the Deity, the monks came highly recommended, so we contracted them to do all metadata and keywording for our digital archive. The process was simple. We would ship our high-resolution scanned images to them on compact discs, they would add all the caption and keyword information digitally and return the finished product to us for uploading. It may seem to have still been a bit of a clunky process, but for many years it was to prove the most efficient and cost-effective way for us to get our back catalogue into our digital archive system.

In June it was the inauguration and opening of the IOC Museum in Lausanne. This was a major undertaking and the culmination of the project initiated by Michael Payne to cover the evolution of the Games by harvesting every available still and moving image. At that time this amounted to around 200,000 still photographs and 10,000 hours of film, plus all manner of Olympic memorabilia, now housed in a magnificent auditorium on the side of Lake Geneva. We had been heavily involved with Michael and this project from the outset and had contributed a large portion of the stills archive. Sensing an opportunity to showcase our technology to a wide and influential audience, we also installed a digital picture desk at the museum, giving them direct access to our ever-expanding digital archive.

I attended the opening ceremony in my capacity as a member of the IOC Press Commission and was back on duty in Monte Carlo in September for the announcement of Sydney as host city for the 2000 Games and it seemed to me that everything was slipping into place. In retrospect, I couldn't have asked for a better lineup of major international sporting events to aid in Allsport's trajectory towards wider recognition and a potential sale. The Olympic Games at Lillehammer in 1994, Atlanta in 1996, Nagano in 1998 and Sydney in 2000, dividing Winter and Summer Games, was designed to maximise the commercial potential for the IOC and the TOP programme, and it was clearly going to do the same for us.

One event that would need all our planning skills was coverage of the 1994 FIFA World Cup and in July 1993, we were appointed official photographers to the US Soccer Federation, which further helped pump up our profile in North America. I had always been keen to see Allsport recognised on as wide a stage as possible by showing the quality and

The second Visions Of Sport compendium celebrating our twenty-fifth year milestone was launched at London's Design Museum and re-united Tony Duffy and Bob Beamon. Pictured here alongside me were (L-R) my father Mike, Bob Beamon, Tony Duffy and my brother Mike.

Photo: Allsport Archive

creativity of our team. We had scored major brownie-points back in 1988 when we published *Visions of Sport*. What worked then might work equally well at our 25-year milestone, so *Visions of Sport 2* was born, but our first book and its coverage was going to be a hard act to follow. Realising that trying to increase our media profile was going to be a challenge, I went back to basics, doubling up on the Duffy/Beaman story. This time, I flew the legendary long jumper over to London for the book launch in London's Design Museum, overlooking one of London's most iconic symbols: Tower Bridge.

When we launched the book to around 500 guests from the world of sport and the media, Tony was reunited with Bob, the two men who had inadvertently set us all on our course with Allsport. Among the people whose sporting prowess we had been happy to chart and record over the ensuing years were Nigel Benn, Tracey Miles, Alec Stewart, Daley Thompson and Tony Underwood. It's fair to say that the launch party was a big bash, and the book featured the very best from our photographers over the preceding 5 years. It also did much to underline the direction in which my career was going: of the 140 images featured on its pages, only two carried my byline. Doubtless I missed the buzz of seeing my pictures published, as when most of your contemporaries are photographers, you are judged by that, but honestly, I was now high on the creative buzz of building a global company; everywhere I looked in our organisation I could see traces of my planning and handiwork. Like a good ship's Captain, my job now was to wander around the globe visiting our ports of call and scanning the horizon for opportunities and danger.

21

WELCOME TO CALIFORNIA

It is almost inevitable that anyone in any position of hands-on authority or responsibility running a small to medium-sized company tends to concentrate most on their business, often neglecting their homes and families. Not intentionally, nor admirably: it just seems to happen. Deadlines come rushing forward, targets need to be met, contracts tied down… all the other aspects of personnel management conspire to fill the time available, and then some. I had always tried to keep clear blue water between my job managing Allsport and my family, as I loved both, but frequently there was overlap. Not least when I uprooted my wife and two young daughters from our home in London and planted them on the side of a Californian canyon.

From the outside, it might appear that Californians are just living the dream. Where we lived, the sun shines 300 days a year and enjoys a coastal Mediterranean climate and the living is, if not easy, certainly laid back, but for every upside there is a downside lurking in the background. West Coast residents had lived forever in an uneasy truce with the San Andreas Fault, which continues to regularly produce earthquakes and land tremors that rock their world. Best documented in modern times was in 1906, where the Bay area of San Francisco was hit by a quake estimated later at 7.9 on the Richter Scale, but you can bet the farm on California doing things higher, wider, more handsomely, if not always better. Where wildfires, earthquakes, landslides and the odd social disturbances were not unusual, in our time there we experienced them all. We saw riots in 1992, wildfires in 1993, but 1994 was entirely different, and not in a good way. More of that later.

By April 1992, we had been living in California for less than two years when we came face to face with the phenomenon of civil unrest, which, especially for a family from London's suburbia, was something of a culture shock. For over a year there had been simmering resentment between the African-American and Korean-American communities in South Central Los Angeles. An incident involving four white police officers using undue force during the arrest of an African-American, Rodney King, was (unfortunately for them) filmed by a bystander and then posted on coast to coast television news. Immediate outrage was stoked further when one year later, a jury acquitted the officers. Then the lid blew off. The rioting that followed lasted for six days. It accounted for the deaths of 63 citizens, injured a further 2,383, prompted the arrest of 12,000 people and ticked up a bill of over US$1 Billion for damage to property, mostly in Koreatown. Widespread looting, assaults and arson prompted the State Governor to call in the National Guard and 2,000 soldiers to close the rioting down. Although the trouble was not immediately near us, we could smell the smoke from our house and discovered all our neighbours were armed to the teeth, as they set up patrols every night in our sleepy little suburb. Despite my army background and familiarity with firearms, it came as quite a shock to see our friendly and, in some cases, quite elderly neighbours, armed with what were clearly semi-automatic weapons. Welcome to America and the Second Amendment of the US Constitution!

1993 produced a fresh challenge. On 2nd November, I had just flown into the UK on one of my regular trips to Allsport's London office and settled down in my usual room at the Petersham Hotel when I was interrupted by a phone call from our Santa Monica office. I might like to turn to CNN if I had access, as Calabasas was in flames and our house was featured on television. I found the right channel and boy, were they right. There was my house and behind it, covered in smoke and flames, was the other side of the valley at the top of Old Topanga Road. I watched and listened as the news anchor was making it clear that the Calabasas fire was out of control. I immediately started calling Beans on our landline and her mobile, but there was no answer from either so I called the office back and spoke to my brother Mike, who gathered up brother Stuart before heading off to our home to see how they might help. This was assuming that our home was still standing!

Beans was shopping in a mall in the San Fernando Valley when a disturbance outside a TV shop alerted her to the fires. Although our 4-year-old daughter, Sophie, was at school in the Valley and therefore

safely out of harm's way, 6-year-old Lucie wasn't, as she had just started at Bay Laurel Elementary School in Calabasas, right at the top of the ridge that was burning. Beans is notable for keeping her cool through most of the things I had thrown at her over the years, but understandably, was in something of a panic now and set off to try and collect our daughter from school. Unfortunately, as happens in these situations, everyone was rushing to rescue someone, or just get out of the firing line. She was immediately caught up in gridlock on the freeway and spent the next two hours repeatedly trying to contact the school as she edged slowly forward. Getting no answer, she had to make do with looking up at the Santa Monica mountains as they burned, while the smoke just got worse.

Now I cannot imagine the anguish and fear that a mother might experience in this situation, but she coped again and as she remarked later: "I didn't have much choice, really." Over two hours later, after what should have been a ten-minute journey, she joined a long queue of cars at the school with parents collecting their children. Fortunately, the school had an incident plan to cope with wildfires and it was working. Although there was a lot of smoke, there was no obvious evidence of fire, so Beans calmed down a little while waiting her turn. After picking up Lucie, she faced the traffic again to collect Sophie and eventually headed home, to find Mike and Stuart standing there with garden hoses at the ready. Strangely, the girls thought this was all a great hoot, especially when they learned that they, our golden retriever, Charlie, and the rabbit, were all to be evacuated to a friend's house.

Eventually I managed to talk to Beans and told her I would be on the first available flight home, so after a sleepless night and eleven frustrating hours in the air, we made our final approach into LAX. The normally beautiful view looking over towards the Santa Monica mountains was just an ominous mass of thick grey smoke. I'd been out of touch for eleven hours and anything could have happened but coming out of the terminal I was relieved to see my usual driver waiting for me. Even before his customary greeting, he blurted out: "It's OK, Mr. Powell. I drove up to your house this morning, and all's well. Your brothers are there."

What had begun as a local story had swiftly morphed into major international news and all forms of media were now fully engaged in covering the escalating story. As a stringer for the *New York Times* reported it:

"A fierce fast-moving wall of fire roared down from the Santa Monica Mountains to the Pacific coast today, incinerating canyon ranches, hillside mansions and some of the multimillion-dollar estates of the exclusive oceanside town of Malibu. Late this evening, the fire jumped the Pacific Coast Highway, and thousands of fleeing residents clogged the highway, the only reliable way out of the area. The authorities ordered the evacuation of most of Malibu, and Coast Guard cutters assembled offshore, preparing to evacuate people in case the Pacific Coast Highway was cut off. The fire, which started just before noon has consumed about 20,000 acres of prime coastal real estate and at least 125 homes in a 12-mile section from the Santa Monica Mountains to Malibu, including Topanga Canyon, a New Age mecca of old wooden houses and bridges, and quickly spread south and west toward the Pacific Ocean. The fire was moving at 15 to 20 miles an hour, outracing fire trucks and helicopters and planes that tried to douse it."

Soon after our move to California we were treated to a succession of natural disasters. What would normally be a tranquil view over the Santa Monica mountains was now ravaged by a fire heading for our home.

Photo: Alamy Archive

We watched from our back garden as monster helicopters fought to keep pace with the blaze by water-bombing a fire that was driven along at 20mph up Topanga Canyon by the wind off the ocean.

Photo: Alamy Archive

By some inexplicable quirk of fate, the winds had changed and saved our home, whilst blowing the fire down the valley to Malibu. That evening, I sat in our back garden with my brothers, overlooking the valley and hills behind us, drinking whisky and watching converted Lockheed C130's and helicopters water bombing the hills above what had been one of the most exclusive and sought-after tracts of real estate on the Californian coast.

Just when we thought things couldn't get any worse, our family and natural events collided again when the mudslides began. Mudslides had always been a feature of life in the Santa Monica mountains and just the previous spring, several houses had been lost in Calabasas and Topanga Canyon, but that had been after thirteen days of continuous rain. This time, as over 200,000 acres had burned in six counties, it only took a little rain to start the destabilised land moving. For the next few weeks, everyone in the canyon sat there in their hillside abodes watching on local television as one house after another slowly slid down to its destruction. For someone raised in England and no stranger to rain, about which I had a remarkably benign attitude, I found it hard to believe that it had the latent power to destroy homes in our canyon, but it could. There was nothing we or anyone else could do about it, except wait in hope.

Less than two months later, we found ourselves facing destruction of a totally different sort and it was a measure of family unity that throughout these years, no one ever questioned whether my choice for our home had been entirely appropriate.

Just before 4.31am on the morning of 17th January, what became known as the Northridge earthquake recorded 6.7 on the Richter and 9 on the Mercalli Scales, with its epicentre at Reseda, 20 miles northwest of downtown Los Angeles. I remember this very precisely as I was already wide awake, contemplating whether I was well enough recovered from a nasty case of Strep throat to go back into the office, when I heard the noise approaching. I knew it didn't bode well as it sounded just like a high-speed train heading towards me. Years before, in my misspent youth, I had heard something just like it, not up a Californian canyon, but while hitch-hiking at night on a country road in deepest Scotland. The total disorientation created by what turned out to be an express train travelling at full speed alongside the road visited me again. Back then, I stood confused and frightened, frozen rigid, as the train hurtled past me just inches away and now, I heard that noise again, but lying at home in bed. Less than a minute later, the noise arrived and with it the quake ripped through our house. I am not, by any standards, a small man, but the impact threw me into the air. While still airborne, I saw Beans thrown even higher, so I grabbed her and as we came down. I screamed at her to get downstairs and was running almost before I touched the ground. With Beans out of the immediate firing line, my next priority was our daughters who had been asleep in bedrooms down the hall, but the tremor was still going on and those hall walls were now buckling and twisting like crazy mirrors as I ran along. It's strange the things one recalls in times of stress. I can distinctly remember having complained some weeks before while doing repairs that we had spent all this money on a house that was just timber with lathe and plaster walls. Now I was repeating to myself: thank God they're not brick! Thank God they're not brick!

The first shock lasted for 20 seconds, but it felt much longer, seeming to go on forever. I gathered up a couple of terrified girls and shepherded the whole family downstairs, getting them all under our rather solid kitchen table just as the first major aftershock hit. With a magnitude of Richter 6 in its own right, it was truly terrifying. By now, the floors were strewn with broken glass, crockery, paintings, chairs and cupboards, whose contents were scattered everywhere and in the dark, I had no way of seeing if the house had sustained any serious structural damage. Clearly it was still standing, which seemed to me to be something of a

bonus. Grabbing a pair of boots I went outside to see how the neighbours were faring, and from what I could gather, all of them seemed to be in a similar situation to us; stunned, but with no major injuries, so I went back into the house to hunker down with the girls and our rather frightened golden retriever.

As the aftershocks continued, being British we sang songs and waited for dawn, praying the next aftershock wasn't 'the big one'. We had made up a little tent under our kitchen table and the girls were looking a little happier, but every aftershock brought us up short. There were dozens of them, hundreds over the next few days, but we tried to disguise our concern. The girls had no real idea of how scared we were, but from time immemorial, if Mummy and Daddy showed a brave face then all must be OK! Dawn, when it came, brought some relief, as generally everything looks better in daylight. It was about then that Beans remembered that our good friend, Sandy Arnold, was alone with her two boys who were about the same age as our girls. Her film producer husband, Geoff, worked in Hollywood and had been away on location for the last couple of weeks. When we tried calling, of course all the lines were down, so there was nothing for it but to go and find her, so I set out in my trusty Ford Bronco to cover the five miles to their home. Driving down to the valley shortly after dawn was an eerie experience and I hesitate to use the term, 'like driving through a film set', but it really was.

The aftermath of the quake was extensive. Any brick-built structure had sustained significant damage, there was rubble everywhere, power lines were down blocking the roads, water mains had burst flooding everywhere, and there was a pervading smell of gas. A lot of people were wandering aimlessly about with a look of shock on their faces as they assessed their situation, while their more proactive neighbours had started the clear up. Many had already set up tents or were camping out of their cars and cooking breakfast on camping stoves. Our house was less than 8 miles from the epicentre, but every turn I made took me closer and as I drove beneath the Ventura Freeway, the extent of the desolation there and beyond became obvious. I was not alone on the road, but the only other traffic was largely made up of emergency vehicles, sirens blaring, on their way to other incidents.

I found Sandy and her boys safe but frightened, as their house had taken quite a hit. Like us, it had been left without power, heat or water with a lot of damage to their brick fireplace which had left a gaping hole in the side of the house. Sandy bravely opted to stay put rather than return with me, but it took a further 48 hours before husband, Geoff,

managed to get home to her. Back at our home, the girls were still playing at camping and by now, Beans had swept all the debris out of the kitchen so she could make breakfast. Typically determined, she had decided that life would soon be back to normal for the Powell family; apart from the aftershocks, that is.

We had kept an emergency earthquake kit in a large plastic bin in the yard and now we broke into it to reveal fresh drinking water, food, candles, clothes and blankets, but all we really needed then was water for a cup of tea, so I got out the camping stove. While Beans prepared breakfast for the kids, I assessed the situation. Externally the house looked OK with some movement in the brickwork, but that was to be expected. The pool was clearly damaged, as the water level had dropped three feet and would continue to empty through two obvious cracks in the bottom. Inside, every room was littered with broken ornaments, books, paintings and furnishings, but bizarrely, all the broken stuff was on the north-south axis, while the ornaments and paintings on the east-west axis remained secure and in place. Clearly the quake had passed us as a 'wave', and it had come from the north.

During breakfast I received a call on my mobile phone from Senior Editor, Tony Graham, who, along with Systems Manager, Robert Stark, had managed to reach the office, the first to arrive. Tony explained that while he had got into the office successfully, it was a mess with large cracks in the walls and lighting fixtures down. Allsport occupied the second and third floors of an old office building and two of the large front windows had blown out, leaving computer and picture scanning equipment scattered all over the place. A lot of the steel filing cabinets had been knocked over and now, their contents of tens of thousands of valuable 35mm original transparencies lay scattered about the office and, even worse, in the street outside. The bigger problem appeared to be structural damage to the roof, so I asked them to recover all the pictures from the street and said I would be with them as soon as I could. This call brought me down with a thump. It was, after all, winter, rain was forecast and there were millions of dollars worth of assets at risk and I needed to do something fast.

This was another example of responsibilities to family and business meeting head on, but with things getting back to something approaching normality at home, give or take the odd missing window and re-arranged interiors, Beans and I knew where my other priority lay. Getting to the office was going to be the challenge though. On a good day, our Santa Monica office was a 50-minute commute over Topanga Canyon, down to

the Pacific Coast Highway and then into Santa Monica, but I knew from experience that after a quake like the one we had just experienced, the Canyon would be impassable. Rockslides regularly closed it in normal times, but I also knew that roads were the most vulnerable to earthquakes and I'd seen the damage to the Ventura Freeway, so that route was out of the question as well.

Fortunately, among the toys in the garage was my Honda XR600R desert racing bike and I felt fairly sure that I could get over the big canyon on that. As I had expected, the canyon road was closed and a Los Angeles Police Department (LAPD) patrol was on station, but I showed my press card and explained the situation. They kindly let me through, explaining that there were many rockslides, and I might not make it; which was heartening. Despite the many rockslides, some of them huge, I managed to get over or around all of them, even though in a couple of areas the slides were still happening, triggered by the aftershocks. My luck held out and this was for sure the correct vehicle for the job as it would have been impassable for anything else, so reaching the Pacific Coast Highway, I was met by another police patrol, who said they had been expecting me. It was probably the first and only time that I felt any fondness for the LAPD, a force with a fearsome reputation.

When I arrived at the office, I was impressed to see Tony Graham and half a dozen of the guys who had managed to get in, now busy gathering transparencies off the streets. Al Bello, one of our photographers arrived, having been out taking pictures and wanted to know whether we could process and transmit. A quick inspection of the offices revealed chaos, but we had power and our phone lines were working, so we split up into work teams by skill sets. The photographers hand processed their own film, the techies picked up the computer systems and restored the network and, despite the damage, quake pictures were being transmitted to London newspapers within an hour of getting back into the building – all this while the library staff carried on securing our valuable, original transparencies. Tony rather plaintively muttered that if we hadn't had a re-filing problem before the quake we certainly did now, as he began the mammoth task of recovering and cleaning up the transparencies that now littered the road and floor of the library.

Many of these were not our copyright, but that of contributing photographers from the old Focus West days and briefly, I thought back to the 'ugly on Tuesday' story and realised that we were potentially liable for US$1,500 per image if they were damaged. Currently, we had tens of thousands of them scattered all over the office and street outside.

My job, however, was not to worry about that, but to source tarpaulins and labourers from our landlord to weatherproof the windows and roof before the rains arrived. It was a task in which I was ultimately successful, but only after many threats of lawsuits, the most effective negotiating tool in California. From a most unpromising starting point at the beginning of the day, our technical guys had done a brilliant job in getting the systems and network back online. We were fortunate that our high-speed ISDN lines were still up and running, but all the while, we were living with multiple aftershocks which would temporarily halt work while everyone went quiet and looked at each other, waiting; just in case. We had our earthquake pictures published in the next day's newspapers all over the world, from New York to London and Hong Kong and, according to our contacts in NY, our pictures were the first up on the AP's PhotoExpress Service. Once again, we had dipped into the world of hard news and come out with our heads held high.

Despite appearances, I hadn't totally abandoned my wife and kids. Mobile phone services improved as the day progressed and we spoke regularly. In her usual calm way, Beans assured me they were just getting on with clearing up as best they could and all the neighbours had been around, swapping earthquake stories and with offers of help. By the time I got home much later that night after another traverse of the now treacherously wet and dark canyon road strewn with even more rockslides, Beans had cleared all the broken glass and crockery, furniture had been reset and paintings re-hung. The kids were still playing under the kitchen table, candles were lit, and a hot meal was being prepared on the camping stove. It would be several days before we saw utility workers, nearly a week before our power was restored and our water supply cleared for drinking, and over two months before the girls felt comfortable enough to sleep in their own rooms.

The second largest metropolitan region in the US, Los Angeles is home to 18 Million residents and for such a laid-back community, Californians take the threat of natural disasters, be they earthquakes, wildfires or mudslides, pretty seriously. Their local media features advice very regularly, though whether this helps to relax the citizens, fill psychiatrist's appointments book or just prepare them for the apocalypse, is not totally clear. All the advice that was regularly broadcast before the Northridge quake advised that if and when 'the big one', which they quantify as of a magnitude of over 7 on the Richter scale hits, you need to be prepared to survive on your own for a minimum of 7 days, before getting any support from the authorities. I now understood very clearly what they meant.

This quake had been a mere 6.7 but was disastrous for many people: there were 57 fatalities, 8,700 injuries and estimates of repair cost to homes, freeways and other infrastructure were rising to US$40 Billion. Meanwhile, I had less than three weeks to get my bit all sorted before I had to fly out to Norway for the Winter Olympics in Lillehammer. Pressure; what pressure?

22

SNOWFALL, FOOTBALL AND HARDBALL

The fallout from the Northridge earthquake that had damaged so much of the Los Angeles metropolitan area, including our offices in Santa Monica and our home in Calabasas, was still rumbling about as I left to cover the Winter Olympics in Lillehammer. The area was still experiencing a considerable number of aftershocks, some of them over magnitude 5 on the Richter Scale and over the next nine months, close to 10,000 would be recorded; as if we needed reminders.

My route from LA to Lillehammer included a stopover in London to allow me to check out the major refurbishment and expansion works that had been going on in my absence from the office. Changing priorities and work practices meant that the large photographic studio area was no longer fully utilised, or profitable, as our business was now exclusively live sports news and stock photography. We needed to expand our digital scanning support, darkrooms and traditional filing cabinet storage to support this, so re-purposing the studio seemed the obvious answer. Bob Martin had been overseeing the works and when finished in March, this added an additional 5,000sq.ft. (460m²) of library storage. Converting the similarly sized studio floor area into a state-of-the-art digital production suite allowed the whole process of scanning, captioning, adding metadata and storage to be brought back in-house and this was to become the powerhouse for our Digital Image Archive and Retrieval System (DIARS).

Lee Martin was to lead the team at Lillehammer, and it would be a mix of photographers, technicians and editors from both the London and Santa Monica offices. Although he had effectively run the Barcelona

operation because of my incapacity, I had been on hand at all times, but for Lillehammer, I had promised him full control. For the Barcelona games in 1992 I had commissioned our Operations Manager, Dick Scales, to create a playbook to cover every aspect of taking a large team to a foreign country and bringing them home again safely. Its depth of detail was astonishingly comprehensive and would help me in my goal of passing on to Lee the knowledge that he would need to absorb to bring this off. To underline the changing order of responsibility, I took an assignment for *Time Magazine* to let him get on with it.

The Games were an immense success for everyone, with the possible exception of me! Everyone knew their job and Lee ran our part of the event like clockwork. We had a very experienced team of photographers including Mike Powell, Steve Dunn and Nathan Bilow from LA, who joined Bob Martin, Chris Cole, Clive Brunskill, Mike Hewitt, Pascal Rondeau, Phil Cole, Simon Bruty and Shaun Botterill from London. We also had our new Japanese agent, Koji Aoki's team and our French agent, Gerard Vandystadt, working with us. Overall, an amazingly talented group of experienced winter sport photographers. All our top editors and techies were also there, along with our TOP sponsors team, led this time by James Nicholls. It was to be the first major event at which the team worked independently of my input, and it was to prove to be one of the slickest and the best.

Sports Illustrated had first US magazine rights to our output and Steve Fine, Deputy Picture Editor to the great Heinz Kluetmeier, was working in Allsport's office in the main Press Centre alongside our own editors. I had been commissioned to shoot for *Time Magazine* by their Director of Photography, Michele Stephenson, on the recommendation of Deputy Picture Editor, MaryAnne Golon, who was also working at the Press Centre in the *Time* office. Picture editors are no less competitive than us photographers and they had set the stage for the great shoot out; Steve Powell versus the Allsport guys, *Time Magazine* versus *Sports Illustrated,* and it finally confirmed my change of direction within our company.

It was never something voiced, but we all knew it was happening. I was the one who carried the burden of reputation and many a time when talented Allsport photographers working with me on assignment did not perform to their obvious abilities, they blamed my presence. On this occasion, they were to teach me a lesson. You can't be on the top of your game if you're not practicing your trade every day and I hadn't picked up a camera in anger since the previous Winter Olympics in Albertville two years before. Every day, Steve Fine would delight in the great images

the Allsport guys were bringing in while every day, MaryAnne would say kind words and massage my ego, but the situation was obvious to me. If she wasn't disappointed in my output, I certainly was.

On reflection, this had happened before, notably in the build up to the Albertville Games. On assignments for *Sports Illustrated* with other young photographers also covering the same story, I'd look at their coverage and realise that it was great compared to mine. When I'd check back with the *Sports Illustrated* picture editors in New York, they'd be singing my praises about what a great shoot, but when I asked about another photographer's work, they'd just say it was OK. I realised that they were judging me on my reputation, not on the work I was delivering, and this probably hurt the most. In retrospect, I should have hung up my cameras after Albertville, or possibly before, but I didn't. After Lillehammer I did, not with any sense of bitterness or hurt or regret, but because I didn't want to be judged on reputation alone. It was the work that mattered and clearly, I had spent too much time in a suit and tie, so the only real damage was to my ego. When I got back to the office after Lillehammer, all my cameras and lenses slowly found their way into the camera bags of our new cohort of young photographers, which I regarded as necessary up-cycling. Amusingly, many years later, as I set off on my quest to sail around the world, shortly after departing the UK I realised that I didn't own a camera, occasioning an unscheduled stop in Gibraltar to buy one!

Back in Santa Monica, I found the repair works to the office completed and life getting back on track, despite the continuing aftershocks. People were still a bit stunned, but the rebuild was underway with a vast amount of Federal aid pouring into the region. Friends and neighbours were all taking full advantage with complete home refurbishments going on everywhere, paid for by the insurance companies and the government. At home we faced a repair bill of US$80,000 (about US$140,000 today) but common with all Californian quake insurance policies, they would only pay out 75 cents in the dollar. Federal aid was supposed to make up the difference, but we discovered a strange anomaly. As 'Legal Resident Aliens', a wonderful expression, my brother Mike and I were not entitled to Federal Aid. As an 'Illegal Alien', my brother Stuart was. A strange world indeed.

While we never considered moving from our Calabasas home, the damage to the office building prompted me to consider a move for the business, and truth to tell, I'd been thinking about that for a while. Even with half the photographers away on assignments, we were now too tightly packed and needed more room for expansion, so it was inevitable

we would move eventually. I started looking around for somewhere suitable, simultaneously testing the water with Tony Duffy and the other Directors. I found immediate support from London, but there was a strange reluctance from Tony. I didn't worry too much about it at the time as I was used to his caution, but it was later to mark the turning point in our relationship.

While all this was holding my attention, preparations for the FIFA World Cup began in earnest. Fortunately, most of the organisation and planning had been done in the London office by Director, David Cannon, who was also our senior football photographer, together with Tony Graham, a Brit seconded to our LA office for the duration. Once again, Dick Scales had been in overall charge of all logistics involving shipping huge quantities of equipment all over the States and booking over 300 flights for our team criss-crossing the continent. This, he modestly described, as without doubt the most complex operation in Allsport's history. From the opening game on Chicago's Soldier Field, our people would track the action. Pasadena to Detroit, Dallas to New Jersey, Stanford to Orlando and Boston to Washington DC, the distances involved in this coverage were immense and spread around all four corners of the USA. In a truly co-operational international operation, our American team got to work alongside our British team, with our French, Japanese, Mexican and Italian agents all working with us and all co-ordinated by Tony Graham, running everything from Santa Monica.

For the 15th edition of soccer's international men's showpiece, the US had been chosen back in 1988 and, after some initial surprise - well, soccer was very much the newcomer to the North American sporting scene, and they didn't call it football even if the rest of the world did – the host nation threw its not insubstantial resources and organisational experience behind the competition. Among the sponsors were a number that we had worked with in our Olympic coverage and elsewhere; Adidas, Canon, Coca-Cola, Gillette, Fujifilm, JVC and MasterCard, to name a few. General Motors and American Airlines came on board as host country supporters, so our contact list of big corporate players expanded again.

We had prepared well for this World Cup in what would give us major exposure in the USA and beyond, and a combination of slick marketing, national and international media blitzes and vast viewer numbers would make this the most financially successful at the time. A global audience of over 3 Billion had watched 24 teams battle it out for the Jules Rimet Trophy over 52 matches in 30 days. Television coverage of the final was watched by 2 Billion fans. Much to my relief, my only

involvement with the competition that year was to get tickets to the final, which Adrian and I watched with Lee Martin, a huge football fan. I sat back in the sunshine and watched the game, just thinking back to 1982, my last and indeed only World Cup, and Maradona. I didn't have to pretend that I enjoyed the final, as it was generally declared to be a disappointment, featuring Brazil and Italy, who appeared to be too frightened of each other to come over the halfway line. The game finished scoreless after extra time and history records that Brazil eventually won 3:2, decided on penalties. This was not a result that the large American audience ever understood, but the shoot-out was recorded spectacularly by brother Mike using a 600mm lens from the Fuji blimp, probably the best image of the final.

To say that Americans embraced the concept of football's World Cup is probably overstating things and a scoreless final that was decided on penalties left them cold. Probably the best shot from that final came from the Fuji blimp during the penalty shoot-out.
Photo: Mike Powell/Allsport

Shortly after this, he approached me with an idea. Despite all our contracts with sponsors and governing bodies and the huge commercial demand for sports images, 99% of all our images were only cleared for editorial use. In order for a sponsor or advertiser to use any of these, there was a complex and costly process of trying to buy the image rights from

the athletes and venues, so we had always tried to avoid it. We attempted to get images that reflected the spirit or atmosphere of a sport where the athletes weren't recognisable, but it was difficult and was just like the problem we first faced producing the Asian Games posters in 1974. We had to find ways of blurring the images so the identity of the athletes remained disguised.

We were used to seeing quite comical parodies of athletes running and jumping, supplied to advertisers by traditional stock photographers using models. Mike argued that only real sports photographers who understood how athletes moved could actually produce a believable image. He proposed that we move into the commercial world of stock photography by creating powerful sports images using real athletes for whom we owned all the rights. This would involve significant outlay in setting up the shoots, hiring the venues or stadiums, paying the athletes and getting model releases on everything, but he had a business plan and laid it out using our traditional, well-tried, three-year schedule. The first year would involve a lot of effort and expense, the second would be similar, but we would plan to launch our first stock catalogue and start earning by the end of the year. In the third year, we would begin to see the payoff.

I could hardly reject his idea, as the opportunities were enormous, so Mike set up a team to work with him comprising Peter Schnaitmann as his producer/art director and Marcus Boesch, as editor and production assistant. Together they started shooting and by the middle of the second year the concept was proved, and they published our first catalogue which began to earn ahead of schedule. Allsport Concepts was to be a vital cog in our overall offering and became a massive commercial success, but at the time it was another major gamble. To help me manage this new facet of our business, I took on Greg Walker in the newly created joint roles of Vice President Sales and Marketing and General Manager. Originally from Oregon, Greg came with a CV that suggested he had a lot of knowledge and experience of the photographic community and how it worked in a changing technical landscape.

Another obvious asset was that he shared my long-held mantra to ride the tide of new technology, particularly in digital delivery and reproduction, which made him ideal for ramrodding the next phase of our development. True to form, I had been more interested in getting to know what sort of man he was, and hadn't produced anything as formal as a job description, just sort of letting that evolve as we got deeper into discussion. In his final interview he rather plaintively asked

me what I thought his role was really destined to be, to which I replied: "That's easy. You are responsible for everything." I thought that was pretty clear and unequivocal.

Meanwhile, I was still sticking religiously to my travel and work schedule of four weeks in LA and two weeks in London, plus IOC commitments and visits to the NY office and our agents. My next scheduled IOC meeting was with the Atlanta '96 Organising Committee and the host broadcasters to define and refine positions for photography and filming as part of one of our regular venue inspections. On arrival, I met IOC Press Director, Michele Verdier, and we embarked upon a two-day tour of all the facilities, which went well enough until day three. We were calmly going through the various venue reports and observations with the organising team and eventually came to discussing the press village, an integral part of my brief to ensure a proper working environment for the media.

One of the tenets of the IOC is that there should be a tangible legacy to benefit each host city and its residents, not just a massive spend on the Games themselves. Atlanta had genuine problems with housing its large socially deprived community, but not since Union General, William Tecumsah Sherman, burned it to the ground in 1864 had the city been so much altered by the political elite. Large tracts of public housing disappeared to accommodate everything from the host stadium to lesser venues, but one shining light was how they were to house the athletes and media.

The campus of Georgia Institute of Technology became the centre of a US$240 Million investment to accommodate the Olympic village. The building programme took what had previously been accommodation for 6,900 students and expanded it by a further 2,400 on the Georgia Tech site, plus a further 2,000 units which reverted to use by the Georgia State University next door after the athletes and media left town. All very impressive, until we came to discussing the press village. We went through our checklist of all the basic facilities, agreed they were great, but then struck a serious problem. Normally, in fact in every other media facility at every other modern Games, recognising the need for a little down-time rest and relaxation, there would be an outside seating area and bar. Here, all the journalists and photographers could relax with a drink after what would usually have been long, hard days. When I casually asked about the location of the bar, I was shocked to discover that at these Games there would be no bar, as alcohol was banned by Georgia State Law on any of its campuses. I searched for clarification. Did they really mean all alcohol,

and could we not even take a bottle into the village? Yes, all alcohol and no we couldn't, was the humourless reply.

At this point in the conversation, I began contemplating a vision of 5,000 journalists and photographers from all over the world, turning up at their accommodation for a month and being told they couldn't have a drink. All I could see was disaster writ large, so I needed all my negotiating skills to break the logjam. I explained very slowly and carefully what a huge mistake this was going to be, and pointed out that technically during the period of the Games, the State of Georgia did not actually control this campus. The IOC did. The organisers agreed to send a request back to the State Governor to resolve the impasse, the request being titled, 'Powell's Drink Problem'. How did they know? I went on to win that one and the Governor passed legislation permitting alcohol on campus during the Games, but then they hit me with a real problem.

Because the Centennial Olympic Stadium was earmarked to be used by the Atlanta Braves baseball team after the Games, there would be no photographer's moat in the stadium. I had been fighting hard since my first meeting with the stadium architects back in 1992 to have a moat incorporated into the design around the outer edge of the stadium floor, in common with every main Olympic stadium since Munich 1972. With an expected 900 photographers or more attending the Games, not having this facility would severely hinder their ability to work and cause mayhem for TV positions and public seating. The architects had previously assured me that my moat would be dug, but now they told me no, they might find the budget to have it dug, but strangely, couldn't find the budget to fill it in after the Games. I predicted that this would be something approaching a disaster, and so it would prove to be. Two years later, vast gantries were built on the stadium floor to accommodate hundreds of photographers giving them a great view, but they blocked big areas of public seating that couldn't be sold, because those seats had no view of any action. It also pitted TV camera positions and photographers against each other, a battle we were never going to win, and this was to prove to be just one of a number of disasters that were to challenge us at Atlanta '96.

On our last night in Atlanta, Michele and I dined together and reviewed our visit. She would be returning to Lausanne and I was bound for LA, so it was a good chance to compare notes. I was facing the entrance and Michele had her back to the door when Jean-Michel Jarre, the French composer and rock star, walked in. I started to blether, explaining to Michele that I had dined with royalty, met and worked with some of the most famous sports stars in the world including Muhammed

Ali, but there was only one person in the world that could make me go gaga and he had just arrived. I had followed him for years, listening to his music, going to his concerts, once flying thousands of miles to attend one, and now there he was. Michele smiled knowingly, turned around and waved: "Bonsoir, Jean-Michel." She obviously knew him and as they were chatting polite catch-up talk, in walked his then wife, Charlotte Rampling. I didn't know where to look and now I was in real trouble as Jean-Michel Jarre invited us to join them for drinks after dinner. I want to say that it was a fabulous evening, as they very kindly kept the conversation in English, but the truth is I was so awestruck and nervous that I just babbled the night away. It must have amused Michele to see this large Englishman, supposedly master of his own universe, brought to heel, but she was too polite to ever mention it again.

Back in LA I immediately started preparing for another trip to the UK, as I only had a turnround of about ten days in our office there and needed to deal with lots of issues. Not least the urgent need to write my speech for the IOC's Centennial Olympic Congress, which was next on my itinerary straight after London, but I detected there was something wrong here. I couldn't really put my finger on it, but there was a distinct change in the atmosphere and because of my schedule, I just carried on to London without realising that we had a deep-seated problem. Too pressured to look into it at the time I just put it down to post World Cup fatigue: but what I wasn't aware of was that Tony had been making small and subtle changes to personnel and overriding some of the weekly management meeting decisions. Simple things in themselves, but deeply unsettling for the staff who were used to making decisions and taking responsibility, which was how I had shaped our team to operate.

After a week in London reviewing projects and planning the next steps with the Board, I flew to the IOC Headquarters in Lausanne for the Congress on the relations between sport and the mass media, hosted by IOC President Samaranch. They had asked me to speak in the conference's section entitled '*Challenges for the 21ˢᵗ Century*' and following a good number of heavy hitters in the Olympic movement, my humble contribution turned out to be a little controversial. I used my address to the delegates to highlight an issue that was coming into the conversation between major sports leagues and photographers. Their rights of access.

Television broadcasters had traditionally been charged substantial rights fees for access to sporting events, while photographers had not, enjoying open and free access. This was based on the fact that in the early days, photographers were almost exclusively newspaper staffers, but with

*My address to the IOC Congress
on how I saw the challenges for
the 21st. century turned out to be
controversial, in facing the looming
question of fees for access.*

Photo courtesy of the IOC

the rise of freelancers and independent agencies like ours, some sport bodies were expressing interest in monetising access to their venues. With such offers as exclusive access for a fee, those offers might have appeared attractive to us, as the largest player with the most resources, but I resisted strongly. I maintained that entering the venue to photograph sport was an act of journalism and as such, we must all maintain our independence and the ability to report not just the good things about sport, but also the elements that sport might not like publicised. Witness the many occasions when, despite our close relationships with governing bodies, we had syndicated stories that did not show sport in a good light. Michael Payne and the IOC understood this clearly when we established our Chinese Wall and perhaps driven by this benchmark, most other governing bodies also understood it as well. However, a few, especially in the USA, saw it as purely a commercial action that made us, the photographers, a profit and they wanted their cut. Who knew?

It was certainly an offer that had some attractions. Purchasing exclusive rights to major sports events would have significant financial potential for us and we had the resources, but I had too often seen the broadcast media back away from showing the unpleasant side of an event. ABC's whitewash of problems at the Lake Placid Olympics and the BBC's coverage at the Hillsborough Stadium disaster may have been motivated

by perfectly good underlying editorial reasons, but when large sums of money are involved in the relationship with the sport, it would leave room for questions. I delivered my presentation, made the point as forcefully as I thought appropriate and sat down. Afterwards, Samaranch went out of his way to talk to me, asked about the issue and finished with: "A very important point, well made." I thought I'd just been given a tick and a gold star, and it was always good to have powerful friends.

My return to the Santa Monica office delivered something of a shock that would have far-reaching consequences in my personal and business life. Tony was clearly not a happy man and appeared to be imposing his feelings by making changes to our plans at every level, without proper consultation. The arrangement that I had come to with him and the Board - what had underpinned and persuaded me to move my family to California - was simply that I would take over running Allsport USA. For four years this arrangement had worked well, and by his own choice, Tony had not involved himself in any aspect of managing the company, choosing to concentrate purely on his photography. This suited both of us and we had continued with our regular lunches, albeit less frequently, because of my travel schedule. Now and for no apparent reason, his attitude appeared to have changed during my recent absence.

For his own reasons that were not immediately obvious or commercially logical, he had arbitrarily decided to involve himself in everything, often not fully understanding the implications of his interventions. There were several major expansion plans on the table. These included a move to a large new office and of course, plans for selling the business were advancing, so obviously Tony was none too subtly showing that he had reservations about our direction of travel and what it meant for him. Nevertheless, it came as a shock when I realised the implication: what had started out between us as sparky yet positive exchanges over different management styles had degenerated and polarised into serious differences in thinking and eventually, difficulties in communication. If this unsettled me, seeing the disagreements and growing friction between us was more unsettling for the people we worked with every day who were now genuinely unsure who was running the company. The inevitable product of this was confusion and disillusionment, and we began to lose key members of staff.

I am normally pretty adept at getting conversations going at any level, but Tony had become a closed book. Having tried all the usual options for communication with him I realised that we needed to clear the air once and for all. As Christmas 1994 approached, I called for a Group Board

meeting so we could all table our concerns. The timing to accommodate everyone's schedules meant that this would need to be in London to coincide with my next visit, just before the holiday. Entirely of his own volition, Tony had chosen not to attend any of our regular Group Board meetings for several years, leaving us to get on with planning and running the business, so this would be the first occasion for some time for him to talk face to face with his co-directors.

The relationship between Tony and the Board loomed large as we convened the meeting. There were pressing decisions that needed our attention and all of them would have potentially long-term impact on the Allsport Group, so this was the perfect opportunity to air them, with all the Directors in attendance. One of the agenda items was to agree and sign off on an expansion to our Executive Share Option Scheme. I had initiated this scheme when moving to the States, as a way of recognising the contribution of our senior staff and co-director's. The aim was to incentivise them as we embarked on far-reaching developments that would prepare the company for further investment in advancing technology and for a potential sale. This scheme had been in place for four years and the vote to expand the scheme had been discussed at length, and had gathered general approval from the Board, but now that it had reached the point of voting its implementation, Tony alone went cold on the idea. I had always seen the re-distribution of shares as a move to improve the overall stability of the group and acknowledged that it would undoubtedly alter the balance of interests. We had all bought in to the concept but perhaps it was now, when faced with the reality of how the company needed to change in preparation for a possible sale, Tony was bridling at what he now saw as dilution of his influence. Whatever his reasons, it quickly became clear to us that the gulf between what we had all been striving to achieve and his aspirations, appeared irreconcilable. Perhaps predictably, this meeting resolved very little with Tony, and to say that it was a disaster would be an understatement.

With the exception of our recently hired John Witts, the other Directors, Adrian Murrell, Lee Martin, David Cannon, James Nicholls and Mavis Streeton had risen through the ranks and were used to seeing Tony and I joined at the hip and they were finding it difficult to understand or accept the change. So was I. With no real resolution to the festering sore that Tony harboured, the following months were grim at a very personal level. It was a dire Christmas and New Year and I make no apologies for admitting that the stress got to me again. I took some time off before returning to oversee the fit out and move into our new

office space, something which would normally have fired me up, but I was not enthusiastic: Tony, in his unusually disruptive and destructive mood, remained the elephant in the room. I then took a decision, that most people around me who were not intimately aware of the issues, saw as unfathomable. I decided that in order to reduce the tension between us, stem the haemorrhaging of staff in Santa Monica and reverse the damage that all this was doing to the company, I and the family would move back to London. Big call. Whilst there, I would try to plan the best course of action and the other Directors would continue to try to reason with Tony at arm's length, but none of us were happy with any part of that situation.

Throughout the life of Allsport, our relationship had always worked, despite of, or perhaps because of, the differences in our management and creative styles which led to vigorous debate, but generally reaching a workable consensus that benefited the business. Now we had entered another world. After finally recognising and accepting that there were totally irreconcilable management differences between us for the direction and growth of the business, we came to a decision. We, the Directors, offered to buy Tony out, which he considered and accepted. Ten months down track from that disastrous board meeting, the terms of the buy-out deal were agreed and signed off, including both a lump sum for his shares and a five-year freelance contract so he could branch out on his own, which I think is what he wanted. In retrospect, buying out my long-time mentor and friend was the most difficult thing that I had ever done. Our partnership of 20 years, so productive in so many ways, had come to an end. Our friendship continued, albeit at a distance.

23

VIRTUOUS CIRCLES AND THE ROOF OF JAPAN

Strangely, our time back in London while I tried to resolve the issues with Tony and negotiate his buy-out was productive and uplifting in many ways. It gave the kids lots of quality time with their grandparents, Beans got to spend time with old friends, many of whom she hadn't seen for years, and I got back into the swing of things in the London office. I found the major refurbishment of the offices invigorating once more, and was able to bury myself in technical issues, building and expanding our business reach, something I always enjoyed. More than anything, it was just nice to be back working alongside the old team again, rather than seeing them during what had been short, flying visits. Now there were plenty of things for me to concentrate upon.

We had two big interlocking events planned for 1995. The first was a major exhibition at the Royal Photographic Society's Head Office in Bath entitled *Sporting Eye* and linked to that, our inaugural International Agents Conference. Jeremy Richens, now our Overseas Sales Manager, had invited our top selling agents to spend three days with us during which we would deliver presentations on the future of photography and our take on technological advances in the pipeline. We would also sketch out Allsport's relationship with them and follow this with a visit to Bath to view the exhibition. A gratifyingly large number of them decided it would be worthwhile and flew in from Australia, Japan, Mexico, South Africa, all our European agents joined us, as did Greg Walker and Markus Boesch from the US.

Our relationship with our agents in overseas territories was almost exclusively based upon mutual respect and trust, with skill sets that fitted

Increasingly important were our agents in overseas territories so with both improving technologies to present and an exhibition of our work at the Royal Photographic Society in Bath, it seemed like a good moment to bring everyone together. Attendees are pictured outside the Petersham Hotel in Richmond, Surrey in a break from presentations.

Photo: Allsport Archive

all our ambitions for developing the market. Agents were financially important for us as they represented about 15% of our annual sales turnover and the working model was simple. Once every two weeks we would ship out to them our picture package of duplicate transparencies, sporting events of the month, previews of upcoming events and feature stories. They would then sell these into their own countries and send us 50% of the value of every sale achieved using our material. We would always reserve the right to deal directly with newspapers in their territory that could take our live feed, but other than that they had exclusivity in their territory. Later, when some of our top agents went digital, they took over this element as well.

By the beginning of 1995 we had working relationships with 38 agents, some of whom serviced several countries, so we were represented in about 45 different territories. The push was always on to find and sign new agents, as the incremental cost to us for each new signing was modest,

comprising an extra set of dupes and a postage stamp, so insignificant in the overall picture. The real value of agents to us wasn't the income they generated, important as that was, nor was it the promotion of the Allsport brand, as most agents didn't actively promote our name in their territories. Only a handful of our best agents, notably Gerard Vandystadt in France, Jane Symons in Australia, Koji Aoki in Japan and David Leah in Mexico, actively and successfully promoted Allsport. Most of the rest simply sold our images under their own branding, but with our bylines.

The real motherlode value of our agents to us was in our ability to show that we were having pictures published all over the world, reaching an estimated weekly viewership of 50 Million people globally. Of course, there was no way of substantiating that figure, but by collating readership numbers across the world we could certainly argue the case and, as with all circulation figures, it was difficult to disprove and nobody knew any better. Armed with this ammunition, we compared well with all the major agencies when negotiating access to the most important events, and it was a tempting target for major league sports wanting to promote their brands globally. There was no argument so compelling as handing the Director of Communications for Major League Baseball an article on US professional baseball in a Russian magazine. The message was obvious. We can promote your sport internationally and it will help you sell global television rights.

The ultimate goal was for all our clients, potential clients and competitors, whenever and wherever they travelled, to see an Allsport picture and, if we succeeded in that, we would dominate the major markets of the US, Europe and Oceania. Our Hong Kong agent serviced the small but growing Chinese market, our South African agent covered most of Africa, our relationship with *Sportstar* meant we were the primary source of international sports pictures in India and we had strong representation in the Americas and the Middle and Far East. The role of our agents in the Allsport story was, therefore, critical to promoting the twin myths. For our clients and potential clients, it was that there was simply nowhere else to go, as only we had the creative skills and the domestic and global reach to meet their needs. For our competitors, the message was simply that it was too late; the train had left the station and they had been outmanoeuvred and left on the platform. The agent's conference was a great success and not only gave us the opportunity of meeting everyone face to face but also to show them the digital future we were planning for them. The positive reactions to our message and the farewell dinner that followed their visit to the

Sporting Eye exhibition helped rebuild my faith in what we were doing. It underlined the importance of pushing forward, despite the internal problems with which we were wrestling.

My most immediate problems were the repercussions and aftermath that flowed from the inability of Tony and I to reconcile our differences: it had shocked not only the Board and senior management, but the entire staff on two continents. Anyone in business will know how quickly uncertainties can creep into people's minds at the best of times, but in times of turmoil, there are doubts everywhere. I am sure that the world is populated by people who are so confident that all their decisions are the correct ones, but I am not one of them. I have always questioned my choices and have never hesitated to change direction if things were not working out as intended, so my priority now was to regain everyone's trust and explain fully my game plan to the Board. They had taken an immense amount of my operational management on trust, but now I needed to explain the important role that they would play in the future of our business and my goal of keeping Allsport working, growing and profitable, whilst devising the best way of offering it for sale.

The first and most important task was to restructure the shareholding freed up by Tony's withdrawal to reflect their contribution and I included not only all the Directors in the redistribution, but several of our most senior photographers too. We also set up an employee share option scheme based upon length of service, from which everyone would benefit. In all my years with the company, I had never lost sight of the value of the people around me. This redistribution of shares gave me the perfect opportunity to enshrine that value, and the calculation was more about how best to do this. Even though I had finished up with a majority shareholding I felt that the best interests of Allsport's future, in what were uncertain times, would be to balance risk with reward. After the buy-out had been completed and shares re-allocated, my co-directors and more senior colleagues collectively owned 49% of our stock which would give them skin in the game when it came to bigger decisions, particularly on going to market. Although I now owned the remaining 51% of the company and effective control, I took the unusual step of lodging 2% of my stock into non-voting escrow.

One of my biggest strengths has always been my ability to convince other people that I am right. Some have uncharitably compared this process to less like a debate on the floor of the United Nations, more a gladiatorial clash. Although I had ultimate ownership of that 2% shareholding and thus the company, although it was a risk, I wanted to give the other shareholders

the opportunity to out-vote me if they thought I was wrong. I hoped that this would not only empower them and create trust, but it would help me. My biggest reservation was that perhaps my enthusiasm for any particular project would run away with me. I had learned over the years that just because you can do something and persuade others to follow you, doesn't necessarily mean you should. I reasoned that if I couldn't persuade at least one other shareholder that I was right, then maybe I was wrong. This backstop strategy was never to be put to the test, but I still believe it built trust amongst us over the next few challenging years. Having senior management at my back was comforting.

In the late summer of 1995 I moved the family back to the US and re-assumed control of the LA office, but it was with some little trepidation, as it had been a difficult time for our staff there. I didn't quite know what the reception might be, but I was fairly secure in the knowledge that I had made every effort to avoid them becoming embroiled in a boardroom dispute. The very reason for moving the family back to the UK was to de-escalate the situation between Tony and myself and avoid involving the staff. Greg Walker and my brother Mike had successfully kept things going, so the priority was to sit down with the management team to assess our situation. Although the buyout settlement and the office expansions in London and LA had left the company saddled with considerable debts, I passionately believed that this restructuring and investment was the right thing, at the right time. This was a moment in our business when short-term profits needed to be sacrificed for long-term growth. With the support of the main Board and the management team I set about raising funds for another upgrade of systems in both LA and the New York offices, moving more staff to the East Coast.

In May 1995, I had moved our West Coast operation into a great new office building on the corner of Sunset Boulevard and the Pacific Coast Highway, with views that extended over the ocean from LA Airport to Malibu. Coincidentally, it was also the spot where they often filmed Baywatch, not that we would have the time to watch that going on! The negotiations with the landlord had been swift. We had signed a ten-year lease on about 14,000 sq.ft. (1300 m²) of space on the first floor, nearly three times bigger than our existing office. This gave us the capability to not only replicate the processing, duplicating and dispatch systems we had in London, but also to build a complete copy of our Digital Image Archive and Retrieval System (DIARS), bringing all our scanning and captioning in-house. I poached a young man called Matthew Schoen from a rival agency and gave him an almost unlimited

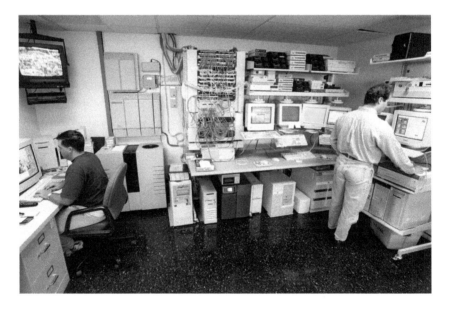

Taking occupation of our new offices in Los Angeles gave us the chance to install a complete mirrored facsimile of our London Digital Image Archive and Retrieval System (DIARS), but with new scanners, faster communications, and bigger storage in what was now our own high-tech Scriptorium.

Photo: Allsport Archive

budget to create the most state-of-the-art system achievable, which he set about with some gusto. Constant upgrades, new scanners, faster communications, bigger storage and we created our own Scriptorium conveyor-belt for captioning and metadata.

This move was a very obvious statement of intent and, coupled with my return, had its desired effect on everyone, stimulating new confidence and enthusiasm everywhere. Matthew's first impact was to introduce Allsport to email and this immediately improved communications in-house and inter-office, with our photographers using it in the field. One early beneficiary was Head of Sales, Peter Orlowsky, by now back in New York with his family and signing new deals on a weekly basis. His technique was to invite representatives from a chosen sport's governing body to our offices, many of whom were trying to create their own in-house photo services. Once they'd seen our set up and facilities, it wasn't long before he persuaded them that we could handle their needs at little or no cost to them and simultaneously promote their sport globally. The deals started to flow. First up was Major League Soccer (MLS), which was really an obvious one, given our European background. Not long afterwards, we secured deals with Major League Hockey (MLH), Major League Baseball (MLB) and the National Football League (NFL). The Professional Golfers Association (PGA) and the National Association for Stock Car Auto Racing (NASCAR) followed suit. We signed huge contracts for trading cards collections in all the major sports and not only supplied the photos for these deals, but once again handled some of the production elements, this time digitally.

Against this backdrop of exponential growth and a massive injection of confidence in our staff, the opening of the IOC Olympic Museum two years before had led to us doing a great deal of work with their archivists, integrating our Olympic collection into their archives. As a bonus, they had granted us global marketing rights to their wonderful, historical collection. With the centenary Olympics fast approaching, this partnership was paying dividends and by merging the two archives, we created the Allsport Centennial Olympic Collection. This comprised 100 images from 100 years of the Olympic Games and branded with the Centennial Olympic Rings, it was the opening volley of our marketing strategy for Atlanta '96. Seven months out from the games, we started to get traction with published preview articles, our goal being to whip up as much media excitement as early as possible and feed that interest with more and more Olympic previews, culminating in our live coverage.

Traditionally, although the archive of old black and white pictures had been seen as a great asset, in reality they returned very little revenue as the need and occasion for their use was too limited. It was more a marketing tool to show the provenance, strength and depth of our archives. Even the famous Bob Beamon image made very little money after its initial use in 1968. The vast majority of monetary returns had been achieved by our marketing campaigns in 1988 and 1993, celebrating our 20th and 25th anniversaries. However, what the early success of the Centennial Olympic Collection showed was there was a great demand for content, and publishers in all media forms were hungry for new ideas and alternative ways for approaching stories. This may have been partially driven by the vast improvement in the photographic content in newspapers since they changed to colour, but television also played a major role with the significant increase in broadcasting rights fees. To maximise their mammoth investment, simple live coverage of the event was no longer enough. Their solution was to produce lots of previews and lead-in stories, again to whip up interest in the event for which they had paid so much. This, in turn, drove interest and demand in the printed media, leading to the formation of another virtuous circle, including us and other content providers, in the middle.

We had recognised the trend back in 1994 which had prompted us to approach Brian Deutsch, owner of The Hulton Deutsch collection. Formally the BBC Hulton Picture Library, it was one of the finest and largest collections of old monochrome archives in the world with an estimated 50 Million pictures on its files dating back to the beginning of the century. It covered every aspect of life through the eyes of the British press. It also housed the Keystone Press Agency files, now long defunct, with my modest contribution from 'The Troubles' in Northern Ireland. Brian had been struggling to make it pay since buying it from the BBC four years previously and there were strong opinions expressed at the time of the sale that it was a national treasure and shouldn't have been sold to a commercial enterprise. I suspect that, on occasion, Brian might have agreed with them, as he discovered that the maintenance and upkeep of a national treasure like this was all very well for a publicly funded organisation like the BBC, but tough to justify in the real world. I took Adrian and Lee with me to meet him for the grand tour and he made it clear he was keen to do business, so we secured syndication rights to all of Hulton's sports-related content. We sent in a junior researcher, Paul Prowse, with a scanner and a brief to search for the best of what they had. It proved to be a treasure trove.

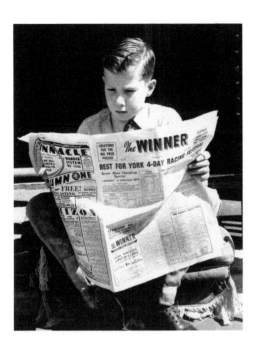

In a move to further expand our historical archive, which was becoming more valuable by the month, we secured syndication rights to all of the Hulton Deutsch sports related content. Among the treasure trove were pictures of a young Stirling Moss in his pedal car and this 1948 picture of the 13 year-old Lester Piggott studying form.

Photo: courtesy of Hulton Deutsch

Paul spent many months there, researching, scanning and captioning some of the finest old pictures in sport. There was a picture of Lester Piggott as a young boy reading a racing newspaper, Stirling Moss as a young boy in a toy car and another of him driving his Mercedes Benz to his classic victory in the 1955 Mille Miglia, heralded as the most iconic single day's drive in motor racing history. Timeless images from a century of sporting greats including Joe DiMaggio and Babe Ruth from the world of baseball; golfers Bobby Jones and Ben Hogan; skating star Sonja Henie; athletes Paavo Nurmi and Peter Schnell; tennis great Suzanne Lenglen; basketball's Magic Johnson and Wilt Chamberlain and, of course, Cassius Clay, soon to be Muhammad Ali. The mine of wonderful pictures was effectively bottomless, and they were pouring into our digital archive, so we re-branded our old black and white archives as the Allsport Historical Collection and marketed it heavily. We also started distributing small historically linked stories before all major upcoming events, readily taken up by television and print press, giving us a way to make money out of this old black and white stock.

As an adjunct to the search for old pictures, on one of my trips to New York, I called the great *Life Magazine* photographer Neil Leifer, as I wanted to talk to him about syndicating his pictures. His most famous images were probably those of Muhammad Ali standing over a defeated

Sonny Liston and the iconic aerial shot over the ring of Ali walking away with his hands in the air as Liston is sprawled out on the canvas; probably one of the first uses of a remote camera and certainly one of the best. Neil invited me to dinner and explained that he was *allowed* to eat once a month at a Harlem restaurant and he had a booking that night. It was called Rao's, so was I happy to go there?

Although Harlem has been gentrified now, in those days it was an area of New York that would not have been my first choice, but I bowed to his local knowledge and we drove through some of the most deprived areas in the city, with me holding my breath in anticipation at every stoplight. We arrived and parked on E 114th Street next to a very run down, dark and intimidating Jefferson Park. As we walked towards the restaurant, Neil pointed out a line of black limos parked around, but with no drivers in sight: "If you check them out, all the limos are unlocked with their keys in the ignition." The implication was quite clear. It was a Mafia restaurant, so no-one would dare touch them, which gave me pause for thought.

The front door was a heavy wooden affair with a hatch which slid open on Neil's knock, to reveal the eyes of the owner, Frank Pellegrino, peering carefully at us. Recognising Neil, he ushered us in. We sat in one of the booths and in the absence of any menus, Frank asked what we wanted to eat. He would then create our dinner from those preferences, but he also suggested that when the diners arrived to occupy the large round table in the corner, we should perhaps pay our bill and leave. Neil and I discussed my proposal, but because he was planning to create a fine art company based around his iconic images and needed exclusivity, we couldn't do a deal, but we had one of the finest Italian meals I've ever eaten, before or since. Some hours later, the diners for the round table arrived, we left, but I never found out why Neil was *allowed* his monthly treat there. Frank died in 2017, his son, took over and Rao's is still a great restaurant, but the front door is now more welcoming. Frank Jr. serves more celebrities than Mafia Dons, though the publicity for this eatery still carries the legend 'a successful restaurant is made by making guests feel like they're part of the family'; which must mean something.

My next stop would be on the other side of the world, in the central Chubu region of Japan, 230 kilometres northwest of Tokyo, Nagano is the biggest winter sports resort in the country. Often called the Roof of Japan, it was no surprise that it had received the nod from the IOC to host the 1998 Winter Olympics and this was my next destination.

Trust is an amazingly powerful tool in business, especially when the relationship has other challenges such as language or culture. In 1984

I had met a young Japanese sports photographer called Koji Aoki at the Sarajevo Olympics. I was trying to get an unobstructed view of a medal ceremony, but there was a solid wall of photographers in front of me. Running along the line I eventually saw a gap occupied by a photographer rather shorter than the rest, so I just slid my 400mm lens over his head and, taking advantage of my two-metre height, worked happily away. Moments later he realised I was there and smiling up at me said: "We work well together." We met often over the next few years, mainly on the World ski circuit, and he would always regale me with his ambitions and plans for his Tokyo-based agency, Aflo. "I want to be the Allsport of Japan", he would explain and each time we met I'd ask him how big Aflo was now, and he'd proudly explain his new hires and expansion plans and would always ask politely when he could represent Allsport. Although things had started well with Keystone Japan, their sales had slowed down a lot and I had the sneaking feeling that all was not well there. They were concentrating more on general stock photos, so in 1991, as I was due to go to Tokyo for the World Athletic Championships, I finally agreed with Koji that I would visit Aflo and meet his team.

Although his colleagues were relatively few in number, they were young and obviously very enthusiastic. Koji made a small presentation explaining that he felt Allsport was well known around the world for the very best in sports photography and service, yet we were unknown in Japan. I had to agree. He and his team appeared determined to change all that and promised that in just one year, they would make Allsport well known in Japan's editorial markets. This was enough to convince me, so I appointed Aflo as our new agent, though with a slightly different contract. The standard agent contract in those days was a 50/50 split on sales in the agent's territory, but what I proposed was that for the first year he would not pay us our half and use all the proceeds from sales to promote Allsport through Aflo in Japan. Then in the second year he must give Allsport a minimum guaranteed financial return, or risk losing the contract. He jumped at the deal. I could see his team got very excited and I have always been a firm believer that after creativity with the camera, enthusiasm for the job is paramount and backed my belief. By the end of the second year, Koji had tripled the minimum guaranteed sum and it was never mentioned again, as sales went from strength to strength.

While we had been together in Barcelona for the 1992 Summer Olympics, Koji and I talked about the forthcoming Winter Olympics in Nagano. This may have seemed a little premature, as this Japanese town had only been awarded the games the year before, and we were

still six years away, but Koji had big plans. He had seen how our route into the Olympics, first via the official book, then as IOC official photographers, had broken down all the barriers to entry put there by the big establishment media players of the time. In our early days, this had been a major struggle for Allsport and if the status quo reigned supreme in most sporting areas, then the hierarchy of establishment interests in the Japanese media were legendary. Kyodo News dominated everything and on the balance of probability, if they wielded their undoubted clout, were going to be appointed as official photo agency to the 1998 Winter Olympics; which would leave Koji and Aflo very much out in the cold, literally. Our man explained that unless we could change things, he would probably only be able to get himself into the games based on his reputation as a ski photographer, but had little or no chance of getting his agency accredited. This would be a disaster, so we hatched a five-year plan.

Our plan had two facets. First, Koji would promote the idea of creating a special Japanese Olympic archive and start developing the idea of an official Japanese Olympic photo book. Then, I would try to use our influence as official photographers to the IOC and the TOP Program to see if we and Aflo might be appointed official photographers to the Nagano Olympic Organising Committee (NAOC). This was rather a long shot, but worth a try. Previously, Allsport had successfully negotiated an official relationship with the organising committees of Winter and Summer games in Calgary, Seoul, Albertville and Barcelona, but this was essentially to give their sponsors access to our sponsor support team. The thought that the Japanese Olympic Committee might allow a British agency, albeit with a Japanese wing, to be appointed in this way seemed farfetched at best. With a clear plan in place, we both started in our own ways to promote and influence where and who we could.

En route to my next IOC commitments in Nagano, I met Koji in Tokyo to get an update on the situation and he reported some progress and briefed me on some of the key players that we would have to influence. Early the following morning I caught the bullet train to Nagano. On the train they separate passengers from their baggage while travelling and on arrival, I found that someone had unhelpfully stolen my solitary suitcase. Fortunately, my translator met me at the station and we reported the theft to the Railway Police who, with perfectly inscrutably straight faces, advised me there was no crime in Japan and it must have been Korean gangs! They would make a report, but that was it and basically, don't hold your breath. I was now reduced to the clothes I stood up in and ahead of me I had five days of meetings and venue tours in the

depths of winter, with the most senior people in NAOC. In the normal course of events this would not have been the end of the world. A quick visit to a local department store should have resolved my problem, but try as I might, I couldn't find anywhere in this rather small provincial town that stocked anything that came close to my size. Thus, I was stuck with my standard travelling outfit of cowboy boots, jeans, white shirt, sports jacket and fortunately, a heavy long raincoat: all serviceable if not ideal.

Over the next few days, I met with Makato Kobayashi, Director General of NAOC and all his venue directors. On every occasion my hosts, NAOC Media Chief, Ko Yamaguchi and the organising committee's photo chief, Yasuo Azuma, would politely explain my predicament, creating much amusement at the discomfort of this rather large foreigner. Every night after a fabulous Japanese dinner with too much sake, I would do my laundry and prepare for the next day. Not for the first time in my visits to Japan it was becoming obvious that the biggest problem I was going to have with these Games was in communicating my ideas and advice. Despite having a full-time translator and a photo chief who spoke some English, each morning I'd find a gaggle of junior managers waiting for me outside the hotel. Their refrain became ominously familiar: "Mr. Powell, when you said this yesterday, what did you mean?" I would explain again through the translator, who would then have a rapid back and forth, before everyone would suddenly stop the questioning, smile nicely, bow, and indicate they understood. The next morning it would all start again, with the same questions and a whole load more.

I only realised later that instead of coming back with follow-up questions if they hadn't fully understood my answer, the interpreter was fielding my answers and answering their follow-ups, so no wonder they were confused. This was to lead to several major miscommunications, one of which I spotted several months later in Lausanne at a meeting of the IOC. NAOC representatives were there, as were all the TOP sponsors, so it was a high-level event, and I was there on IOC Press Commission business. Coming out of my hotel one morning I spotted a familiar-looking group of Japanese gentlemen waiting for me, but this time a more senior group headed by Yasuo Azuma, the Photo Chief.

Over coffee, he apologised profusely, explaining that they had spent months negotiating with the event organisers and course officials, but they would not agree to my film couriers skiing down the pistes between the competitors. At first, I didn't really understand, but then it slowly dawned on me. At all major alpine events the on-course photographers are supported by film couriers, experienced skiers, who would slowly ski

down the edge of the course between the public fencing and the course itself, where all the course officials, television crews and photographers were positioned. The couriers could only move during the short intervals between competitors racing on the course and with 90 seconds between each, they would descend in short hops, picking up film as they went. Eventually arriving at the bottom of the run, they would deliver the film to the various agencies for processing and timely distribution, while the event was still in progress.

However, Yasuo and his team had been arguing for the film couriers to ski down the actual course in between each competitor, so no wonder the event organisers and course officials were horrified, and this simple misinterpretation had led to months of confusion. Now, he said, the NAOC insisted that the film couriers must ski down outside the course in the public area. But this was also a big no-no for me, having witnessed a most horrific accident at my first Winter Games, when the Austrian ski team doctor, Joerg Oberhammer, died after colliding with a member of the public and was crushed by a moving snow grooming machine. I knew how dangerous their proposal was and explained that I would resolve the impasse and get back to him. I took it up with the IOC and the International Ski Federation, who were responsible for on-course events at the Games, so we resolved it. Translation and misinterpretation were to be an ongoing problem, we'd dodged that bullet, but there was to be worse to come.

Christmas at home came as a welcome break from what had been a very stressful year.

24

THE IMAGE BUSINESS

With plenty of other things and events to occupy our minds and our photographers' time, when it finally arrived, 1996 proved to be the most momentous year in our corporate history, marking our move into third generation digital image storage and distribution. As David Jacobs, one of our British competitors commented at the time: *"Towards the middle of the 1990s, sports photography had finally found its niche. It became much more commercially driven, with major sponsors investing increasingly heavily in all sports and their requirements changing from what had been primarily ad hoc usage of branded images towards a desire for dedicated bespoke photography. Allsport led the way in providing the pictures and all the accompanying service."* Always nice to be recognised by the opposition and it was patently clear that, by now, we dominated both European and Stateside sports coverage in all areas of the marketplace, reaching a vast daily global readership.

From the first moment that I had picked up a camera, I found that what I enjoyed most from photography was communicating what I saw and felt on any subject. The subject was largely irrelevant, and that I had stumbled into sport rather than news or war reportage had also been irrelevant. After that, I had always seen myself as an entrepreneur who made photography work commercially, because that's what it means to be a professional photographer. I wasn't the best snapper in the business, but I'd had my successes and built something of a reputation, but I also knew just enough about the creative and technical aspects to command respect from the people around me, which was important. Over the years I found that I had developed the ability to construct an environment that creative

people trusted and in which they could perform well and flourish, so I ring-fenced and jealously guarded it. The real success, however, was all about organisation, seeing opportunities to grow the business and turning Allsport into a marketing vehicle for creative expression. Less the business of taking images, but more those images as a business opportunity. Now, if carefully managed, it had come to the point where my aspirations for the agency were likely to realise some serious return, but that was not the only driving force. We had proved to the market that we had the best team of photographers and backroom staff in the industry, so creatively and organisationally, we had nothing left to prove to ourselves.

I have never disguised the fact that I am extremely competitive in every facet of life, and I suppose that this showed up most obviously in business. It had always been my intention to build the Allsport Group into *the* major player in the world of sporting photo agencies, but it was only now in the 1990s that I fully comprehended that doing this began to position the company as a target for acquisition. With this realisation, most recently the question had been when and how to put our company on the market? What thinking about this had done was to focus my mind on how best to groom the agency for its next step. Whether a trade sale, a public offering, or an interesting venture capital investment from outside the industry, I needed to gain the full support of the Board in bringing the next moves together.

At our first Board meeting of the new year, we discussed at length the changes that were happening in our world, specifically the move to digital and the opportunities that this presented, set against a backdrop of an industry buzzing with rumours. There were several organisations, both old established and new players, looking hard at how editorial and stock photography could be maximised, including the Telegraph Group, Bill Gates' Corbis, Reuters, the Press Association and the rapidly emergent Getty Communications. Our industry had a few large players but was mainly made up of small, specialist companies representing freelance photographers and collections. Being both labour and space intensive, margins tended to be low. The impending change to digital would transform all that, but it wouldn't be cheap and very few companies had the resources to properly fund the change. Opportunities were there, and some could see them. They probably saw Allsport as a relatively small player in the industry overall, but in our sector, we were the dominant and most influential player and controlled most of the routes to market. We had built significant barriers to entry based upon the accreditation system in sports coverage and the millions of duplicate transparencies that

lived in filing cabinets in the offices of our clients and agents worldwide. Coupled with our early adoption of digital and the creation of our Digital Image Archive and Retrieval System (DIARS), it simply made it very easy for our clients to access our product, so to break through these barriers would be nigh impossible for any newcomer, however large they were.

During that Board meeting I laid out my case again and received a more significant response to that of just 12 months ago, as all my fellow Directors and shareholders now saw clearly the possibilities allowing us to move forward as one. While Europe and the majority of our territories were showing progress in growth and turnover, we needed to replicate those things in North America. In our judgement, the boost we got from the FIFA World Cup and with the 1996 Atlanta Summer Olympics on the horizon, our profile and profitability would both grow immeasurably, our value would rise and at their conclusion, would conceivably never be higher. We all left that meeting with a clear goal, to drive turnover and profitability as hard as we could and we tasked our Group Finance Director, John Witts, with trimming the fat. Based upon that decision, we then politely declined all approaches and enquires, telling people that we would not be on the market until 1997, which we reasoned would be the optimum moment for us to realise the company's real value.

Also coming to a head was another major project that I had been working on with Matthew Schoen in LA and Les Symes in London. Les was an ex-Associated Press old school wire technician who had successfully re-trained into digital. Together we were working on the third generation of DIARS, the third in just eight years. We had started in 1988 with Hasselblad's proprietary system, with which we had been much involved in its early development and launched at the Seoul Olympics. Client access could only be gained through their own scanners and required proprietary Hasselblad Picture Desks to receive our images, but other technologies had now overtaken it. In 1992, in partnership with the Associated Press and Leaf Systems, we launched the second generation at the Barcelona Olympics. This was a considerably more open system that could take images from many sources and could be accessed through all PC and Mac-based systems, and Leaf's own software. Now, working with Applied Graphic Technologies (AGT) of Rochester in New York State, we were helping to build the software for the next generation. A completely integrated, multi-workstation system, that would manage the digital workflow from camera to client at speed and which could be accessed via Netscape and the World Wide Web. The plan was to use the Atlanta Games later in the year as its launch platform.

Two critical components of the plan were the launch of Netscape Navigator in mid-1995 and Kodak's new Photo CD Scanner. The beauty of this scanner was that it could scan very high resolution 18MB (2048 x 3072 pixel) files that could be compressed down to about 6MB. The quality of the re-opened files was more than sufficient for almost all high-end magazine and book publishing needs, and nearly indistinguishable from the original. With advances in bonded Integrated Services Digital Network (ISDN) lines, our clients could download these compressed files in just minutes and reproduce in better quality than the duplicate transparencies we would otherwise supply. These scanners could handle up to 240 images an hour, significantly faster than anything we had achieved before. Previously scanning at 18MB, we would be pushed to deliver that number of images in a 12-hour day. AGT added the front-end capability, allowing rapid scanning, image optimisation such as colour correction, sharpening, orientation and editing. It also featured one of the first, if not *the* first, uses of a digital lightbox, which allowed clients to select multiple images from several search criteria and store them in a personalised lightbox browser window. They could then share the digital lightboxes over multiple workstations, allowing clients with several office locations to work collectively on image edits over the internet, using the Allsport Archive as the medium of exchange. This is all very standard practice now, but was very innovative at the time. We played no small part in establishing all the early protocols and work practices that were to become the industry standard.

It also added the data entry process and embedded the International Press Telecommunications Council (IPTC) archival standard header and Exchangeable Image File Format (EXIF) data fields into the image, providing the link into our archiving system. Adobe subsequently adopted this technology as the foundation of its Extensible Metadata Platform (XMP) and combining all these elements now provided us with a full end-to-end production suite. AGT's Digital Link system, that I am proud to say we worked on and launched at the Atlanta Olympics, went on to be adopted as a digital asset management solution by many newspapers, periodicals and other publishers. Early adopters included the Daily News, Springer Verlag and Conde Nast, advertising agencies Ogilvy, Saatchi and others, together with large companies such as Mercedes Benz, Universal Studios, Warner Bros and the Walt Disney Studios.

Netscape Navigator was a new benchmark for many companies and industries, being the first browser that made surfing the internet a practical and enjoyable experience. Although we had been using the

internet for some years, most of our client's downloads were on bonded ISDN telephone lines with all the associated telecommunications costs. By moving all our archives onto the internet and allowing our clients access via Netscape Navigator, it would represent a significant cost saving for them and a game changer for us.

Meanwhile, the newspaper and publishing industries in the USA were starting to really take on and engage with the digital revolution and began catching up with their competitors in Europe. To hammer home the message, we invested heavily in stand space at industry trade shows all over the States, five in February alone, which we attended with full demonstration suites. Our team was Greg Walker, Sue Baldus and Peter Orlowsky, with me fitting in some of the more important shows: there, we demonstrated our current systems and gave early insights into the way forward. The investment in time and effort bore an immediate return and off the back of these trades shows we finally cracked the North American newspaper market. Simultaneously, several of our top agents also went digital, notably Vandystadt in Paris, Aflo in Japan, APL in Australia, and Allsport Mexico, reaffirming the value of our agent conference the previous year.

By the middle of the summer, our next play was to launch www.allsport.com, our first website and, unlike today, when anyone can rustle up a website in minutes with all the tools and services available online, back then it was truly a mammoth task. Apart from all the now familiar pages recounting the Allsport history, marketing materials and individual photographers' profiles and portfolios, we had live event calendars and event coverage schedules worldwide. Now anyone, anywhere, could read it and better still, interrogate it, but the jewel in the crown was hidden behind a secure login screen. This let our qualified clients enter our digital archives directly, search, compare, create lightboxes and download images in multiple resolutions, with complete IPTC metadata, accessed via the internet and Netscape Navigator. This, I believe, was a world first in the industry, allowing picture searching and downloading through a browser and probably second only to the porn industry!

Three weeks before the Atlanta Games were scheduled to begin, AGT loaned us two technicians, Simon Moran in London and Robert Godwin in LA, to help train our editors and technicians on the new system. Although our guys were probably the most experienced in the industry, having by then worked on digital scanning and archiving for nearly eight years, these were complex systems. It wasn't just about learning the new hardware and software, but now it was about integrating the new system

into our process of managing workflow and deadline commitments. If you let the workflow commitments of an Olympic Games get out of control, that would be the end of your games. The mantra that when the games begin, they wait for no one, was one that I repeated constantly to our suppliers, very few of whom really understood the brutal world of media deadlines, so we continued bug fixing and training right up to our launch date on the 19th July.

I arrived in Atlanta with our advance party a week ahead of the opening ceremony to set up the most complex systems we had ever taken to any event. My first duty, wearing my IOC hat, was to tour all the venues and check on the coverage positions, where my worst fears were confirmed. Everywhere, television and photographer's positions would clash, particularly in the main stadium. Agreements with the Organising Committee, which had been fought for long and hard, had simply been ignored. I met with Manolo Romero who ran the host broadcaster for the Organising Committee providing the neutral feed of all the sports action to the world's broadcasters, with whom I had been negotiating for years and his uncompromising message was basically: "It is what it is, deal with it." Faced with his intransigence, I knew this was going to be a tough Games for photographers, and I would spend most of my time firefighting problems and resolving disputes. The layout in the main stadium was ridiculous. There was one small trench at the end of the 100-metre finish for the major agencies, plus a huge scaffolding gantry so large and inappropriately positioned that it blocked large sections of seating, making them unsaleable. On most days, there would be up to 600 photographers and film crews from all over the world jockeying for position on this gantry and the technical nightmare was that anytime anyone moved, the gantry would vibrate, promoting screaming fits amongst the television crews. If only they had dug a moat!

Back at our office in the main Press Centre, senior Picture Desk Manager, Steve Rose, together with Matthew Schoen and Les Symes, were busy setting up the scanning, storing and digital distribution network. Although we had a couple of back-up options, our whole digital output from the Games relied on the new AGT third generation DIARS working. We had a lot riding on it, so we had arranged for AGT's Robert Godwin, who had been working with us in the development phases, to come to Atlanta for the duration. I spent the last couple of days before the opening ceremony working with the team, ironing out the final bugs and walking through the process with the editors and scanning techies who would work in shifts, 24/7, for the next 17 days. This was the bit

Atlanta's Summer Games proved problematical when the local organisers failed to listen to advice from the IOC Commission and to realise the mayhem that would be caused by their approach to accommodating up to 600 photographers and film crews who were forced to share an inadequate trackside facility.

Photo: Gary M. Prior/Allsport

that I really enjoyed, finding solutions to the challenging technical and workflow problems, but unfortunately by the time the games began, I had to leave it to them, as my increasing involvement with IOC committees had changed my role. No longer was I the Allsport photographer and team leader, but now worked virtually full-time for the organisers. As it transpired, most of my time would be spent refereeing disputes between television crews and photographers, less like an adrenaline-fuelled hamster on a wheel and more like swimming uphill through soup.

By the time everyone arrived in Atlanta, we had arguably the finest team of sports photographers ever assembled for any event, a quite extraordinary fund of talent, which would outshoot Reuters and AP, and

everyone else come to think of it. Even though we were on the cutting edge, the digital cameras of the time were still too slow compared with a motor-drive Canon or Nikon film camera. Our coverage of the Games would still be shot on film, 12,500 rolls of it, or as some wag said: "That's 450,000 frames that need editing!" Now, for the first time, with our high-speed scanning and multi workstation editing and captioning suite, our digital output would mirror traditional duplicate distribution, not just an edited selection as on all previous events.

Atlanta provided Allsport with another opportunity to showcase its talent and technology. A truly remarkable group of photographers and support staff were assembled to service media and sponsors. Behind the Author on the far left is David Ashdown of the Independent, still a friend twenty-seven years after we had joined Keystone together in 1969.

Photo: Allsport Archive

Once again, Lee Martin led our team and prepared for what would be a full-on daily operation, harnessing multiple streams of content and channelling them into the main feed as our primary edit that would be picked up by all our clients worldwide, either through our new DIARS or via direct transmission. We backed this up with our traditional physical distribution of duplicates, amounting to hundreds of thousands of them. This distribution was also going to 38 agents, and

hundreds of direct clients. Many sent editors to the Games demanding country-specific edits from those images not selected for the main feed. It seemed that everyone was expecting individual attention throughout the Games so to prevent this distraction, I would politely explain that during the Games we create a river of images for which you buy the rights to fish. You can catch as many fish as you like, and if you want a different type of fish there was a lake over there, full of unedited images that you can trawl, but *we* don't trawl the lake or change the course of the river.

We had multiple first rights deals, by territory, sector or project, such as the official Olympic Book, whose representatives also scoured our secondary resource. Managing all this and keeping track of all our images, both digital and physical, was to challenge the system, but Lee and the team handled it all and watching the different processes was quite surreal. On the one hand, it required a team of up to 10 people to mount, caption, sleeve, and stuff envelopes full of thousands of physical duplicates for shipping, as part of our traditional distribution. On the other hand, and in complete contrast, there was one man sitting at a terminal in the same room, zipping thousands of digital images around the world in a matter of minutes. The opportunity for rationalising the industry was never better illustrated or more starkly apparent.

Just to get a handle on where the content originated, it was the first occasion in modern history when all 197 recognised National Olympic Committees were represented in competition, taking part in 271 events. By the time it was over, the Summer Games had cost US$1.8 Billion to stage and though the media operation went off relatively smoothly, the Games were not without their problems, notably the media and public bus systems which were a disaster. Unable to source sufficient buses and drivers from metropolitan Atlanta, the Organising Committee had, in their wisdom, brought in school buses and their drivers from all over the country, most arriving just a couple of days before the opening ceremony. Presenting them with a map of the venues to be taped to their dashboard inevitably resulted in most of them spending the first week completely lost, dropping people off at the wrong venues or just giving up the battle in some back street. Then there was the scheduling, results and information computer system that crashed frequently, coming close to stopping the Games, as everything revolved around it.

For many people, including some in the press corps, Atlanta will be remembered not just for the performance of athletes, but for the bombing that took place. As our colleague, AP's Paul Newberry reported:

"The Centennial Park was opened just a week before the Olympics began, built on an area formerly occupied by vacant and decrepit buildings, with sponsor's buildings, concert stages and exhibits. The bombing took place in the early hours of July 27ᵗʰ, killing two and injuring one hundred revellers. The blast shattered windows, rocked buildings and echoed through downtown, where thousands have gathered every night since the Olympics began." It threw a tragically negative light on what should have been a universal celebration of excellence, but the Games continued unabated.

Most of my memories of Atlanta were pretty dark, particularly the realisation that years of detailed forward planning, visits to the city by multiple IOC advisers, including myself, had essentially been ignored. Everything that went wrong had been foreseen and flagged up by the IOC's Athletes, Officials, Transport, Facilities and Media Commissions, but the Atlanta Organising Committee had carried on, regardless. At the closing ceremony, IOC President, Samaranch, broke with tradition by calling the games "most exceptional" rather than his more regular accolade of "the best Olympics ever" and that rather summed it up for all of us who had been intimately involved in its delivery.

I do have some fond memories, not least of the talent and creativity of our photographers, whose output was astonishing, delivering images that will live forever in Olympic folklore. And the moment in the opening ceremony when Muhammad Ali walked out onto the podium to receive the Olympic flame from Evander Holyfield: a palpable wave of emotion swept across the audience as they realised who it was. I could physically see the shock wave of realisation coming towards me and when it hit, even an old media cynic like me was moved to tears of joy. It had been the best kept secret of the games and it was a master stroke. I had worked with him back in 1980, on assignment for *NOW! Magazine* with Alan Hubbard, just before Ali's fight with Larry Holmes, which was credited for his eventual descent into Parkinson's disease. We went to his home, met the family, followed him through training and he was the most charming and graceful athlete I have ever met. Now, watching him receive the flame and light the fuse to the cauldron, it was heart-breaking, as very obviously, Parkinson's had got the better of him. Suddenly the audience realised what they were seeing, and the cheers of recognition changed to cheers of support for 'The Greatest', the best boxer the world has ever known.

Last, but by no means least, I remember with a mixture of awe and some pride the success of our support team and especially of our new fully integrated digital workflow. For the first time we achieved the

Now suffering visibly from Parkinson's disease, the world's best-known boxer, Muhammed Ali, walked forward to accept the Olympic flame at Atlanta's opening ceremony to an arena-wide wave of emotion.

Photo: Michael Cooper/ Allsport

syndication of more live images than our traditional physical distribution could ever hope for, which was a vindication of our investment in Allsport's digital future. We were not the only people to have recognised this leap forward and shortly after the games I received a phone call from Mark Getty: "Just passing through," he said, "would I be free for lunch?" We had been approached earlier that year by Mark and his partner, Jonathan Klein, and had given them our standard line; that we were not ready yet, but by 1997 we might be more receptive.

Looking back, as Allsport had grown in market stature over the years, it had regularly been the target for fishing trips and approaches from potential buyers, some serious, some less so, but none as serious as Getty. Everyone knew the name of course. Grandson of John Paul Getty, the founder of Getty Oil, son of Sir Paul Getty, who had developed the refining and petrol retailing business in the US and sold it to Texaco for US$9 Billion, in what was then the biggest takeover in American corporate history, Mark had many reasons for doing nothing. But even more for making his own imprint in business. Having worked at the

New York investment bank, Kidder Peabody, he returned to the UK to work for Hambros Bank, where he became a Corporate Finance Director. Among his colleagues there were South African-born banker, Jonathan Klein, and Nick Evans-Lombe. Together they made an engaging and formidable team and if Getty was the household name that would open doors, Klein was the strategic thinker and Evans-Lombe the enforcer who made the wheels turn.

In 1995 they decided that they could do better outside the Hambros orbit, raised an investment fund of their own and began looking for acquisitions with growth potential. Using some Getty cash and a healthy slug from Rothschilds and elsewhere, they found themselves as principal shareholders in control of Getty Investments LLC with a fund of £60 Million and the chance to look for investment opportunities. Their criteria were simple. They needed an industry that was about to go through a major game change, buy in at the highest level of business competence, and drive it as the agent of change. Using best investment banking practice, they looked at everything from the security business to florists and do-it-yourself, but after months of due diligence they homed in on photography and particularly photo-image libraries. Very astutely they had spotted the transition our industry was going through, and the significant costs involved. Companies that wanted to stay competitive would have to invest millions. Most of them didn't have millions. By late summer 1996, Getty had acquired the assets of Tony Stone, one of the biggest beasts in the stock photo jungle, together with Kodak's Image Bank and Visual Communications Group, from which I deduced that they were serious.

I accepted the lunch invitation and we talked about the future of the industry and the changes that were happening. Mark obviously wanted to know a lot about Allsport and our plans, so with an eye on the main chance, I was happy to oblige. He then asked if it was still our plan to go to market in the next year and I told him that that decision would be made at our next AGM in December, but it was likely. Then he opened up in a way that I found both disarming and slightly surprising by talking me through the process of bringing a company to market; how we would need to find a merchant bank to represent us and finally, how we must sieve out the expressions of interest, retaining a select few who we saw as real potentials.

We would then have to make detailed presentations to all of these suitors, culling the list down even further to a handful with whom we would engage in further, more detailed talks, as a prelude to receiving

offers and terms. At that point we would have to choose our preferred bidder and go into a period of exclusivity. We could then expect the buyer to do their due diligence and bring into play their lawyers and accountants, whose goal would be to present the worst and most damming report, attempting to shave their original offer price. This process could be brutal, and we would rarely get the original offer price he said, more helpfully adding: "We don't care who you talk to, we're confident that there isn't a better buyer than us."

As I left him, I realised that despite all my grand plans, before this lunch I had had absolutely no idea how to sell the business, but thanks to my host, I knew a lot more now. I am sure it was quite deliberate on his part in what I saw as a softening-up process, yet another indicator that he was serious. His parting words were very reassuring, but now I needed to find a way of establishing value and that could only be achieved by testing the market. There was still a lot to learn, and I was going to be on a rapid learning curve.

My 44th birthday was fast approaching, and I had planned to have a long weekend away with Beans in the Napa Valley. Once again, I went up a few days early to sit in the hotel room doing my plotting. It was clear that handled badly, trying to sell the company could be a disaster and if our staff became aware, the mere knowledge that we were looking for an exit would have a major impact on them. It would need careful management, as the potential for wild speculation and inaccurate gossip could undermine their confidence and throw up all kinds of issues. The same would apply to the rest of the industry, so it had to be done quietly: very quietly. Complete confidentiality would be paramount, particularly in the early stages, so as I always did, I then went through multiple scenarios and noted potential hazards, with possible results. I also had to decide where to base the sale. At least half the potential interest might come from American media organisations, but both London and New York were capital markets with the skill sets needed to take a company through the sale process. By the time Beans arrived to join me for the weekend, I had formulated my game plan.

25

INTO THE DRAGON'S DEN

Early in 1996 I had alerted my colleagues on the Board of the Allsport Group that I considered the most advantageous time to put the company on the market would be during the first quarter of the following year. This had met with their general approval, with the obvious proviso that before taking a final decision to proceed we had to find the right way of achieving the best value on the open market while recognising the contribution of our team. Having secured their mandate to move matters forward, I had spent the next nine months preparing for that process, with all the intricacies that this would involve, so my first job now was to find out precisely what would be required of us. Particularly how the process needed to work, in order for us not to appear totally naïve when we faced the market, red in tooth and claw, as we suspected that it would be. As with so many things in this life it was not so much *what* you know as *who* you know. I began trawling through my little black book of contacts looking for someone I trusted who might help me understand how to gain access at the correct level in the mysterious closed world of merchant banking. Tony Cadman appeared a likely candidate for this.

I had known Tony since the 1980s when we lived opposite each other in London. He was gregarious, good humoured, amusing, a bon viveur and importantly, very well connected. In fact, there appeared to be few people in London that he didn't know. We had kids of similar ages, our families socialised and talking with him, I had picked up that he was some sort of high-powered client handler with the Saatchi & Saatchi advertising group. He moved in business and City circles

largely beyond my experience, with a significantly more enviable contact list than mine. Now, when I needed a trusted steer into the murky world of international corporate disposals, he seemed like a good starting point.

All my previous dealings with bankers had been with the high street variety, notably NatWest, who had been so supportive of Allsport in its earlier days of expansion; but merchant banks were something else and already I was out of my comfort zone. I had a rough idea of what they did, of course. Essentially, advising on mergers and acquisitions, fundraising, project counselling and from our position, underwriting company offerings. I knew some of the bigger players by name and reputation as reported in the business media, but how did I go about gaining entry through the door of a Rothschild, Goldman Sachs, Nomura or Morgan Stanley?

Now facing the prospect of taking Allsport to market, it was no longer the friendly High Street bank manager across the desk, but a group of high-flying corporate players from the City of London that we had to convince; and that was before we entered the dragon's den of potential buyers.

Photo: Alamy Archive

Tony Cadman, who would later prove to be a trusted lieutenant in another business venture, had ideas of course and immediately assumed the role of consigliere. Once more it was the who, not the what, that kicked in, as Tony steered me towards a mutual friend in the shape of Charles Tilley, who I had met in recent years on the slopes at Val-d'Isére. I knew that he was something in the City, but as our previous encounters had been entirely social, on and off the piste, it was only after we had been more formally brought together by Tony that I discovered his background. Originally qualified as an accountant and rising through the ranks in a 14-year stint with KPMG, he moved to become Finance Director of the merchant bank, SG Hambros. Now when we met again, he was at the end of a spell of gardening leave before a temporary secondment to the smaller and more niche banking operation of Granville. The pieces of what I had seen as a complicated jigsaw were fitting together and Charles looked like the man to advise me on how to move the process forward and open useful doors.

We met in London in December 1996 during my visit to chair Allsport's regular end-of-year AGM. We talked through a scenario of which merchant banks he thought we should approach, how we should present the Company, what information they would need and what time scale was attainable and realistic. All good stuff, but best of all, being between jobs he had time on his hands to advise us, so could set up and attend meetings with me and bring together the bare bones of a sales prospectus, all on mate's rates. Finally, we agreed that I'd call him after the AGM and providing the Board agreed, I would brief him to set up meetings in early February 1997, to coincide with my next scheduled trip to London.

It had always been in the plan to promote internally to strengthen the Board and provide back-up for me whilst I was largely out of the day-to-day running of the company pursuing the sale, so our first order of business was to promote Lee Martin to the position of Joint Managing Director of Allsport UK. His track record in sales and marketing spoke for itself, Adrian Murrell and Lee worked exceptionally well together, and their skill sets fitted perfectly. Another advantage was that sharing the duties of Managing Director would allow Adrian to focus on all the other elements of the business, particularly day-to-day operations. Critically, it would free him up to work with me as and when required in the sale process. I was determined to have at least one other Director present at all meetings, just so we could bounce thoughts and observations off one another, so Adrian's no-nonsense pragmatism and caution would be a perfect foil for my enthusiasm.

Again, with an eye to how our management structure might be perceived by potential purchasers, I also proposed that we appoint two new Directors to the main Allsport Group Board. First of the obvious candidates was the Senior Vice President of Allsport USA, Greg Walker, whose handling of the difficult challenges in the American office over the previous two years had been exemplary. The second was my brother, Mike, who I had tried so very hard to stop coming into the business, but was now one of the best photographers in the agency and had established an enviable international reputation for his work across many sports. He was also a key part of the US management team, and the launch of his Allsport Concepts project was adding a serious revenue stream to the bottom line of the business.

With that over we got down to the main business of the day, which was obviously the potential sale. My question to my colleagues was simple. Did the Board think we were ready to go to market? Adrian reported on which companies had historically expressed interest in Allsport, together with rumours swirling around the industry, while I went through my conversations with Mark Getty and Charles Tilley. Then I walked them through my battle plan and what had been achieved so far. At the previous AGM I had asked them to maximise our profits for 1996 and for our Finance Director, John Witts, to trim the fat and that had clearly worked in a major way. The year had seen our worldwide turnover increase by 50% and our profit margin by 300%, so the grooming for potential sale had put us in a vastly improved position and made us an even more attractive target.

The debate was quick and the vote even quicker. We were unanimous that now was the right moment and we were fully committed. I briefed them once again that I was going to leave them to continue to drive the business, apart from a couple of technology projects that I wanted to see delivered and would continue overseeing. Otherwise, I would spend all my time on the sales process and IOC commitments and stressed how important it was that we didn't get distracted by the sales process, as it was vital that we maintained profitability and continued to hit our targets. I wound up the meeting by stressing the need for complete confidentiality. We couldn't afford this information to get out to our staff, or the industry, so all conversations were to be private, all communications should be private email only and anything produced in hard copy should be kept under lock and key. The sale process needed a name, so we called it *Project Athens*, in honour of the home of the Olympic Games.

Later, Lee was to describe my summary at our meeting as like a rousing speech to troops on the night before battle. He was right; it felt great and as a team we were ready, so we wished each other the compliments of the season before I flew home to California, knowing that we had made the correct decisions. We faced one hell of a year ahead of us.

In the new year I called Charles Tilley and we agreed that he would set up meetings with various banks in early February. I prepared my brief presentation positioning who we were, what we did and the opportunity that Allsport offered. I felt that the biggest obstacle we might face would be that we were a relatively small operation compared to those that these institutions are generally used to. Our annual turnover was less than £10 Million (around £19 Million in today's money), but our trading pattern was better than good. Turnover and profits had grown progressively, and we were absolutely dominant in our sector. This growth and market dominance represented our best shot at convincing banks more used to representing companies with turnovers of at least five times what we brought to the table. They needed to see that despite that discrepancy, we would be worth their time and effort. If I couldn't convince them of the substantial and exploitable hidden value in our wholly owned archives, coupled with the explosive potential of our technology in a rapidly changing industry, then I'd just be wasting all our time.

Back in London, Charles had set up five exploratory meetings over two days, two with major players in the shape of Schroders and SG Hambros, offset by three smaller boutique banks, in Phoenix Securities, Bott & Co and Granville & Co. Adrian would accompany me to all of them. The first day's meetings with Schroders and SG Hambros went well. I made my pitch of who we were and where I saw the opportunity. They came back with their pitch on who and how big they were and how many doors they could open. Despite our modest size as a company, both banks appeared keen to represent us and Hambros' head man, Giles Money-Coutts, made a big play about their reputation for doing media deals. I hadn't had too many dealings with anyone whose business card listed him as an 'Hon.' and as the Eton and Oxford educated son of a Lord, I felt that if anyone could open doors, it would be this impressively tall, pinstripe-clad banker.

Our second day of meetings with the smaller boutique banks produced similar reactions. Again, all seemed keen to represent us while explaining the advantages for us of bespoke operations working regularly on deals of this size. The following day, Charles, Adrian and I met for lunch to discuss the options. After running through how each of the

meetings had gone, we decided that, based upon their experience of the media sector, Hambros had been most impressive and the best we had met. In retrospect, I was perhaps a little naïve, but we had been treated well and the impressive wood-panelled boardrooms, pinstriped suits and old school ties were everything one imagined merchant bankers should be. Surely that would get us through all the right doors to secure our deal, so Hambros it would be, and we asked Charles to go back to all of them with our thanks but ask the Money-Coutts team to draw up a Mandate.

Flying back to LA, for no obvious reason that I could put my finger on, concerns and doubts began to creep in; had we made the right decision? Let's face it, I thought, despite our obvious successes we could be seen as just a bunch of photographers who had done rather well, and although Hambros had a reputation for working in media financing and transactions, we still represented a tiny deal for them. My main concern was that we would be relying on them totally to value the company and establish an expectation level, whereas I knew in my gut that our value could not be based on like-for-like or comparable deals or, for that matter, purely on the figures.

It was vital that we should find a way of establishing value that recognised Allsport beyond just its turnover and profit. We must go into the market with a clear understanding of the unique hidden value on offer, represented by our dominant position in the industry, the barriers to entry that this afforded us and the considerable value vested in our knowledge-based technology and vast digital archives. I wasn't sure that I could convince Money-Coutts of that. We were from such different backgrounds, he from an old-money titled family, public school and university educated whereas, I who couldn't read or write until the age of nine. I had emerged from the 'other ranks' and still remembered my military background and its in-built deference to authority. Which, in a strange and irrelevant way, he now represented.

I was less concerned about any social imbalance and much more that in their eagerness to get the sale away, Hambros would under-value the business, advise us to accept a quick sale in response to the first easy offer and I would be outmanoeuvred. What we needed to find was a knowledgeable buyer who already recognised our potential value and for whom the only issues would be in manipulating the cost. I felt confident that in the Getty organisation, we had just such a buyer, but we still needed to test the water to establish that value. It was also important for us and our advisors, whoever they turned out to be, to create a sense of excitement and jeopardy around the sale. Although I was confident

that Getty was the right buyer for us, unless they believed we had other serious offers in the pipeline or on the table, we would never get full value. In my mind, it was becoming clear that we may not really need the old school tie to get us through any doors, as from our knowledge of the market we knew who the interested parties were likely to be and there were only a handful. We just needed to ensure that we didn't get rolled over or sell too easily or too cheaply.

Back in the LA office, I put my concerns temporarily to one side as we were in the middle of going live with one of my pet projects. For the past ten years we had relied for our multi-currency accounts, integrated bespoke library management and client support packages on an IBM System 36 mini mainframe. By now, this was seriously in need of an upgrade to address our changing world. Although I was personally against paying sports bodies rights fees, it was clear that the future in the sports media was going to be a lot more complex. Now we faced a business model that would include celebrity, venue and event image rights, all pressurising a move to revenue sharing, so we needed a way of managing it when it happened.

Content partnerships with sporting leagues, athletes and other third parties such as trading card companies required us to keep track of new attributes of sales data to support royalty processing in greater volumes and with this came more complex multi-tiered calculations. To address this, we chose a mid-sized accounting system called Maconomy: it supported external integrations, multiple currencies, and multi-site installations, but its core asset was that it ran on an Apple platform, which was, by now, becoming our chosen operating system. The unique nature of the image attributes that contributed to determining sales royalties required the creation of a custom order management platform. Here our sales staff could track details such as sport categories, athletes, major events, commercial versus editorial use and other critical dimensions. Matthew Schoen and I had been working on the software to support this for about nine months and our plan was to launch it in our LA office and run it in parallel with our existing system for six months. So much of it was new custom software that we needed plenty of time to debug and tweak it before our planned installation in London the following year.

At the beginning of March, I flew out to Japan again for the IOC in preparation for the Nagano Games and this time, my clothes arrived with me. My brother, Mike, had been there for two months photographing all the World Cup pre-Olympic test events that were taking place and producing our set of preview images, and during that time, he had met

most of the top people in the Nagano Olympic Organising Committee (NAOC). Mike is married to a Japanese American, Judy, so his smattering of the language and knowledge of their culture had made him popular and cemented some good relationships. I had flown in a couple of days early so I could meet up with Mike and our agent, Koji Aoki from Aflo, and Mike briefed me on all the issues that would face photographers, which gave me a head start on the venue inspection tours and meetings.

Koji brought me up to speed on our negotiations with the Japanese Olympic Committee (JOC) and the NAOC, so now we had just a year to negotiate and prepare to deliver the deal that had been proposed four years before. Both Koji and I were experiencing considerable push-back from Kyodo News and their friends in the JOC and NAOC, so he had spent months travelling back and forth to meetings and explaining his ideas both for the photobook and the special Japanese photo archive that would start in Nagano and then form the basis of an important Japanese-specific Olympic record. Aflo would manage this on behalf of the JOC, and it would be added to after all future Games. I had been quietly working on NAOC and their Photo Chief, Yasuo Azuma, underlining how important it would be to co-ordinate and control the sponsor's photographers, so they did not interfere with the main media coverage and resources. I very politely pointed out on numerous occasions how this had been organised and resolved at previous games by appointing Allsport as official photographers to the relevant local organising committees, thus keeping it 'in house' and under control. I am sure the IOC's Michael Payne had also played no small part in pointing out the benefits of this arrangement to the highest levels within the JOC and NAOC, but we still weren't making enough progress. Always, there would be another hurdle to jump. Koji explained that his big concern was that the constant delays to agreeing a deal would lead to Kyodo News being appointed official photographers by default, leaving he and his team out in the cold, so we agreed to keep plugging on.

The venue visits went well. Yasuo Azuma and I got on famously and skied most of the proposed courses, agreeing photo positions, mainly from Mike's briefing. All the venues seemed ready and it was great to see test events going on in most of them. On our final night, Yasuo invited me out to dinner, and we were joined by the overall Press Director, Ko Yamaguchi, and his team. After an entertaining dinner of unagi, the regional speciality of freshwater eel, accompanied by sake, lots of sake, they invited me to a karaoke bar for a bit more drinking. I accepted, determined not to let myself down again, so I matched them whisky

for whisky, but I knew what to do with my side order of Coca Cola this time. Everyone got up to do their thing on the karaoke stage and slowly the pressure for me to perform became tangible. Karaoke and I don't mix, never have done, but I thought I could get away with it if I just growled the old classic, *I Was Born Under a Wandering Star*, as so memorably performed by Lee Marvin in the film, *Paint Your Wagon*. Well, I don't know if my rendering was memorable, but I growled a lot and moaned a little and got through it. Sitting down, I looked around for a little support or approval when Ko Yamaguchi stared at me and offered the immortal words: "Mike Powell, very good." Suitably chastened, I realised that I would never get it right in this country.

Despite what had been interminable negotiations and many setbacks, a couple of months later Koji told me he finally had a contract ready for us to review, so our Marketing Director, James Nicholls, and I flew into Japan and joined him for what would be the definitive meeting. We met with Makato Kobayashi, Director General of the Nagano Olympic Organising Committee (NAOC) and his coterie of directors, managers and under managers. Koji had warned me that even though there was a contract, the saga of our negotiations wasn't over yet and there were still people trying to stop us. When it was finally handed to me to look over, it would, of course, be written in Japanese. Knowing a little of how the Japanese mind worked, it was probably assumed by the NAOC team that having met and made polite conversation, I would then take the contract away to have it translated, before arranging another meeting to go over any sticking points. Only then would a final draft be tabled for signature, so plenty of opportunity for mischief there, I thought.

Came the moment and with due ceremony, they passed the contract to me. I looked at it gravely and in front of Mr. Kobayashi and all his team, looked at Koji and asked him if *he'd* read it. Yes, he replied. Then I asked him if he was happy with it and again his reply was affirmative, so pre-empting any further discussion and time wasting, I signed it. The atmosphere in the room changed immediately as they were obviously not expecting that, and as honour dictated, now they had little choice but to sign it themselves. Far be it for me to suggest that we had very simply out manoeuvred our hosts, but the smile on Koji's face as we left that meeting was pure gold. We had everything we wanted, he would produce an official commemorative photobook and start working with the JOC on his Japanese Olympic Archive project and would have all the photo access he needed during the Games. An added bonus was that working with us as official photographers to the NAOC, he got to work with all the major

Olympic sponsors in Japan. When the Allsport team turned up for the Games, Koji threw a pre-Olympic dinner for us in a fabulous Japanese restaurant, where seventy of us literally drank them dry, first exhausting the beer supply and then the sake. Through tears of joy, the owner said that it was unprecedented. We worked well together, Aflo and Allsport, and under Koji's leadership, Aflo has since produced the official Japanese Photobook of every Olympics, winter and summer, and continues to work hand in hand with the Japanese Olympic Committee. Probably no coincidence, but Aflo is now the largest sports photo agency in Japan.

While I was still in Tokyo, Charles called to tell me that Hambros had drawn up a Mandate and it was ready for signature and he'd send it over to me, but I should know that they were having problems which might impact us. I freely admit that I did not have the time to follow the business press particularly closely so was flying blind. Charles explained that the Co-operative Wholesale Society was the subject of a hostile takeover bid and Hambros was advising the buyer on what looked like a £1.2 Billion bid. Somewhere down the line, the Financial Services Agency had been alerted to the conduct surrounding the bid and now, at precisely the moment that we were negotiating with the bank, it was coming under increasing scrutiny with a potential scandal brewing.

As Charles said, there was no suggestion that the Money-Coutts team was in any way associated with this ultimately aborted bid, but we might consider how this distraction might affect how the bank concentrated on our deal; or more importantly, what the impact of this might have on the credibility of Hambros at precisely the moment that we were going into the market, joined at the hip! It was Peter Hambro who famously said that there were only two sorts of banker, and they should never mix: retail bankers who take deposits from the man in the street, lend them on to companies to finance their businesses and take a small net interest margin for their pains, and merchant bankers who should live off their wits, make or lose fortunes by taking risks and should run their banks or trading operations with unlimited liability, so they share the pain. I didn't object to Hambros sharing pain, but I didn't want our deal to suffer in the same way. I agreed with Charles that this might be serious for us and that I'd get back to him.

I decided that, coupled with my other concerns, we had to rethink on Hambros as our professional advisor, so I re-routed back to London on my way home and met Charles for dinner at the Bombay Bicycle Club in Wandsworth, still one of the best Indian restaurants in London. I noticed that they had set the table for three and the waiter hadn't yet removed

the third place-setting, which I thought odd. About fifteen minutes in and still at the stage of studying the menu, I was using the time to brief Charles that, having talked to the other Directors, we all agreed that we couldn't risk going forward with SG Hambros and needed to go back to the drawing board. At this moment, a man walked in who I vaguely recognised. Coming straight over to our table, he introduced himself: "Nick Harvey from Granville & Co, you'll remember me." I looked at Charles' wry smile and realised that I had been ambushed. Nick then explained at length why he was the only man in the world to do this deal, but he didn't bother to tell me anything about Granville, or any of the doors he could open. This gambit set me back a little, but it revealed his grasp of our company and the market: "You already know who your buyer is, don't you? It's Getty. All we have to do is make sure they pay the right price."

As I later discovered, Nick has many very useful attributes, among which is his ability to know his subject and to talk for England. As he went on about the hidden value in the digital archives and technology, our obvious market penetration and the room for exponential growth with a technology-based buyer, I sat there thinking that this man knew as much, if not more, about my business than I did. By the end of dinner, I was convinced, but there was one last hurdle. Morden, the most southerly stop on the Northern underground line, was a long way from the City and I doubted if few or any bankers had, or would, travel down there by choice, so I said that while I was sold, my Board would need convincing. I would call a meeting of the Board for ten o'clock the following morning and if he wanted the deal, all he had to do was find his way down there and then convince them. Which, to his eternal credit, he did. Like me the previous evening, the Board just sat and listened as he explained our business to us, our strengths and weaknesses and the process of getting a lot of buyers interested with a view to ending up with Getty Communications and two other bidders. Fortuitously, no one at Hambros had bothered to sign the Mandate which left us free to disengage with them and clear to proceed with Nick. We agreed that he would represent Allsport's interests. Oh, and Granville & Co would back him up!

Thus, by the middle of March 1997, we had assembled our perfect negotiating team. Nick Harvey, an experienced banker with boundless energy and enthusiasm in whom I had found my Rottweiler, and Adrian, cautious, pragmatic and sometimes a little distrusting, in whom I had the perfect foil.

26

MEMORANDUMS AND THE NOBU WORLD TOUR

No-one who has ever put their company on the market for the first time and gone through the process required to find new investors or, as in our case, new owners, can possibly forget the near-vertical learning curve that this requires. If reaching the point of deciding to expose your business to the market was tough, that is as nothing to what follows, and as 1997 advanced, I began to appreciate the enormity of the task I had undertaken to sell Allsport, the business that had been my life for so many years. Every facet of our business, every management decision, every basis for our success and our financial performance would be revealed in microscopic detail as we became a target. Potential buyers and their advisors would employ forensic levels of due diligence. Happily, our track record was one of sustained growth in a rapidly developing market and the investments required over the years to support our decisions to ride the tide of technological advancement appeared fully justified. Now bringing rich rewards, I felt confident we were a highly desirable target, but putting all this together was the challenge.

Back in London in early April, I had my first working meeting with Nick Harvey in Granville's boardroom, reassuringly large with an impressively massive table which every banker worth his salt would have envied. We sat, just the two of us, while he began explaining the process, most pressing of which would be a list of who I saw as potential buyers and an information memorandum. Guiding me towards a small side office he suggested that I got started and was slightly nonplussed when I rather tentatively interrupted his flow of instructions with a question:

"Nick, what exactly is an information memorandum?" Give the man his due, he didn't laugh out loud, but from the look on his face, this was the moment when it dawned on him that this might not be as easy as he had thought.

Ever the consummate professional at reading situations, Nick wisely suggested lunch so we could get to know each other a little better. It became the first of many long lunches taken together over the next eighteen months. Topics that day ranged far and wide, as two strong personalities from completely different backgrounds and industries explored their common ground. In his pitch for our business, Nick had said a couple of things that resonated with me. As a mid-cap corporate financial advisor, he needed many of the same creative and entrepreneurial characteristics as the shareholder owners of the businesses he was trying to help. To get the best out of the disposal transaction he needed to do the listening and see if any magic happened, to discover if the company's principals were really serious about going through with the sale.

I was pretty sure that we had made our intentions very clear, which would have reassured him, so now he patiently explained the scale and scope required of the information memorandum. Truly far reaching, it would become the prospectus and complete reference manual to Allsport and the industry we were in, as we went out to prospective buyers. We also discussed all the practical issues that we needed to resolve, not least my being based in LA and effectively commuting to London. Nick agreed that he would find out what email was, as he had never used it before and at this point, I smiled; one all! Email would streamline the exchanges of drafts and documents and without it, sharing documents by fax would be difficult and risky, given my travel schedule and multiple office locations. Nick suggested that my usual hotel in Richmond was too far away from his office, he wanted me close: as the Manager of the Athenaeum Hotel on Piccadilly was an old friend, he'd get me a deal on one of their apartments. I was going to need it a lot. We talked well into the afternoon and evening, and this was the start of a close friendship that endures today.

I moved into the Athenaeum the following morning and true to my discipline of plotting, began to rationalise Nick's briefing and the task of compiling the memorandum. Logically it must re-tell the company's history and background since inception, with a timeline broken down into several different tracks. It needed to detail the growth of the company itself, who we were and what we did, but also our position in the

commercial arena of sport and the media. It would need to list further separate histories covering growth in technology and finances over the last ten years, plus a complete and detailed description of every facet and aspect of our business. All would need to be broken down further into multiple streams covering our main customers, sectorial breakdown, geographic breakdown, archive versus live and digital versus traditional hard copy. That was just for starters.

One of our big strengths and residual values was vested in our relationships with over 40 sport governing bodies so that needed detailing, as did our working practices with our clients. Evidence was required detailing our distribution to newspapers and how we handled magazines, book publishers, agents, sponsors, advertising agencies, merchandising, trading card companies, calendars and jigsaw puzzles, and all needed supporting figures. The document had to describe in detail our multiple routes to market, both digital and traditional, together with the massive barriers to entry that we had created through our distribution of an estimated 10 Million duplicate transparencies, which now lived in the files of our clients and agents, ready for instant use. It was, by necessity, a complex business, all of which needed explaining.

In one of our early conversations, Nick had emphasised that we needed to identify our human and physical assets. Identifying the key players was easy, as we knew precisely their backgrounds in the industry and in our business, and one of our prized assets was our roster of photographers, so listing their track records, specialities and awards would give further weight to our offering. After identifying these human resources, we needed to list and detail all our physical assets. Some of these, like our freehold building in South London would be easy; but others, notably pieces of equipment, were dotted all over the world in our offices and those of our agents or on the road with our photographers. An up-to-date asset ledger would have been great, but we were a small, fast-moving company spread over multiple sites, so I would need to arrange a full asset audit.

Finally, we would have to present fully audited accounts for the preceding three years with budget forecasts for the next three and those financials and forecasts would be the easy bit. Did I say finally? Well, I was wrong. When I had amassed all that material, I would need to compile an overview of our market, starting with the sports industry as a whole, with further identification of commercial, editorial, stock, live, traditional and digital sectors, all with estimates of individual market sizes with substantiating sources. How much easier that would be

today, now all this industry data is available online: back then, it wasn't. Yahoo was still in its early days and Google hadn't yet been born. As we finished the final Armagnac of our first bankers' lunch, Nick mentioned casually: "Oh, by the way, you'll also need a five-year business plan for the future of Allsport."

As with every major challenge or problem that I had faced in my life, my method was first to break it down into its component parts, identify one component that could be tackled immediately and then create a realistic timeline for the rest. I worked on the proven basis that solving something quickly often led to rapid resolution of the whole. Having co-directors to call on, I sent out a memo to them titled: 'If you had ten million pounds to invest in Allsport tomorrow, what would you do?' Simple and effective. Everyone who had ever worked for Allsport had lived perpetually in the looming shadow of deadlines, because that was at the heart of the service we provided. The deadline I faced now, with just two months to research, prepare, compile and print the document that would define the future of the Company, was as taxing as any I had ever encountered. I would need to delegate without giving the game away. 'Project Athens' was brought to life in the Athenaeum and once I had established a timeline and a clear plan, I returned to LA to work from home and prepare the ground.

The responses from my co-directors to the ten-million-pound challenge were illuminating and showed real vision. Most of the hard number crunching landed on the desks of John Witts and Mavis Streeton, but simultaneously, Lee Martin and Greg Walker began working on client analysis and breakdown, while Adrian Murrell helped me collate everything and co-ordinate between both offices. As we sourced more data, each day revealed more facts and figures charting our business and each had to be substantiated, analysed and inserted in the relevant sections of the document and the process was fascinating. By the time we had actual numbers, some really interesting trends or confirmations of those industry-changing strategies we'd put in place many years ago became apparent. The first and the most obvious was, of course, the decision to buck the industry norm, by initially declining to accept commissioned work, thus keeping our copyright. This meant some very lean times in the early years, but now we owned exclusive, permanent rights of usage to most of over 4 million original transparencies in our archives. This had formed the core value of the business generating 85% of all our Group revenues, but there were many other trends and core strengths. Now it was possible to see cause and effect there in the numbers.

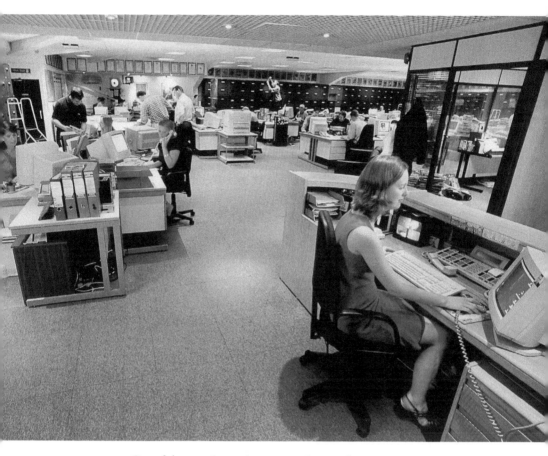

One of the most impressive weapons in our sales armoury was our main London library, now housing over four million original transparencies and growing daily, a motherlode guaranteeing ongoing income.

Photo: Allsport Archive

Second only to owning all our own copyright was the strong foothold we had now achieved in the US market and I felt that this would be a major attraction for any serious buyer. The US operations were now profitable, contributing 34% of group turnover and, without prompting, all the key potential buyers were to recognise the opportunity offered by our strong trading positions in the world's most important media and sport markets. One of my earlier stratagems had been not to focus solely on big value clients to the detriment of smaller ones, as I would rather have one hundred clients paying us £10 that one client paying us £1,000. I reasoned that with this wider and more stable trading base we

would be less vulnerable to changing buying patterns, market shifts, or simply bankruptcy; a common feature in any media or publishing-based business. Although we had seen many of these numbers before at our Board meetings and in monthly management reports, it was only after they had been collated that it became clear that we'd got most things just about right.

Allsport's oldest core client base was still book and magazine publishing, but my concept of better one hundred clients each paying £10 rather than one client paying £1,000 had driven our business model, ring-fenced us from client failures and continued to return a major revenue stream.

Photo: Allsport Archive

Our oldest core client base was still book and magazine publishing which accounted for 22% of our global turnover, but we now had thousands of clients all over the world. When broken down into regions, our revenues demonstrated a healthy geographical spread with 42% emanating from the UK and Europe, 34% from the USA and 24% from the rest of the world. Our risk was well spread, and this would create buyer confidence. Newspapers, a market sector that had been effectively banned to us until Eddy Shah came along and broke the union stranglehold in 1986, now contributed a healthy 15% of our global revenues. This had

been helped in no small way by bucking the industry norms of keeping tight control of every image while monitoring and negotiating every individual use. When we delivered filing cabinets full of our duplicate transparencies to every newspaper picture desk in London with little or no control on their use, there had been just one caveat. Use them as you wish, but please let us know when and how you use them.

Opening up the newspaper market had largely funded our entire digital offering, now ranging from our instantly accessible library through our website giving access to clients on a number of platforms that we could only have dreamed of even ten years previously.

Photo: Allsport Archive

This one conscious play had funded our whole digital voyage, had led to our subscription system now returning 22% of our annual turnover and newspaper groups now making up our three biggest customers. Breaking into that market was only equalled by our early struggles to get full accreditation at sporting events, whose organisers were notoriously protective and picky of who they let in. Our solution had been to offer sports' governing bodies free use of our images in their own publications in return for accreditation to cover events which had previously been barred to us. The secondary and valuable spin-off

from this had been the commissions we received from their sponsors, to which we gained access by our official status; this revenue stream now amounted to 15% of our total income. Our high-profile contract with the IOC, and these contacts within major sports and their sponsors, created value way beyond the pure revenue contribution and we had to find ways of emphasising this.

Our network of agents added a further 15% to revenues and although, historically, we had sold very little into the advertising, public relations and commercial markets, Allsport Concepts had changed all that. Our new model and rights-cleared images sold through a traditional catalogue, added a further 10% contribution from that sector. More interestingly, a full 23% of our global turnover was from small, non-sector specific clients, trading cards, posters, jigsaws and hundreds of other ways for which people wanted to use sports photos. I was proud of that market penetration and diversification and that our highest paying client amounted to less than 2% of our turnover while our top ten clients combined amounted to only 14%. I believe that it was this

Allsport's ability to retain editorial independence in news gathering, while still offering a service to sponsors, increasingly the life blood of sport, had opened many doors and business opportunities.

Photo: Allsport Archive

diversification across markets and the nature of sport, that allowed us to ride out three major recessions without really being affected. Despite the fact that we had seen many clients and projects fail over the years, none had been big enough to hurt us.

Then we had our human resource, our photographers. One of our early decisions had been to prioritise their names when asking for bylines under pictures and this simple choice was probably born out of the fact that the three of us who had founded Allsport *were* photographers. That we continued in that way, even when we started hiring, was again against all industry norms where traditionally the photo agencies would insist on only their byline. The legacy of our decision was there now for all to see: a group of the finest sports photographers in the world, each pursuing their own individual creative careers within the context of a larger company, with all the benefits that brought. Early concerns that promoting individual photographers' names would encourage them to leave to go freelance when they felt their reputation was good enough, proved false. This stable collection of talent was a core value of the company.

One of Nick's early questions had been, why did we want to sell Allsport? Compiling all this data and reading through the growing document, I realised that even I was impressed, which naturally led to privately questioning why *was* I selling. Was it the money? In itself, money had never been a particular motivator for me, so it had to be something else. I can remember many occasions over the years when friends who were off holidaying, partying, or just enjoying free time would ask why I was working so hard. I had a rather trite answer about being fundamentally lazy and wanting to retire before I was 50, but again, this wasn't the true reason either. Sure, I was tired, having been working flat out for nearly 30 years with an extreme travel schedule that had left me permanently jet lagged. A little lazy time would be welcome, but that could be achieved without selling. So why?

My entire life had been about setting targets, managing projects until I met those targets, but once achieved, I would invariably get bored and hand them over to someone else to manage. Was it that Project Allsport's time had come? Well, not entirely. Perhaps it was more likely that as an insider I understood the challenges that the industry would face in trying to digitise its whole operation. These technological changes would require a huge investment, just to keep pace and survive, so my £10 Million challenge to the other directors was no exaggeration. Allsport was where we had purposely positioned it to be in recent years, on the

leading edge of this digital revolution, but realistically, we had hardly scratched the surface. There were going to be huge structural changes to the industry that few would understand or could predict, and it would be the deep pocket players who would win this battle. Perhaps it was my concern about whether we could survive as an independent agency anyway, in that brave new world dominated by a handful of big monied players. Or perhaps I just wanted to do something else. The truth was probably in there somewhere, but what it all pointed to was that in order to grow sufficiently to survive, we needed to align Allsport with somebody or some organisation with very deep pockets.

By the end of May, the information memorandum was nearly complete, and all the other research and data collection was making headway, so then we looked more seriously at potential buyers. Getty Communications and Bill Gates' Corbis were the two obvious front runners, but we would only get one crack at this sale process, so it was only sensible to identify and compile a more comprehensive list of buyers. Because of likely interest from potential bidders in North America, we had considered linking a US bank to our offering, but this dropped off the radar after a visit to New York. We concluded that we probably knew all we needed to about our market and Nick had agreed, so when we got back to London, we had our list of potential buyers, all of whom were actively looking at acquisitions, or capable of making them. To cast the net as widely as possible on both sides of the Atlantic, we listed 32 companies who fit all the criteria.

Now Nick motivated Granville's in-house team and by the end of June, they had contacted all the potentials, many of them our existing clients. All were briefed on the opportunity, with an invitation to respond formally if they were interested in progressing to the next stage, which would entail us issuing them with the now completed information memorandum and arranging a presentation. Of the original list of potentials, 18 had fallen at the first hurdle for a variety of reasons. Some were not interested in taking full control, whereas we wanted a clean takeover; some proved less acquisitive than at first sight and might have just been on fishing trips; some could not meet the price expectation; some, when they got closer, could not see enough synergy; some didn't want to take on our personnel and some had underestimated our asset value. That sieving-out process had reduced the original list to a more manageable 14 hotter prospects.

More manageable was a relative term. Now we had to do presentations to all of them, which we scheduled during three weeks in July, first in

London, then New York. I had done a few presentations in my time, some to very high-level audiences, but nothing had quite compared with what faced me now and certainly, nothing had been quite as critical. I completed my presentation and began rehearsing the final draft about a week before the first encounter. This had to go well. Each presentation would take about an hour and we allowed equal time for questions which would be the point at which I would need to be totally prepared, particularly as it doesn't show at all well if the Chief Executive doing the sales pitch doesn't have all the key facts and numbers at his fingertips. I had to make the presentations interesting and would look at ways of keeping my delivery fresh over the weeks.

We held all the London presentations in Granville's boardroom, kicking off on July 8th with our pitch to Alan Pascoe International (API), part of the Interpublic Group. I had known Alan since his competitive days representing Great Britain at 400 metre hurdles and relay, and had photographed him during a career that had delivered gold medals at Olympic, European and Commonwealth games. Retiring from competitive sport after the 1978 Commonwealth Games in Edmonton, he had founded API in the same year and rapidly parlayed his knowledge at the sharp end of athletics. By the time of our meeting, he was acknowledged to be a pioneer of sports marketing in the UK.

We met with Alan and John Perera, a past Director and still a consultant. With Interpublic's resources behind him and a 60% stake in API's equity, Alan had suggested in his conversation with Nick that they were on the hunt to expand their operations into other areas of the media, hence their interest. I had deliberately scheduled them first to give me a sympathetic audience for my first presentation. It appeared to go well, though we were given no indication of whether we might be of real interest, but their reception gave us all a little more confidence. Having got off to a good start, the next day we presented to the magazine division of International Publishing Corporation.

IPC Magazines was a big client of ours and I knew Mike Matthew, its straight-talking, no-nonsense Chief Executive. Rising through the ranks from tea boy at *Autosport* to head one of IPC's bigger divisions, earlier in 1997 he had masterminded the buyout of the group from under the dead hand of Reed Elsevier in a Cinven-backed deal worth £860 Million, so he was a big beast in the publishing jungle. With well north of 50 titles, it was the largest consumer and specialist magazine group in Europe, inevitably with a big resource vested in its photo archive. As the presentation and questioning went on from their team, it seemed that

they would be more interested in using Allsport as a vehicle to exploit their archives rather than exploit our much bigger potential and appeared a bit sceptical, but who knew.

With two relatively easy ones under my belt, and getting into my stride, we moved on to host East Midlands Allied Press (EMAP), singly the biggest and most active challenger to IPC's monopolistic position. Another of our clients looking to diversify and exploit its own content, it then emerged that they would not want to buy 100% of our business and didn't exude any semblance of urgency, so that was really dead in the water. Fourth up was Reuters and although I had worked with David Viggers, their News Picture Editor, I had never met Brad Hanson who, as Director of New Business Development, was leading their team. We had been competitors for years, and because of this experience I thought that they needed a more nuanced presentation. They were obviously in growth mode and looking to capture and expand their part of the digital online market: witness their recently signed joint marketing agreement with sector highflier, Sportsline USA and the formation of a totally new group called Reuters Newmedia. It seemed their primary interest was in incorporating Allsport into that business and they were also looking for more time to make their minds up. Mentally, they went onto the back burner.

We then had a weekend break and used the time to further prepare for our meeting with Getty Communications – later to become Getty Images - which would be the biggest of the first group. All our earlier presentations had gone well, so my confidence was growing with each one. In retrospect, I was more than a little nervous when Mark Getty, Jonathan Klein and Nick Evans-Lombe walked in that Monday morning, as this was the one that really, really had to work. Adrian and I had both met Mark and Jonathan before, but it was our first meeting with Nick and from the start of negotiations, he came across as their consigliere, the sorter of problems and technician on the deal. The meeting went well, and their questions were to the point, which just confirmed that they knew a lot about the industry and had targeted Allsport as an important part of their plan to break into it.

Next in line was Rupert Murdoch's News International. Their team comprised UK Managing Director, Doug Flynn, Ian Weston from New Business Development and Richard Withey who headed their new media division. They clearly understood the technology of media routes to market and their questions focused on the implications of video and data broadcasting to the consumer market through their Fox Corporation.

Equally encouraging, they recognised the importance of retaining and motivating our management. Our seventh and final London presentation was to venture capitalists John Beckwith and Mark Johnston, whose Pacific Investments vehicle had taken a position in the International Sports Group. Allegedly, they were looking for further investments to enhance their growing sports, media and leisure portfolio, but we were unsure how they would approach us, nor what they would want out of any deal. It quickly emerged that they didn't want the whole package, would require our management to be tied in with a share of equity and inevitably, would look for a fairly rapid exit. Not the deal we could accept at any level, but interesting to see how this sector of the finance market operated.

It was a moment to assess progress and after this first round of London presentations, Nick agreed with Adrian and I that the only two real starters from amongst them were Getty and Reuters. Armed with that information, we decamped to New York on what would be the next leg of what had been christened the 'Nobu World Tour', after our tendency to find good Japanese food and sake in every city in which we found ourselves! If London had been politely instructive, New York was likely to be much more of a bare-knuckle fight, as we had discovered during our previous visit. Then, in a meeting with a private investment firm on Park Avenue whose specialist areas included media and marketing services, they tried with absolutely no subtlety at all to poach our deal from under Granville's nose, in plain sight. We could only hope that the companies we were now about to pitch were of a more ethical bent.

First into the ring was ESPN, the cable sports channel founded in 1979 as Entertainment and Sports Programming Network. Now owned 80% by the Walt Disney company and 20% by Hearst Communications, their mission statement a less than subtle 'worldwide leaders in sports'. Their team of one Vice-President and three Senior VPs suggested that there were taking us seriously, but despite their advances into sports information dissemination, with us they stressed over what they saw as the greatest threat to us and our future commercial projections coming from stills imagery derived from video. Not relevant, so another early runner pulled up before the second hurdle.

The following day we met with Tony Rojas and Steve Davis from Corbis, a company under the Bill Gates corporate umbrella that was swiftly growing into one of the world's leading image archives and licensing businesses. Their collection amounted to millions of photographs, some dating back to the 19th century, plus a growing video archive. Without

question, they were high on our hit list of synergic businesses. They were looking to establish an operation in productions, ventures and images as a serious content provider and they, too, had targeted us, but we had little real idea of how our assets would mesh with their plans. They were serious players, but could they move fast enough?

Collectively, Sports Illustrated/Time Warner was probably one of our most important clients and we had worked with them for many years as content providers so our presentation to Editor, Don Elliman and their Director of Strategic Planning at Time Inc., Victor Lee, would, on the face of it, be a meeting of like minds. They understood the issues of rights and accreditation that we brought to the party and the probable need to pay a premium to get their hands on Allsport. However, it would require a further internal meeting with Time Inc.'s top man to move it forward so we parted on good terms, but slightly in limbo.

As for the rest of the hopefuls on our list, more fell by the wayside on the questions of synergy and cost, while at least one refused to travel to New York, which hardly indicated serious intent. As July came to its close, Nick and I had exhausted our list of potentials and exhausted ourselves too, so we retreated to London to review the options. The next move would be to weed out the tyre kickers and qualify a shortlist of real potential buyers because, as Nick said, valuing our business would be almost impossible under conventional terms. Once we had the group of interested parties in play, the value would emerge out of the competition to secure the deal.

27

END GAME

B y the end of July 1997, we had concluded our travelling roadshow. Thirteen individual face-to-face presentations between London and New York had produced hundreds of questions, often the same ones after each presentation, but we had learned much about how the industry saw us. In theory, all the companies and individuals who had received our presentation were still in the market. However, on review, we agreed that, for many reasons, the majority were likely to take themselves out of the running, either because they couldn't fully appreciate what to do with Allsport or their obvious inability to meet our financial and management expectations. By this point, it was becoming quite obvious to all of us that Corbis, Getty Communications, and Reuters were the most likely suitors and we thought that all three probably recognised what we hoped was a powerful negotiating position. The entire process of preparing the company for sale had boosted our confidence and it was clear that Allsport was a company with considerable asset value and strong finances. Very much masters of our own destiny, we had agreed that our negotiating position would come with certain red lines.

We were looking for a straight purchase of all our equity for an agreed consideration in cash, with safeguards that our working agreements with our team would be honoured. We were also willing to consider offers of a mixture of cash and shares from the right buyer. It was perhaps an indication of the strength of our company that the entire Board of Directors, who were the primary shareholders, had sufficient faith in it to want to remain involved, if we found the right partner. We agreed that for any buyer to make the acquisition work, they needed to share our

view and experience of at least some of the market. They also had to be capable of taking Allsport forward to the next technological level, not just use our considerable photo archive as a cash cow.

The next stage in the process would involve Granville's Nick Harvey and his team contacting all of them to gauge interest levels, beginning to eliminate the obvious no-hopers and inciting the rest to respond with initial offers for us to assess. Nick and I were both off-station during August, he on a well-earned vacation, although attentively working his mobile phone at poolside, while I was in Sydney on IOC business, meeting with the organisers and doing my due diligence on their media planning. Adrian Murrell remained in London and we talked almost daily as each fresh development emerged.

Irrespective of our position, the industry was rife with speculation about which company would ultimately win the approaching digital wars and it appeared to be a two-horse race between Corbis and Getty. The race itself had two very distinct tracks, the first being the acquisition of content, the second being the digitisation process to exploit it. Initially, the two companies took notably different approaches to both tracks. Corbis, originally called Interactive Home Systems in 1989, then Continuum Productions in 1994 and then Corbis, was founded and owned by Microsoft's owner, Bill Gates who was one of the richest men in the world. His original vision was unique in that he believed that people would, one day, decorate their homes with large panels of revolving digital artwork. Thus, his acquisition of the Bettman UPI archive plus the digital reproduction rights to art from Leningrad's Hermitage Museum, Philadelphia's Museum of Art and Britain's National Gallery all made perfect sense. In another strand of his core business, he could make money from building the frames and then make even more from selling the content, scanned to high-end art level, to fill them.

Getty Communications, with its acquisition of Tony Stone Associates in 1995, had made a straightforward statement of intent that it was going to capture traditional photo markets, both commercial and editorial. Stone was one of the world's leading providers of contemporary stock photography with a body of images centred around a tightly edited core of about one million photographs called the Dupe Master Collection, notching up revenues of £27 Million the previous year. The Stone library and archive became the foundation of Getty's business and a year later they acquired the Hulton Deutsch library with its 50 Million images to supplement it. Getty's digitisation would be focused on getting images available online to media outlets; a more commercial and profit-driven

approach than Corbis. About the only thing Gates and Getty had in common in those early days was the vast sums of money they were prepared to throw at our industry.

Bill Gates and his managers, Tony Rojas and Steve Davis, had watched Mark Getty and Jonathan Klein begin their play back in 1995 when they purchased Tony Stone. By the time we went on the market in 1997 and prompted by the emergence of Getty Communications and its first acquisitions, Gates had realised that he needed more than fine art to service a wider and more general market. Buying entire libraries, collections and agencies with licensing rights had arguably less to do with helping the photographic market into its next iteration and more to do with giving his company traction, a more realistic purpose and some chance of turning a profit. Corbis was already on the back foot and playing catch-up by acquisition, hence their interest in Allsport.

First to show his hand was Gates. Corbis came in with a pretty standard offer based on ten times our operating profit, and we had to assume it was just an opening gambit because it showed no real understanding of what we were selling. Adrian's take on Corbis was that Rojas and Davies were essentially managers in the corporate sense and probably lacked the creative awareness to recognise what we represented or the passion to get past their collective caution and risk-aversion. When their offer came in, amounting to less than half our original expectation, it made no-one laugh. It was also a complicated parcel of cash linked to debenture notes covering further payments over the next four years, so in that form this would never fly. Nick suggested that they go away, think again, and come back with something more realistically closer to our price point.

Next to make its opening offer was Reuters, who were known to be acquisitive for growth and who could have become our nemesis, had we been less technically agile. Founded in 1851 by Paul Julius Reuter as the world's first news agency using electric telegraph and carrier pigeons, the first to report the assassination of Abraham Lincoln and the relief of Mafeking, they had just seen twenty years of growth and operated their words and picture service out of 150 countries. According to one insider, in the 1990s, with a head count of more than 20,000, Reuters appeared unassailable, with a powerful brand that meant trust, impartiality and reliability and sold its news stories, photographs and video feeds to newspapers and broadcasters around the world. Maybe because they had been concentrating on their business wire service products, they had lost the lead in the things we continued to deliver well.

*It was prophetic that our voyage from West Croydon to West Coast
America stimulated buyer interest from the City of London to
New York's Wall Street and highlighted Allsport's global offering.*

Photo: Alamy Archive

We also felt that Reuters was likely to pillage the assets rather than
exploit the potential and we had been saying for years that it appeared
hamstrung by various Trust covenants dating back to the 1940s. These
specified that it was solely an editorial business and consequently had
missed a trick by not being able to capitalise and commercialise its sports
image archive. As we had shown, pure editorial work would not generate
sufficient profits to allow investment, but there was a way that we had found
to separate shooting for news and commercial interests. We had worked
through this separation with publishers and sporting bodies, notably the
IOC, that passed all tests of editorial integrity which wire services could
not easily replicate. If Reuters had seen and realised the potential, it might
have been a different story. Instead, it had belatedly homed in on Allsport
as the vehicle that could catapult it into the new world order, though
whether our entrepreneurial management style would ever have fitted into
the more traditional Reuters mould was an open question.

Once Nick had fielded its first offer which was closer to, but still a
way off our target price, we discussed their potential as a partner. The
offer had some things to commend it and made a deal of sense, though we

would have to work on them to raise the bid, so my suggestion was that it would serve as an effective banker if everyone else collapsed. We agreed that it needed tweaking in terms of the corporate governance: notably in the makeup of the new Board, further incremental payments over the four years after the sale and a guaranteed minimum investment over the first three years to align with our Strategy for the Future document that had already been tabled. Even the most optimistic of us felt that talking Reuters into upping the ante would not be easy.

Coincidentally, our earlier pitch to *Sports Illustrated/Time Life* produced a not dissimilar result. We knew them well as a client and, perhaps naively, thought that what we offered would add to their armoury, but while it might have done, it actually wouldn't work. High staff numbers, management ethos and editorial bias aside, and despite their dominance in the market, they too could not see a way of accommodating our commercial operation without compromising their platform. Some years before, *Sports Illustrated* had pushed their syndication department hard, as they could see Allsport taking US market share. They had talked about partnerships and how we organised our relationships with the sport's governing bodies. Several of their syndication managers had been to Allsport at my invitation to explore co-operation, but I was sure they were intelligence gathering trips. When I heard rumours from American freelance photographers, who had no love for Allsport, that *Sports Illustrated* was aiming to put us out of business, I was not surprised, nor concerned. I knew that their core function was publishing a weekly magazine, so even if the potential income derived from competing in our market was attractive, it would always be a side-line for them. This industry was too competitive for non-core businesses to succeed.

The third offer to arrive came from Getty, who we had always viewed privately as the most synergic fit with Allsport and the most likely of the potential purchasers to stay the route and land the deal. We knew that they wanted us, so it was likely to revolve more around price than ethos or synergy. For all their size, Getty Communications still lacked a strong representation in the sports sector which we offered in spades. Their initial offer comprised a mixture of cash and shares, but as I noted at the time, Getty was the only one of our suitors that I would actually take paper from as part of the deal, because their business model was good and they were far more aggressive than the other 'visual' groups. Getty had become publicly quoted on the National Association of Securities Dealers Automated Quotations (Nasdaq) in 1996, and our share value would rise with theirs. Personally, I was fighting the corner for all our

staff and needed to satisfy myself that their futures would be reasonably assured after the sale.

While all this was in progress, I had my IOC work to attend to. In the first week of September, it took me to Lausanne to attend the delegate voting session that decided who would get the nod for the 2004 Summer Games. It went to Greece, incidentally, but more pressingly, I had to report to my colleagues on the Press Commission on preparations in Sydney for the 2000 Games. Though still three years in the future, it was occupying a lot of my time, as we didn't want to be presented with another Atlanta fiasco.

The rest of September was occupied with chasing up offers and getting people off the fence either way, so at least we could have a clear vision of who was in and who was out. The difficulty at that time of the year, as we knew it would be, and Nick was at pains to stress, would be maintaining the momentum of the deal during the holiday period. Nick worked the phone every day with the key players, cajoling them to move on to the next stage, revert with questions, make a commitment, or just up their offer. Anything to keep them in play and Allsport in the forefront of their minds. We couldn't afford to let any of them get involved with a new project or acquisition that might take their eye off us and he harangued them mercilessly, just to keep the focus.

Later in the month, Nick and Adrian joined me in LA, before we flew on to Seattle to meet the Corbis team on their home ground. Coincidentally, we found ourselves on the same plane as Mark Getty and Jonathan Klein, who, unbeknownst to us, were in the last stages of acquiring PhotoDisc. They must have realised that we were on our way to meet Corbis, but rather than compromising our position with them, if anything, it strengthened our negotiating stance by reminding them that they were not the only show in town. Soon afterwards, and perhaps prompted by this, I had a call from Jonathan saying that he was due to be in California and could we meet.

At this stage in the process, I had no real wish to play it solo, so I persuaded Nick to fly back to LA. He needed little persuasion and the three of us met for lunch in Malibu. It was all very friendly, but it didn't tell us much more than we already knew, and I soon realised that Jonathan's offer of lunch and a chat was just that; a friendly offer because he was in town. Although Nick's negotiating skills were surplus to requirements at that lunch, it offered Jonathan and I the chance to get to know each other a little better and to exchange views of where we saw Getty Communications and Allsport going. After the original discussion

some eighteen months previously, their stated aspiration to buy us and their aggressive acquisition of other agencies and picture libraries in the interim, one might wonder why we bothered to look anywhere else. On the other hand, our business had also accelerated and improved so dramatically in terms of revenue and resources we needed to take a value sounding from a wider group of players to establish our real asking price.

Nick's patience knew no bounds, and having spent many hours on the phones chivvying, cajoling and, in some cases, plain bulldozing, by October 6th, eleven of the original fourteen suitors had withdrawn. This left us with three serious bids in place from Corbis, Getty and Reuters, any of which could, on the face of it and with a bit of tweaking, make a good business bedfellow. Each offer was now more than our original target valuation, so now we needed to push hard to establish our *actual* worth.

By now, things were moving quickly so I felt that we needed to get a firm fix from Reuters. I still wasn't happy with the Corbis approach and although they were offering more cash than anyone, I was still uncomfortable with the business synergies. I suspected that Mark and Jonathan knew that, so I felt it was imperative that we got a stronger offer from Reuters to match Getty. Our third-round meeting with the Reuters team in London was amicable, but after they realised where the other offers were pitched, they dropped out of the bidding, leaving Corbis and Getty with near identical offers on the table. Then we embarked in rapid succession on a series of phone calls and meetings, constantly working to maintain the momentum of the deal, which I suspect was helped by the fact that I was constantly travelling, meaning there was always some pressure to get decisions made. At this point we still had a couple of aces up our sleeve. For example, we knew Getty wanted to buy us and had made that very clear. That we were willing to accept 40% of the consideration in shares made the deal cheaper and easier for them. Corbis couldn't offer shares as it was wholly owned by Bill Gates, so every time we said we wanted some way of participating in the success of the future with Corbis they had nothing to offer except more cash, which they did.

To break the impasse and get to the endgame, we changed our negotiating strategy. Up to this point we had been asking for offers and pushing harder each time we felt they fell short, but now we decided that things were close to the limit. Neither side was entirely sure what the other was thinking or offering, each tentatively edging forward, but not wanting to go too far. The risk now was that one bidder would get cold feet and drop out, so to pre-empt this and force the pace, we put our

cards on the table and told them what we actually wanted. Our reasoning was that now we had two very similar offers and if we placed a notional finishing point just north of both, then one suitor and probably both of them, would reach for the line.

By October 15th, we had received formal offers from both parties that met our asking price of £30 Million (£55 Million today) considerably above our original target price of £20 Million. The Corbis offer was all in cash, half on signature, the rest spread over four years, but the offer was complicated by caveats, retention clauses, offset rights and warranties. Getty Communications' offer was simple and straightforward, comprising 60% cash on signature and the residue in publicly quoted shares. No retention rights, no golden handcuffs, no indemnities or warranties.

I had always liked Jonathan and Mark's approach and saw real parallels between how we had changed the game when newspapers went into colour as well as their ambition to change the game by full digitisation, building an archive, maintaining copyright and selling rights to access the asset. In the same way that we had brought about a change in the old world, so they were intent on bringing about change in the new world. If our power play to bring colour to the papers had built an almost unassailable barrier around Allsport and its position in the market, Mark Getty's plan to digitise the world would build that barrier even higher between his image bank and the competition.

When we discussed these offers, all we really had to do was remind ourselves how many lawyers Corbis would have on retainer to complicate things. After some discussions between Nick and the Allsport Board, we all decided that Getty Communications offered us the better creative fit, providing the deal survived the 30-day exclusivity period and due diligence. On October 16th we accepted the Getty offer and prepared for the horse-trading.

Their team would be led by Jonathan Klein, the highly experienced merchant banker, with Mark and Nick Evans-Lombe in support, backed by Coopers & Lybrand, who would do their best for their client to forensically take apart our projections and valuation to reduce the price. Nick, Adrian and I went into play for Allsport. While it often frustrated Nick, Adrian's wonderful ability to suck his teeth and council caution when I was in full go-ahead mode, periodically gave me the opportunity to pause and evaluate every decision. This left the rest of the Board to concentrate on keeping the business running as it was vital that we didn't take our eye off the commercial ball while negotiating the final part of the sale. Nick had warned that this can happen all too often in small

companies when the owners are close to closing a deal, with a loss of focus significantly affecting the ultimate price. We were not going to fall into that elephant trap.

After deciding to accept the Getty offer, my next IOC job was becoming urgent, so I jumped a plane for Nagano. I had planned to call Tony Rojas and Steve Davis of Corbis to thank them for their hard work and explain to them why we went with Getty, but things got in the way. Most unusually, I was struck down with food poisoning, which confined me to my diminutive hotel pod and forced me to spend a good deal of time communing with nature in the bathroom. During one of my regular visits, the phone rang. It was Tony Rojas; Bill would like a word. Surreally, whilst enthroned, I heard one of the richest men in the world say that he had just heard that we were going with Getty, but would a bid of US$55 Million change our direction, US$5 Million more than the Getty offer. And he wanted to know now. I had always shared the decision making on this deal with my directors and fellow shareholders, but this time I would have to make the call solo and hope they agreed. Telling him no was the second cathartic process I went through right then, but I was confident the synergies with Getty would be worth more than the extra US$5 Million to us.

A large part of the exclusivity period we had entered with Getty would involve their due diligence. Once we had agreed the price in principle and told Corbis that we were no longer interested in their offer, we became exposed to the most tricky and dangerous part of the negotiations. If we failed to agree the original terms of the deal after the due diligence process and had to return to the market, Allsport would be seen to be damaged goods, and no matter how the failings of the other side in the aborted deal might be portrayed, the suspicion would always be that they had found something wrong with our company or our business plans. As we would most likely still be on the market, this first failure would hand an enormous advantage to any other potential buyer. They would know full well the negotiating advantage they had and would try to exploit the situation, so this had to work first time.

Fortunately for me, I had been briefed by Mark on what to expect and how to react in just these circumstances during our rather excellent lunch in Los Angeles twelve months previously, with the very man who was now sitting opposite me. We had talked a lot about the buying process, the initial offer, what constituted due diligence and how buyers never anticipate paying the original offer price after they complete it. I think many of the insights offered were to allay any fears we may

have experienced, but I had listened and remembered. Many people deeply distrust accountants, but I understood that in these negotiations they were just there to help their clients get the best deal. What I also understood was that they should look dispassionately at the best available information before making judgements, but after weeks of due diligence and negotiations and at a critical meeting with all parties present, Coopers & Lybrand condemned our accounts as the worst that they had seen in all their years of auditing. This provoked a sharp intake of breath and a feeling of disbelief.

What annoyed me most was that Coopers knew damn well that we had just installed one of the most advanced accounts and client management systems in our LA office and were planning to roll it out in the UK early in the New Year, but they didn't even look at it. Perhaps deliberately to destabilise the price on the deal, they had based all their due diligence on our 10-year-old London IBM system. The accounts of any small privately owned company were unlikely ever to come up to the presentational benchmark expected of a public company, but surprise, surprise, I knew our accounts were fine. I knew every number in the books on both sides of the Atlantic so while they might not present to the highest standards, they were at least accurate and honest. It was at this point that I realised that this was all Coopers had, and that this was just game playing. I also suspected that Jonathan, Mark and Nick were not necessarily comfortable with their advisor's position and were waiting for our response.

This posturing by the accountants produced a remarkably animated reaction from Nick Harvey, calling several things about their seriousness into question and gave us the perfect opportunity to reject their lowered offer and walk away. I was pretty fired up too, so I suggested that if our accounts were that bad, then their client couldn't possibly be interested in buying us. Less emotional and more commercially realistic, I pointed out that if we walked away, they would only be left with significant costs in both time and money, yet we would still be left with the best sports photo agency in the world. One that dominated a market sector that their client was desperate to break into. Having said my bit, I sat back and felt cold as I realised it could all end right here and now. I waited for them to blink; they didn't. We had all invested so much time, money and effort into bringing the two sides of a very synergic deal together for our mutual benefit; something had to happen. As the meeting broke up, the Getty camp must have realised that we were not bluffing; I wondered if they were!

Back in LA, a week later I received a call saying that Mark would like to meet me, one on one, to reactivate talks about the deal: I couldn't think of a good reason not to agree to that. Arriving back in London the night before the planned meeting, I went through my usual ritual; room service dinner, steak and a good bottle of wine, thinking and preparing for the fray. I knew that there was a strong possibility that this deal could still fall apart, so perhaps the best I could hope for was to be strong-armed into agreeing to a reduction in price. Nick wouldn't be in the room to advise so would I be able to hold my nerve against someone as experienced as Mark Getty?

The next morning, I must confess to having some nerves. I went through my normal preparation regime, my suit and favourite red and black tie, known affectionately around Allsport as the 'firing tie'. I say affectionately, because it was well known I was always the last person in Allsport to give up on someone, so when the team saw the tie it often came as a relief to them that I'd got round to dealing with the problem at last. I checked and double-checked that I had all my papers to hand and my crib sheet with all the numbers. Finally, before leaving my hotel room, I did as I always did and checked my laptop for emails. There, at the top of my inbox, was a simple message from my wife, Beans: "Good luck today and remember darling, we don't need the money." Simple the message might have been, but the power it vested in me was priceless. I set off for my meeting with Mark Getty, full of confidence, finally ready for the fray.

28

THE CLOSE

Arriving at Granville's office half an hour early for my meeting with Mark Getty gave me just enough time for a quick update with Nick Harvey before I went into battle. Sitting facing each other across Granville's vast boardroom table, Mark and I jousted for a short while, but it soon became obvious that we both wanted a deal. He had been signalling this for over a year and we knew that Getty Communications was the most qualified buyer, so I set out my red lines. I wanted to hold out for our headline offer price of £30 Million: my ace in the hole was the knowledge that we had already received an offer in dollars from Bill Gates' Corbis that was a useful amount above this, which at the time I had rejected. Mark wouldn't want to be seen to be overpaying and had to consider the market's perception of value in the deal, as we were, after all, a small sports photography business. Being asked to buy us, or indeed any small company, for 30 times its annual profit was almost unheard of.

We had talked of the possibility of this deal for many months and certain things had become clearer. We both understood Allsport's strengths, its market position and its strong foothold in the US market, without which I doubt we would have been sitting together in that room. We both understood the near stranglehold we had on the sports market, editorially and commercially, and the unassailable relationship we had with the world's most important sport's governing bodies, the jewel in the crown being the IOC. We both understood Allsport's technology lead and the power of owning copyright in this new world order that was becoming obsessed with ownership of intellectual property. The final clincher was

that we liked and respected each other, but, at any stage, the deal we had been working on could unravel. I trod with care.

We opened with general statements of what we both wanted for and from Allsport and Getty in the future, in particular my staff, hopefully soon to be their staff. I was keen to reward my team for their loyalty and commitment over the years, while I recognised that Mark was keen to retain them, so we agreed to set up an employee benefit scheme to which we would both contribute equally. This would give everyone in Allsport, from the mailroom to the senior managers, a mixture of a cash reward and stock options as an incentive to stick with the company as it was developing, as a part of Getty's growing business. Talking through these issues, the atmosphere in the room changed. We were now in this together. We were working to resolve things, which, to be honest, we had been in most of our talks over the last year, apart from the glitch from the curve ball thrown by Coopers & Lybrand, which I was still convinced was stage-managed. After agreeing to adjust how certain debts were recorded and other minor issues, we shook hands on a deal that would deliver our headline price.

The next day, November 28th, Nick received a faxed letter confirming the final terms of the deal, just leaving both sets of lawyers to draw up a formal contract by Christmas, with a view to signing on January 1st, 1998. Job done, I thought.

I flew to LA to put our Calabasas house on the market and help Beans pack all our belonging in shipping containers once again. I also had to explain to her that we would be going to Australia for a few months, well maybe six to nine months, before heading home to the UK. I had privately agreed with Mark and Jonathan that as part of our Strategy for the Future business plan, I would oversee the acquisition of the Australian Picture Library (APL), our agents in Sydney. That done, I would set up Allsport Australia to prepare for the Sydney Olympics in 2000. This news was greeted with excitement from the kids and resignation from Beans, but she trusted me to make it easy for them. Our planned route to Australia would be the long way round, back to the UK before Christmas to visit friends and family and put our dog, my best friend, into quarantine. Then I had booked a short skiing holiday for us in France, before returning to London to sign contacts at the beginning of the New Year. After that it would be on to Sydney with a brief stop-over in Hong Kong. With all our belongings now in storage and the house sold, we set off on our nine-month odyssey with just suitcases, travelling light; with seventeen pieces of baggage to be precise.

With everything apparently going smoothly, I had barely touched down in London when I fielded a bombshell telephone call. Getty wanted a meeting. They had a problem. We met the next day in the offices of our lawyers, Cameron McKenna, as we suspected that Getty would ask for changes to the contract that we had thought was agreed. The atmosphere was tense even before Mark spoke. They couldn't sign the deal on January 1st and worse, they didn't know when they could. Of course, our first question was why? They couldn't tell us, except that it was something to do with their acquisition of PhotoDisc currently reaching its conclusion. Not normally a particularly volatile character, Nick just exploded. All this work, all this expense, our futures at risk and all momentum lost and for the first time there were some expletives in the air. Mark and Jonathan continued to apologise and stress that they wanted the deal but weren't allowed to tell us why they couldn't sign, or when they might. Nick continued to simmer gently, so I suggested we went into another room to talk privately about the situation.

I had never seen Nick so unhappy. This was a major shift in the terms of the deal and the risk to this, or any such deal, was that every day they delayed the signing it risked slipping out of the crosshairs. He had seen it too often. Factors change, the world changes and with every day lost, we stood the real chance that the deal might disappear. Also at risk was the deal price itself, as 40% of the package was vested in shares priced on the day of signature. If the share price rose significantly, we would get fewer shares for our money, thus reducing the value of the deal. I had to respect his experience and take him seriously, but what options were available to us? I realised that there were very few, so we either had to take their word on trust or crash the entire deal.

Much to Nick's chagrin, I went ahead with the deal on trust, accepting Mark and Jonathan's assurances that it was a technical issue that they were constrained from explaining to us. Nick agreed on the one condition that they agree to a US$14-19 spread 'cap & collar' arrangement on the share price element of the deal. Thus, if the share price on the day of signature was higher than the top limit of that spread, Getty would grant us shares at the lower 'cap' price of US$19. To protect Getty, if the share price on the day was much lower than the bottom limit of the spread, we would accept shares at the higher 'collar' price of US$14. If the share price was anywhere in between the spread, we would settle on the price of the day. I understood this to be a rather unusual arrangement that was initially resisted by Getty, but it was the only way of managing the risk on the deal's value for both parties, so everyone agreed.

We had known for three months that Getty Communications and PhotoDisc had been moving toward a deal, but what we didn't know, and weren't allowed to know, was that Getty was in the midst of acquiring the fully diluted issued share capital of PhotoDisc for US$13 Million in cash and 9.6 million newly issued shares, making the total value of the deal in excess of US$150 Million at current share prices. What they were finalising was the complex legal process of creating one new US based company to be called Getty Images, with an Initial Public Offering (IPO) of shares on the New York Stock Exchange (NYSE) sometime in the New Year. Too big a prize to be gatecrashed by our deal.

Back in the nineties, any financial analyst worth their salt would have taken one look at our deal and asked why Getty was prepared to buy a small sports photo agency for 30 times earnings. Ten times was considered a good valuation for a business selling itself and any buyer would seek to pay less. The problem was not that Mark and Jonathan were overpaying, but that the market didn't yet understand the new dynamics of content-based valuations. Allsport and any future digitally based company would be valued in relation to its revenues and its capacity to generate future revenues from its content, and not purely from its ability to generate current earnings.

The new valuation dynamics would be based upon a complex mixture of revenues, market share, content ownership, technology, subscriptions and partnership-style relationships with their client base. Allsport had all of these, and one look at today's major online companies: Amazon, Facebook, Instagram, Netflix and Google, for example, are all valued based on variations of this trading matrix. Revenues and market share were prime: earnings would follow. The Getty team had understood this from day one, hence Mark's mantra of whatever anybody else will pay for you, we will pay more. They based their valuation on these elements and paid a price equivalent to three times revenues which was still good, and Getty's growing international network of wholly owned offices in 15 countries could leverage this asset very quickly.

This was all happening in the early stages of the 'dotcom bubble', so trying to explain it in a prospectus to a sceptical market back then would have been challenging at best and risked questions about their judgement that could affect the share price in the IPO. Had we known at the time that this was the concern, we would have been a lot more comfortable with the delay. Without this knowledge, it appeared that we would be in a high-risk twilight zone, possibly for months, during which we also had to maintain the secrecy of the deal. Getty Communications was currently

trading on NASDQ and subject to Securities and Exchange Commission rules, so leaking any of this financially sensitive information before the market was officially informed was a serious offence. We found ourselves in a vice: not knowing why our deal had stalled and also realising that the deal could still be crashed by leaking details. This was developing into a nightmare not of our making!

The financial market is normally fetid with gossip and speculation and positively thrives on both, so perhaps inevitably, rumours began to emerge and circulate. Happily, these were not from our people, but from third parties who were sometimes triggered by the purest flukes of chance and coincidence. One young photographer working for the *Financial Times* spotted us in Granville's office one day and half-heartedly asked if we were selling Allsport. Then one of Reuters' negotiating team bragged to a close friend that they were buying Allsport, but the friend was one of our competitors, who wasted no time in joyfully spreading this gossip around the industry. Eventually we were even being questioned by our own staff, but like Mark and Jonathan, we couldn't comment and just had to deny everything. This was difficult to do when you're not used to lying to your staff, which is what we were doing by force of corporate financial law. Hanging in this unsatisfactory limbo land, I could do nothing more to speed up the process, so we continued with our planned ski trip. Nick even had time to leave the office and join us for a week with his family, which further cemented our friendship. I explained the situation and the risk to Beans, that I had decided to take Mark and Jonathan at their word and continue to Sydney as if the deal had happened. If the deal failed to complete, then I still wanted to buy APL and continue with our plans to create Allsport Australia.

The Powell baggage train arrived in Sydney on January 26th, a week before Australia Day. Jane Symons, who owned APL, had found a house for us to rent on Shelly Beach, overlooking Manly, the beachside suburb of northern Sydney and close to their offices. I had called ahead and enrolled the girls into Redlands, a great school on the north shore of Sydney harbour. All we had to do was meet the head teacher and buy the uniforms. I had ten days to get Beans and the kids all settled in and familiar with the locality before I flew to Nagano for a month to attend the Winter Games.

The first few days at the Olympic site provided the usual routine of rushing around from venue to venue, checking photo facilities and the final last-minute negotiations with the host broadcasters. The Main Press Centre was awash with rumours. The Games hadn't started yet, so everyone was

looking for a story, any story. Every journalist or photographer I met had heard a rumour and I was asked constantly if we had sold Allsport, which I just had to deny, repeatedly. Despite Nick constantly chasing up the Getty team, I still didn't know where we were and Lee Martin, James Nicholls and my brother Mike, the other Allsport Directors there, were equally harassed, but just had to keep their heads down and plough on, as did I.

One embarrassing misunderstanding I stumbled upon was to find that Yasuo Azuma, the NAOC Photo Chief, had printed tens of thousands of photo bibs. Enough for every one of over 900 hundred accredited photographers to have a new bib for every single session, including practice. There were 68 Gold Medal events spread over 15 venues, with most of the events involving multiple sessions, some venues having three or four sessions a day. All these bibs were stored in a warehouse downtown, so the plan was to ship them in each morning and have each photographer queue for a new one at the beginning of every session. This would create mayhem and I had visions of rioting photographers running amok, as our hosts politely tried to enforce this growing disaster. The solution was simple, but time-consuming. I got 1,000 bibs out of the warehouse, signed each one and over-stamped my signature on each with a rubber stamp and a message in Japanese. It could have said anything. I had no idea what, but then I issued an edict: one bib for one photographer, for the duration. Looking back, I guess I should take some responsibility for this situation. Yasuo and I had got along so well over the last few years, but our discussions had been constantly derailed by young translators misunderstanding an issue and being too frightened of higher authority to question it. I had contributed my bit to Nagano's 56% cost overrun, quite modest in Olympic terms.

Throughout this I had been in constant touch with Nick and Adrian back in London. Their news was more positive, as they felt something would happen soon. The night before the Opening Ceremony, James Nicholls and I went to dinner at the IOC's TOP Sponsors Club to meet up with clients. The sushi bar was spectacular, so we took full advantage, along with some fine sake. We retired late to our lodgings in the media village, where Allsport had one wing in a block of flats. I woke early to check my emails and there was one from Adrian. Getty had asked him and Nick into the offices of their lawyers, Clifford Chance, late that afternoon, London time, but there was no further indication of why. I called Lee and James, told them about the email and suggested breakfast. Lee declined as he had to get into the press centre to prepare for a long day, the start of 16 days of intense workload, my brother Mike was already up a mountain

covering qualifying runs in the Alpine skiing competition, so James and I went to breakfast alone. The Club was full and buzzing with lots of sponsors and IOC members all preparing for the opening ceremony later that morning. We sat there in silence, passing the occasional polite comment, but our minds were clearly in a different place. I watched my mobile phone, but it remained stubbornly silent.

Late afternoon London time would be about 2 o'clock in the morning for us, yet here we were seven hours later and still no word. Something must have gone wrong. To ease the tension, I suggested we go to the stadium early, where our IOC 'B' level accreditation gave us access to the VIP and Sponsor section of the stands. There, we spent the time chatting with clients and friends, waiting for the ceremony to begin. President Samaranch and his wife appeared and greeted everybody as they went through, taking the time to thank people, including James and I, for our efforts in bringing the Games to fruition. It was bitterly cold with the threat of snow showers and freezing rain and as the time for the opening ceremony approached, we were about to discover how well that planning would deliver. There were over 2,000 athletes contesting 68 events in 14 venues spread around the mountains, which the locals called 'The Roof of Japan' and this had required a lot of planning and understanding of Japanese culture. Now, there was no hiding place. The Games of the XVIII Winter Olympiad were in motion.

Joining 50,000 spectators and the Emperor of Japan in the Minami stadium, we watched singers, dancers, artists, sumo wrestlers and musicians doing their thing. Choirs from around the world belted out Beethoven's *Ode to Joy*: who knew why? As Eishiro Saito, President of the Nagano Organising Committee, began his stuttering address, my mobile phone vibrated. Fielding the call, I heard the speaker give me the news that I had been awaiting. It was Mark Getty, telling me he had just inked the contract for the newly created Getty Images to acquire Allsport and they were now officially its owners.

It didn't take long for that news to break on the wire services and suddenly we, who lived by providing news stories, briefly became the story itself. It was a little surreal to see our friends among the sports journalists filing copy about us to the Business Desks of their papers. While the city pages of the *Independent, Financial Times, Times* and *Telegraph* all punned the story under the headline, "Getty snaps up Allsport agency", many using Chris Cole's picture of sumo wrestler, The Dump Truck, as on so many occasions in the past, it was the *Daily Mail's* Ian Wooldridge whose prose captured the moment most poignantly.

When the news of our sale to Getty Images broke, it was somehow inevitable that city desks of London's newspapers illustrated the story with our picture of the sumo wrestler, Dump Truck, but whether they thought this showed our unassailable position in the market or the invincibility of Getty remained a mystery.

Photo: Chris Cole/Allsport

"Up in the snow above Nagano yesterday, Steve Powell, Press Photographer, was marshalling his colleagues around the chaotic Winter Olympic Games. Back at their London headquarters, Adrian Murrell, cricket photographer now brought home to base, was supervising distribution of their pictures around the world. What few knew was that overnight both had taken care of the housekeeping for the next few months. Powell was richer by £15 million, Murrell by £4.5 million.

"Their company, Allsport, became the most in-demand sports picture agency in the world. It has five million sports pictures in its library, one hundred and eighty thousand digitised so that any publication on earth can call in any one of them instantly. Allsport sold off this fraction of its assets two days ago to Getty Communications (sic) for thirty million pounds.

"I have worked alongside Allsport men around the world. ... They are always seen plunging into the dawn with a mule's load of equipment while we reporters are having breakfast and returning to

process their results to London from their rooms while we are relaxing over dinner. It's a tough life, no mistake, but what an inspirational challenge to any kid with a great heart and a Kodak."

Breathing a collective sigh of relief and out of purdah, we could now confirm the news to those who asked, which was a good deal easier than the denials that had been forced upon us for the past month. The future of Allsport and all our staff was now secured. For me, not needing the money was one thing, but having it was a marvellous feeling. As the organisers of the Games concluded; sayonara, arigato – goodbye and thank you.

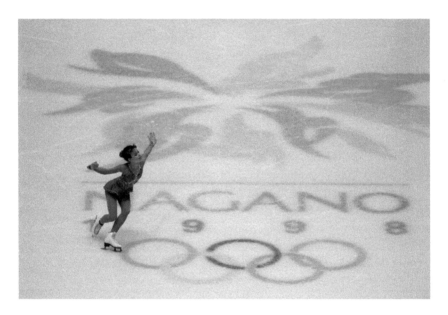

The Winter Olympic Games in Nagano proved to be a seminal moment in the Allsport story and for those people who had brought about its success over the preceding three decades. The Japanese organisers sign-off seemed very apt: Sayonara, Arigato.

Photo: Matthew Stockman/Allsport

29

THE GETTY YEARS
AND BEYOND

I t is perhaps inevitable that throughout life, we are subjected to an everlasting rollercoaster of emotions and for every high there is an equal and opposite low to balance it. These shifts may be caused by personal or business relationships, interest in the job or just the cycle of activity that goes with building and maintaining a business. I had come to recognise this cycle most particularly when we had been pushing the limits of technology and personal ability to deliver blow-the-doors-off results from serious events like the Olympics. Often after weeks of full-on photographing in less than perfect conditions and the euphoria of delivering the best imagery and news output that was possible, we would return to base and the mood would be flat. Not flat, like we hadn't done the job, but flat because of adrenaline withdrawal symptoms and because the relative inactivity felt like a wipe out.

That one day in Nagano perfectly demonstrated the highs of finally landing the deal that recognised the real value of our work over so many years but threatened a void to follow it. It would be naïve to suggest that in the days before contracts were finally signed, I had been a model of calm. Even though I had plenty of things to occupy my time around the Games' venues, I had been absolutely on edge. I had placed my trust in Mark and Jonathan, and true to their word, immediately after details of the merger between Getty and PhotoDisc creating Getty Images became public, they acted, and our deal was done. Mark and Jonathan had played the long game, establishing a relationship with us informally, early on, often giving us signals as to how things would pan out and the bear traps that might lie ahead. This had built trust, something that was vital

if we were to work together in the future. In turn, we played our part by hiring the best advice while going through the long process of taking the company to market. When the deal was finally struck, we knew we had achieved its full value and had a deal that was fair to both parties.

After the Opening Ceremony, James and I went back to the Allsport office in the Press Centre, walking in on the organised mayhem of a busy news agency transmitting images around the world. I quietly brought Lee up to date and then called for a time-out to announce the deal to our staff. Looking around at familiar faces, I realised that most of them probably knew already, but there was a feeling of excitement and anticipation of even better things to come; and lots of congratulations. James and I got to celebrate a little at the TOP Sponsors Club, in the guise of updating our clients. We met Michael Payne and told him of the sale, and I assured him that I would continue in my role with the IOC and Allsport, at least until after the Sydney 2000 games. Then, after the brief moments of euphoria, we all just got on with the job. Sixteen days of constant pressure, and hard work, mixed with the joys of photographing the world's best winter athletes, in the company of the best photographers in the world: Allsport photographers.

I travelled straight back to Sydney after the Games, so celebrating with my fellow Directors would have to wait until my next London trip. Taking a moment to consider where we were as a family, the kids were already busy at school, so no holidays yet, and Beans was in her usual calm routine. Never fazed, just getting on with it, because you have to, don't you? I settled into a different routine, working between 5am and 10am each morning on calls with LA, New York and now Seattle. The evenings between 7pm and 10pm were devoted to calls with London. This left a useful chunk of the day during which I could concentrate on other things. Initially I finalised the negotiations with Jane Symons to split Australian Picture Library (APL) into two. The general stock photo agency that she would retain and the sports photo agency, Allsport in all but name, that Getty Images would now buy from her. The final step would be to set up Allsport Australia, but as Jane and I had often spoken about this, it was relatively easy. Value had been established, so it was mainly about process. I finalised the deal with Jane and took over the staff and files that would form the backbone of Allsport Australia. To maintain continuity, I appointed John Mikulcic, a long-term and highly effective salesman of Allsport images for APL, as Managing Director, and together we set up his team, hiring some of the best freelance photographers in Aus.

The second thing that my daytime freedom allowed me was the opportunity to re-evaluate my priorities and discover that there was indeed life beyond Allsport, photography and the media. I discovered sailing. Arguably no better place to learn to sail, Sydney Harbour provided the perfect base. If family holidays on bareboat charters in various parts of the world had piqued my interest in sailing, perhaps, inevitably, I was not content with just pottering about: I needed something more. The 'more' came in the form of getting a recognisable qualification, so I signed up for an instruction course. I knew about the Royal Yachting Association, of course, and discovered that their internationally recognised Yachtmaster training programmes were operated by Australian Sailing, so one of their local training centres seemed like a good place to begin this new adventure.

We had only arrived in Sydney in late January 1998, but I hooked up with a training centre in the Spit Bridge Middle Harbour in Mosman, went training most days in their Beneteau 37 and started crewing on Thursday night races out of the Middle Harbour Yacht Club to get the miles under my keel. Two months later and after a particularly windy weekend north of Sydney in Pittwater where I became the only member of our crew of six not to fall into the nauseating grip of mal de mer, I qualified as a Day Skipper. Mission accomplished and as Allsport Australia was ready to trade: my work there was done. In August we flew home to the UK, enrolled the kids in a small preparatory school near our rented farmhouse in Hampshire's New Forest National Park and Beans started house hunting.

Looking at the bigger picture after a 16-month absence from the coalface deal-making, the team had proved more than capable of not just running the business but growing it. Mark was to comment later that Allsport was the only company that Getty had acquired that didn't see its sales drop away during the acquisition period and the only one that hit its first-year targets. I had no intention of trying to take back control or interfering with what the team was doing; I knew the risks. Once you have handed over responsibility, trying to grab it back is destructive to morale and I needed to let the team run things their own way. There were issues of integration of course, but apart from resolving these with Jonathan and Mark, the calls on my time just got less and less.

Nominally I had an office in Getty's North London base, but I had no intention of commuting daily from Hampshire, so mostly I worked from home. I reverted to my travel routine of inspection tours for the IOC, visiting our offices around the world and encouraging ideas and

new projects. My role now was more roving ambassador, Chairman rather than Chief Executive. As it was Allsport's 30th anniversary, I attended book launches and exhibitions all over the world, shaking hands, pressing the flesh, smiling and making speeches. I also took some family holiday time and generally learned how to live with my wife in longer stretches than of one week at a time.

Being out of the mainstream couldn't last, of course, and I probably didn't want it to. Early in 1999, Jonathan called me and asked if we could meet. Mark was there, and we sat chatting about how things were going, goals and challenges, before they ambushed me. First the softening up. You're not doing a lot at Allsport these days, it seems to be running itself. I heard myself agreeing and saying it was something I was proud of. Then the clog dropped. How would I like to become President of GettySource, a new division of Getty Images that they were setting up to combine and market all their editorial content? Together with Allsport, it would combine the New York-based Liaison Agency and Hulton Getty, some 50 million photographs from the British press archives dating back to the 19th century and photographs from the Keystone Press Collection. Full circle, I thought, as I jumped at what I saw as a perfect opportunity to mould the new division into the Allsport way, which I knew from hard-won experience, worked.

Getty had made its strategic move into photojournalism in March 1997 with the acquisition of the Liaison Agency for around US$9 Million. Liaison had been in business since 1966 and apart from its own library of millions of images and news stories, it had a convoluted production and distribution alliance with the Paris-based Gamma Presse Images SA and traded in the US as Gamma Liaison Inc. Collectively, the group had contracts with around 750 photojournalists spread around the world and serviced magazine, book and multi-media publishers through agents in 50 countries. With its contemporary stock photography business and a corporate assignment division, it was a big player. The only problem was that its founder and long-time CEO, Michel Bernard, wanted out and very typical of companies that had larger-than-life characters running them as a personal fiefdom, it was all centred on his knowledge, contacts and relationships.

When Bernard quit, his previous management style revealed a massive gap in the company, which was now screaming for leadership and structure. This merely underlined one of Getty's more pressing issues, that having grown by acquisition of companies that had all operated independently, the process of co-ordinating and integrating them would

require hands-on attention to kick them into shape. Mark and Jonathan saw GettySource as the vehicle to redress their problem, with me to trouble-shoot the business.

The only difficulty was that they wanted me to base myself in New York and take over as President of Liaison, while pulling the new division together. In view of how I had dragged my family around the world in the past ten years, it was one move too far, but I suggested a compromise. I would commute to New York and spend four days a week there and with judicious use of Concorde on Tuesday mornings, I could be at my desk in Manhattan by 11am, then take the red eye home on Friday night. Four days in Manhattan, three days at home, I was back in the swing. For the next 18 months that is exactly what I did; every week.

I restructured Liaison, building the management team that it sorely lacked, and suggested two acquisitions to help boost its offering and bring in new blood. The first was Online USA, a celebrity photo agency, owned and run by Paul Harris, one of the original digital evangelists. The second was Newsmakers, a small but influential online news photo agency owned and run by Richard Ellis. Once on board, Paul and Richard would form the core management team along with David Bloom, another new hire. This integration had required a good deal of education from our side, most notably in imbuing the new division with the concept of immediacy.

Prior to acquiring Allsport, Getty's online archives had, at times, taken months from the point of scanning an image to making it available on their website and adding new images required re-compiling their entire search index each time. We spent many days in conference rooms explaining how critical it was that to be competitive in the editorial/ news market it was essential to have an image available on the website in minutes, not hours, and certainly not days. Bringing this concept into play turned Getty's technology platform completely upside down and drove significant changes in how they approached image metadata, searchability and core platform infrastructure. This was going to have lasting impacts in their whole business and this sense of urgency and meeting deadlines was to serve them well in the new instant gratification world of online media. In the process, we had created the structure of four channels that survive today in Getty Editorial: News, Sports, Entertainment and Archival.

Another Allsport technology initiative was the concept of hosting our clients' digital material. This had begun life under the acronym ADAM (Allsport Digital Asset Management), but we were yet to get the platform off the ground when Allsport was purchased. The intention had been to host our customer's assets, along with those they viewed from

Allsport, to further embed us more deeply in their digital workflow, making purchasing from Allsport over a competitor far more likely. This was effectively a digital version of hosting our images in filing cabinets in our client's offices. Both Mark and Jonathan greatly liked this idea at the time, and a few years later Getty Images would purchase Image.net to serve as the foundational platform for this offering.

Life in the Getty camp was not all about work. In July 2000, Mark and his wife, Domitilla, invited the Executive Management team and their partners to their summer home in the hills above Siena. This Italian hamlet comprised just six ancient farmhouses, surrounding an equally ancient olive oil press and had been abandoned after the Second World War, as many Italian villages were. Mark had been spending his summers in these hills all his life and knew them well. The main Getty summer estate was close, but buying it had been neither simple, nor quick, and indeed, was still partially in progress!

Their first discovery was that what they wanted to buy was owned by multiple descendants of several families: a hangover from the Napoleonic Code of 1804 which stated that all property must be split equally between the heirs of the deceased. What seemed fair for the first generation is less obviously viable by the tenth or twelfth generation, where dozens of distant cousins each own and jealously guard a small slice of a property or land holding, often just a few square metres. This is what had happened here. At the time of our visit, there was still one small room, untouched for years, showing signs of having once been occupied by livestock. Mark explained that they still hadn't found the owners, but he thought that they were getting close. In all, it took them 15 years, and Getty-sized resources, to trace all the owners and complete the purchase of the whole property.

We were there ostensibly for an Executive Management meeting, but Mark and Domitilla were to entertain us royally, and it started from the moment we arrived. Each of us assigned to our own suite in one of the now guest houses, all restored to their former glory in traditional Tuscan style. This gathering was to be as much about getting to know each other as getting any business done, so dinner that evening, simple Italian food, but the freshest pasta I have ever tasted, and excellent wines, was all comfortable and relaxed.

As our meeting got underway the next morning, Mark formally introduced us to Bill O'Neill, the newly appointed Vice President of Human Resources, who came with an impressive track record in large corporations: fifteen years at Motorola, finishing as Global VP of HR, followed by a similar role for Coca Cola's China Division in Hong Kong.

He explained his experience in restructuring large organisations and then proceeded to enlighten us on his plans for Getty Images. Through the process of growth by acquisition, Getty had dozens of leasehold offices all over the world and huge overlapping roles, particularly in back-office staff. Bill was looking for 10% staff redundancies across the board before merging offices and shedding leases. As I listened, I can remember thinking, I am sure his mother loves him, but I couldn't fault the plan in any way. In New York alone, where I was working, there were seven different offices, with too many people essentially doing the same job. For the next few years, Getty Images was going to undergo growing up pains.

We all left the meeting slightly shell shocked, but I think everyone understood the logic and certainly no one argued against his plan. It was the obvious and natural next step for Getty Images, but it was going to be painful, as most of us in the Executive Management team had built these companies up from scratch. To help ease the gloom, Mark had something up his sleeve. Siena is rightly famous for many things, from Chianti wine to pappardelle pasta, its medieval architecture and museums, to the twice-yearly Palio horse race. If running with the bulls through the streets of Pamplona is on the suicidal side of dangerous, the ten riders each clad in the colours of one of the city's wards, racing bareback around the cobbled Piazza Del Campo in the centre of the city, comes pretty close.

Mark had secured us front row seats to experience a piece of Tuscan history unfold, as it had done since the 6th century, and sharing it with thousands of partisan Sienese singing, dancing and waving huge banners was all-embracing. The winning rider and the contrada he represented had bragging rights, while the losers just bragged about how they were going to redress the balance next time. I had watched a lot of sporting events in my professional life, but this was one of the most enjoyable spectacles I had ever attended. The best table in the square for dinner after the race and showing us something so different was, I thought, a very clever way of easing the pain of impending company surgery as we flew out and returned to our offices.

By now, GettySource was taking proper shape and the integration of Allsport was finally complete. Despite the best efforts of the HR Department, we had managed to maintain our management structure and style, but in the midst of this major restructuring and rationalisation, and looking to reduce the workforce as different companies merged, I saw it as an opportunity to review my options. The thought of presiding over any future redundancy rounds did not appeal. As we had been predicting and as Mark Getty had recognised, the image business was

changing fast. Getty Images was acquiring new companies and archives at a prodigious rate, and restructuring and rationalising these assets was essential. The industry was maturing and now with quarterly reporting to markets and accountability to institutional investors, what Getty needed more of were finance directors and experienced CEO's, and less a maverick photographer turned businessman. All of which I understood. As I had done many times in my working career, once a project had been successfully delivered, I didn't so much lose interest, but more felt the need to pass it on to the team that would have the responsibility of running it, leaving me free to move on to the next thing. This was the moment when I felt that I had done as much as I could for Allsport, and Getty Images and I announced my retirement at the Sydney 2000 Olympic Games.

It was the perfect time to retire from the fray and look for new challenges. What I hadn't realised was that one of the biggest challenges would be in adapting my lifestyle from a perpetual round of international travel and negotiation, to one where I had become modestly wealthy and could set my own agendas and schedules. This might sound like a bit of a first world problem, but at first it was surprisingly difficult. Throughout my years at Allsport I had essentially been a salaryman, the same as all my staff. The Japanese coined the term 'salaryman' for white-collar workers who show overriding loyalty and commitment to the corporation that employs them. The second meaning suggests someone who may eventually die from overworking. I had certainly been loyal to Allsport and committed to its growth and prosperity, but I hadn't often been seen in a white shirt or wearing a tie and had certainly avoided keeling over in the saddle, but salaried I had been. Allsport didn't pay out dividends to its shareholders, all of us reinvesting all our profits, so, when I finally sold the company, I was sitting on modest savings and a house with a large mortgage. The transformation from salaryman to independently wealthy came as a bit of a shock, and had its own wrinkles.

For the first couple of years while continuing on the Getty payroll, life continued pretty much as normal, a salaryman still, and I didn't have to face up to the decisions that I would need to make on retirement. But on retirement, bizarrely, one of the first questions that faced me was: what kind of lifestyle could we afford? We were wealthy compared to our previous lifestyle, but we weren't so wealthy not be concerned over money. I was, after all, retiring at the tender age of 48. This was still a long way off pensionable age and still with two daughters, at private school, on the payroll. As always, if I didn't know the answer to a problem, I

sought out people who might and there followed a series of lunches with 'wealthy' friends, trying to determine just what lifestyle was affordable and sensible.

I enjoyed some good lunches in engaging company, but the natural reluctance of all Englishmen to discuss money made the exercise futile, and I emerged still none the wiser. A nice problem to have, I hear you say, but it was still a problem, and the situation was compounded by something I had come across many years before. Working with successful young sports stars, the assumption by the media and wider world was that once they had won their first gold medal or world title, they emerged from the experience as a fully formed media star, and mature adult. More often than not, this was far from the truth. Success in a very narrow discipline or field does not necessarily prepare you for the fame and challenges ahead, and many a young sports star has stumbled at this hurdle. My success was in the narrow field of sports photography, thanks to thirty years of in-depth industry knowledge, and a sharp eye for opportunity. The assumption by my friends, colleagues and advisors was that having achieved that success, I had become a fully formed Master of the Universe and would have all the answers. Once again this was far from the truth, but for a proud man it's very hard to disabuse them of that thought, so we all stumbled on.

Probably, for the first time in my life, I didn't have a plan. We were happy, healthy and having fun, and I had appointed a wealth manager to help develop our investments, but not a financial advisor, probably because I was starting to believe the Master of the Universe myth generated by some of those around me. Accommodation was a pressing issue, so we bought Ladycross Lodge, one of the largest and oldest Royal Hunting Lodges in the New Forest. More accurately, I should say I bought it, as Beans would have been happy in something a little more modest, but Ladycross spun its magic. It was tired, run down and in need of a major restoration, but it was a project; and I was desperate for a project. It didn't take long for huge sums of money to begin pouring out of our coffers, as we had close to fifty builders working fulltime for over two years on what became a serious building site. My passion for the project wouldn't let me cut corners or costs, so I determined to find more funds to help stem the flow and feed the habit.

I dabbled in the markets, as we all did during the height of the 'dot-com bubble', won some, lost some, but I soon got bored. You have to have a real passion for money to succeed in the markets, but I never did. To me money was always a by-product of successful projects. This lack of a plan

meant I drifted in and out of a couple of Non-Executive Directorships, invested in a couple of companies, hoping they might suddenly come good without any time and effort from me. I soon found myself back in the old familiar world of stress and sleepless nights, whilst of course maintaining an outer veneer of calm confidence, as every Master of the Universe should. Fortunately, I got bored with the markets just before the bubble burst in October 2002 and survived with only modest losses, but I did have one major investment that was hurting.

Sport Business was a small trade magazine and reports publisher with aspirations to become an internet portal, the coming thing. Whether it was because of the potential to break into a new market segment that interested me or because it was owned by a long-term Allsport client is debatable, but I plunged in and invested. In 2000 we were approached by a management buy-in team backed by Warburg Pincus & Co, heavy with £20 Million, and a typical dot.com business plan. Essentially, they suggested, if we throw enough money at the space, they will come. Warburg bought out some of the team, but I stayed in for the ride, purely as an investor. The newly appointed Managing Director proceeded to burn through the £20 Million cash pile at a furious rate. By early summer 2003, the dot-com bubble had burst, the plan was looking pretty sick, and the spending was unsustainable.

An investor meeting was convened and it was quickly decided that we should take back control to stem the cash bleed, but a quick glance around the table identified me as the only one in the room with any experience of actually running a company. I was volunteered by my colleagues to take back control. Maybe I just didn't fancy watching my investment managed by someone else or perhaps I wanted the turnaround challenge, but however it occurred, the following Monday morning and armed with the mandate of the investors, I walked in unannounced and fired the Chairman and Managing Director. I was back in harness. Despite the huge sums of money that had been spent, it had all gone on the development of the portal, which was significantly ahead of its time and client base. Worse, it was £20 Million down track, and still not functional.

At that point, the shrewdest move I made was to persuade an old friend, Tony Cadman, to join me as my number two. Tony has the uncanny ability of being able to sit in an open plan office and figure out what and where the problems were, in short shrift, so in no time at all, we started to reverse the outflow, returning it to a traditional trade publishing company. Then, in early 2004, I had a freak horse-riding accident, breaking my back in two places, which confined me to my bed at Ladycross in a steel

harness for three months, which rather captured my attention. Tony took over, continued the encouraging start on recovery and working closely with Stewart Newton, another investor, was able to turn the company round. Tony secured *Sport Business'* future when he identified a fledging trade title called *iGaming* as the future and acquired it. Two years later, *Sport Business* and *iGaming* were sold to The Electric Word Plc, and both *Sport Business* and *iGaming* are now the premier portals of their industries.

As for me, I had enjoyed plenty of plotting time. In many ways those last few years had been the most confusing of my life, and it was all to do with coming to terms with money; having it and discovering what to do with it in order to keep hold of it. Having spent most of my business life formulating plans and then successfully executing them, for the first time since selling Allsport I had no obvious plan to work to and this proved to be a big mistake. Dabbling here and dabbling there was a surefire way of losing it all. In the long days and weeks of recovery, I had plenty of time to think. After leaving Getty I had been under pressure from friends around me, especially Nick Harvey and Tony, to get involved with another business and use my skills to make a greater fortune. I soon realised that my dabbling was a symptom of reluctance to get deeply involved again. I had felt it during my short time at *Sport Business*, but now I really knew it. In my heart I'd had enough, I wanted something more and something different. I needed a new challenge, a new project. If I went back into business, it would only be for the money, and I didn't need that. I had enough, I rationalised, to be comfortable.

So it was, that some way into my recovery, and only eighteen months after moving into Ladycross, Beans and I sat down for a family conference, where I explained that I didn't want to have to work again. I wanted to get more involved in sailing and do some serious offshore cruising, together, as a family. I then explained that the consequence of that would be that at some time we would probably have to sell Ladycross and downsize, it was after all a project. Once again, Beans was faced with a 'good news' - 'bad news' situation, and her immediate difficulty was in deciding which was which. Six months later I bought my first boat. I had finally made a lifestyle decision, probably my first.

AFTERMATH

I t is often said that history is written by the winners, but even with the benefit of hindsight there were no real losers in the story of how Allsport became the target for Getty Images and Corbis. Ours was a relatively small punctuation mark on the pages of corporate history, but looking back on what happened to the major players in the years after the acquisition gives a fair appreciation of what was achieved. Had we not had our feet securely on terra firma in the months leading up to the deal, we could all have been guilty of the hubris that comes with being pursued by two of the richest and most aggressively acquisitive men on the planet. We viewed bringing Allsport to market as another project to be delivered in the best way possible and above all other considerations, this kept us rooted in reality; in a process too complex to take lightly, too important to screw up.

Of our two suitors, Getty Images, led by Jonathan Klein, has gone on to build a hugely successful image business that has continued to grow both organically and by further acquisitions, to become the largest visual content provider in the world. Listed on NASDAQ in 1996, then on the New York Stock Exchange, it became majority owned by Hellman & Friedman in 2008 with a valuation of US$2.4 Billion. It was then jointly purchased by the Carlyle Group and Getty Images for US$3.3 Billion in 2012, and in 2018, it reverted to full control by the Getty family, the company having come full circle.

Bill Gates either lost interest in what photography offered, or just dropped the ball: in hindsight it was one of our best decisions not to hitch our wagon to his star. The people he employed to manage his wholly

owned business, ten in 20 years, all failed to drive Corbis Images in the right direction and despite the potential for growth and the investment thrown at it, probably never returned a profit. Finally, in 2016, he sold his image business to the Chinese company, Visual China, which subsequently granted exclusive access to all their image resources to Getty. Where would that have left us?

So, what of our team?

Of my original colleagues, Tony Duffy had sold his shares and left Allsport before the acquisition, continuing to cover track and field athletics all over the USA, where his heart had always been. Still living in California, in 2020, he was presented with a Lifetime Achievement Award by US Athletics. His original partner, John Starr, left Allsport in 1981, setting up a studio in Covent Garden where he worked on major advertising campaigns. Moving to Dubai and finally Egypt, to follow his other passion of architectural design, he spent 15 years creating projects as varied as office buildings, service centres and parts of the new Grand Egyptian Museum. Returning to the UK, he is now living in retirement in Wiltshire. Don Morley stepped away from Allsport in 1982 and teamed up with his photographer wife, Jo, and together they travelled around Europe photographing Grand Prix motorcycle racing. After retiring at the age of fifty, he has pursued a successful career competing in classic motorcycle trials and championships. He has now published 24 books on motorcycling and photography.

After the acquisition, Adrian Murrell remained with Getty Images for 16 years, becoming Senior Vice President: Editorial. He left in 2014 to help set up Silverhub, a celebrity, entertainment and sports photographic agency. Today he is a fine art photography consultant to a number of art collections and using his extensive knowledge of the Indian subcontinent, is working on a photographic book, *The Changing Face of India*. Lee Martin stayed with Getty Images, rising rapidly through the ranks to become Senior Vice President: Global Business Development, and served on the Executive Management Committee for 16 years. Now semi-retired, he continues to consult for Getty and works at board level for a number of youth and sport-facing charities, including Fight for Change, Black Prince Trust, Foley ABC and Dylan Howells Foundation. David Cannon is still with Getty Images as a working staff photographer, covering all the major golf tournaments around the world. He has now covered eight FIFA World Cups and has published two books on golf courses. Getty Images has honoured him by creating The David Cannon Collection, a legacy that will form part of his family's inheritance.

Mavis Streeton, who had contributed so much to the administration of Allsport in its formative years, keeping us all on the financial straight and narrow, retired from Getty Images in 1999 and settled down with her husband Reg, in Morden. In her retirement, Mave became a happy shopper enjoying nothing better than spoiling all those around her, especially her granddaughters, Hollie and Betty, and lifelong friend, Jenny Tilley. Sadly, she passed away in the summer of 2020.

My brother, Mike, stayed with Getty Images until 2005, pushing his Allsport Concepts project, before going freelance. Working on major commercial and advertising photographic campaigns, his client work has included Nissan's Usain Bolt campaign and Oakley's award-winning 2012 Olympic campaign. His career reached a new high in 2012 with the publication of two notable art books, *The Greatest Race,* on the centenary of the Tour De France, and *A Game of Love,* celebrating the tennis Grand Slam tournaments. He ended the year with a perfect assignment for *Sports Illustrated* at the London Olympics, with the simple brief to cover anything he wanted, only shooting for covers and double page spreads. Retiring from professional photography shortly afterwards, he now lives in the Pacific Northwest, where he runs his own marine business, a sailing club youth programme and spends his downtime sailing, skiing and mountain bike riding with his kids; Sean and Emma.

Allsport was the only agency that retained the bulk of its staff after being acquired by Getty. Today, over 50 of our people are still there, 22 years later. Of all the larger agencies, only one or two are left on the Getty payroll and at some there are none at all, which is a testament to our employment ethos and management skills.

As for me, having retired in 2000, two years before my deadline of 50, I was never going to be content without projects to initiate and manage. Most of these personal priorities now involve my family, making up for 30 years of enforced neglect and the biggest of these was the restoration of Ladycross Lodge, one of the oldest Royal hunting lodges in the New Forest and our new home. Having learned the basics of sailing in Australia and then acquiring some professional qualifications, I was going to put them to use. I raced small keelboats in the UK and commissioned a bigger yacht for Bluewater ocean cruising. Having explained that the consequence of that would be that at some time we would probably have to sell Ladycross and downsize, it had been, after all, a project. In reality, we continued to live in our beautiful forest lodge for sixteen years, the longest time by a country mile that I had ever lived in one house in my life. This desire to go cruising evolved into seven years travelling

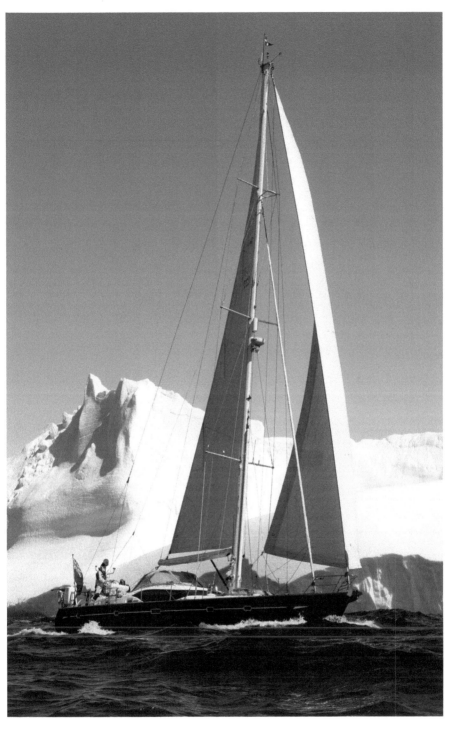

The author sailing his yacht UHURU among the ice mountains of Antarctica.

Photo: Mike Powell

the world's oceans with Beans, our family and friends, and included sailing to Antarctica and Patagonia (shades of *Master and Commander*, or as some who sailed with us christened me, Captain Bligh). Now having downsized, we are happily settled into proper retirement in Hampshire, leaving me the time to pursue the more sedentary pastimes of gardening, furniture making and golf, with a little light sailing on the side. My life and other oceans, you might say, but that is an entirely different story.

ACKNOWLEDGMENTS

There are many people who helped along the way. I owe a considerable debt of gratitude to Bertram Garai at Keystone, who must have recognised some potential in me and gave me my first job in the photographic world. Similarly, to Tony Duffy and John Starr, who lured me away from Keystone and into their emerging business and showed me what could be achieved by the power of imagery. I am also more than grateful to the IRA, for not kneecapping me during my unofficial visits to Belfast during its troubled years.

I have been fortunate enough to have watched and learnt from some of the most talented and creative photographers in the world, most of whom worked alongside me at one time or another as we built our agency into its pre-eminent position. I thank them for their wisdom so generously imparted and to all those editors and picture editors around the world who entrusted me and our agency with coverage of the biggest sports stories over three decades. To all my colleagues at Allsport, particularly Adrian Murrell, Lee Martin, David Cannon, and Mavis Streeton, the force of nature who kept our finances in order in the early years: my eternal thanks for your support, often through difficult times, as the business grew and morphed into the major player in sports news coverage. I hope that you shared my pride in a job well done and enjoyed the rollercoaster ride.

Much of our successes were achieved by recognising rapidly changing technology and getting on its leading edge. I salute the people who created the Acorn micro-computer and those with whom we worked at AGT, Hasselblad, IBM, Leaf Systems and Scitex, together with Paul Harris, the

original 'Digital Evangelist', who shared my vision of the pixel religion. To Eddy Shah, who helped us break into the world of newspapers, to the IOC's Michael Payne, who recognised that what we provided could fit within his far-reaching ambitions for marketing the Olympics, my thanks to you both, as your help was invaluable in positioning Allsport at the head of the pack. To Jonathan Klein and Mark Getty, who saw Allsport as precisely the right vehicle to add to and spearhead their growing portfolio of companies that became the force that is now Getty Images; we all knew that it could happen.

Many more people are recognised in the pages of this book, too many to list here individually, but to Bob Beamon, Daley Thompson, the other Mike Powell and the recently departed Diego Maradona who, with the Belgian national football team, gave me 'that photo' and to all the athletes in whichever disciplines whose images we have captured and given to the world, I thank you all.

My special thanks to all those friends and colleagues who helped me in the process of writing this book, in particular; Tony Duffy, Adrian Murrell, Lee Martin, David Cannon, Mike Powell, Darrell Ingham, Dick Scales, Matthew Schoen, Nick Harvey, Tony Cadman, Koji Aoki, David Botterill and Evan Sepion and any errors or omissions are entirely my own.

To John Walker, my friend of over forty years and now my Editor and collaborator, who not only suggested the book, but coerced me into writing it and has spent long hours converting my initial ramblings into recognisable English, for which I am very grateful.

I am most indebted to my parents who instilled in me the facets of fairness and truth that have guided me throughout this voyage, and to my brothers, with whom I have shared so many experiences and occasionally, dangers, particularly Mike, who I tried so hard to dissuade from following me into this business. He persevered and became one of the most accomplished sports photographers in the world.

Finally, to my wife, Beans, and our beautiful daughters, Lucie and Sophie, who have followed me, unquestioning and unprotesting, as I have moved them around the world in pursuit of my personal goals; my love and thanks to them. Only they know the sacrifices they have made on my behalf, but who agree that it was all worth it.

Steve Powell
1ˢᵗ September 2021

INDEX

Lightning Source UK Ltd.
Milton Keynes UK
UKHW020754281021
392935UK00004B/142/J